80-10-3

W9-ACD-159

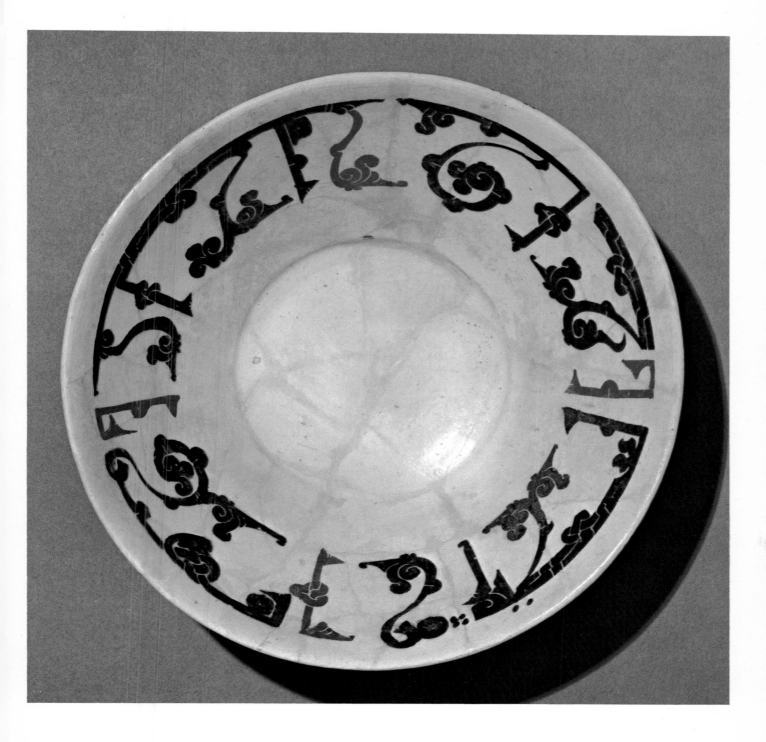

Ceramic dish with Kufic inscription (see No. 10).

الحمد لله الذي انزل على عبده الكتاب

بسم الله ما ندكر العالم الاعلى الوهاب

والصلوة والسلام على محمد وآله واصحابه خير الانام

انما ندخون ميام من تاسبات ترماندي وتوفيقات سخني

ازبشرو نرونعمت نابلدان وهربيني ازصفحات سعادت

اين كتاب كرام واجب الاحترام كره مطلعي اخترست

عباراتش درلطاف

من خامش مبرست ازسيم هدايت درخشان

ونكين ايباد لقريش

عون جان شيرين نودكطراوت جون مرجان

ارايش جويم تطبى

جون كرشمه شكرلبان شور انكبر ومعاني جب

بال انكرسال هاسبى

سبزخطان دل آويز مهند سان سال خورده انكا

دردور خوش ماند هلهء

بفقان كردين اند كتاب سنان مشكين توقع بقالميز

معاينش درزبرحرف سياه درخشنا جون همو روشن جماه

نا دشكل همهاى خاننب ومالى دل

دزنكارنش كه ازغايت خط نسخ برتشمه زرنكارمهر ولوحه

اغرايب اثار وتصوير اوراق بلايع نكاره وترتيب الكا

NK 3636.5 .A2 W44
Welch, Anthony.
Calligraphy in the arts of
the Muslim world

by Anthony Welch

Calligraphy in the Arts of the Muslim World

Published in Cooperation with
The Asia Society, New York
UNIVERSITY OF TEXAS PRESS
Austin

WITHDRAWN
RITTER LIBRARY
BALDWIN WALLACE COLLEGE

Calligraphy in the Arts of the Muslim World is the catalogue of an exhibition shown in Asia House Gallery in the winter of 1979 as an activity of The Asia Society to further greater understanding between the peoples of the United States and Asia. Subsequent showings will be held in the Cincinnati Art Museum, the Seattle Art Museum, and The St. Louis Art Museum.

LIBRARY OF CONGRESS CATALOGING IN PUBLICATION DATA

Welch, Anthony.
 Calligraphy in the arts of the Muslim
 world.

 "Catalogue of an exhibition shown in Asia House Gallery in the winter of 1979 as an activity of the Asia Society."
 Bibliography: p.
 1. Calligraphy, Islamic—Exhibitions.
I. Asia House Gallery, New York.
II. Asia Society. III. Title.
NK3636.5.A2W44 745.6'199'27
78-11796
ISBN 0-292-73818-8
ISBN 0-292-73819-6 pbk.

Copyright © 1979 by The Asia Society, Inc.
All rights reserved
Printed in the United States of America

Designed by George Lenox

This project is supported by grants from the National Endowment for the Arts, Washington, D.C., a federal agency; the Andrew W. Mellon Foundation; and Exxon Corporation/Esso Middle East.

Opposite title page:
Page from a manuscript of the
Shahnamah of Firdausi (see No. 32).

Opposite:
Silk tomb cloth (see No. 62).

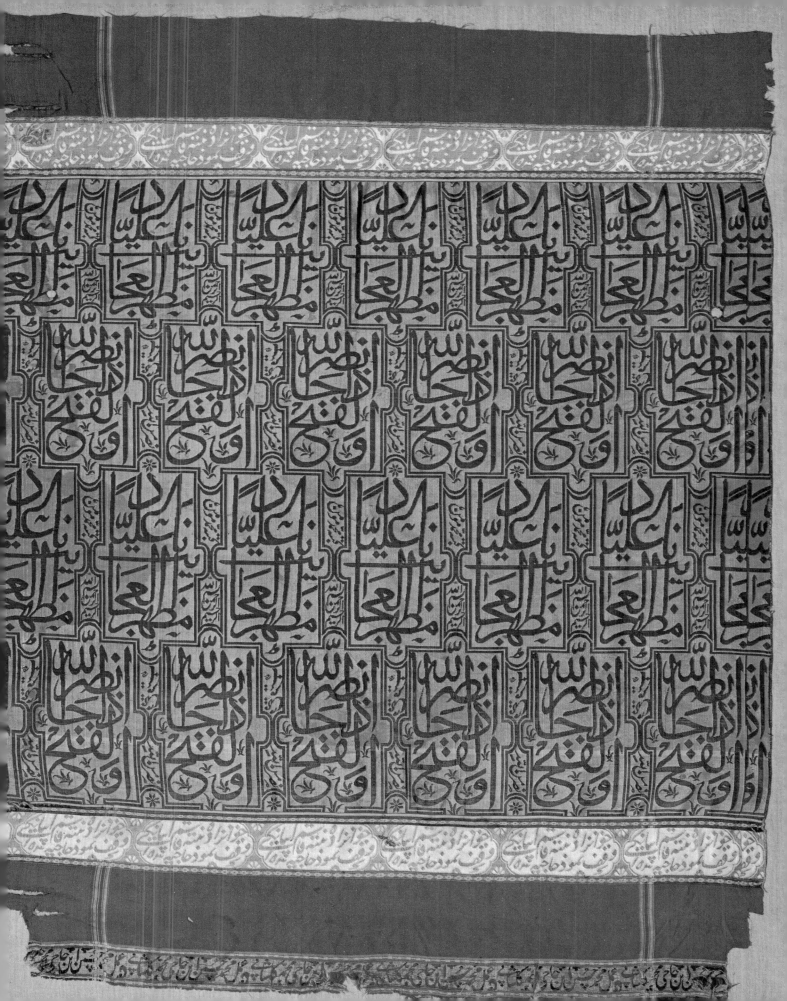

بِسْمِ اللَّهِ الرَّحْمَٰنِ الرَّحِيمِ

الم ۞ ذَٰلِكَ الْكِتَابُ لَا رَيْبَ ۛ فِيهِ ۛ

هُدًى لِلْمُتَّقِينَ ۞ الَّذِينَ يُؤْمِنُونَ

بِالْغَيْبِ وَيُقِيمُونَ الصَّلَاةَ وَمِمَّا رَزَقْنَاهُمْ

يُنْفِقُونَ ۞ وَالَّذِينَ يُؤْمِنُونَ بِمَا أُنْزِلَ

إِلَيْكَ وَمَا أُنْزِلَ مِنْ قَبْلِكَ وَبِالْآخِرَةِ هُمْ

بِسْمِ اللَّهِ الرَّحْمَٰنِ الرَّحِيمِ

الْحَمْدُ لِلَّهِ رَبِّ الْعَالَمِينَ ۞ الرَّحْمَٰنِ الرَّحِيمِ

مَالِكِ يَوْمِ الدِّينِ ۞ إِيَّاكَ نَعْبُدُ وَإِيَّاكَ

نَسْتَعِينُ ۞ اهْدِنَا الصِّرَاطَ الْمُسْتَقِيمَ

صِرَاطَ الَّذِينَ أَنْعَمْتَ عَلَيْهِمْ غَيْرِ

الْمَغْضُوبِ عَلَيْهِمْ وَلَا الضَّالِّينَ

Contents

Lenders to the Exhibition

Prince Sadruddin Aga Khan
American Numismatic Society, New York
The Art Institute of Chicago
AXIA, London
Edwin Binney, 3rd
Cincinnati Art Museum
The Cleveland Museum of Art
David Collection, Copenhagen
The Detroit Institute of Arts
Fogg Art Museum, Harvard University, Cambridge, Massachusetts
Institut de France, Musée Jacquemart André, Paris
The Keir Collection, Ham, Richmond, England
Kungl. Livrustkammaren, Stockholm
Los Angeles County Museum of Art
The Metropolitan Museum of Art, New York
Musée des Arts Décoratifs, Paris
Musée du Louvre, Paris
Musée Historique des Tissus, Lyons
Museum of Fine Arts, Boston
Nelson Gallery—Atkins Museum, Kansas City
Royal Asiatic Society, London
The St. Louis Art Museum
The Textile Museum, Washington, D.C.
Victoria and Albert Museum, London
The Walters Art Gallery, Baltimore

Opposite:
Ex libris from an album made
for Shah Jahan (see No. 85).

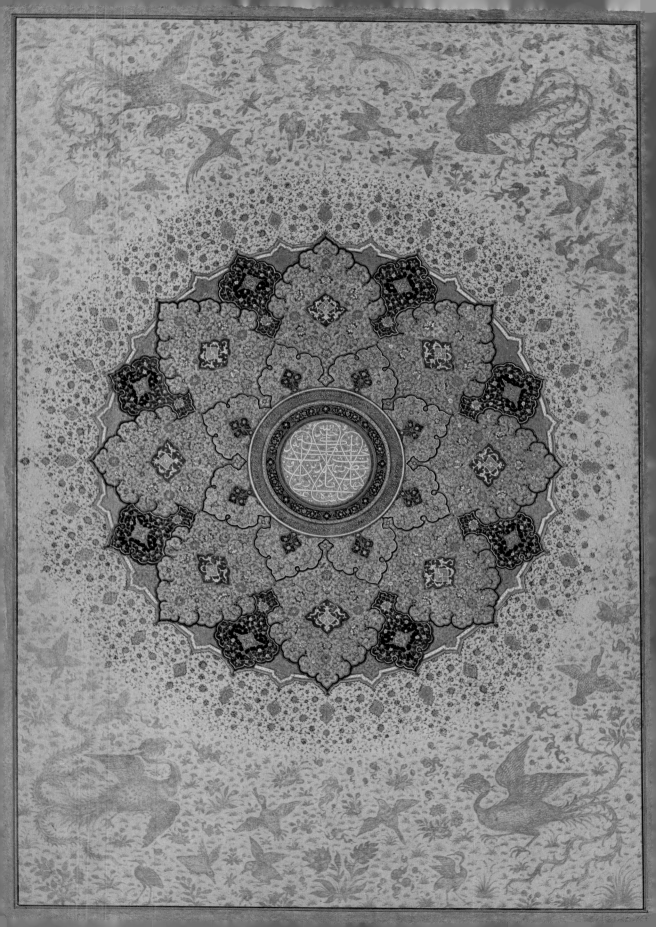

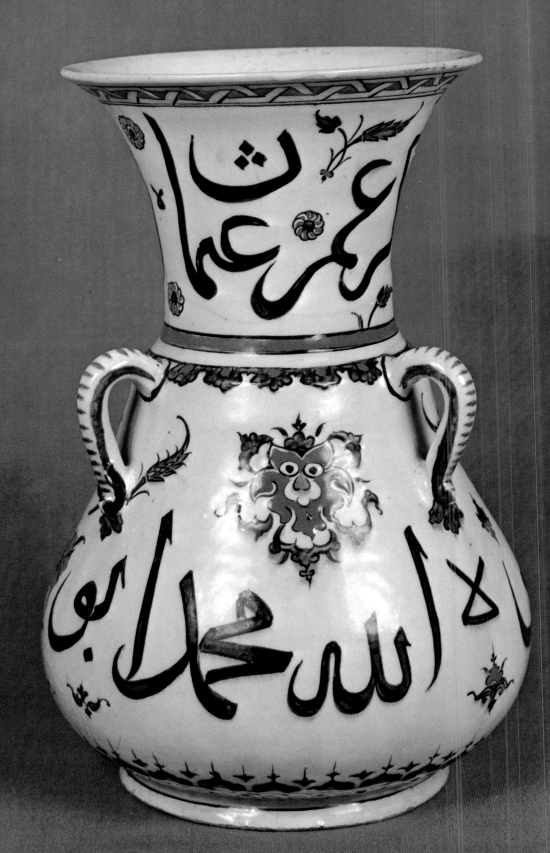

Ceramic mosque lamp (see No. 31).

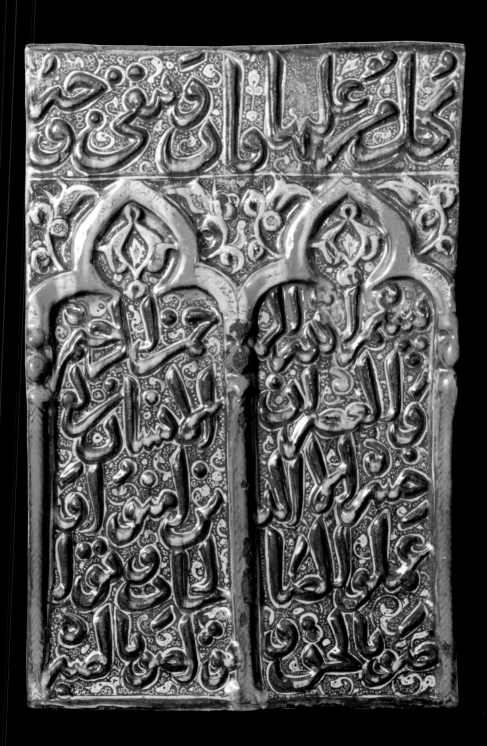

Ceramic *mihrab* (see No. 42).

والصلوٰة والسلام علی خیر خلقه محمد وآله واصحابه جمعین

مانصیحت بجای خود کردیم روزگری درین سپر بردیم
ترنیاید کوش غبت بکس بر بر مولان بنام باشد پس

کتبه العبد المذنب الفقیر محمد حسن الکشمیری
غفرالله ذنوبه و ستر عیوبه
فی شهور سنه تسعین تسعمائه
بلدۀ فتحپور

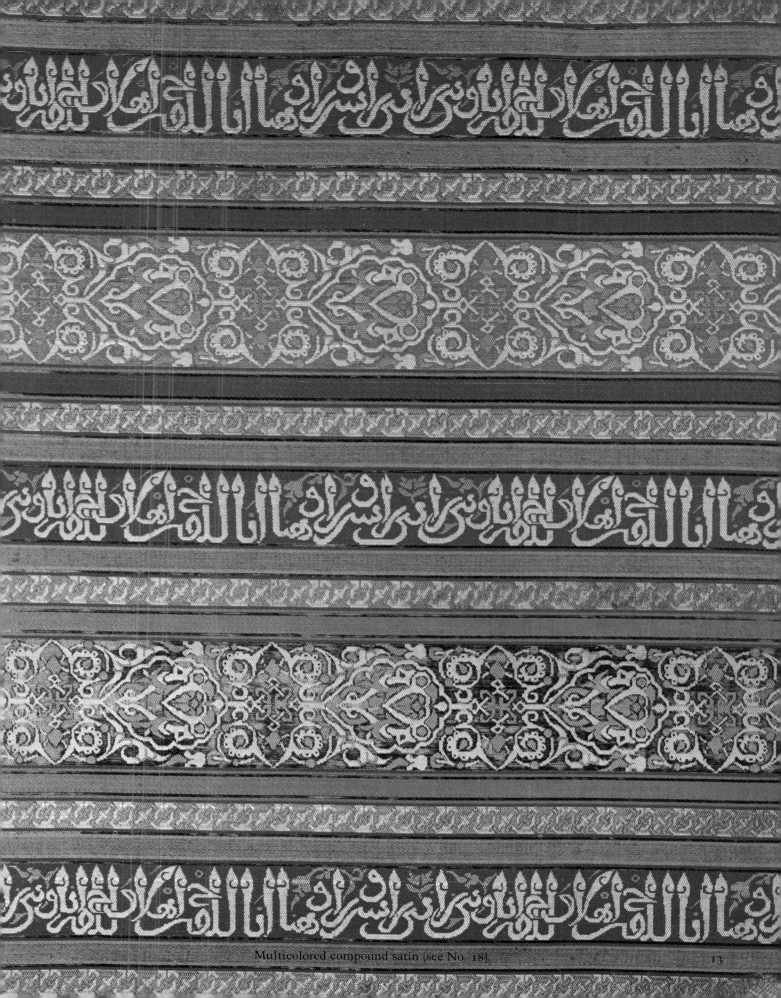

Multicolored compound satin (see No. 18).

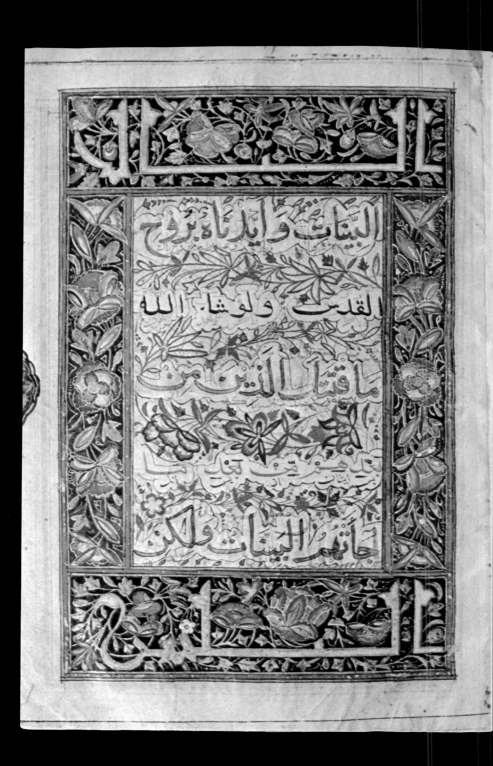

Manuscript of the *Qur'an* (see No. 75).

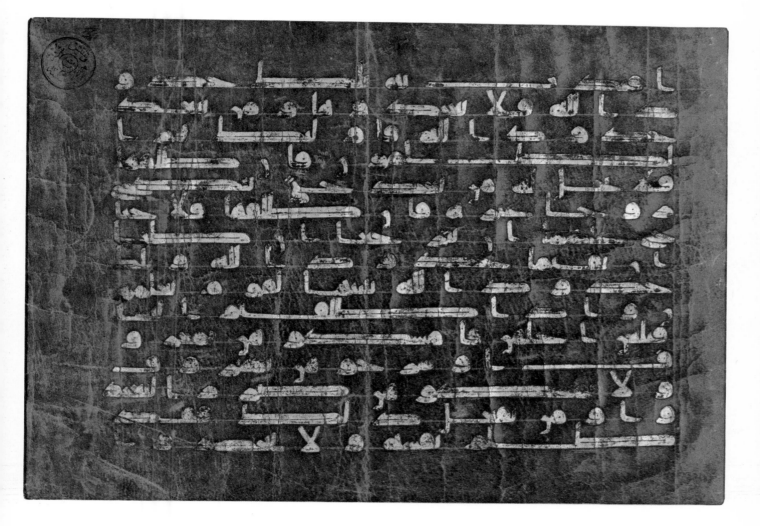

Page from a blue vellum *Qur'an* (see No. 4).

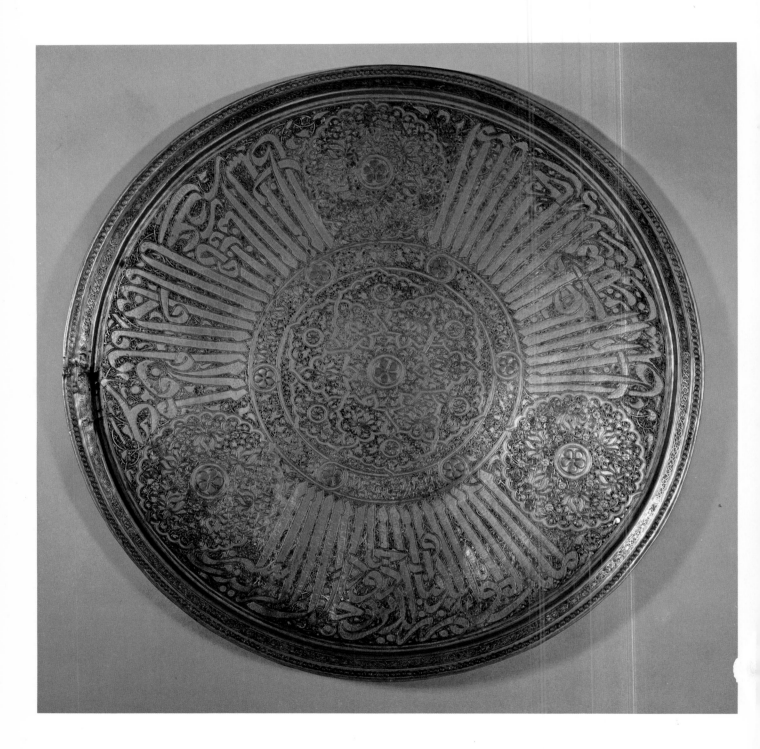

Bronze tray (see No. 24).

Foreword

Taken from the Greek, the word *calligraphy* quite simply means beautiful writing. Among certain cultures, however, the concept of calligraphy goes far beyond this definition. For the Islamic world, the art of writing has always been of extraordinary importance. Because it was used to create the *Qur'an*, Islam's most holy text and the visual embodiment of Allah's message to mankind, Arabic script came to possess a spiritual force difficult for non-Muslims to comprehend.

In the West, a similar manifestation of faith in the power of the beautifully written word is found in the manuscripts that were produced by countless anonymous monks in the Middle Ages; but their art never reached very far into secular circles, and it died with the birth of printing. By contrast, in the cultures of Islam, the use of the written word as a symbol with both religious and aesthetic significance is pervasive and is as important today as it was over a thousand years ago.

Throughout the history of Islam, calligraphy could be practiced by any man, whether he was a professional scribe or a common believer. If it was carried out in a trained and disciplined manner, the very act of writing could produce a beautiful work of art that was also a pious expression of faith. As Dr. Welch tells us in his introduction, certain texts are also thought to have additional specific power, and might procure forgiveness of sins, assure the attainment of knowledge, or prevent misfortune and disease. Some letters are even believed to have their own mystical properties, and others have acquired pictorial associations. Given this emphasis, it is not surprising that calligraphy is ubiquitous in the arts of Islam. It appears on architecture, on virtually all forms of the decorative arts, on coins and jewelry, on textiles, on weapons and armor, on tools and utensils, in paintings, and of course, in manuscripts.

Although such an obsessive preoccupation with one single art form might be thought to have a stultifying effect, the development and use of different scripts and the inventive way in which the calligraphy is made to fit into the given spaces of an object, page, or architectural element provide endless fascination and variety to this art. The generosity of the many lenders in Europe and the United States enables us to show the finest examples of different scripts as they appear on various types of objects. This exhibition thus provides a broad view of the beauty and pervasiveness of calligraphy as decoration in Muslim arts.

This is the second exhibition assembled for Asia House Gallery by Anthony Welch, associate professor, history in art, University of Victoria. In 1973, we presented *Shah ʿAbbas and the Arts of Isfahan*, an exhibition chosen by Dr. Welch, who also wrote the catalogue. He has carried forth this calligraphy project with similar enthusiasm, taste, and efficiency and has selected objects of the finest quality to illustrate his study. Because of the complexity of the task of translating so many different scripts, Dr. Welch has relied on the expertise of several colleagues to supplement his own extensive knowledge in the area of Islamic texts. We join him in our thanks to all of these scholars for their assistance.

Following its display at Asia House, the exhibition will travel to three other cities in the United States. For their help in arranging details of the tour, we thank Millard Rogers and Daniel Walker of the Cincinnati Art Museum, Willis Woods and Henry Trubner of the Seattle Art Museum, and James Wood and Richard Cleveland of the St. Louis Art Museum.

Much needed financial aid for this project has come from many quarters. Expenses for the publication of the catalogue have been defrayed by an on-going assistance grant from the Andrew W. Mellon Foundation. Two grants were received from the National Endowment for the Arts: a planning grant which enabled Dr. Welch to travel to museums and collections in this country and Europe to locate objects for the exhibition, and an aid to special exhibitions grant. The gallery continues to benefit from the generosity of the Starr Foundation for underwriting some of the costs of installation, and two most generous contributions for general support for the project were received from His Majesty Sultan Qaboos bin Said of Oman and Exxon Corporation/Esso Middle East.

As always, the gallery staff has performed most ad-

mirably, pulling together loans, photographs and information from many different sources and keeping abreast of the many demands of such a complex project. Assistant director Sarah Bradley, registrar Terry Tegarden, publicity coordinator Kay Bergl, and secretary C. Lew Wang have given their wholehearted assistance wherever it was needed. Cleo Nichols and his installation crew have created a proper setting for these objects, and Otto Nelson has been on hand to supply us with much needed photographic assistance in his characteristically professional, cheerful, and untiring manner. We hope these efforts will convey the qualities and significance of Islamic calligraphy to our ever-growing audience.

Allen Wardwell
Director, Asia House Gallery

Preface

Calligraphy occupies the central place in Islam's visual culture, yet Western art history has focussed far more on Islam's figural than on its calligraphic arts, and there is little awareness of the art that pervades Islamic civilization. This state of relative neglect has provided much of the initial impetus for this exhibition and this book; each in its way is an attempt to create balance in our understanding of one of the world's great cultures. But the subject is too vast and even too diffuse. What is presented here is a small sampling of the aesthetic, cultural, and scholarly wealth available. The Asia Society's attention to the lands east of the Euphrates has given me the opportunity to deal with Iran and India in some depth, while still presenting a comparative body of material from Muslim lands to the west. But there are areas and periods that have been omitted or too sparsely dealt with, and only some of Islam's many styles of Arabic script have been presented here. While I have tried to maintain balance, true justice has eluded me.

Theoretical considerations and larger historical problems have been examined in the Introduction. The individual entries have been arranged in two ways. The first fifteen objects, chronologically early and provided with inscriptions in angular scripts, are grouped together under the generic term *Kufic*. The remaining seventy-five entries, largely in cursive scripts, are divided geographically and chronologically. Though some of their inscriptions are repetitive, they nevertheless do reveal something of the richness of Islamic literatures. Although I have not used a formal system of transliteration, I hope that Arabic, Persian, and Turkish words rendered in English in this book will be clear both to scholars and to the wider public.

Any scholar owes a debt to his colleagues, and I perhaps more than most. My introductory essay owes much to the work of five scholars, and without the writings of Nabia Abbott, Adolf Grohmann, Martin Lings, Franz Rosenthal, and Annemarie Schimmel I could not have written my own. But I am also indebted to many others, for I am not a literary historian, and it has been a blessing that I could turn to talented and generous colleagues for help. Jerome W. Clinton of Princeton University read and translated the inscriptions on entries Nos. 32, 43, 44, 45, 46, 52, 54, 65, 66, 67, 68, 73, 78, 81, 83, 85, and 87, and the elegance and accuracy of his work indicate his enormous gift of time and expertise. Roy P. Mottahedeh, also of Princeton University, generously read and translated Nos. 2, 17, 25, 38, 55, and 71, and both he and Jerome Clinton offered valuable insights about objects and their epigraphs. In preparing their translations professors Clinton and Mottahedeh made frequent reference to 'Abbas Zaryab of the University of Tehran, whose generous help they would like to acknowledge, as would I. Roy Mottahedeh would also like to acknowledge the kind assistance of Amin Banani of the University of California, Los Angeles, in reading No. 71. It is obvious from the sheer number of objects with which professors Clinton and Mottahedeh have dealt that this has been a time-consuming and exacting labor. I and this book owe much to them.

So too am I indebted to Annemarie Schimmel of Harvard University, who read the inscriptions on Nos. 80 and 88 and also read most of the manuscript of this book. Despite the pressures of many other commitments, she caught errors, both great and small, made valuable suggestions about objects, and with her kindness and generosity gave me confidence in what I was doing.

The section on Islamic coins (Nos. 90a–90v) could not have been written without the assistance of Michael Bates of the American Numismatic Society, who freely gave many hours of his time on this book's behalf.

Several other objects were read by other scholars: Howard Crane of Ohio State University read No. 34; Harold W. Glidden read and translated No. 18; and the two translations from Turkish, Nos. 56 and 72, were done by Maria Subtelny. Other translations are my own or are cited in the text.

Louise Mackie of the Textile Museum, Washington, D.C., gave me much valuable advice, as did Jere L. Bacharach of the University of Washington.

Allen Wardwell, director of Asia House Gallery, has

enthusiastically supported this project from the outset
and watched over its progress with care. Virginia Field,
formerly associate director, provided valuable initial
assistance. Sarah Bradley, assistant director, oversaw the
planning of the exhibition and the writing of this book
with patience, good humor, and expertise, and for her
constant readiness to help with details and with grand
design I am deeply grateful.

Nothing could have been done in this endeavor if
public institutions and private individuals had not been
willing to lend the objects exhibited and published here.
To the public institutions and their curators and to the
private collectors, who did so much to make this project
possible, I owe real thanks.

Since the spring of 1976 my research on this project
has been supported by grants from the Asia Society and
the National Endowment for the Arts, and I acknowledge
their help with gratitude. During my 1977–1978 sabbat-
ical year I have been generously supported by several
institutions, and it is a pleasure and honor to thank them
here: the University of Victoria, the Social Sciences and
Humanities Research Council of Canada, and the Shastri
Indo-Canadian Institute. Their assistance has enabled
me to complete this book and undertake new research
in other areas.

I should like to dedicate this book to Muriel, Nicholas,
Bronwen, and Emily, who have given me the strength to
write it.

Anthony Welch
Victoria, British Columbia

Introduction

1

The pen is the beacon of Islam and a necklace of honor with princes, kings, and chiefs.[1]

Arabic script is the central form of Islam's arts and was the first and is the foremost of its characteristic modes of visual expression. Throughout the vast geography of the faith its use unites believers and helps to mark them off from others. Whether transmitting the holy *Qur'an* or rendering indigenous language, the Arabic script is basic to Islamic culture, and the shapes and character of its alphabet have permeated every level of society. While handwritten books and single calligraphic pages serve as the primary vehicle for the written word, almost any physical object can bear the script, so that architectural structures and precious objects, whether for sacred or secular use, provide innumerable surfaces for the written word.

The visual presence of the word is found in the earliest years of Islamic culture; and, although succeeding eras vary greatly in the kinds, qualities, and quantities of arts produced, every period possesses impressive calligraphy. The role of script was too central and its production was too varied for its use to be substantially curtailed. The reasons for the chronological, social, and geographic pervasiveness of the calligraphic arts lie in the central fact of Islamic culture—the *Qur'an*. For while Islamic calligraphy owes its historical development to human inventiveness and genius, it owes its origins to the revelation of Islam's holy book.

1. Edward Robertson, "Muhammad ibn 'Abd ar-Rahman on Calligraphy," *Studia Semitica et Orientalia* (1920), p. 65.

2

Thy Lord is the Most Bounteous,
Who teacheth by the pen,
Teacheth man that which he knew not.[2]

This verse from the *Qur'an* refers, not simply to knowledge in general, but to specific knowledge gained from revelation. To Muslims the one hundred and fourteen *surahs* (chapters) presented by Allah to His Messenger, Muhammad, in spoken form have existed for all time; they are Allah's direct words, transmitted to humanity through Muhammad. Thus the written form of the *Qur'an* is the visual equivalent of the eternal *Qur'an* and is humanity's perceptual glimpse of the divine. The holiness of the *Qur'an* extended to lend a special aura to all forms of the written word, which thus became in essence the "sacred symbol"[3] of Islam. Where almost every other faith made use of figural images to convey its core convictions, Islam's early theocracy chose the word and saw in figural arts real implications of idolatry. Whether by clear design or less overt development, it came to be Islam's response to the icons of opposing religions and served as the most effective means of visually separating the Muslim's world from the world of others. For anti-Muslim opponents to the west and east and for non-Muslim governed peoples under the authority of Islam, the Arabic

2. *The Glorious Koran*, trans. Marmaduke Pickthall, *surah al-'Alaq* (The Clot) 96:3–5. All subsequent quotations from the *Qur'an* are from this bilingual edition by a gifted Arabist whose native tongue was English, but who was also a Muslim. Passages from the *Qur'an* have been cited in the following manner: the Arabic name of the chapter or *surah*, followed by the English name in parentheses, and concluded by *surah* and verse numbers. The only exceptions are those few *surahs* whose names are untranslatable and, therefore, are not supplied with English names.
3. A term used by Franz Rosenthal, "Significant Uses of Arabic Writing," *Ars Orientalis* 4 (1961), pp. 15–23. Islam's attitude toward the figural arts is complex but seldom officially amounted to an outright and wholesale prohibition. It can be argued, however, that orthodox Islam's disinclination toward the use of figural images to convey religious subjects was a significant impetus in the development of calligraphy. For a recent review of this problem see Anthony Welch, "Epigraphs as Icons," in Joseph Gutmann, ed., *The Image and the Word*, pp. 63–74.

script and its calligraphic renderings became the vital symbol of Islamic belief.

But like the icons of most other faiths, script also represented power. Its preeminent use—to write the divine message of the *Qur'an*—of course endowed it with extraordinary strength and transcendent significance: from this world's manifold possibilities Allah had chosen it, and the Arabic language it initially expressed, as the vehicle for his final revelation. Thus whether understood as content or simply perceived as form, the Arabic script carried with it an implicit affirmation of authority. That this was early clear is indicated by *Hadith*:[4] "When the Prophet intended to write to the Romans, it was said to him that they would not read his letter if it did not bear a seal. So he ordered a ring of silver to be made and its impress was Muhammad the Messenger of Allah."[5]

Within two generations script became one of the dominant manifestations of power. In its early decades Islam had used the coins or numismatic imagery of conquered states, chiefly Byzantium or Sasanian Iran; their figural cast signified validity and value long after the collapse of the systems that created them (see No. 90a). By the end of the seventh century A.D. the Arabic alphabet had assumed this role, and a decree from the caliph 'Abd al-Malik (685–705) ordered that Arabic should be the administrative language of Islam and that epigraphic statement should replace the portrait of the ruler on coins: from this point on it was to be largely word and not image that gave value to, and legitimized rule on coinage, the art form most seen and most used by the populace. On documents, doorways, minarets, and objects it was also the ruler's name, and not his face, that symbolized the state.

As Muslim Arabs conquered other lands, their script and faith went with them, and the peoples they ruled generally acquired both. Thus as Persians and Turks accepted Islam their scripts, though not their languages, fell into disuse and disappeared; the scripts were too much in touch with the pre-Islamic past (the Jahiliyyah) to survive. The script served as the binding visual medium of the state—both to its Muslims and to its many minorities—and was the formal expression of Islam's universal aspirations.[6]

With such a central position in Islamic culture script soon assumed a personal as well as a social role. The writing of the *Qur'an* was a pious act, in which not only professional scribes but also rulers and the more ordinary devout and literate Muslims engaged.[7] The writing of the *asma' al-husna* (the ninety-nine most beautiful names of Allah), as well as the names of the Prophet, his kin, and the imams were also favored religious activities, while a beautiful rendering of the *bismillah* (the words "in the name of Allah" that begin the *Qur'an*, almost every pious statement, and, until modern times, every book) was thought to bring forgiveness of sins. Calligraphic ability was closely connected with piety. A large measure of contemplative life centered on the written word, for observation of verses from the *Qur'an* and the names of Allah and holy persons constituted one of the most used aesthetic roads to religious experience: like the icon, the epigraph in content and formal harmonies functioned as a manifestation of the intangible and eternal divine.[8]

4. The *Hadith* are sayings of the Prophet Muhammad. Thus the *Qur'an* is Allah's words, and the *Hadith* contain the Prophet's and form a body of scripture second in authority to the *Qur'an*. There are six orthodox collections of the *Hadith*. This quotation is from Mawlana M. 'Ali, *A Manual of Hadith*, pp. 362–363.

5. This incident is said to have taken place in 6 H. (627–628 A.D.). According to another *hadith* ('Ali, *Manual of Hadith*, p. 363), the words were arranged horizontally on the signet: "Allah" was written at the top; "Messenger" in the middle; and "Muhammad" at the bottom. The "Romans" referred to here are the Byzantines.

6. The importance of the script as a visual statement of Islamic unity is negatively indicated by Ataturk's determined Latinization of Turkish. His success significantly separated the national state of Turkey from its Islamic past and from its Muslim neighbors. Similarly, the Cyrillic alphabet has largely supplanted the Arabic in the Muslim lands of the Soviet Union.

7. The Mughal emperor Awrangzeb, attempting to gain greater status as the defender of Islam in India, piously and rather publicly made a number of copies of the *Qur'an*. It was advisable for Maghribi young women, seeking a good marriage, to write at least one copy of the holy book.

8. See Erica Cruikshank Dodds, "The Image of the Word," *Berytus* 18 (1969), pp. 35–58.

3

**And this is a confirming Scripture
in the Arabic language.**[9]

Modern scholarship has established that the Arabic script
is derived from the Aramaic Nabataean alphabet in use in
the early centuries of the Christian era in the lands imme-
diately to the east of the Jordan River.[10] Major develop-
ment of both Arabic language and script took place in the
pre-Islamic Arab kingdom of the Lakhmids, which occu-
pied a large area south and west of the Euphrates, and
then spread throughout the Arabian peninsula. It is basi-
cally a consonantal script of twenty-eight letters, record-
ing long but not short vowels.[11] These letters are derived,
however, from only seventeen distinct forms, distin-
guished from one another by a dot or dots placed above or
below the letter. Short vowels are also often indicated by
small diagonal strokes above or below letters. In Islam's
early centuries the use of diacritics and vowel markers
was sometimes regarded with suspicion: a truly educated
reader ought to have no need for them. In order to avoid
insult to a reader, scribes of some manuscripts eschewed
their use (Nos. 3 and 4). But without the marks and with-
out foreknowledge of the text, the reader not only could
find words hard to read but also could easily misunder-
stand them. Until and even after the use of diacritics
became customary, there were spirited and colorful de-
fenses of them: "ʿAbd al-Hamid said: Barren soil is some-
thing desolate. A flower garden on the other hand, is
something pretty, and when it is in bloom, its beauty is
perfect. Thus a handwriting without dots and diacritical
points is like barren soil. On the other hand, a handwrit-
ing that is provided with dots and diacritical points is like
a garden in bloom."[12]

Written from right to left, the Arabic script at its best
can be a flowing continuum of ascending verticals, de-
scending curves, and temperate horizontals, achieving a
measured balance between static perfection of individual
form and paced and rhythmic movement. There is great
variability in form: words and letters can be compacted
to a dense knot or drawn out to great length; they can be
angular or curving; they can be small or large. The range
of possibilities is almost infinite, and the scribes of Islam
labored with passion to unfold the promise of the script.

Little in the early history of the script had presaged its
emergence as the major artistic vehicle of a great civiliza-
tion. Pre-Islamic Arabic script was a tool suited to its
functions, then largely administrative and commercial.
It was only after the revelation of the *Qurʾan* and the
spread of Islam far beyond the boundaries of Arabia that
the script acquired the characteristics of sanctity and
versatility essential to its role. By the end of the seventh
century A.D. it was being used administratively, on archi-
tecture, and on coins and the necessity to pen impressive
epistles to foreign rulers and produce large, handsome
Qurʾans for mosques and princes provided the impetus
for calligraphy to become Islam's most distinctive and
innovative visual feature.

9. *Surah al-Ahqaf* (The Wind-curved Sandhills) 46:12.
10. For the origins of Arabic script see Nabia Abbott, *The Rise of the
 North Arabic Script*, and Adolf Grohmann, *Arabische Paläographie*.
11. Persian adds four additional letters.
12. Franz Rosenthal, "Abu Haiyan al-Tawhidi on Penmanship," *Ars
 Islamica* 13–14 (1948), p. 18.

4

Handwriting is jewelry fashioned by the hand from the pure gold of the intellect. It also is brocade woven by the calamus with the thread of discernment.[13]

Script came to permeate the culture. Letters conveyed the ninety-nine beautiful divine names, as well as the *Qur'an*; and because of these functions they were studied, not just by scribes eager to render them in the most impressive possible manner, but also by scholars and mystics who sought in them hidden knowledge and special powers. Belief in the particular, even magical, efficacy of the letters of the Arabic script was widespread in Islam, though learned Muslims often regarded this aspect of their culture with grave suspicion.[14]

The immense body of lore based upon the properties of letters can only be hinted at here.[15] It found its most dramatic expression in the writings of the Hurufis, whose *'Ilm al-Huruf* (science of letters), systematized in the fourteenth century and later, gave organized form to earlier occult treatments of the alphabet. According to this way of thinking, the twenty-eight letters could be divided into four equal categories, corresponding to the alchemical elements of fire, air, earth, and water. Certain combinations of letters were therefore judged to be effective talismans against particular afflictions: letters of the "water" group could reduce or eliminate fever, while "fire" letters could increase the intensity of a war or conflict. The letters *alif*, *lam*, and *mim*, which begin the *surah al-Baqarah* (The Cow) of the *Qur'an*, were deemed to have healing powers, and to some other individual letters were also ascribed special strengths.

Each letter of the alphabet had a numerical equivalent in a system known as *abjad*, which had some immediate practical applications in the pagination of prefaces and in the writing of dates. In the latter a demanding art of the poetical chronogram developed and was useful for the composition of epitaphs containing the date of demise. Cabalistic researchers analyzed words (notably those of the *asma' al-husna*) for their numerical value, and magical procedures used the precious quantities derived from them. For mystical thought this kind of analysis was also fruitful, as a single, well-known example indicates. The two words *Ahmad* (a man's name) and *Ahad* (a divine name, signifying "unity") differ only by one letter, the *mim*. Now the *mim* has a numerical value of forty: therefore, the stages of mystical ascension separating the wholly human from the wholly divine were judged to be forty. Parenthetically, the Prophet Muhammad's name begins with *mim*, while the divine name Allah (and also *Ahad*) begins with *alif*, the first letter of the Arabic alphabet, the numerical equivalent of one, and the symbol of divine unity.

Since they occupied such a prominent place in mystical Islam, it was only natural that letters should be used as metaphors in poetry, imbued as it was with mystical thought.[16] To those filled with a love of the alphabet's forms, the letter *mim* resembled the mouth; the letter *'ayn* an eye; the *alif* an upright, slender youth; the *dal* a person bent with age; and the combined letters *lam* and *alif* a close embrace between two lovers.

I saw you in my dream embracing me
Like as the lam of the scribe embraces the alif.[17]

The resemblance between the form of the Prophet's name and a worshipper bowing in prayer was often noted, and the fact that both the name Allah and the basic profession of faith ("There is no god but Allah") consisted almost wholly of ascending vertical letters was taken as calligraphic evidence for both the divine origins of the script and the truth of the faith. Almost all the letters could be

13. Ibid., p. 13.
14. Ibn Khaldun, *The Muqaddimah*, trans. Franz Rosenthal, pp. 171–227.
15. Further initial information on this problem can be found (with a bibliography) in the *Encyclopaedia of Islam*, 2nd ed., I: 97–98 (article on *abjad*); II: 733–735 (article on Fadl Allah Hurufi); and III: 595–601 (articles on *huruf, huruf al-hidja'*, and *hurufiyya*).
16. See Annemarie Schimmel, "Schriftsymbolik im Islam," in Richard Ettinghausen, ed., *Aus der Welt der Islamischen Kunst*, pp. 244–254.
17. Quoted and translated by Rosenthal, "Significant Uses of Arabic Script," p. 19. This poem has been attributed to various authors.

5

employed metaphorically, and their widespread use in poetry is a vivid indication of the degree to which the alphabet's forms had permeated Islamic society. Even the art of calligraphy itself acquired status in poetic literature, particularly in Turkish:

Those basil lines about thy lip the judge
Before the lines of Yaqut doth prefer[18]

wrote the fifteenth-century Ottoman poet Ja'far Chelebi in a complex play on words which needs elucidation. The initial words, *"khatt-i rayhani"* can be translated as either "those basil-like hairs" or "the *rayhani* script," a well-known type of cursive writing. One of the most distinguished practitioners of *rayhani* was the thirteenth-century calligrapher Yaqut, whose name means "ruby." Thus in one sense the connoisseur and judge prefers the beloved's "basil lines" to Yaqut's *rayhani* script, and that is high praise indeed; in another sense the judge esteems these "basil lines" more than those around the ruby-like lips of other beautiful youths. In English explication this skillful verse seems strained and overdone. Its loss of power and acquisition of artificiality under Western eyes measures both the intensity of the metaphor and our distance from its cultural boundaries.

18. E. J. W. Gibb, *A History of Ottoman Poetry*, II: 282.

The calamus is the most potent amulet, and handwriting is its result.[19]

If the revelation of the *Qur'an* altered the earlier, utilitarian role of Arabic script and transformed simple letters into divine creations with metaphoric and talismanic powers, it also changed the way in which the instruments of writing were regarded. Now they too figured among the very first divine creations and came to serve as ready similes for mortal lives. With its power to preserve knowledge and extend thought over time and space, ink was compared to the water of life that gives immortality, and human beings were likened to so many pens in Allah's hand.

On a more mundane level, instruments of writing were of great importance, and much of the copious Muslim literature on calligraphy concerned itself with practical matters of sound materials and proper application.[20] Almost exclusively, these ample sources dealt with the written word in its most usual environment—on parchment, papyrus, or paper. Their neglect of other calligraphic habitats like precious objects and architecture was not bias; it mirrored, instead, some clarifying facts, part economics and part art. Most calligraphers were first and foremost scribes who earned their livings writing holy writ or documents of other people's words. Their training, exercises, and finished products were almost all on paper (or its antecedents), and it was on this material that nearly all the innovations in Islamic script were brought to finished form. After the first few decades of Islam most scribes did not work on other materials, and when their handwriting graced other surfaces it did so as design and not as artifact. Calligraphers wrote their

19. Rosenthal, "Abu Haiyan al-Tawhidi on Penmanship," p. 15.
20. See, for example, the following sources in English translation: Ibn al-Bawwab's poem on technique in Ibn Khaldun, *Muqaddimah*, II: 388–389; Qadi Ahmad, *Calligraphers and Painters*; and Sultan 'Ali's poetical epistle in Qadi Ahmad, *Calligraphers and Painters*, pp. 106–125. The extensive and varied Muslim literature on calligraphy is admirably examined in Grohmann, *Arabische Paläographie*, I: 4–32.

words on paper and left it up to specialist artisans to transfer them elsewhere.

Most often the writing instrument was a *qalam* (calamus) made from a reed, the most esteemed reeds being those of the coastal lands of the Persian Gulf. They were valued objects of trade throughout the Muslim world. Their length varied between twenty-four and thirty centimeters, and their diameter generally measured approximately a centimeter. Each style of script required a different *qalam*, cut for the specific script, so that an accomplished and versatile scribe would need many different *qalams*. Shaping the reed was crucial: "Make your knife sharper than a razor; do not cut anything else with it but the calamus, and take very good care of it. Let your *miqatt* be the toughest wood available, so that the point may come out evenly."[21]

Inks were of many different types and colors. Most often black or dark brown inks were used, though their intensities and consistencies could vary greatly. Some calligraphers' manuals offer explicit instructions on the preparation of ink, while others imply that recipes were sometimes closely guarded secrets. Silver and gold inks could be used (No. 4), although some orthodox theologians disapproved of them. Inks of other hues were not suspect, and reds, whites, blues, and yellows, as well as other colors, appear with regularity, particularly in illuminated headings. There were other substantial trappings of the trade: inkpots (No. 40), polishing stones, and sand for drying letters were some of the paraphernalia which made copious penboxes (No. 48) necessary.

Initially, some portions of the *Qurʾan* had been incised in bone or leather or wood, but in the first two centuries of Islam complete copies of the scripture were written on parchment, a writing surface which was durable, lustrous, and luxurious, though its two sides did not accept the ink with equal grace. Papyrus, far more brittle, could not be erased, and hence was widely used for gov-

ernmental records. The two materials were expensive, and their costliness precluded both rapid expansion of the scribal profession and the kind of systematic practice and numbing repetition advised by later masters of the art.

Paper was introduced from China by way of Samarqand in the middle of the ninth century, and it dramatically altered the art. The essential material was now cheaper; immensely more abundant (Egypt had enjoyed a near monopoly on papyrus); more easily cut, shaped, and pasted; and more receptive to color. This technical innovation had a decisive impact on almost every aspect of Islamic civilization. While papyrus was still used occasionally in the eleventh century and while *Qurʾans* in particular continued to be written on parchment long after that in some parts of Islam, paper became the new medium of written communication. It was, therefore, on paper that nearly all subsequent inventions and reformulations of the Arabic script took place.

21. Rosenthal, "Abu Haiyan al-Tawhidi on Penmanship," p. 16.
 Miqatt was the hard material on which the *qalam* was placed for cutting.

6

There is no doubt that the key to the gates of happiness and the luminary in the niche of enlightenment is the reed, fragrant with amber, whose offspring animate the tumult (of the epoch).[22]

The offspring of the reed were legion, but they did not come entirely unannounced. Nabataean had used at least two basic forms of script. One was solid, stately, angular, and monumental, designed to call attention and to impress, particularly when carved in stone. The other was a quicker, slighter, much more fluid script, curving with the natural movement of the hand and used to transcribe and to be legible. This sensible distinction between a script for all time and a script for the moment accompanied the evolution of the early Arabic script from Nabataean.[23]

By the middle of the eighth century there was a substantial number of different styles of script, some angular (and, until the twelfth century, this style was most favored in the arts), some cursive. But individual samples did not bear labels; and, since descriptive terminology tended to be imprecise and eulogistic, it is in many cases impossible to connect a known name with known variation of the script.[24] We must therefore remain uneasily content with grouping the obvious diversity of early angular scripts under the loose rubric *Kufic*, which is traditional in Muslim and Western sources but surely inexact. For later cursive hands, used in the arts, it is possible to be a good deal more precise.[25]

Early medieval calligraphy is far from the uniform entity that the all-encompassing term *Kufic* implies. Numbers 1–15 indicate the enormous range of possibilities in the angular scripts alone when used by skillful masters. Within the bounds of certain canons words could be divided when and where the scribe chose; letters could be horizontally stretched to extraordinary lengths; they could be abruptly compacted or drawn out; they could hug their base line or rise generously above it; and they could be plaited, twisted, leafed, or hung with flowers according to a designer's sense for ornamental form. Transformed by art, this *Kufic* was both powerful and highly individual, meant to be read or admired, a blend of content and design not always simply legible but conveying the central symbol of the faith.

22. Qadi Ahmad, *Calligraphers and Painters*, p. 49.
23. For a detailed exposition of this development see Abbott, *Rise of North Arabic Script*.
24. In ibid., Abbott was able to identify four distinct scripts for the first two centuries of Islam.
25. On this problem two recent books have made extremely valuable contributions: Martin Lings and Yasin H. Safadi, *The Qur'an*, and Martin Lings, *The Quranic Art of Calligraphy and Illumination*. The term *Kufic* is derived from the early Islamic city of Kufa, where a particular variant of the angular style developed. From being the name of a specific script it came to be used generically to denote all angular scripts. Similarly, the term *naskhi* means "the style of the copyist" and denotes a particular style. For decades many Western writers used it to indicate all cursive hands and assumed, quite incorrectly, that *naskhi* evolved out of *Kufic*.

7

[Ibn Muqla] is a prophet in the field of handwriting; it was poured upon his hand, even as it was revealed to the bees to make their honey cells hexagonal.[26]

To some later Muslim writers the high individuality and sometime obfuscation of this early period's calligraphic arts apparently implied disorder, for they regarded Ibn Muqla (886–940 A.D.) as a figure of heroic stature who laid the basis for a great art upon firm principles and who created the *sitta* or six styles of writing.[27] The first of a triad of genius, he was followed by Ibn al-Bawwab (d. 1022 A.D.) and Yaqut al-Musta'simi (d. 1298 A.D.) who built upon his achievements so well that to scribes, connoisseurs, and literati from the fourteenth through the eighteenth centuries these three calligraphers appeared to be the sole creators of the "modern styles" and assumed the role of semilegendary figures personifying developments that took place over many centuries and through the work of many scribes. Each came to be viewed as an exemplar of certain admirable personal characteristics or as a model for necessary calligraphic skills.

Thus Ibn Muqla's achievement represented the adoption of sound geometric principles for calligraphy, while his life exemplified devotion to his art despite great personal suffering. Like many calligraphers Ibn Muqla was also a state official. Between the two roles there was often an intimate connection, since good writing was the indispensable tool for anyone aspiring to high governmental rank. His career was stormy, in part as the result of his own actions. At the age of twenty-two Ibn Muqla was already serving in important posts, where he not only practiced his skills as a scribe but also engaged in heady infighting and intrigue. Three times vizier under the 'Abbasid caliph in Baghdad, his struggle against court enemies and political disintegration was ultimately unsuccessful. Some time after his political disgrace and

replacement in 936 A.D., his property was confiscated, and he was cruelly imprisoned. Subsequently, his right hand was cut off, a dreadful punishment in itself but particularly horrible for a celebrated master of the written word. After still more outrageous maltreatment, he died in the summer of 940.

While Ibn Muqla was often credited with the invention of the cursive scripts, like *naskhi* and the other *sitta* styles, it is next to certain that he invented no script style at all. Instead, he applied to the whole available art of calligraphy specific reformist canons, which amounted to a new method for transcribing already familiar scripts. He provided the means for replacing more individual calligraphic inclinations with styles based on ordered, objective, and universally applicable rules. Thus his *khatt al-mansub* (proportioned script) offered for the first time in Islamic calligraphy a fixed unit of measurement —the rhomboid point of ink left by the pressure of the reed pen in one spot. The upright vertical stroke of the *alif* was to be measured in its terms: some scripts made *alifs* of three points in height, others, five or even seven. Curving letters, like the *nun*, which formed a half-circle, had diameters the size of their script's *alif*, and every other letter stood in fixed relation to the *alif* or the rhomboid point. Script was now regulated on geometric principles, and the passion for mathematics and musical harmonies that characterized so much of medieval Islamic culture found another outlet in the central Muslim art.

Unfortunately we have no authentic work in Ibn Muqla's hand, though his principles are clear.[28] They rapidly became influential but were apparently viewed as too strictly governed by mathematical certainties, for two generations later Ibn al-Bawwab was credited with bringing elegance and grace to the application of

26. Rosenthal, "Abu Haiyan al-Tawhidi on Penmanship," p. 9.
27. The *sitta* were the following scripts: *muhaqqaq, rayhani, thuluth, naskhi, tauqi'*, and *riqa'*. All six styles plus a good many more almost certainly existed before Ibn Muqla's time.

28. Robertson, "Muhammad ibn 'Abd ar-Rahman on Calligraphy," has summarized these principles, as has Abbott, *Rise of North Arabic Script*, pp. 33–38; particularly see p. 35, where she presents a tentative reconstruction of Ibn Muqla's script. See also by Abbott, "The Contribution of Ibn Muklah to the North-Arabic Script," *American Journal of Semitic Languages and Literatures* 56 (1939): 70–83.

Ibn Muqla's rules. Employed in Baghdad and Shiraz during the latter part of the tenth century and the early eleventh, Ibn al-Bawwab also founded a calligraphy school that was active until the time of Yaqut in the thirteenth century. Later credited with the invention of both the *muhaqqaq* and *rayhani* scripts, his major achievement lay in broadening the principles and beautifying the products of Ibn Muqla's system. Famed for its consistent elegance and harmony, his script fetched high prices even during his lifetime.[29]

The third figure in this assembly of virtue was the thirteenth century scribe, Yaqut al-Musta'simi, who adhered to the geometric principles of Ibn Muqla and to Ibn al-Bawwab's strivings for aesthetic grace but decisively altered their implementation. His achievements have been succinctly described by the sixteenth century Iranian chronicler Qadi Ahmad:

In the art of writing he followed the tradition of Ibn Bawwab, but in the trimming of the qalam *and in the clipping of its nib he altered the manner of the earlier masters The cynosure of calligraphers (Yaqut) cut the end of the* qalam. *Thus he altered both the rule and the writing, because writing is subordinate to the* qalam. *For this reason his writing is preferred to that of Ibn Bawwab for its fineness and elegance, and not for the sake of the basic rules; for the essence of writing, it is the same as invented by Ibn Muqla from the circle and the dot*[30]

Yaqut's innovation was to cut the *qalam*'s nib at an angle, thus enabling him to achieve greater fineness, thinness, and linear variability. Often called the "sultan" of calligraphers, he and his writing have remained quintessential models until modern times.

29. For Ibn al-Bawwab see Ibn Khaldun, *Muqaddimah*, pp. 385–389, and, especially, D. S. Rice, *The Unique Ibn al-Bawwab Manuscript in the Chester Beatty Library*.
30. Qadi Ahmad, *Calligraphers and Painters*, pp. 57–58.

It is known that if a hand is legible
It is a sign of good writing.
Writing exists in order to be read.
Not that [readers] should get stuck in it.
A beautiful writing renders the eye clear,
The ugliness of writing turns the eye into a bathstove.[31]

Ibn Muqla's reform had created a method both creative and critical: a regular, proportioned script could be produced according to his rules, and one already at hand could be evaluated by measuring its letters in terms of the rhomboid point and *alif*. This regularity did not mean that scripts rendered along these lines were beautiful; instead, they possessed the potential for a certain kind of beauty. Despite admiration for Ibn Muqla's principles after the tenth century, early monumental *Kufic* was still considered beautiful, and even up until the present day it has retained something of its early hieratic status. Thus there were other variables that made aesthetic judgment possible; whether or not a script subscribed to early or reformist canons was not the whole account.

Other aesthetic standards are more elusive. Ibn al-Bawwab brought grace and elegance to Ibn Muqla's way and added art to scientific method, and words like "refined," "excellent," "delicate," "mature," and "tasteful" abound in the descriptive literature about calligraphers. They tell us more about the taste of authors than about the art of scribes. A sense of calligraphic beauty was more dependent upon long experience as a practitioner and connoisseur of script than upon the tools of precise measurement.

Still, a good eye was not entirely subjective; some more objective criteria were available. Besides adhering to its own stylistic canons, a script had to come up to other expectations, and the words of Ibn Muqla's contemporary, al-Suli, are as applicable to early as to later styles of writing. To the question of what constituted good writing, he replied:

31. From Sultan 'Ali's treatise on calligraphy quoted in ibid., p. 111.

When its parts are symmetrical, its alif *and its* lam *made long, its lines regular, its terminals made similar to its upstrokes, its* 'ayns *opened, its* ra *clearly distinguishable from its* nun, *its paper polished, its ink sufficiently black, with no commixture of styles, permitting of rapid visualization of outline, and quick comprehension of content, its separations clearly defined, its principles carefully observed, its thinness and thickness in due proportion It should disregard the style of the copyists and avoid the artistry of the elegant writers, and it should give you the suggestion of motion, though stationary.*[32]

There was a certain etiquette of script as well. Selection of a style depended not only upon patron's preference and scribe's ability, but also upon the function that a particular communication had to perform. Thus the almost exclusive choice of an angular, *Kufic* style for *Qur'ans* in the early centuries of Islam was not at all haphazard: it had been the lapidary script, devoted to stone monuments and meant to last. Slow-moving and dignified, exacting in its application and requiring skill to read, it bore the connotation of eternity and visually defined Islam's perception of the holy book. Long after it was no longer used to record whole *Qur'ans*, its use continued in a hieratic guise to write the Arabic of *surah* headings (No. 47), in religious architecture, and on precious objects of diverse sorts (Nos. 21, 36, and 51). Held in reverence, the angular styles evolved some of Islam's most convoluted calligraphic shapes, sacrosanct through form at least as much as content (Nos. 7 and 14).

In pre-Islamic times nonmonumental, the cursive hands took on a more exalted role as Islam's culture widened and grew rich. By the eleventh century, if not before, *Qur'ans* were written in *naskhi* (Nos. 29 and 47), a legible and stately script that long remained in favor for its straightforwardness, adherence to the horizontal, and simple virtuosities. Muhaqqaq (Nos. 27 and 49) too

32. Robertson, "Muhammad ibn 'Abd ar-Rahman on Calligraphy," p. 70.

was a beloved *Qur'anic* script, its verticals more attenuated, its outlines finely honed, its endings pointed like fine steel. To *thuluth* devolved many of the functions *Kufic* had fulfilled: it wrote the words of *surah* headings (No. 27) and impressive pious epigraphs (No. 35); it rendered princely titles and exalted honorifics (No. 24). Towering but a little ponderous, it moved too slowly for entire texts but was in many regions of the Muslim world the cursive monumental script par excellence (No. 86). Regional styles flourished in Islam's wide orbit: under Muslim sultans in north India *Bihari* was a favored style for fine *Qur'ans*; its roots in *naskhi* were still discernible (No. 75).

From these substantial innovations of their eastern neighbors the Muslim peoples of the Maghrib remained estranged, and the reforms of Ibn Muqla stayed largely foreign. Their scripts, grouped under the geographic rubric *Maghribi*, were the only cursive styles known to have developed directly out of *Kufic* angular modes. Rounded, versatile, and given to grand gestures, the *Maghribi* hands retained the individual freedoms, the virtuoso masteries, and the elusive canons inherent in their *Kufic* antecedents (No. 16).

Other scripts were less often used for the *Qur'an* and turned toward other texts. Thus fluent, tempered *ta'liq*, a stream of words each flowing down from right to left, was ideally suited for conveying the growing riches of Persian secular literature after the twelfth century (No. 68). Its more effusive and ebullient relation, *nasta'liq* (No. 73), became the fitting, major vehicle for Persian poetry in the Muslim world after the fourteenth century. Like their later extreme derivative, *shikastah*, which transformed natural motion into nervous agitation (No. 65), these scripts communicated on more mundane levels too, being plied by the hands of governmental scribes. Bureaucracy was well served by *diwani*, and its association with the *tughra* rendering of royal names was a natural relationship (No. 33).

Though the major ones, these styles are but a fraction of the scribes' repertoire and only give a partial glimpse of possibilities. Dozens, even hundreds, of scripts are

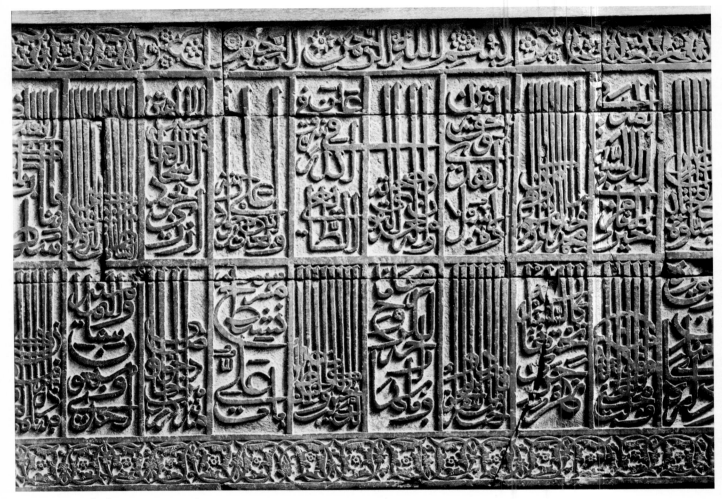

FIG. 1. Detail of a commemorative stone from the palace of Barbak Shah, Gaur, Bengal, mid-fifteenth century. Photograph courtesy of the University Museum, Philadelphia.

known by name or by example. Imaginative or ambitious scribes were also given to experiment, particularly by combining different scripts: thus *nasta'liq* is said to have come—initially as dream—from Mir 'Ali Tabrizi's work to blend the virtues of the *naskhi* and the *ta'liq* hands.

Established scripts could undergo peculiar treatments. In *muthanna* form an epigraph was faced with its mirror image (No. 64), while in *musalsal* guise its letters were linked in a consistent flow that broke most orthographic laws (No. 86).

Scripts did not exist in isolation. Fine *Kufic* variants were enhanced by close association with more mobile *thuluth* and *naskhi* (No. 38); and sober *Kufic* could balance playful *naskhi* (No. 39), while *thuluth* was enlivened by the more active *nasta'liq* (No. 62). In one of the masterpieces of medieval stonecarving, *tughra* letters, their curves packed tight and verticals lined up in stiff attention, are made less rigid by their more easygoing companions in *thuluth* script (Fig. 1). This sensitive association of two strong styles belongs to a massive set of stones nearly two and a half meters long, commemorating the construction of a reservoir and gate appended to the palace of Barbak Shah, the medieval Muslim ruler (1459–1475) of Bengali Gaur.[33]

33. This inscription has been published and discussed by Nabih A. Faris and George C. Miles, "An Inscription of Barbak Shah of Bengal," *Ars Islamica* 7 (1940): 141–146.

Handwriting is spiritual geometry by means of a corporeal instrument.[34]

Technical aspects were not separated from aesthetic and even personal criteria. On being handed a badly written petition, 'Abdullah ibn Tahir, who was the powerful governor of Khurasan in northeastern Iran from 828–845 A.D., replied: "We were willing to accept your excuse, but in view of your bad handwriting we changed our mind. If you had been truthful in stating your case, the movement of your hand would have aided you. Or do you not know that a beautiful handwriting speaks for the writer, makes his arguments convincing, and enables him to obtain what he wants?" The connection between moral rectitude and calligraphic excellence is stressed by nearly every writer on the art. Thus Sultan 'Ali advises aspiring calligraphers not only on technique, but also on right living:

Only he who of trickery, intrigues, and hypocrisy
Has cleansed himself, has become master in writing.
He who knows the soul, knows that
Purity of writing proceeds from purity of heart.
Writing is the distinction of the pure.[35]

Despite such theoretical emphasis on moral virtue, sound training and technique were basic. Some of the standard criteria for aesthetic judgment were founded in straight expertise: Did the scribe cut his pen in the manner prescribed for the script he chose to write? Was his hand steady? Were all his letters consistent with the style?

Good implements were not to be neglected; but a truly great calligrapher could write well even if deprived of suitable supplies, and the image of a master scribe labor-

34. Rosenthal, "Abu Haiyan al-Tawhidi on Penmanship," p. 6. This statement is variously attributed to Euclid, Galen, or Plato in Islamic sources. The quotation below is also from Rosenthal, "Abu Haiyan al-Tawhidi on Penmanship," p. 14.
35. From Sultan 'Ali's treatise on calligraphy quoted in Qadi Ahmad, *Calligraphers and Painters*, p. 122.

ing under such material difficulties occurs with frequency in the legends of the art. Deprived through punishment of the use of his right hand, a master would write equally well with his left; and when that too failed him, he would use his mouth or feet to produce a script astounding his admirers. When the Mongols captured and sacked Baghdad in 1258, the illustrious Yaqut took refuge in a minaret: "He took with him ink and a *qalam*, but he had no paper for practicing. All he had was a towel of Baalbeki *mithqali* linen, and so he wrote a few words on that towel in such a manner that looking at them one is seized with wonder."[36]

There were proper exercises for the writing hand, and calligraphers, like musicians, were careful to protect their hands. The scribe of the ʿAbbasid caliph al-Taʾiʿ (reign, 974–991 A.D.) drew on personal experience to point this out: "There is nothing more useful for a calligrapher than to avoid using his hand for lifting up or putting down a thing, especially if it is heavy Recently, I lifted a whip with my hand several times and cracked it over the head of my mount. As a result, my handwriting was changed for a while."[37]

According to Sultan ʿAli, an aspiring scribe was expected to observe his predecessors' arts with a careful eye and imitate them with a diligent hand in order to perfect his own skills and find the style most suited to his nature:

Collect the writing of the masters,
Throw a glance at this and at that.
For whomsoever you feel a natural attraction,
Besides his writing, you must not look at others,
So that your eye should become saturated with his
writing,
And because of his writing each of your letters should
become like a pearl.[38]

Ibn al-Bawwab reproduced the writing of Ibn Muqla so exactly that his employer, the Buyid amir Bahaʾ al-Daula of Shiraz, could not tell the hands apart.[39] The incident was a proof of this scribe's skill, his versatility, and his sound knowledge of tradition. It was the highest sort of praise.

Single-minded devotion to one's profession was essential. By his own account Sultan ʿAli suppressed all other desires in order to achieve the inner discipline necessary for a scribe, and he wisely advised the young to emulate his way:

You will abandon peace and sleep,
Even from your tender years.[40]

The single-minded practice and total commitment that was the ideal of the calligrapher is well, if perhaps apocryphally, illustrated by an incident alleged to have occurred during the great earthquake of 1776–1777 in Tabriz:

The calamity fell in the middle of the night. At dawn survivors were running hither and thither hoping to find those buried in the debris who might still be alive. One search party discovered a spark of light from deep down in the basement of a ruined house. They set to work frantically, hoping to effect a rescue. When they finally dug their way through, they discovered a man sitting on the floor bent over a small piece of paper, working by the light of a candle, intensely absorbed in writing. They called to him to hurry out, more shocks were coming, and the ruins were still dangerous; but there was no response. He bent over his work, still absorbed. Several times they shouted to him, till finally he looked up, asking why they were disturbing him. When informed that the town had been almost demolished by an earthquake, that thousands had been killed, and there was

36. Ibid., pp. 59–60.
37. Rosenthal, "Abu Haiyan al-Tawhidi on Penmanship," p. 7.
38. From Sultan ʿAli's treatise on calligraphy, in Qadi Ahmad, *Calligraphers and Painters*, p. 117.

39. Abbott, "The Contribution of Ibn Muklah to the North-Arabic Script," pp. 71–72.
40. From Sultan ʿAli's treatise on calligraphy quoted in Qadi Ahmad, *Calligraphers and Painters*, pp. 121–122.

10

hardly time left for him to escape, he replied: "What is all that to me?" and proudly exhibited his paper on which was a perfect waw, *a particularly difficult letter to make. "After many thousands of trials I have at last achieved one that is absolutely perfect," he said, "and such a perfect letter is worth more than the whole city."* [41]

Perfected technique exemplified personal achievement in both skill and spirit, but it was also a necessary attribute of power, recognized by Muslims and, they assumed, naturally accepted by others. Thus in an oft-cited Islamic legend the Muslims' most enduring Christian foe, the Byzantine Empire, had monarchs of good taste who in their appreciation of the aesthetic power of Arabic script implicitly acknowledged Islam's power. On holidays a finely written letter from the caliph al-Ma'mun (reign, 813–833) to the emperor was regularly exhibited and abundantly admired by the people of Constantinople,[42] and the monarch numbered among his treasures a sample of the handwriting of Ahmed ibn Abi Khalid, the secretary of the same 'Abbasid caliph.[43] Script was not only the sacred symbol of Islam; it was also the visible statement—in both content and style—of Islam's power, and it was widely seen as such: "Al-Ma'mun, looking at a beautifully written official document, said: 'How wonderful is the calamus! How it weaves the fine cloth of royal power, embroiders the ornamental borders of the garment of the ruling dynasty, and keeps up the standards of the caliphate.'" [44]

41. Arthur Upham Pope and Phyllis Ackerman, eds., *A Survey of Persian Art,* p. 1726n.
42. Ibid., pp. 1712–1713.
43. Rosenthal, "Abu Haiyan al-Tawhidi on Penmanship," p. 9.
44. Ibid., p. 14.

Among the mementos which [Mir 'Ali Haravi] has left are these verses which he wrote in large characters, scattering pearls, on the lofty mausoleum of Imam Riza, equal in degree to the highest sphere of heaven—on its pilgrims a thousand thousand mercies and blessings! [45]

Calligraphy assumed its most monumental form on the exterior and interior surfaces of buildings, but this aspect of the art can only be summarily discussed here, primarily in order to illustrate a few of the splendors of architectural calligraphy and to indicate some of the ways in which it could function.[46] As the costliest and most public material creations of the state, architectural structures were most frequently provided with statements proclaiming the official convictions of the faith. Such fundamental beliefs were often rendered in *Kufic,* the most sacrosanct of Arabic scripts, and located near a mosque's *mihrab,* the physical focal point of Muslim prayer. Thus the penultimate verse of the *surah al-Hashr* (Exile) 59:23, which asserts Allah's uniqueness, affirms Islam's uncompromising monotheism, and includes several of the *asma' al-husna,* is inscribed in a horizontal line of tesserae directly over the tenth century *mihrab* of the Great Mosque of Cordova in southern Spain: "He is Allah, than Whom there is no other God, the Sovereign Lord, the Holy One, Peace, the Keeper of Faith, the Guardian, the Majestic, the Compeller, the Superb. Glorified be Allah from all that they ascribe as partner (unto Him)."

Religious statements on edifices as important as this one were chosen with care, not by scribes or designers, but by theologians whose selections were often determined by the purposes a building was to serve and by the needs of its patron. When the Dome of the Rock was erected in late seventh century Jerusalem, the city was still largely Christian in population, and Caliph 'Abd al-Malik was keenly aware that their sacred structures, which used figural images to proclaim the tenets of their

45. Qadi Ahmad, *Calligraphers and Painters,* pp. 126–127.
46. See the stimulating essay by Dodds, "Image of the Word."

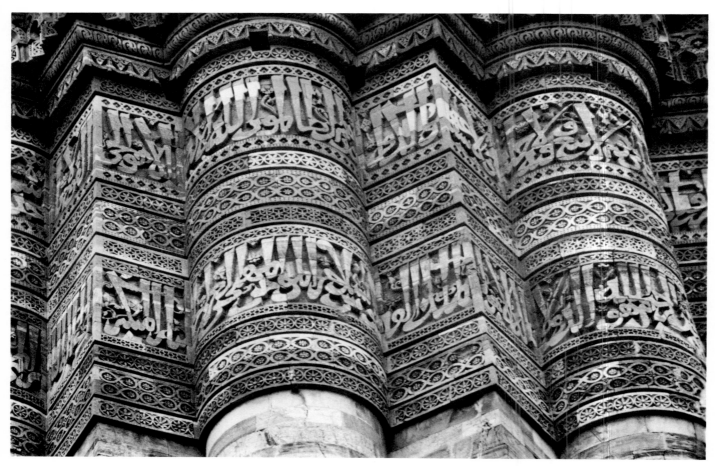

FIG. 2. Detail of the Qutb minar, Quwwat al-Islam Mosque, Delhi, late twelfth or early thirteenth century. Photograph: Anthony Welch.

faith, amply adorned the city. As the first major Muslim contribution to the urban monumental environment, the Dome of the Rock therefore served to demonstrate Islam's religious essence, and, though the epigraphs (mainly from the *Qur'an*) in the shrine's interior are small and difficult to see, they offer a unified theme, centered on the contemporary rivalry of the two faiths. Allah's uniqueness is affirmed, and the divinity of Christ and the Trinity are denied. Christ's role as a prophet in a succession of prophets is asserted, but the role of Muhammad as the last prophet and the Messenger trans-

FIG. 3. Dome and main eyvan of the Masjid-i Shah, Isfahan, 1612–1638 A.D. Photograph: Anthony Welch.

FIG. 4. Detail of main arch, Bara Gumbad Mosque, Delhi, late fifteenth century. Photograph: Anthony Welch.

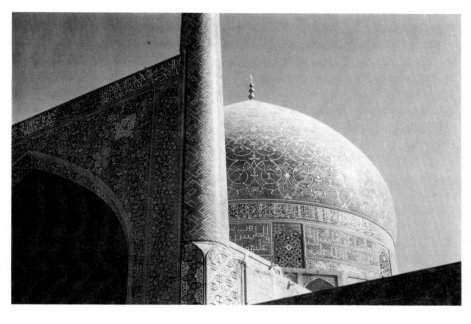

mitting the *Qur'an* is underscored. Those who reject Islam are warned of the awful consequences.[47]

Similarly, later and further east, the towering minaret of Islam's first mosque in northern India—the late twelfth and early thirteenth century Quwwat al-Islam Mosque near Delhi (Fig. 2)—is provided with inscriptions from the *Qur'an* particularly stressing the errors of polytheism and vigorously attacking the practices of idolators. Ruling over a populace almost entirely Hindu and Jain in belief, the area's Muslim rulers clearly wished to have a monumental statement sharply separating Islam from the local disbelievers whose sacred use of figural imagery and evident polytheism they must have found alarming.

Buildings were not always supplied with verses from the *Qur'an* alone. *Hadith* that suited religious and political circumstances could be chosen. The enormous gateway into the early seventeenth century Royal Mosque of Isfahan is provided with statements attributed to the Prophet that intone the righteousness of Shi'a Islam, the official faith of Safavi Iran, and bolster the claims of Shah 'Abbas I (reign, 1587–1629) to the mantle of 'Ali and the leadership of his followers (Fig. 3).

Not only religious structures, but also ostensibly secular ones could bear pious epigraphs; the late medieval palace of the Alhambra in Granada displays on nearly every wall the sentence "There is no Victor but Allah."

Some epigraphs were more favored than others. The throne verse, *surah al-Baqarah* (The Cow) 2:255, which adorns so many precious objects, was one of the most frequently employed architectural inscriptions, particularly in rulers' tombs. The *asma' al-husna* appear with similar regularity.

Certain locations were deemed most appropriate for inscriptions: on the exterior, portals, minarets, and drums of domes; on the interior, the *mihrab*, *qibla* (prayer wall), and the drum and center of domes. Almost any space, however, could be provided with the written word, and sometimes simple buildings, like the late fifteenth century Bara Gumbad Mosque in Delhi (Fig. 4), were quite transformed by dense and splendid epigraphs.

Early favored, *Kufic* has remained in architectural use up to the present day. It was to a large extent, however, supplanted after the twelfth century by cursive monumental scripts like *thuluth*, which was used for the complex series of inscriptions on the Taj Mahal.[48] Other scripts, like *ta'liq*, *nasta'liq*, and *shikastah*, were far less often used on buildings, for they lent themselves less well to monumental purposes.

Architectural inscriptions, like those on objects, were more often observed and admired than read. While their content was specific and often directed at a special and identifiable historical situation,[49] to the mass of believers they served a symbolic function, asserting the power and rectitude of Islam simply by their presence.[50] By analogy few Christian believers understood the complex theology that imbued the sculptures of Chartres cathedral, and few Hindus comprehended the equally abstruse iconography of the Kandariya Mahadeo Temple at Khajuraho. The sight of intricate thought given visible form may have pleased patrons and theologians when the structures were erected, but intellectual satisfactions like these are not the substance of religious faith. To one who lived within the testimony of Islam its epigraphs were an affirmation of religious and cultural belonging, and, while the script had content and did serve to decorate and enliven the surfaces of buildings, this affirmation was its vital social function.

47. For a discussion of the epigraphs on the Dome of the Rock see Oleg Grabar, "The Umayyad Dome of the Rock in Jerusalem," *Ars Orientalis* 3 (1959), pp. 33–62.

48. Transcribed and translated in Muin al-Din Ahmad, *The Taj and its Environments*, and newly studied by Wayne Begley in a forthcoming book on the Taj Mahal.

49. As, for example, on one of the most notable of Mamluk structures in Egypt, in Oleg Grabar, "The Inscriptions of the Madrasah-Mausoleum of Qaytbay," in D. K. Kouymjian, ed., *Near Eastern Numismatics, Iconography, Epigraphy and History*, pp. 465–468.

50. See Richard Ettinghausen, "Arabic Epigraphy: Communication or Symbolic Affirmation," in Kouymjian, ed., *Near Eastern Numismatics*, pp. 297–318.

11

Civilization and sedentary culture developed greatly everywhere in the various Muslim dynasties. Royal authority increased, and the sciences were cultivated. Books were copied, and they were well written and bound. Castles and royal libraries were filled with them in an incomparable way. The inhabitants of the different regions vied with and rivaled each other in this respect.[51]

Of central importance in the cultural, administrative, and religious life of Islam, scribes were an urban profession, and their roles and relationships were correspondingly diverse. Most importantly, of course, they conveyed the words of Allah in the *Qur'an*, of the Prophet in the *Hadith*, and of hundreds of pious persons who wrote religious commentaries. They produced copies of histories, biographies, scientific treatises, works of literature, and single pages of poetry, letters, devotional literature, and calligraphic talismans; they preserved culture and enabled it to be dispersed throughout the Muslim world.

Calligraphers, however, did not function in the world of books and written pages alone. A large percentage of them were adept at designing inscriptions for buildings, where their art was taxed by problems like exacting compensation for distance and for angular observation or by the needs of artisans in stone, brick, ceramic, or stucco who, perhaps barely literate themselves, would have to transfer a calligraphic design onto architectural material. It was a major occupation for a fine calligrapher and one that was not only replete with honors and enduring respect for his name but also possibly more profitable than work on paper.[52] A commission to supply epigraphs for a major mosque was a mark of signal distinction, undoubtedly the cause of eager competition among highly placed and well-known masters. One of Yaqut's major students was so rewarded: "The first of [these students] was the son of Shaykh Suhravardi, born in Baghdad.

There the inscriptions on buildings are mainly his work; in the cathedral mosque of Baghdad he wrote the entire *surah al-Kahf*, and the stonemasons reproduced it in relief, without embellishments, merely with baked bricks."[53]

The designing of inscriptions for objects is rarely cited in literary accounts of calligraphers' lives. Less monumental and less public, such work may not have been considered worthy of mention; but other factors may have been in force as well. Where objects do bear signatures, these are most often the names of makers—potters, metalworkers, weavers, or other artisans—and only rarely, as in No. 62, is the designer of the inscription mentioned. Indeed, there was a good reason why no designer was named, for in many, if not most, cases there was probably no special designer at all; instead, the object's maker selected an inscription from a repertory of standard, usually appropriate, epigraphs which he possessed. As a result, a large number of objects use a limited number of inscriptions, which tend to be repeated over and over again: such epigraphs may be laudatory honorifics (Nos. 6, 21, 22, 24, 26, 39, 40, and 48), popular poems (Nos. 18, 45, and 46), favorite single words (Nos. 11 and 14), or choice pieties and imposing *Qur'anic* verses (Nos. 7, 17, 31, 35, 37, and 43). In general, in objects one meets with more orthographic errors and omitted words (No. 48) than in architectural inscriptions or the art of the book, and some inscriptions seem haphazardly chosen (Nos. 45 and 46), neither fitting nor corresponding to the object they adorn. Obviously, some of the artisans who supplied such formulas were not persons of culture and were, at best, less literate than the calligraphers cited in literary texts.

Their range of scripts is also more restricted than that of their more educated colleagues plying the art of the book, but within this more limited stylistic field they work in a less "conventional" manner, sometimes decorating their letters with a dense and integral ornament, comparable more to illuminated headings than to texts

51. Ibn Khaldun, *Muqaddimah*, II, pp. 385–386.
52. Nearly every other calligrapher discussed by Qadi Ahmad, *Calligraphers and Painters*, had significant architectural commissions.

53. Ibid., p. 60.

of manuscripts. While their creations often rank as superb calligraphy, they almost always follow the stylistic leadership of formal scribes from whose writing on papyrus, parchment, or paper developed nearly all new variations on the script.

If their roles in Islamic society were almost as varied as the many styles of script they wrote, how did most calligraphers make a living? The great majority of those who supplied inscriptions on objects were probably employed in workshops, where their occupation was not primarily calligraphic. Some professional calligraphers, like Ibn Muqla, earned salaries as governmental officials. Other esteemed calligraphers were not employed as scribes at all: Ibn al-Khall, a twelfth century legal scholar in Baghdad, was so celebrated for his script that people sought his advice simply in order to get a sample of his penmanship.[54] Many were on the staffs of libraries, where they copied books; and those who were library directors, like Ibn al-Bawwab, held distinguished and often very lucrative posts. Other scribes had more humble jobs and conducted the correspondence and kept the records of kings, princes, and aristocrats in distant provinces: Mir Munshi Husayni, the father of the late sixteenth century Iranian chronicler Qadi Ahmad, first acted in this secretarial capacity for the Safavi shah's brother Sam Mirza in Herat.[55]

Some calligraphers lived more directly off the products of their hand: one of the greatest of Safavi calligraphers, Shah Mahmud Nishapuri, lived for twenty years in Mashhad "retired and alone. From no source had he any pension or grants of land, and he received no patronage from anyone."[56] He is known to have written specimens of calligraphy during this period, and he, like some other scribes, may have sold them on the open market or to solicitous friends. A fourteenth century master, ʿUmar Aqtaʿ, offered to Timur a tiny *Qurʾan*, "so small in volume that it could be fitted under the socket of a signet ring," but the conqueror rejected it as too minute to be worthy of the great book. Undeterred, the scribe went back to work and returned with another copy so mighty that he had to tie it "on a barrow" to take it to the king. This copy of the *Qurʾan* achieved the desired result, and Timur "rewarded the calligrapher with great honors, marks of respect and endless favors."[57] ʿUmar had found his patron's weak point, and his effort had been worthwhile.

Students had to learn, and teachers of calligraphy were paid for their labor, though teaching does not seem to have been a road to fortune. Some calligraphers doubled as bookdealers, selling what they produced and often employing other scribes. Although princely patronage, like that awarded ʿUmar Aqtaʿ, could pay lavishly, it was rarely a secure living, dependent as it was upon a patron's fortunes, taste, and passion for the art. Commitment could be mutable: Shah Tahmasp, who ruled Iran from 1524 to 1576, devoted himself with energy and skill during the first half of his reign to the art of the precious book and gathered around him his country's finest calligraphers; but in mid-reign he turned his attention from his youthful dedication, busied himself with government, and dismissed his atelier of talented masters. They dispersed throughout the state and beyond to Turkey, India, and central Asia. This sudden change of fortune, which left a scribe like Mahmud Nishapuri in the lurch, was by no means uncommon, and many were the calligraphers throughout Islam's history who had to migrate in search of livelihood and reward.

Of course, not all calligraphers practiced their skills full time. Some were aristocrats, like Timur's grandson Baysunghur (No. 49), gifted amateurs who sought personal aesthetic satisfaction and the encomiums of

54. Robertson, "Muhammad ibn ʿAbd ar-Rahman on Calligraphy," pp. 62–63.

55. Qadi Ahmad, *Calligraphers and Painters*, p. 76.

56. Ibid., pp. 135–136. Before his retirement to Mashhad, Shah Mahmud Nishapuri had copied the text of one of the finest creations of Safavi art, the 1539–1543 *Khamsah* of Nizami in the British Museum. Later he also participated in the production of the 1556–1565 *Haft Awrang* of Jami for the shah's nephew, Ibrahim Mirza. This work is now in the Freer Gallery. His career is discussed in Anthony Welch, *Artists for the Shah*, pp. 152–153, and idem, "Patrons and Calligraphers in Safavi Iran," in *MELA Notes* 12 (1977): 10–15.

57. Qadi Ahmad, *Calligraphers and Painters*, p. 64.

their peers. Some were poets who could turn a fine hand: Mawlana ʿAbd al-Rahim, who served Yaʿqub Aq-qoyunlu, the Turcoman ruler of western Iran during part of the fifteenth century, was only one of many.[58] Even a few physicians were celebrated for their penmanship, as was Hakim Rukna who served as personal doctor to Iran's Shah ʿAbbas I, until that monarch dismissed him for alleged malpractice.[59] Some soldiers, painters, and illuminators were noted for their writing too, and many pious *sufis* were extremely active in the art.

To professional calligraphers, their patrons, and their observers, ancestry appears to have been of great importance. Despite the notable social mobility of Islamic societies, the profession often stayed in families. That Shah Mahmud Nishapuri was the nephew of the noted master of *nastaʿliq*, Mawlana ʿAbdi, who served for many years under Shah Tahmasp, was not at all unusual. Among his contemporaries there were many similar instances: the calligrapher, illuminator, and painter Zayn al-ʿAbidin was the grandson of the great Safavi painter Sultan Muhammad; the calligrapher Mawlana Ibrahim, who had to flee to Istanbul in 1577–1578 because of his religious views, was the son of the great scribe Malik Daylami whose brother-in-law was ʿAbd al-Hadi Qazvini, another calligrapher of note whose father was the famous scribe Shahra-Mir Qazvini; Muhibb ʿAli was not only the son of the famous master Rustam ʿAli, but also the grandnephew of Bihzad, one of the towering figures in Iranian painting. Such illustrious lineage was as much in his favor as his considerable talent. At least at this period intermarriage between artistic families was more the rule than the exception: talent may have been thought to be hereditary, and family connections surely helped in landing impressive commissions and positions.[60]

If aspiring calligraphers did not train with members of their immediate family, they sought out scribes known for their mastery in a particular style and school. Thus artistic lineage is often cited, most notably in the case of the followers of Yaqut, the thirteenth century Baghdadi master credited with so much inventiveness. As the treatise of Sultan ʿAli makes clear, however, more than a celebrated teacher was essential: moral, as well as professional, self-discipline was required, and long years of diligent application had to pass before a student could hope to claim proficiency in the most exalted of Islam's arts.

58. Ibid., pp. 100–101.
59. Ibid., pp. 169–170.
60. See Welch, *Artists for the Shah*, pp. 150–158; and Welch, "Patrons and Calligraphers in Safavi Iran."

The Kufic Age

1. Milestone from the Jerusalem road

Palestine; 685–705 A.D.
H. 39 cm., W. 56.5 cm.
Musée du Louvre, Département des Antiquités Orientales (Section Islamique)

The ninth caliph of Islam and the fifth in the Umayyad line of rulers, ʿAbd al-Malik (reign, 685–705 A.D.) ranks as one of the great patrons and builders of Jerusalem and Palestine, among the leading centers of early Muslim culture. It was through the express interest of ʿAbd al-Malik in the Holy City of Jerusalem that the Dome of the Rock was constructed, and it is in this structure that the earliest examples of Arabic architectural epigraphy survive. It was under ʿAbd al-Malik too that Muslim coinage, hitherto strongly influenced by the figural coins of Byzantium and Sasanian Iran, became almost solely epigraphic and that governmental affairs, until then recorded in Greek and other languages, began to be written in Arabic.[1] The caliph himself undoubtedly deserves much of the credit for this Arabization of the empire, and it is fitting that the earliest inscription in this exhibition should mention his name.

The highway . . . ʿAbdullah ʿAbd al-Malik, amir of the faithful, Allah's mercy be upon him, this mile is eight miles [from Jerusalem].

Found in a ruin north of the watchtower at Bab al-Wadi on the road from Jerusalem to al-Ramla (Lydda), this and other surviving stones[2] showed the distance on the highroad from the coastal plain to Jerusalem.

It is to be expected that a "sign" of this sort should be simple and legible, and the *Kufic* script used here, while bearing a close relationship to pre-Islamic Arabic, is plain and unembellished, a combination of circles, lines, and sharp angles with few decorative flourishes. In the arabesque at the base, however, we can see the beginnings of what is to be a vital and continuing connection between script and ornament.

NOTES

1. A recent review of this problem is found in Anthony Welch, "Epigraphs as Icons: The Role of the Written Word in Islamic Art," in Joseph Gutmann, ed., *The Image and the Word*, pp. 63–74.
2. Published in Adolf Grohmann, *Arabische Paläographie*, II : 83.

PREVIOUSLY PUBLISHED IN

Max van Berchem, *Inscriptions Arabes de Syrie*, No. 1, pp. 118–119, pl. I.
———, *Matériaux pour un Corpus Inscriptionum Arabicarum*, No. 2, pp. 18–19, fig. 2.
Arts de l'Islam, Catalogue of an Exhibition at Chambery, No. 142.
A. Grohmann, *Arabische Paläographie*, II, pp. 72, 83–84, and pl. IV/1.
L'Islam dans les collections nationales, Catalogue of an Exhibition at the Grand Palais, No. 71.

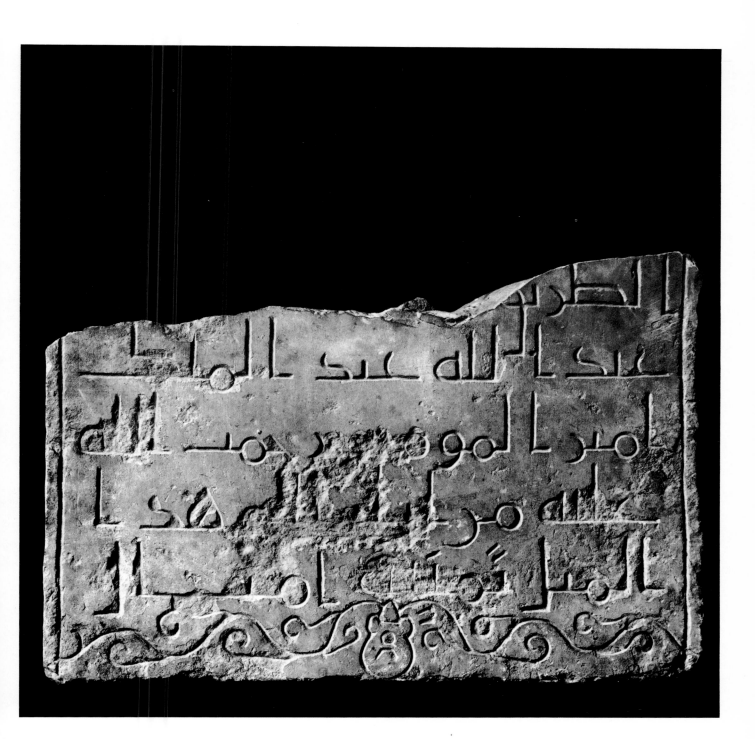

2. Portion of a marble tombstone

Egypt; tenth century
H. 27.9 cm., W. 24.1 cm.
Los Angeles County Museum of Art; Gift of Joan Palevsky

This marble slab must have been cut from a larger grave marker, for its epigraphs are noticeably incomplete. Inscribed in an ornate *Kufic* with letters that widen into flowers, leaves, and half-palmettes, the central panel of ten horizontal lines must have originally included at least one more line, for the initial words—"There is no god but Allah"—are absent except for the three final letters of "Allah," which appear on the top line. They are followed by this text:

Muhammad is the Messenger of Allah, Allah's blessings and peace be on him. This is the grave [qabr] of Muawiyya ibn Salih [?], Allah have mercy on him and forgive him

The death date, normally included on such memorials, is absent.

The long vertical panel on the right frames the *bismillah*, complete except for its last word, of which the first three letters are written. It was presumably finished in an upper extension of the tombstone that also contained the first three verses of *surah al-Tauhid* (Unity) 112:1–4,[1] for the vertical panel is occupied by the fourth and final verse:

And there is none comparable unto Him.

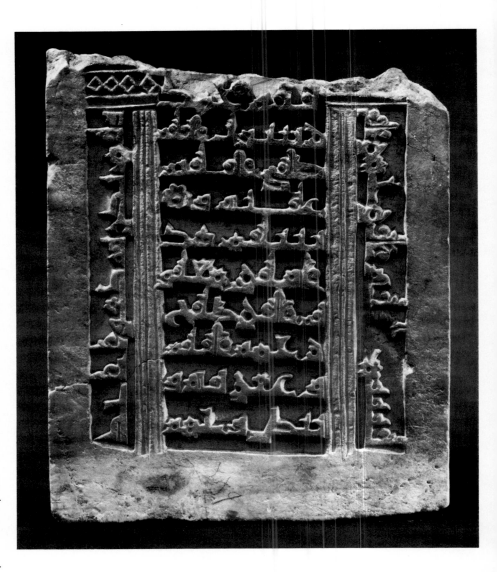

NOTES

1. In a later, complete tombstone (No. 38) the entire *surah* is written, and other lacunae from No. 2 are filled in.

PREVIOUSLY PUBLISHED IN

Pratapaditya Pal, ed., *Islamic Art: The Nasli M. Heeramaneck Collection*, No. 347.

3. Page from a small Qur'an

Probably North Africa; ninth century
H. 4.1 cm., W. 7.7 cm.
Fogg Art Museum; Purchase, Alpheus Hyatt Fund

Small, portable *Qur'ans* were popular in the highly mobile Muslim world, but their restricted size posed special problems for their scribes, and their creation was frequently regarded as a special test of skill. The owner of the manuscript from which comes this vellum page, written in dark brown *Kufic*, must have taken pride in his knowledge of the *Qur'an*, for there are no vowel markers or diacritical marks to aid in reading and, as in No. 4, words are divided both within and at the end of lines to satisfy aesthetic needs. Resembling larger *Kufic* of the period, the letters are compacted or stretched along the horizontal to satisfy both calligraphic canons and individual inclinations.[1]

The text is from *surah al-Mu'minun* (The Believers) 23:92–104:

[Knower of the Invisible and the Visible! and Exalted be He] over all that they ascribe as partners (unto Him)!

Say: My Lord! If Thou shouldst show me that which they are promised,

My Lord! then set me not among the wrong-doing folk.

And verily We are Able to show thee that which We have promised them.

Repel evil with that which is better. We are Best Aware of that which they allege.

And say: My Lord! I seek refuge in Thee from suggestions of the evil ones,

And I seek refuge in Thee, my Lord, lest they be present with me,

Until, when death cometh unto one of them, he saith: My Lord! Send me back,

That I may do right in that which I have left behind! But nay! It is but a word that he speaketh; and behind them is a barrier until the day when they are raised.

And when the trumpet is blown there will be no kinship among them that day, nor will they ask of one another.

Then those whose scales are heavy, they are the successful.

And those whose scales are light are those who lose their souls, in hell abiding.

The fire burneth their faces, [and they are glum therein].

NOTES

1. These two criteria are discussed by Nabia Abbott, *The Rise of the North Arabic Script*, pp. 25–27.

4. Page from a blue vellum Qur'an

North Africa; late ninth or early tenth century
H. 28.6 cm., W. 37.5 cm.
Fogg Art Museum; Purchase, Francis H. Burr Memorial Fund

(Shown only at Asia House)

One of the leading cities of medieval Islam, Qairawan[1] was a religious, administrative, commercial, and cultural center for the Maghrib from the eighth to the eleventh century. The Great Mosque of Qairawan was the focal point of an intense religious life that made the city famous throughout the Muslim world for Islamic and Arabic studies. Either there or at some of the many other religious institutions in the city worked some of the preeminent masters of the *Kufic* script who produced *Qur'ans* prized far beyond the bounds of western North Africa.[2]

This page is from a nearly complete manuscript of the *Qur'an* that is one of the wonders of Islamic calligraphy.[3] No more than three or four *Qur'ans* on colored vellum are known, and of them this splendid copy of the holy book is the most well known. The conceptual source for writing in gold ink on blue vellum may have come from the Christian Byzantine Empire, medieval Islam's religious and military opponent, for official Byzantine documents were often written on blue or purple vellum with gold or silver ink.[4] That this adopted idea was not more widely used may be the result of Islam's early reluctance to use the precious metal for decorative purposes. In writing surface and in writing material one of the most luxurious of all *Qur'ans*, it is a climax to the tradition of the vellum *Qur'an* in *Kufic* script.

The text of this page is from *surah al-Baqarah* (The Cow) 2:229–231. Often referred to as the "*Qur'an* in little,"[5] the *surah al-Baqarah* presents most of the essential points of revelation, both doctrinal and legislative. These particular lines spell out the procedures for divorce:[6]

[. . . And if ye fear that they may not be able to keep to limits of Allah, in that case it is no sin for either of them] if the woman ransom herself. These are the limits (imposed by) Allah. Transgress them not. For whoso transgresseth Allah's limits: such are wrong-doers.

And if he hath divorced her (the third time), then she is not lawful unto him thereafter until she hath wedded another husband. Then if he (the other husband) divorce her it is no sin for both of them that they come together again if they consider that they are able to observe the limits of Allah. These are the limits of Allah. He manifesteth them for people who have knowledge.

When ye have divorced women, and they have reached their term, then retain them in kindness or release them in kindness. Retain them not to their hurt so that ye transgress (the limits). He who doeth that hath wronged his soul. Make not [the revelations of Allah a laughing-stock . . .]

Fifteen lines of script hug the horizontal on an oblong page characteristic of early medieval *Qur'ans*. It is a sparse *Kufic*, sparing only the basic letter forms and eschewing all distractions: neither vowel signs nor diacritical marks inhibit the single-minded progression of letters from right to left. Verticals are thus subdued, rendered only twice as high as many horizontals, and while the letters stand out strongly from their deep and lustrous background, they are not as incisive or as sharply cut as others of the period.[7] This script is designed for beauty more than legibility: the marks, essential to differentiate between otherwise identical letters, have been so sharply reduced in number that they distinguish only two letters; and in keeping with a script conceived as letter not as word, lines end with words unfinished and completed by a final letter back at the right on the line below. While a *hafiz*[8] might have had few difficulties with such a text, it must surely have presented some of the same problems to a medieval reader as it presents to us today.

Beyond these textual observations there are others, perhaps more crucial. Words vary greatly in size, some short, compact, and even crowded, while others are stretched to abnormal lengths. Those words that undergo extension tend to be those that seem essential to the meaning, like "limits" or "wrongdoers." Their increased linear dimension seems to have been executed not only for stunning visual effect, but also to reflect the sonorous stress upon these key words during the recitation of the text itself.

NOTES

1. Often spelled Kairouan, the city is located south of the present-day Tunisian capital, Tunis.

2. Many North African *Qur'ans* (including this one) of this period were formerly attributed to Iraq or Iran. That they were actually produced in Qairawan (through its religious preeminence logically a major center of calligraphy) has been clearly established by Martin Lings and Yasin H. Safadi, *The Qur'an*, pp. 20–28.

3. Virtually all of the manuscript is in Tunis in the National Library (Ms. No. 197, Rudbi; published in *The Arts of Islam*, No. 498 and in Titus Burckhardt, *Art of Islam*, pl. 23) and the National Institute of Archaeology and Art (published in Lings and Safadi, *The Qur'an*, No. 11). Some pages were removed from the manuscript in the early twentieth century and entered the collection of Frederick R. Martin, who remarked: "I have quite recently acquired leaves from the *Koran* which was written on blue vellum by order of the Caliph al-Ma'mun for the tomb of his father, Harun al-Rashid, at Mashhad" (*The Miniature Paintings and Painters of Persia, India, and Turkey*, p. 141). If the manuscript was ordered by al-Ma'mun, it must have been produced in North Africa, whence it never left or to which it was later returned. Three pages are now in the Beatty Library, Dublin (Ms. No. 1405; published in Arthur J. Arberry, *The Koran Illuminated: A Handlist of the Korans in the Chester Beatty Library*, No. 4 and page 4, plate 12); one is in the Museum of Fine Arts, Boston (No. 33.686); and one is the page under discussion here.

4. Richard Ettinghausen, "Manuscript Illumination," in Arthur Upham Pope and Phyllis Ackerman, eds., *A Survey of Persian Art*, p. 1944.

5. *The Glorious Koran*, trans. M. Pickthall, p. iii.

6. The spread of Islam was for women in the early medieval world a distinctly liberating force, assuring them property, marital, and other legal and social rights they had not had before.

7. See No. 5.

8. A *hafiz* is a person who has memorized the *Qur'an* and may often function as a professional reciter of the holy book.

See color illustration on page 15

5. Page from a Qur'an

Iraq or Iran; ninth century
H. 19.3 cm., W. 24.1 cm.
Cincinnati Art Museum; Fanny Bryce Lehmer Fund

These lines come from the *surah al-Kahf* (The Cave) 18:16–19 and describe the persecution and flight of several pious youths who eventually were directed by Allah to take refuge in a cave, where they were preserved without aging for a number of years. Since this page begins and terminates near the end of verses 16 and 19, the completing words are included in brackets.

[And when ye withdraw from them and that which they worship except Allah, then seek refuge in the Cave; your Lord will spread for you of His mercy] and will prepare for you a pillow in your plight.

And thou mightest have seen the sun when it rose move away from their cave to the right, and when it set go past them on the left, and they were in the cleft thereof. That was (one) of the portents of Allah. He whom Allah guideth, he indeed is led aright, and he whom He sendeth astray, for him thou wilt not find a guiding friend.

And thou wouldst have deemed them waking though they were asleep, and We caused them to turn over to the right and the left, and their dog stretching out his paws on the threshold. If thou hadst observed them closely thou hadst assuredly turned away from them in flight, and hadst been filled with awe of them.

And in like manner We awakened them that they might question one another. A speaker from among them said: How long have ye tarried? They said: We have tarried a day or some part of a day, (Others) said: Your Lord best knoweth what ye have tarried. Now send one of you with this your silver coin unto the city, [and let him see what food is purest there and bring you a supply thereof. Let him be courteous and let no man know of you.] [1]

Written in sixteen lines with dark brown ink on vellum, this early *Kufic* accentuates horizontal letters in order to conform to the oblong format of the page. Red dots are used as vowel markers, a use that was abandoned after the eleventh century in favor of employing dashes as vowel indicators and dots as diacritical marks. Individual letters are slightly thinner and the space between words is greater than in No. 4. There is also a slight diagonal tilt to some of the vertical forms. It is a compact script, its letters sharply edged and precisely proportioned, balanced with a harmonious distribution of space. [2]

NOTES

1. This revelation bears some similarity to the Christian story of the Seven Sleepers of Ephesus. In Islamic tradition the names of the Seven Sleepers are sometimes rendered as calligraphic talismans. See Annemarie Schimmel, *Islamic Calligraphy*, pl. XLIIIa.
2. This page apparently comes from a manuscript now in the Iran Bastan Museum, Tehran, No. 4251 (published in Martin Lings, *The Quranic Art of Calligraphy and Illumination*, pl. 2).

6. Cotton and silk "cloth of honor"

Iraq; 908–932 A.D.
H. 10.4 cm., W. 24.5 cm.
The Textile Museum

The production of costly textiles was virtually a state monopoly during much of the 'Abbasid period (750–1258 A.D.). Imperial factories were responsible for the creation of textiles intended both for palace use and for presentation as gifts and awards to worthy officials. Thousands of fragments of these *turuz* ("cloths of honor") have survived, indicating that they were produced throughout the medieval Muslim world, and the way in which they were created and used is admirably presented by the great medieval Muslim historian, Ibn Khaldun (1332–1382 A.D.):

It is part of royal and governmental pomp and dynastic custom to have the names of rulers or their peculiar marks embroidered on the silk, brocade, or pure silk garments that are prepared for their wearing. The writing is brought out by weaving a gold thread or some other colored thread of a color different from that of the fabric itself into it Royal garments are embroidered with such a tiraz, *in order to increase the prestige of the ruler or the person of lower rank who wears such a garment, or in order to increase the prestige of those whom the ruler distinguishes by bestowing upon them his own garment when he wants to honor them or appoint them to one of the offices of the dynasty.*

The pre-Islamic non-Arab rulers used to make a tiraz *of pictures and figures of kings The rulers later on changed that and had their own names embroidered together with other words of good omen or prayer. In the Umayyad and 'Abbasid dynasties, the* tiraz *was one of the most splendid things and honors. The house within the palaces in which such garments were woven was called the "tiraz house." The person who supervised them was called the "tiraz master." He was in charge of the craftsmen, the payment of their wages, the care of their implements, and the control of their work. [The office of* tiraz *master] was entrusted by the 'Abbasids to their intimates and their most trusted clients.[1]*

More than one hundred fragments are known that bear the name of al-Muqtadir, one of the least competent of the 'Abbasid caliphs, who during a reign of twenty-four years (908–932 A.D.) presided over a court increasingly incompetent and wasteful. After his reign the truncated 'Abbasid Empire came under the control of the Iranian Shi'a family of the Buyids.[2] This particular cloth is made of undyed, glazed cotton with an inscription embroidered in dark blue silk.

The letters, only four millimeters high, are in an unusual rounded script that seems to be mediating between *Kufic* and *naskhi* and is quite uncommon for the period. Its slender uprights yield to broad sublinear curves, while the whole inscription is written closely together, packed into a surprisingly dense configuration. The inscription is strikingly different from the thinner, more angular, and more spacious script of Egyptian textiles of the same period; and it is therefore likely that it was produced in a workshop in the vicinity of Baghdad.

Though the minute inscription is aesthetically very impressive, its orthography leaves much to be desired, as the result of either a less-than-literate embroiderer or a careless scribe. Both spelling mistakes and superfluous letters make it impossible to offer a full, clear translation. Nevertheless, the key words "caliph" and "al-Muqtadir" can be deciphered, and it is also obvious that the remainder of the inscription presents a standard recitation of blessings and good wishes for the caliph.

NOTES
1. Ibn Khaldun, *The Muqaddimah*, vol. II, pp. 65–66.
2. See No. 8.

PREVIOUSLY PUBLISHED IN
Ernst Kühnel and Louise Bellinger, *Catalogue of Dated Tiraz Fabrics: Umayyad, Abbasid, Fatimid*, pp. 33–34 and pl. IX.

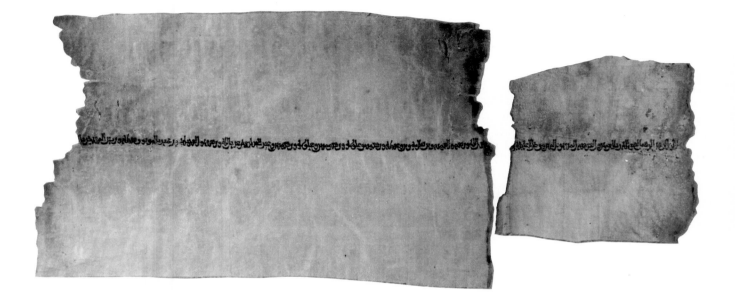

7. Ikat cotton cloth with applied gilt decoration

The Yemen; tenth century
W. 79 cm., L. 45 cm.
Museum of Fine Arts, Boston; Helen and Alice Colburn Fund

Legendary for its wealth derived from carefully irrigated agriculture and from its strategic location on a major trade route from India to the Mediterranean, pre-Islamic Yemen supported a rich civilization, mentioned not only by early Arab poets but also in Roman records and later in Firdausi's *Shahnamah* (The Book of Kings), which refers to the period from 575–628 A.D. when the land was under Sasanian suzerainty. In 628 the Yemen became part of the widening Islamic state. It remained a distant province of the Umayyad and ʿAbbasid empires until the ninth century, when it came under the control of Zaydi imams, representing one of the branches of Shiʿism. Until their power was curbed in 1062 A.D. by the Fatimids of Egypt, they encouraged active Zaydi missionary activity from the Yemen to many areas of the Muslim world.

Yemeni textiles had been famed before Islam, and both Umayyad and ʿAbbasid caliphs maintained factories for the production of *tiraz* there.[1] Cotton was grown in southern Yemen, as well as imported from India; and the city of Sanʿa, today still the major urban center of the Yemen, had extensive facilities for the production of textiles. A speciality of the city was the striped cotton cloths known as *burud*, referred to briefly by the Arab geographer al-Muqadassi in the tenth century and praised in the eleventh century by the Ismaʿili traveller, Nasir-i Khusrau, who wrote: "Sanʿa is the largest, richest, and most industrious city of the Yemen; her striped coats, stuffs of silk, and embroideries have the greatest reputation."[2]

This handsome textile is predominantly blue, with brown and white areas. There is a broad brown stripe at the right. Before this type of cloth was woven, the individual warp threads were dyed in two or three colors. The resultant woven patterns are either narrow vertical stripes, as in this example, or a somewhat broader vertical succession of lozenges.[3] While some surviving *burud* have embroidered inscriptions, others, like this one, bear epigraphs that have been painted in gold, outlined in black, directly on the fabric. The elaborately convoluted and dramatically incisive *Kufic* script, clearly related to contemporary epigraphy in Egypt, is written in three lines.[4] In the upper center are three words:

Glory [is] from Allah [?]

Below it in letters twice as large is a full, exuberant line:

In the name of Allah. And the blessing of Allah be upon Muhammad

In the lower left is an undeciphered word which may be a place name.

NOTES

1. For a wider discussion of the history of Yemeni textiles see R. B. Serjeant, "Material for a History of Islamic Textiles up to the Mongol Conquest," *Ars Islamica* 13–14 (1948), pp. 75–87.
2. Quoted in N. P. Britton, *A Study of Some Early Islamic Textiles in the Museum of Fine Arts, Boston*, p. 73.
3. A piece of this type, bearing an inscription naming a Zaydi ruler—Yusuf ibn Yahya ibn al-Nasir al-Din—is in the Cleveland Museum of Art, No. 50.353.
4. Deciphered and read by Richard Ettinghausen and F. Day in Britton, *Study of Early Islamic Textiles*, p. 75.

PREVIOUSLY PUBLISHED IN

N. P. Britton, *A Study of Some Early Islamic Textiles in the Museum of Fine Arts, Boston*, p. 75, No. 34.115 and figure 92.

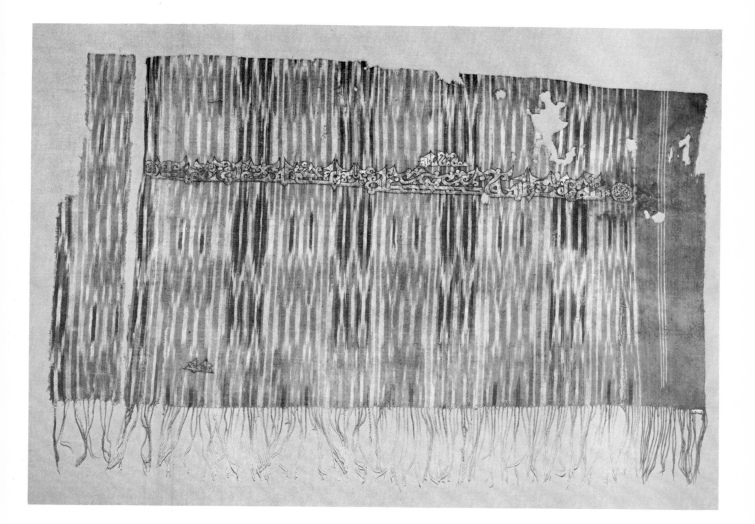

8. Gold bracelet

Western Iran or Iraq; first half of tenth century
Diam. 7.8 cm. (interior at widest point)
The Walters Art Gallery

In keeping with several *Hadith* (traditional sayings) of the Prophet Muhammad that warn against hoarding and ostentation and urge simplicity in dress and manner, Muslim theologians generally disapproved of the use of gold and silver except for coinage. This attitude, however, appears to have had more influence upon the making of objects for religious purposes than for secular uses, and there are, as a result, substantial numbers of objects extant that were produced in these precious metals for secular patrons.

The creation of the exterior of this bracelet depended upon a rich variety of techniques—sculpture in the round, repoussé, filigree, and granulation.[1] The inscription on the interior was simply engraved on the smooth gold surface and almost certainly indicates that the band was a gift from a father to his daughter:

Delight to Zainab, the daughter of ʿAli,
* the Daylamite.*

Its calligraphic style suggests an origin in the first half of the tenth century, for the rather squat angularity of the letters is relieved by the curving ascension of several letters, hitherto written below the line. The inscription's content also suggests this date. Inhabiting a small area of northern Iran just south of the Caspian Sea, the Daylamites began to expand to the south in the tenth century, and in 946 A.D. a Shiʿa Daylamite family, the Buyids, seized effective control of the ʿAbbasid caliphate in Baghdad.

NOTES

1. Four other bracelets of similar size and appearance are in the Metropolitan Museum of Art, the Seattle Art Museum, the Freer Gallery of Art, and the Los Angeles County Museum of Art. Along with the Walters bracelet, the first three are discussed in Miriam Rosen-Ayalon," Four Iranian Bracelets Seen in the Light of Early Islamic Art," in Richard Ettinghausen, ed., *Islamic Art in the Metropolitan Museum of Art*, pp. 169–186. For the Los Angeles bracelet see Pratapaditya Pal, ed., *Islamic Art: The Nasli M. Heeramaneck Collection*, No. 275.

PREVIOUSLY PUBLISHED IN

Dorothy Miner, "A Bracelet for a Princess," *Bulletin of the Walters Art Gallery* 15 (May 1963).

Miriam Rosen-Ayalon, "Four Iranian Bracelets Seen in the Light of Early Islamic Art," in Richard Ettinghausen, ed., *Islamic Art in the Metropolitan Museum of Art*, pp. 169–186 and figure 2.

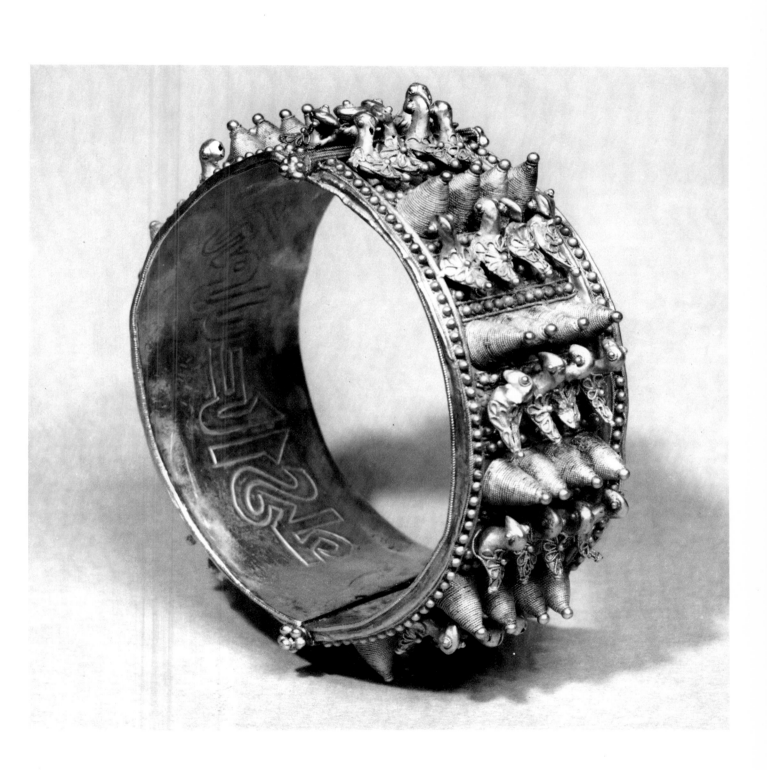

9. Ceramic plate with Kufic inscription

Northeastern Iran; tenth century
H. 6.7 cm., Diam. 37.2 cm.
The St. Louis Art Museum

Ruling eastern Iran from the late ninth until the early eleventh century, the Samanids were keenly interested in pre-Islamic Sasanian patterns of culture and kingship, and they tended to favor forms in art and literature that bespoke this imperial past. This plate with its impressive inscription does not, however, conform to this generalization, and it has been argued that these ceramics were produced for humbler, though certainly well-off, patrons.[1] To a wealthy middle-class with different taste in art and literature the inscription's meaning may have had special significance:

Planning before work protects you from regret.

Other plates and dishes of this type support similar aphoristic epigraphs, like those one reads in *Poor Richard's Almanac*, advising the viewer to be virtuous, assiduous, careful, and cautious. Together they make up a collection of sound, homey advice, as applicable now as a thousand years ago.

The inscription is written in black *Kufic* script on a white ground. Letters are stretched and lengthened to provide a perfect harmony of reclining and ascending letters: ten tall verticals are elegantly spaced around the center, their sharply cut tips almost touching the plate's inner depression. Other letters, pulled and flattened out of regular proportion, mark the vessel's rim with a rhythmically broken line, while large and small curves alter angularity. There is nothing haphazard in this perfectly tuned and timed inscription.

Clearly related to the script of eastern *Kufic Qurʾans*, and, if anything, even more difficult to read, the letters here are innovative and original in conception and design. In pottery of this type we have one of the few instances in Islamic history in which objects, rather than pages or manuscripts, appear to have been the vehicle for an important variation in script.

NOTES

1. In Lisa Volov-Golombek, "Plaited Kufic on Samanid Epigraphic Pottery," *Ars Orientalis* 6 (1966), pp. 107–133. The translation comes from this source.

PREVIOUSLY PUBLISHED IN

L. O. Nagel, "Some Middle Eastern Ceramics in the City Art Museum of St. Louis," *Oriental Art* 4 (1958), p. 116, fig. 2.

Charles K. Wilkinson, *Iranian Ceramics*, New York (1963), No. 22.

Lisa Volov-Golombek, "Plaited Kufic on Samanid Epigraphic Pottery," *Ars Orientalis* 6 (1966), pp. 117–118, fig. 2.

Arts of Islam, Catalogue of an exhibition at the Hayward Gallery, London (1976), No. 279.

10. Ceramic dish with Kufic inscription

Northeastern Iran; tenth century
H. 9.6 cm., Diam. 27 cm.
David Collection

Vessels inscribed with *Kufic* epigraphs during the Samanid period in northeastern Iran range from the stark *Kufic* of No. 9 to the ornate richness of this plaited *Kufic* dish. Letters on this dish have unpredictable propensities and swell up into blossoms, flatten into broad palmettes, or tie themselves into knots to satisfy an elegant but almost overdressed aesthetic. The epigraph's base line shares its center with the vessel's rim, but its pristine concentricity is broken by two letters dipping slightly past the horizontal edge. Verticals' tops form a circle too, but one with a lilting rhythm.

Like its cousin (No. 9), this brilliant composition is formed from an aphorism, though one less homey and more pious:

He who believes in the pact (with Allah) is generous to [dependents?]. [1]

Though not directly from the *Qur'an*, this Arabic adage is surely adapted from *surah al-Baqarah* (The Cow) 2:177, where Allah reveals the true ties between rectitude and charity:

It is not righteousness that ye turn your faces to the East and the West; but righteous is he who believeth in Allah and the Last Day and the angels and the Scripture and the prophets; and giveth wealth, for love of Him, to kinsfolk and to orphans and the needy and the wayfarer and to those who ask

Unlike most Samanid calligraphy bowls, this one bears a clearly religious inscription.

A cluster of four dots marks the beginning of the inscription, and letters are in red and black. Out of nine possibilities, only one letter—near the very end of the epigraph—is supplied with the dots so critical for the proper identification of otherwise identical letters in

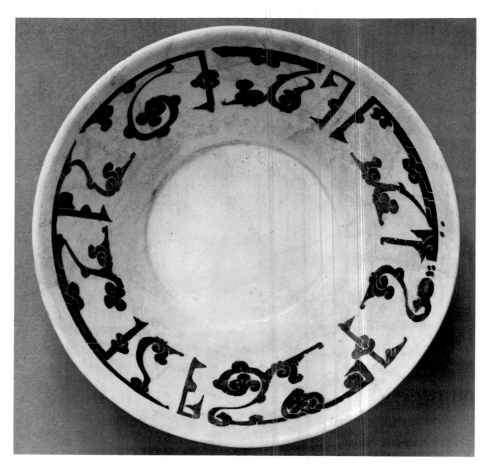

Arabic, and these seem to appear not as sudden elucidation, but as a kind of visual prelude to the four dots that end the pious saying. This inscription is rendered in one of the most ornate styles in any Muslim script, so decorative that it actually verges on illegibility: "reading" it becomes the deciphering of a conundrum. From No. 12 we can infer that this effort was as necessary in the tenth century as it is now; despite the importance of the message, its visual complexity and ingenious design were more important than its content.

See color illustration on page 1 (on paperback edition see cover)

NOTES

1. With the exception of the final word, which I have suggested, this translation is from *Arts of Islam*, No. 282.

PREVIOUSLY PUBLISHED IN

Davids Samling, *Islamisk Kunst*, pl. 21.

11. Ceramic plate

Iran; tenth or eleventh century
H. 4.0 cm., Diam. 36.5 cm.
Museum of Fine Arts, Boston; University Museum—M.F.A. Persian Expedition

In a green slip against a white ground on this plate is apparently written the most common secular inscription in Islamic art—"blessing to the owner." The two words are sometimes found alone as here; often they occur as the final words of a longer inscription, usually filled with a more detailed listing of good wishes for the owner. The script is *Kufic* and clearly Iranian with its tall verticals ending in points as seen in contemporary *Qur'ans* (see No. 13). Here, however, "correct" form has been altered for the sake of aesthetics, and several letters that do not normally rise above the horizontal ascend to satisfy aesthetic needs.

12. Pages from a manuscript of the Qur'an

Iraq or Iran; eleventh century
H. 25.4 cm., W. 19.5 cm.
Collection of Prince Sadruddin Aga Khan

This fragment of a *Qur'an* consists of thirty-six, generally nonsequential, folios, gathered together apparently in the late eighteenth or nineteenth century and bound in a simple leather binding. No other pages of this particular *Qur'an* are known, though it must surely be considered one of the most impressive eastern *Kufic Qur'ans*.

Illustrated here is a double page marking the beginning of the thirtieth *juz'* (part) of the *Qur'an* and the first words of *surah al-Naba'* (The Tidings) 78:1–5, which brings warning of the Last Judgment and the punishment awaiting those who rejected Allah's revelation:

In the name of Allah, the Beneficent,
* the Merciful*
Whereof do they question one another?
(It is) of the awful tidings,
Concerning which they are in disagree-
* ment.*
Nay, but they will come to know!
Nay, again, but they will come to know!

The elaborate gold illumination of the left page is a mirror image of the design on the right. Three *ansas* dominate the side margins; the upper and lower are filled with vegetal forms. The central ansa encloses compact *Kufic* that identifies this portion of the *Qur'an* and is bounded by an interlocked hexagon and six-petalled blossom. In an equally complex geometry at the top of the page, two blue circles, linked by a blue oval, intertwine white right-angled forms emerging from the center of each blue shape. It is a masterful linear arrangement, reflecting the concern with visual mathematics central to Islamic art.

A repetitive pattern of curling tendrils forms a dense, but subdued, background for the bold, dark *Kufic* of the text. In the lower left of the right page three letters begin a diagonal thrust toward the upper right; in the left-hand page three long

verticals are placed in identical positions before the sun-like roundels marking verse ends. Aesthetic considerations have been of utmost importance to the unnamed scribe of this marvellously proportioned double page.

While vowels and diacritical marks are written in bright red, it is not an easy script to read. The scribe apparently understood the difficulty, for under some of the letters, rendered more beautiful but also less clear, are small blue and very legible letters: a script providing great aesthetic delight also required orthographic clarification.

PREVIOUSLY PUBLISHED IN

Anthony Welch, *Collection of Islamic Art: Prince Sadruddin Aga Khan*, II, Ms. 2, pp. 21–27.
Martin Lings and Yasin Hamid Safadi, *The Qur'an*, No. 37.
Martin Lings, *The Qur'anic Art of Calligraphy and Illumination*, p. 18 and pl. 12 and 13.

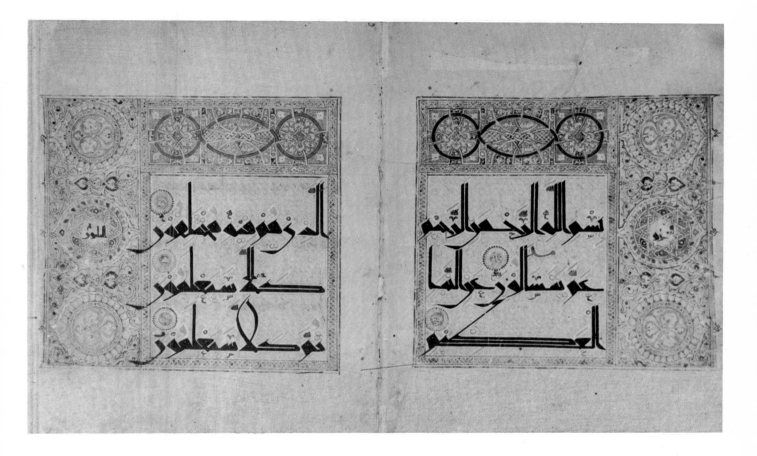

13. Page from a Qur'an

Iran; late eleventh century
H. 24.4 cm., W. 17.0 cm.
Private collection

This page is from a widely dispersed manuscript that is one of the glories of Seljuq art in Iran.[1] As if in relief against a dense, more tightly curling background, pale tendrils and pale blossoms form a subdued, but active, plane across which bold, black *Kufic* letters move with noble elegance and grand demeanor. Throughout this *Qur'an* vowels are marked in red, and the enclosing border of the page is a slender golden rope.

One of the supreme achievements of the written art, this variant of *Kufic* script[2] consists of slender, towering verticals, rising to six or seven times the height of horizontals, which are, in contrast, dense, compressed—a compact, rocky stratum from which the verticals ascend. The conjoined letters *lam* and *alif* (seen here twice in the fourth line) form a nearly perfect oval, an eye-like shape with pointed ends. Sharp diagonals slice decisively below the horizontal and add a new direction to this dramatic script. In a form notably characteristic of eastern *Kufic*, the word "Allah" in the upper right begins with a giant *alif* and then constricts to a tight knot of letters, tilting to the left to intimate in larger form the reed pen's single lozenge dot: the calligraphic building block reflects the faith's true center.

Written in four lines on paper rather than the vellum of earlier manuscripts of the holy book, the razor sharpness of this brilliant script recalls the beauties of Samanid pottery.[3] Such close parallels of calligraphic form imply a similar origin in northeastern Iran, while another *Qur'an*, dated 1073 A.D., which is in a less perfectly proportioned but closely allied script,[4] is evidence for a late eleventh century date for these dispersed pages. Northeastern Iran was a seminal region for the creation of forms dominant in architecture and metalwork produced under the patronage of the Seljuqs who ruled Iran from the middle of the elev-

enth until the middle of the thirteenth century. Along with other variants of eastern *Kufic* script, this distinctive style of writing exercised a similar influence on Seljuq calligraphic arts.

The text is from the *surah al-Ma'idah* (The Table Spread) 5:54:

. . . Allah will bring a people whom He loveth and who love Him, humble toward believers, stern toward disbelievers, striving in the way of Allah, and fearing not the blame of any blamer.

NOTES

1. Eleven folios are in the Beatty Library, Dublin, Ms. 1436 (reproduced in Arthur J. Arberry, *The Koran Illuminated: A Handlist of the Korans in the Chester Beatty Library*, No. 37, pl. 25; Martin Lings, *The Quranic Art of Calligraphy and Illumination*, pl. 17; Arthur U. Pope and Phyllis Ackerman, eds., *A Survey of Persian Art*, pl. 931B and 932A). Other folios from this manuscript are found in the Keir Collection (reproduced in Basil W. Robinson et al., *Islamic Painting and the Arts of the Book: The Keir Collection*, No. VI, 5 and 6); the Metropolitan Museum of Art; and the Minneapolis Art Institute. There is an additional page with a fine blue background in the private collection from which this page comes. Further pages are reproduced in the *Encyclopaedia of Islam*, 1st ed., I, pl. V (article on "Arabia"); Ernst Kühnel, *Islamische Kleinkunst*, p. 28; and S. al-Munajjed, *Le Manuscrit Arabe*, No. 10.
2. It is often termed "Qarmathian Kufic."
3. See No. 9.
4. This manuscript (Imam Riza Shrine Library, Mashhad, Ms. No. 71) was copied and decorated by 'Uthman ibn Husayn al-Warraq, a master who must be closely associated with the scribe of the dispersed manuscript under discussion here. It may be possible to posit a Mashhad origin for both manuscripts. For an illustration of the Imam Riza Shrine manuscript see Lings, *The Quranic Art of Calligraphy and Illumination*, pl. 11.

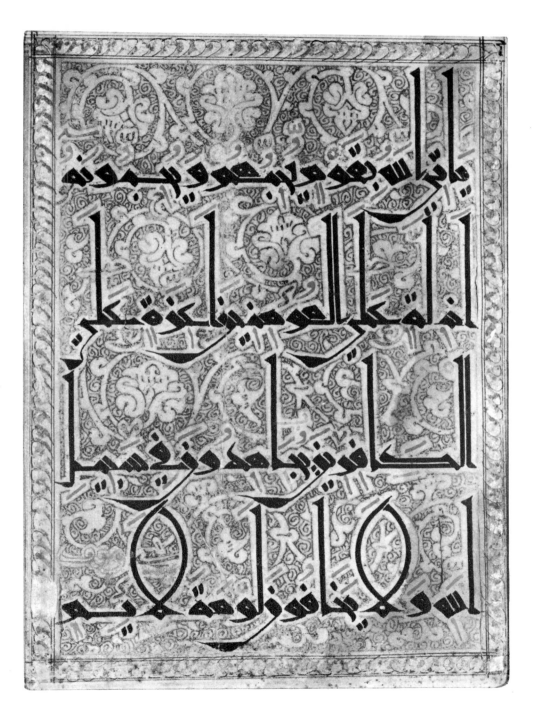

14. Ceramic plate with turquoise glaze

Northwestern Iran; twelfth century
H. 5.5 cm., Diam. 30.6 cm.
The Metropolitan Museum of Art; Gift of Horace Havemeyer, 1929

The smooth rim, unadorned except for four simple medallions, is in strong contrast to this plate's larger central area, alive with lush vegetation and vibrant *Kufic* letters. Carved in low relief and less thickly glazed than the darker background, both elements stress verticality but bend to match and accentuate the contours of the plate. The letters most likely form the word *al-ʿizza* (glory): the first two letters branch into palmettes at the top; the middle letter supports an exuberant flowery growth; and the final letter, which should be on the horizontal, responds to its formal environment and rises, bifurcating into two verticals, which are orthographically unnecessary and even confusing but form an aesthetic counterpoint to the first two letters.

Glory is a common epigraph, but it almost always appears in the company of other words invoking blessings on the owner. Hence its use alone as is done here, in one of the most impressive pieces of Seljuq epigraphic pottery, is rare.

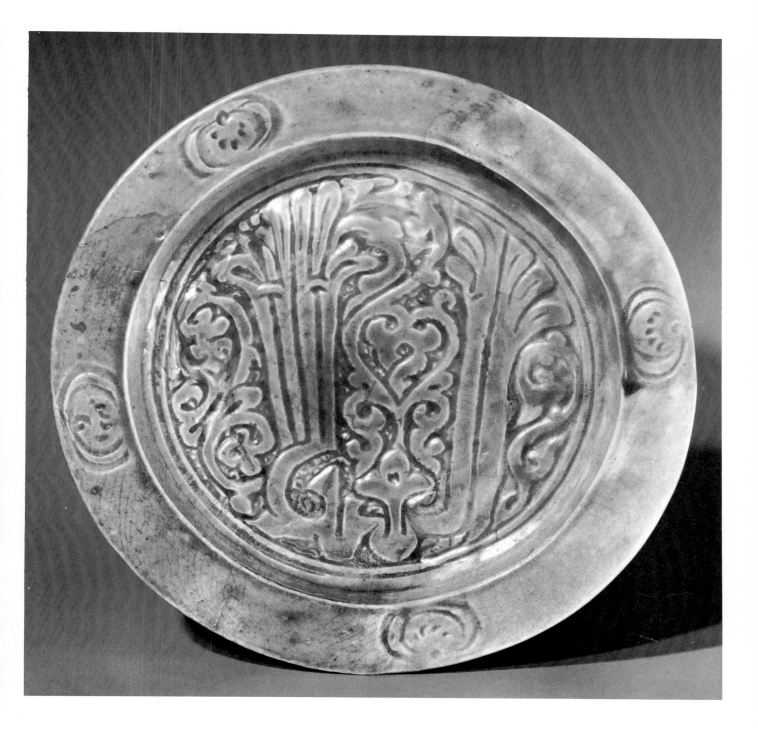

15. Copper plaque with Mary Magdalen and pseudo-Kufic inscription

France, Limoges; ca. 1210–1220 A.D.
H. 26.4 cm., W. 16.4 cm.
The Walters Art Gallery

This gilt and blue, champlevé enamel copper plaque was originally part of a larger composition: Mary Magdalen occupied the left end of a large altar cross, and her gaze was directed toward the crucified Christ. Pseudo-*Kufic* inscriptions, similar to that on the left side of this plaque, can be found in virtually all the arts of France and Germany from the twelfth through the fourteenth centuries, although the thirteenth century was the high point in the European use of decorative Arabic script.[1] Transmitted largely from Muslim Spain by means of precious objects like ivories, metals, and textiles, pseudo-*Kufic* served an ornamental function, conveying a sense of wealth and exoticism but not intentionally transmitting a Muslim message of faith.

This inscription repeats a basic unit of two verticals separated by a small, semicircular rise supporting two curling tendrils. Most of the pseudo-*Kufic* epigraphs on Limoges enamels are variations on this simple type, apparently a standard atelier formula. It is adapted, however, from the decorative treatment of the single most important and repeated word in Muslim inscriptions—Allah.

NOTES

1. For two excellent discussions of the use of pseudo-*Kufic* in European art see Kurt Erdmann, *Arabische Schriftzeichen als Ornamente in der abendländischen Kunst des Mittelalters*, and Richard Ettinghausen, "Kufesque in Byzantine Greece, the Latin West and the Muslim World," in *A Colloquium in Memory of George Carpenter Miles*, pp. 28–47. For a wider view of the problem see Rudolf Sellheim, "Die Madonna mit der Schahada," in *Festschrift Werner Caskel*.

Spain and North Africa

16. Page from a Qur'an

Spain; twelfth century
H. 52.7 cm., W. 55.4 cm.
The Cleveland Museum of Art; Edward L. Whittemore Endowment Fund

Islam came to Spain in the early eighth century, and within a hundred years this most westerly region of medieval Islam began to develop a distinctive Muslim culture, closely tied with North Africa to the south and exerting a powerful influence on Christian Europe to the north. In the middle of the twelfth century, in response to political fragmentation among the local Muslim rulers and to the threat of Christian reconquest from the north, the Almohad dynasty of North Africa occupied the Muslim lands of Spain and created a powerful state, strongly influencing Mediterranean politics. The Almohad court at Seville supported a brilliant, though short-lived, culture that was famous for art, learning, and philosophy. While the manuscript from which this page comes bears neither date nor place of origin, an attribution to twelfth century Almohad Seville, though tentative, is plausible.[1]

These seven lines are written in a rich gold *Maghribi* script on a large, square sheet of vellum. Long after it had been supplanted by paper in the central and eastern lands of Islam, vellum continued to be used in North Africa and Spain as the most suitable and durable material for the writing of the *Qur'an*. This particular page is from the *surah al-Nur* (Light) 24:59–61, which reveals rules of personal and family conduct:

[And when the children among you come to puberty then let them ask leave even as those] before them used to ask it. Thus Allah maketh clear His revelations for you. Allah is Knower, Wise.

As for women past childbearing, who have no hope of marriage, it is no sin for them if they discard their (outer) clothing in such a way as not to show adornment. But to refrain is better for them. Allah is Hearer, Knower.

No blame is there upon the blind nor

Fully developed by the beginning of the twelfth century, *Maghribi* is the only cursive script which arose directly from *Kufic*. Its line is far more variable than that of the parent script and can slide from relative thickness and darkness to almost vanishing thinness. It does not thrive on the regularities of *Kufic* or *naskhi*, for its letters can markedly change appearance from one line to the next; nor is the perfect steadiness of hand —a valued characteristic of *Kufic* and the cursive scripts used for the *Qur'an*—as prized here. Other virtues are at work: virtuosity of word or line of text is esteemed more highly than virtuosity of letter; large, open curves, often dipping deep below the horizontal (and even touching, though never overtaking, adjoining words and letters) provide a stately grace and slow fluidity that is the very essence of this style.

In contrast to the usual practice in cursive scripts of marking vowels with short diagonal lines, vowels here (and in other *Maghribi* manuscripts) are indicated by short red horizontal strokes above or below the line. Similar letters are differentiated by small gold dots, while other markers are in blue, red, and green. *Surah* headings are generally written in a script different from that of the text, and in this great manuscript titles are written in gold and in an archaic western *Kufic*, somewhat more convoluted than that found in earlier times. Sometimes marked by three large gold dots, verse endings are more often signalled by elaborate bastion-like roundels enclosing richly colored combinations of geometric and floral illumination.

The script owes its name to the region —the Maghrib (modern Morocco, Algeria, and Tunisia)—where it continued to flourish long after Islam had left Spain. Unlike *Kufic*, *naskhi*, and other cursive scripts, it was reserved almost exclusively for manuscripts and was rarely used in architecture or on precious objects. It was also one of the most geographically restricted of Muslim scripts, for its use did not extend beyond the Libyan desert. Its lack of appeal outside the Maghrib is perhaps best explained by the remarks of the fourteenth century historian Ibn Khaldun:

We are told about contemporary Cairo that there are teachers there who are specialized in the teaching of calligraphy. They teach the pupil by norms and laws how to write each letter Writing is not learned that way in Spain and the Maghrib. The letters are not learned individually according to norms the teacher gives to the pupil. Writing is learned by imitating complete words. The pupil repeats (these words), and the teacher examines him, until he knows well (how to write) and until the habit (of writing) is at his finger tips. Then he is called a good (calligrapher).[2]

Thus not only calligraphic style but also training and procedure worked to put the *Maghribi* script at variance with the *muhaqqaq* and *thuluth* scripts of Cairo.

NOTES

1. The manuscript to which this page once belonged is in the Museum of Turkish and Islamic Art, Istanbul, Ms. No. 360. Pages from it are reproduced in Titus Burckhardt, *Moorish Culture in Spain*, pl. 11; idem, *The Art of Islam*, pl. 24; and Martin Lings, *The Quranic Art of Calligraphy and Illumination*, pl. 97 and 98.
2. Ibn Khaldun, *The Muqaddimah*, trans. Franz Rosenthal, vol. II, p. 378.

17. Terracotta font

Spain; fourteenth or fifteenth century
H. 17.7 cm., W. 19 cm.
The Walters Art Gallery

Originally attached to a wall, the five sides of this font are decorated with a combination of arabesques, geometry, and epigraphy, such as can be seen in objects and architecture throughout the Muslim world. While two sides show the eight-lobed rosette enclosed by an octagonal star that is part of the geometric repertory of Islamic art, the central side has an oblong cartouche containing an inscription that is also repeated in the hexagons directly below the rim: *al-ʿizza li-llah* or "Glory belongs to Allah."

While these particular words occur as part of several verses in the *Qurʾan*,[1] the single word *al-ʿizz* (or *al-ʿizza*), also meaning glory, frequently appears on secular objects, such as Nos. 14 and 39 in this exhibition.

NOTES
1. For example, *surah al-Nisa* (Women) 4:139; *surah Yunus* (Jonah) 10:65; and *surah al-Malaʾikah* (The Angels) 35:10.

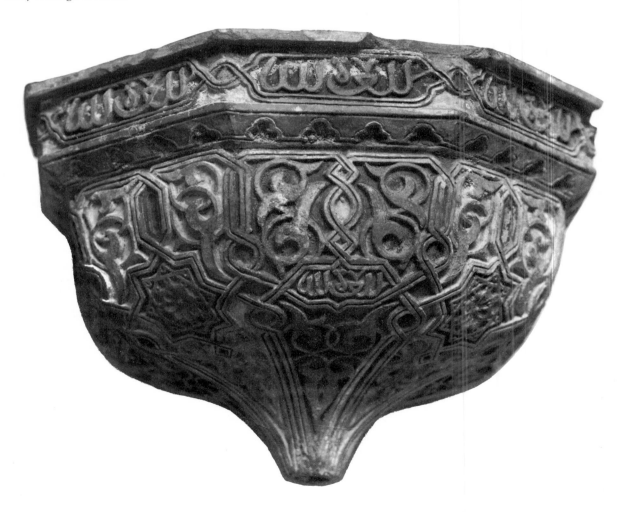

18. Multicolored compound satin

Spain; ca. 1380–1400 A.D.
H. 73.7 cm., W. 137.2 cm.
The Textile Museum

Sericulture and silk weaving became significant industries in Spain after the establishment of the Umayyads in 756 A.D., and Spanish raw silk and silk textiles were economically and artistically important for the rest of Islam's history in Spain. Even in its last century Nasrid Granada was famed for its satins, striped in intense hues of red, green, yellow, and blue and often provided with inscriptions. The script used in this example is an irregular cursive type, revealing some *Maghribi* elements along with the influence of the *thuluth* popular farther east in Mamluk Egypt. Most Nasrid inscriptional satins offered standard statements of blessings and good wishes. Repeatedly written in the one shown here, however, is an epigraphically complex, but not particularly distinguished, Arabic poem, directly referring to the sumptuous satin and obviously composed for this purpose:

*I am for pleasure. Welcome. For pleasure
 am I.
And he who beholds me sees joy and
 delight.*

See color illustration on page 13

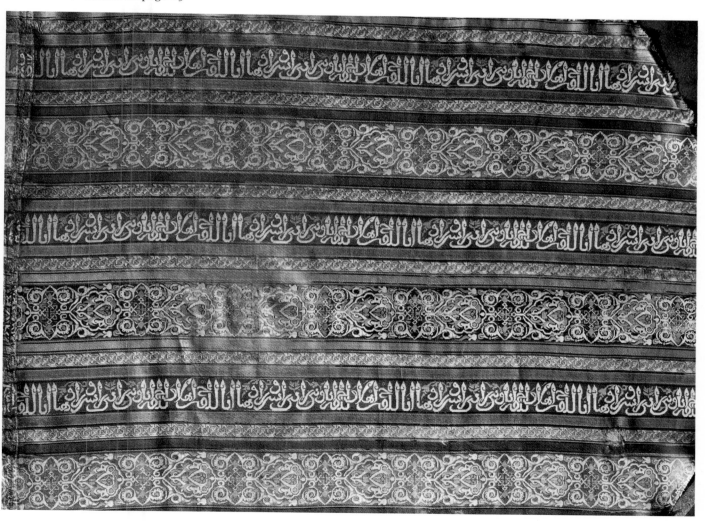

19. Lusterware dish

Spain, Manises (Valencia); 1420–1430 A.D.
Diam. 47.4 cm.
The Metropolitan Museum of Art; The Cloisters Collection, 1956

A rich area of Muslim civilization since the seventh century, the province of Valencia in eastern Spain was conquered in 1238 A.D. by Christian forces under Jaime I of Aragon (reign, 1213–1276). Despite this change of authority and the resultant influx of Christians, Islamic culture continued for more than two centuries thereafter to be an abiding presence in the life of the province. Thus in the fifteenth century, when Valencia became a center for Catalan poetry, substantially influenced by the poetry of France and Italy, there were also many Muslim potters, particularly in the small town of Manises, whose ceramics were commissioned by the kings of Aragon, secular and ecclesiastical officials, merchants, and even private individuals. Valencian pottery was exported to Italy as well. Altogether it must have been a profitable enterprise, and the Christian overlords of Manises demanded, received, and often then sold ten percent of the output of the kilns.

A number of Valencian vessels of the period use this basic design in gold and blue luster and testify to an enduring taste for Islamic and Islamic-type artifacts. Against a dense background of fine gold spirals, dots, and leaves is a central geometric design, an eight-petalled flower within an eight-pointed star, with a long history in the arts of Islam. Around this inner area are four ovals with blue arabesque and four broad bands containing a pseudo-inscription, repeating three *Kufic* letters, apparently derived from the Arabic word *al-ʿizz*, which figures on many medieval Muslim objects. As with other pseudo-inscriptions, whether for Muslim or Christian patrons, what was written here was not meant to be read: it served instead to convey the impression of elegance and wealth long associated with the earlier Muslim arts of Spain.

PREVIOUSLY PUBLISHED IN

V. K. Ostoia, *The Middle Ages: Treasures from the Cloisters and the Metropolitan Museum of Art*, No. 91, pp. 198–99.
Timothy Husband, "Valencian Lustreware of the Fifteenth Century: Notes and Documents," *Metropolitan Museum of Art Bulletin* 29 (no. 1, 1970), pp. 11–19.
Alice W. Frothingham, *Fine European Earthenware*, No. 3, p. 19.

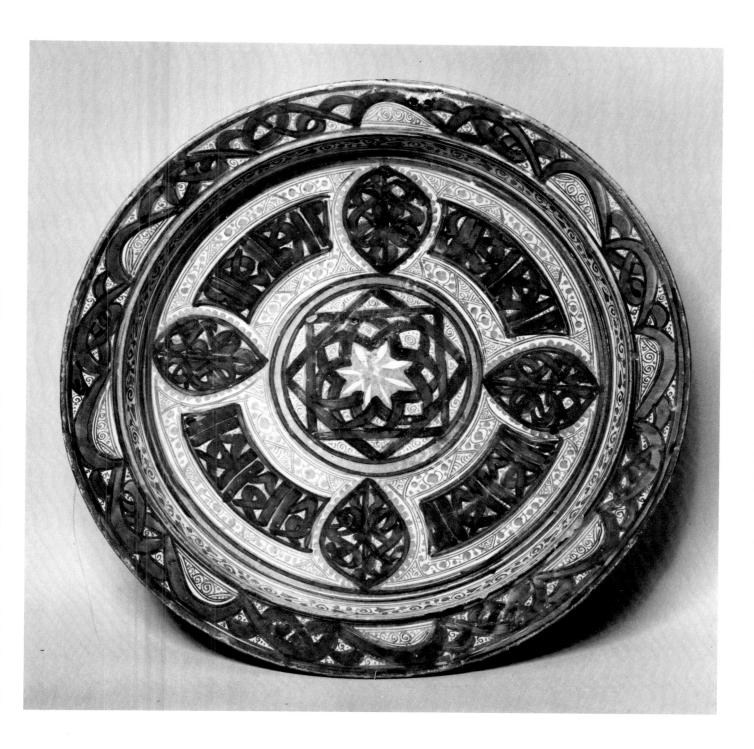

20. Silk pilgrims' banner

North Africa; dated 1094 H. (1683 A.D.)
L. 337.9 cm., W. 194.5 cm.
Fogg Art Museum; Gift of John Goelet

The pilgrimage to the holy city of Mecca is incumbent on all Muslims once during their lifetimes. Since the journey could be both difficult and dangerous, pilgrims often travelled in large groups or caravans; and, if they were also affiliated with a particular organization, banners such as this one, held aloft on tall poles, might be carried at the head of the procession.

This large dark maroon silk banner bears a rich ornamental and epigraphic program. Brocaded decorative panels are filled with eight-pointed stars, circles, and octagons, which apparently were intended to serve as talismans to ward off evil; they form a dense vertical pattern corresponding to the three strips of silk sewn together to make this banner.[1] The large, double-bladed sword represents the celebrated *Dhu'l-Faqar*, the miraculous sword given by Muhammad to his son-in-law 'Ali, who was famed for his heroism and military exploits and revered by Sunnis and Shi'as alike, and reveals the military origin of such banners.[2] The inscription on the two blades is appropriate, for it comes from the first four verses of the *surah al-Fath* (Victory) 48:1–4:[3]

Lo! We have given thee (O Muhammad) a signal victory,
That Allah may forgive thee of thy sin that which is past and that which is to come, and may perfect His favor unto thee, and may guide thee on a right path,
And that Allah may help thee with strong help—
He it is Who sent down peace of reassurance

It is written in a small, compact *naskhi*, similar to that which one finds on Ottoman sword blades.[4] The base of the hilt contains the word "Allah," repeated eight times and interlocked to form a decorative pattern with an octagonal star at its center.

The same verse, though somewhat shortened, is written in a large, angular *Kufic*, arranged in three horizontal lines in a broad band near the top of the banner. Here the initial words "In the name of Allah, the Beneficent, the Merciful" and the last words "He it is Who sent down peace of reassurance" from the inscription on the sword are absent. The repetition of the verses from the *surah al-Fath* not only relates the banner to its military prototypes but also refers to the spiritual victory to which the pilgrims bearing it aspire.

A third script, a *Maghribi* version of *Kufic*, is written in nineteen lines in a long, rectangular panel immediately below this verse. It has been identified as an Arabic religious poem, and its meaning refers to the banner's use. It has been summarized as follows:[5]

In the name of Allah, the Beneficent, the Merciful.
Were it not for him, there would be no pilgrimage and no place of pebbles.[6] Were it not for him, there would be no tawaf.[7] Neither man nor jinn would have come to Safa to drink from Zemzem.[8] O, he whose praise is as sweet as the Profession of Faith, be my intercessor on the day of resurrection! You are a refuge for every penitent and sinner! Accept a slave who comes to you in hope of felicity, who has named Abu Bakr as exalted of station.[9] Whoever visits ('Abd al-Qadir) attains every desire . . . the Sultan of the people of the East and West O, felicity of the slave who visits him in a garden![10] Blessings on [Muhammad's] house . . . so long as a single star shines in the sky. O, ye who set out to the Holy One, make a perfect chronogram: 1094.[11]

Among the many references to Allah, Muhammad, and Abu Bakr the inclusion of the name of 'Abd al-Qadir, the twelfth-century mystic who had a large and powerful following in North Africa, is especially striking, for it makes it clear that the large banner was carried by members of his Qadiriyya religious order on their long pilgrimage from North Africa to Mecca.

The use of diverse scripts on objects, whether large or small, is common, but this banner's three different calligraphic styles convey not simply aesthetic variety: *Kufic* is an appropriate, traditional script for a large religious inscription meant to be seen by a wide public, as would have been the case here; *naskhi* is often found on swords; and *Maghribi* is the favored script of Muslim North Africa from the twelfth century to the present.

NOTES

1. A great deal of the information in this discussion is derived from an excellent article by Walter B. Denny, "A Group of Silk Islamic Banners," *Textile Museum Journal* 4 (No. 1, December 1974), pp. 67–81.

2. Banners were often carried by Ottoman troops on military expeditions, and the adoption of this type by a religious order implies the continuing influence of the Ottoman *ghazi* (or religious warrior) ideal and the militant spiritual orders.

3. See No. 64 for an additional use of this *surah*.

4. See No. 30, where the *surah al-Fath* is also used.

5. By Prof. Wheeler Thackston, Harvard University, in the article by Denny, "A Group of Silk Islamic Banners."

6. On the tenth day of the pilgrimage pilgrims gather at a spot near Mecca to cast stones at a boulder, which symbolizes the devil.

7. The *tawaf* is the ritual circumambulation of the Ka'ba in Mecca.

8. Pilgrims drink water from the sacred well of Zemzem near Mecca.

9. Abu Bakr was the first caliph (632–634 A.D.) after the death of the Prophet Muhammad.

10. A twelfth century mystic, 'Abd al-Qadir al-Gilani, had a very widespread mystical following, the Qadiriyya, a dervish order extremely prominent in Turkey, North Africa, West Africa, Egypt, and India.

11. The Muslim date corresponds to 1683 A.D.

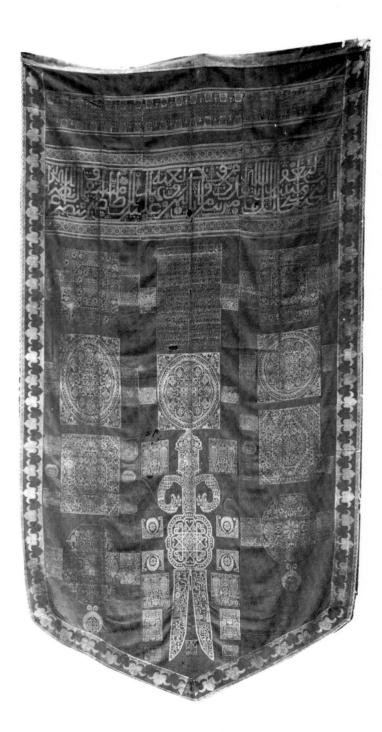

Syria, Egypt, and the Yemen

21. Brass vase inlaid with silver

Made for Sultan Salah al-Din
Syria; 1237–1260 A.D.
H. 45.0 cm.
Musée du Louvre, Département des Antiquités Orientales (Section Islamique)

Of Kurdish descent, the progenitors of the Ayyubid dynasty first served as soldiers for Muslim rulers of Syria and Egypt, but, as before in Muslim history, the recruited soldiery assumed the master's role. The most celebrated of the Ayyubids, Salah al-Din (Saladin) became ruler of Egypt in 1169, removed the last of its Isma'ili Fatimid caliphs,[1] returned Egypt to Sunni orthodoxy, and launched a successful holy war against the Christian Crusader states. Distant portions of his kingdom he parcelled out to close relations: thus after 579 H. (1183 A.D.) the great Syrian city of Aleppo was ruled by one offshoot of the Ayyubids, while Damascus was ruled by another. They reigned for nearly a century, keeping in relatively close contact with their Egyptian cousins and with Ayyubids ruling elsewhere in the Near East, until they were extirpated by the invading Mongols. Indeed, this vessel may have been one of the objects seen by the Mongols when they took Aleppo, for it had been made for the last of that city's Ayyubid rulers, the first Saladin's namesake, al-Malik al-Nasir II Salah al-Din, who reigned from 1237 to 1260 A.D.

One of the masterpieces of medieval Muslim metalwork, this large vase is in nearly perfect condition. Arabesques, figures, and inscriptions achieve a flawless equilibrium of varied forms; and surface—whether bare, incised, or inlaid with silver—is a balanced harmony of tones. The tall neck is dominated by the vase's largest, most visible, and most impressive inscription; in splendid *thuluth* script it is appropriately the vehicle for the sultan's name:

Glory to our lord, the sultan, al-Malik al-Nasir Salah al-Dunya wa al-Din

Two narrow bands or arabesques frame the inscription, but their leaves are animated, transformed into the heads of animals killed in the hunting scenes below and ranged like trophies round the monarch's name.

A pair of ridges divides the vessel's body into two parts. In the upper part two epigraphic bands frame a broad zone of figures and arabesques. The higher inscription, separated into six sections by six roundels of birds of prey pouncing on their victims, is written in a clear, regular, undramatic *naskhi*:

Glory everlasting, complete good fortune, victory and long life, support and repose, compassion and victory over foes, good health forever to the owner.

Below it is a broad band of incised and silver-inlaid arabesques with six eight-lobed medallions: four show various hunting scenes; a fifth encloses two men battling with swords; and in the sixth is a woman riding a camel.

Underneath is a band of fine, occasionally slightly rounded, *Kufic*, likewise divided by six roundels of birds, similar to those above; not everything in the inscription is uniformly legible, and at least two words are misspelled:

Great glory, secure life, happiness . . . , great success, and repose, and high position.

The bottom portion of the base is similarly divided into a larger figural-arabesque field bordered by two epigraphic bands. Like its counterpart above, the upper inscription is written in a tall *naskhi*, but separated into only four sections by bird roundels:

Glory to our lord, the sultan, the very great king, al-Malik al-Nasir, the wise, the just, who supports (the heavens), the triumphant, the victorious, the one who leads religious war, who is responsible for the frontier fortress, Salah al-Dunya wa al-Din, pillar of Islam and the Muslims, he who causes the truth to triumph by means of disputation, he who makes justice live in the two worlds, Abu'l-Muzaffar Yusuf, son of sultan al-Malik al-'Aziz.

The broad field below it is filled with arabesques and four twelve-lobed medallions enclosing four scenes of the hunt. The base of the vase is marked by a final line of epigraphy, written in a *Kufic* somewhat more rounded and less elegant than the *Kufic* inscription in the upper portion and containing what appear to be standard good wishes to the owner (though often either incorrectly or illegibly rendered) and the information that the vessel was made for the "cellar of al-Malik al-Zahir."[2]

Both polylobed medallions and small roundels contain scenes corroborating the inscriptions, for they present figural renderings of the ideals of power and aristocratic life to which the epigraphs refer. It is striking, however, that two of the five epigraphic bands have notable inaccuracies; they are not those written in cursive scripts that contain the sultan's name but rather those in *Kufic* that, with its more pronounced aesthetic convolutions, was probably less likely to be read with ease or care. Here therefore style of script connotes different purpose: *thuluth* and *naskhi* are used to beautify and communicate important information; *Kufic* communicates less, obfuscates more, and lends an archaistic and slightly sacrosanct epigraphic quality to the vase.

NOTES

1. See No. 90G.
2. The term used is *sharabkhanah* or "house for drink," a reference to a structure built and named for Sultan al-Malik al-Zahir Ghiyath al-Din, who ruled Aleppo from 582 to 613 H. (1186–1216 A.D.).

PREVIOUSLY PUBLISHED IN

Gaston Migeon, *Manuel d'art musulman*, I, pp. 56–58 (1927) and II, fig. 151, (1907).

Gaston Wiet, *Répertoire chronologique d'épigraphie Arabe*, XII, pp. 48–49, No. 4468.

Arts de l'Islam, Catalogue of an Exhibition at the Orangerie des Tuileries, No. 151.

L'Islam dans les collections nationales, Catalogue of an Exhibition at the Grand Palais, No. 275.

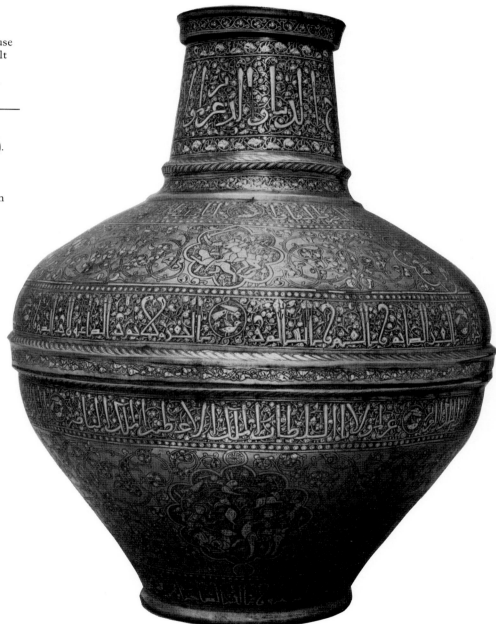

22. Brass basin inlaid with silver

Egypt; thirteenth or fourteenth century
H. 23.5 cm., Diam. 55.6 cm.
The St. Louis Art Museum

Although virtually all the Mamluk sultans first came to Egypt as young, non-Muslim slaves imported from the Caucasus or central Asia, they developed into some of Islam's most distinguished patrons. Trained as soldiers and educated in the Muslim faith, they were especially avid in their construction of towering urban structures—notably madrasas (theological seminaries) and personal tombs—and in their commissions of impressive portable objects like this basin, richly adorned with superb inscriptions. Under these newly Muslim rulers, many of whom had only brief reigns, calligraphy in particular flourished, and two of Islam's great monumental cursive scripts —thuluth (for buildings and large objects) and muhaqqaq (for Qur'ans) reached high points of artistry.

Used for personal ablutions, this deep, broad basin continues a formal type developed in Egypt and Syria in the twelfth century. Both interior and exterior are richly inlaid in silver, which forms a complex composition uniting epigraphy and ornament. On the bottom of the interior a circular medallion encloses swimming fish, a frequent motif in medieval Muslim metalwork. The flaring sides are decorated with six large medallions, containing either rhythmic arabesque or large vegetation around a central pinwheel design. Between these medallions and against a background of dense arabesques are six sections of thuluth calligraphy:

The high authority, the lordly, the great amir, the learned, the diligent, the conqueror, the holy warrior, the masterful, (the officer of) al-Nasir.[1]

The pinwheels recur in two narrow ornamental bands on the exterior that frame a tall *thuluth* inscription, divided into four parts by four medallions; it contains a similar high-sounding message:

The high authority, the lordly, the great amir, the conqueror, the holy warrior, the defender, the protector of frontiers, the fortified by God, (the officer of) Al-Malik al-Nasir.

While the interior medallions rely on the curving pinwheels to create a sense of movement, the exterior medallions focus on a central hub of vertically accentuated letters, which repeat essentially the same honorifics. Although a later owner has inscribed under the rim "Made for our lord al-ʿImad," there is no mention of either maker or patron in the three sets of original inscriptions.

Verbal repetition on the piece itself did not matter, nor was it apparently of concern that these inscriptions in their thorough sameness reiterate the epithets of large numbers of surviving metalworks. This absence of originality implies that the aristocratic owner's interest lay, not in unique personal statement, but rather in replication of accepted formulas with splendid artistry.

NOTES

1. The titles used here indicate that the owner was a member of the highest class of Mamluk officer.

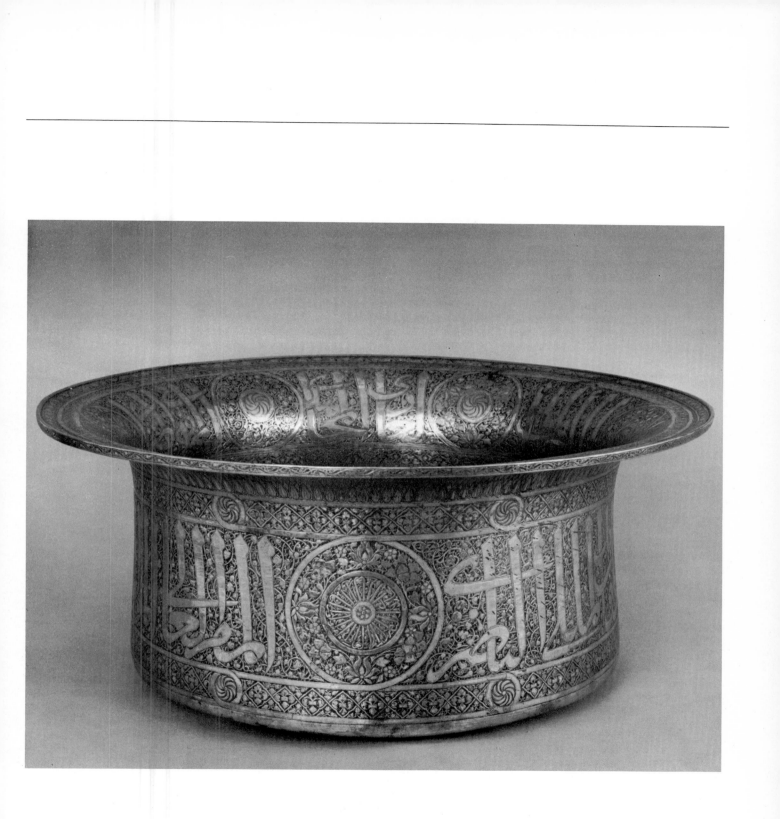

23. Brass basin

Made for Hugh IV of Lusignan, King of Cyprus
Egypt or Syria; 1324–1359 A.D.
H. 27.5 cm., Diam. 57 cm. (at top)
Musée du Louvre, Département des Antiquités Orientales (Section Islamique)

A medieval French family with strong international ties and with branches powerful in England and France, the Lusignans had also vigorously participated in the Christian Crusades in the Holy Land. For some time they served as kings of Jerusalem and thus as the titular leaders of Crusader Christendom; long after the city had passed into Muslim hands again, they retained the title. After 1192, when they were granted the island of Cyprus, their real authority was exercised as kings of Cyprus, where they ruled until supplanted by Mamluk and Venetian power in the fifteenth century.

The island had been a Byzantine province for more than two centuries before the Lusignans acquired it. Its population was largely Greek speaking, but after 1192 the court and aristocracy were French in language, customs, and culture. With the extinction of Christian power in the Holy Land by the Mamluks in 1291, Cyprus assumed crucial strategic and economic importance, both as the vanguard of Christian military forces and as the leading center for trade with the Muslim Near East.

Hugh IV (reign, 1324–1359) was a quiet, scholarly man who nevertheless established an alliance with the papacy, Venice, and the Knights Hospitalers of Rhodes and successfully seized Izmir (Smyrna) briefly from the expanding Ottoman Empire. Despite this military adventure his reign was generally peaceful: polite relations were maintained with the Mamluks of Egypt, and Cyprus' role as a commercial entrepôt led to considerable prosperity. It was the last flourishing of Lusignan power in medieval Cyprus. In the fifteenth century the island was overrun by the Mamluks and later incorporated into Venice's Mediterranean empire where it remained until the Ottoman Conquest of 1570–1571.

In form, style, and technique this basin,[1] originally inlaid in silver and gold, is virtually indistinguishable from other high-quality Mamluk basins like No. 22. Its exterior is dominated by a broad epigraphic band, separated into six sections by large medallions, and framed by a narrow band of running animals above and below; three of the medallions enclose heraldic blazons, while the other three contain *thuluth* inscriptions, written to form a radiating, wheel-like pattern. This same decorative scheme is continued on the interior except that the basin's bottom is incised with a complex astrological composition in which a central sun is circled by six human figures representing the planets, themselves surrounded by twelve figures standing for the zodiac. In all of this, there is no noticeable departure from traditions of Islamic metalwork.

The narrow band above the broad inscription of the interior, however, is not filled with running animals as is the case on the exterior. Instead, it contains a French inscription in Latin script which reads:

Most high and powerful king,
Hugh of Jerusalem and of Cyprus,
may God maintain (him).

This identification was presumably for those Cypriote French who could not read Arabic. For others there is the handsome *thuluth* inscription, virtually identical in the broad epigraphic zones and in the medallions on both exterior and interior. It has been read as follows:[2]

Of what was made for the most high
Excellency, the splendid, noble
Eminence Hugh, who has received the
favors (of God), who rises in the van of
the elite troops of the Frankish kings,
Hugh de Lusignan, may his power
endure.

As can be noted in a comparison with No. 22, both wording and titles used here differ from those commonly used on objects made for Mamluk rulers themselves. They are, in fact, highly unusual and appear to have been composed specifically for this piece. Four medallions on the exterior and the interior also contain the arms of Jerusalem, while the two remaining medallions enclose Maltese crosses. The beginning of the large exterior inscription is marked by a small cross, almost lost in the dense mass of letters and background foliage.

It is not possible that this basin—unique in the history of Islamic metalwork for its inclusion of the name, titles, and insignia of a Christian monarch—was made by a contemporary Mamluk ruler (of whom there were nine during Hugh's reign) as a gift for the Christian king; for the basin's titles are not those officially used by the Mamluks for the kings of Cyprus. Nor is it likely that a Mamluk patron would have sanctioned the inclusion of crosses and the arms of Jerusalem, then very much under Mamluk control. Instead, this splendid object must have been commissioned by Hugh or by someone close to him, for the king's basin uses nomenclature of Christian, not Muslim Mamluk, devising. Whether it was made in Mamluk territory or by a Mamluk-trained artisan working in Cyprus can probably not be determined. What is clear, however, is that for the Christian Lusignans basins of this form with large *thuluth* inscriptions expressed an ideal of power and kingship in a way which they desired to emulate.

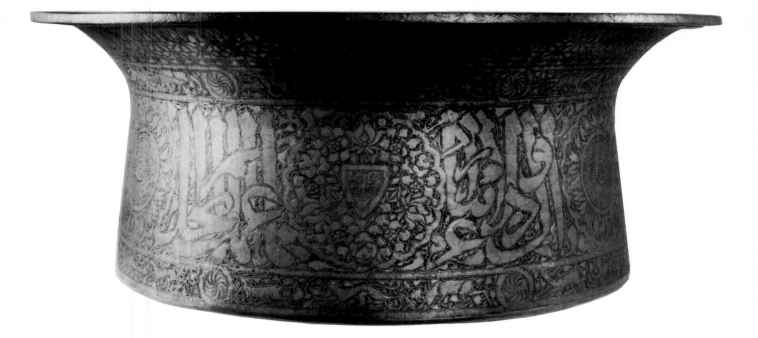

NOTES

1. It has been carefully published in a basic
 article (from which much of this entry is
 derived) by D. S. Rice, "Arabic inscriptions
 on a brass basin made for Hugh IV de
 Lusignan," in *Studi Orientalistici in onore
 di Giorgio Levi della Vida*.
2. This reading is from ibid., in which the
 peculiarities of the inscription are analyzed.

PREVIOUSLY PUBLISHED IN

D. S. Rice, "Arabic inscriptions on a brass
 basin made for Hugh IV de Lusignan," in
 *Studi Orientalistici in onore di Giorgio Levi
 della Vida*, II, pp. 390–402. Earlier bibliog-
 raphy is also listed in this work.
Arts de l'Islam, Catalogue of an Exhibition
 at the Orangerie des Tuileries, No. 165.
L'Islam dans les collections nationales,
 Catalogue of an Exhibition at the Grand
 Palais, No. 491.

24. Bronze tray

Made in Egypt for the ruler of Yemen (1321–1363 A.D.)
Diam. 77.5 cm.
Musée du Louvre, Département des Antiquités Orientales (Section Islamique)

Seventeen, small reddish copper five-petalled flowers are enclosed by silver circles and placed in prominent positions on this large tray. One of these small flowers is in the exact center of the tray and of a large open blossom, radiating out in six equal parts, with the outer petals also marked by smaller red copper flowers. Six more small flowers are in the narrow band of ornament circling the central blossom; and a final three copper flowers rest in the centers of the three large outer rosettes. It is not simply an attractive decorative device: the five-petalled flower is the dynastic emblem of the Rasulid dynasty, which ruled the Yemen from 1229 to 1454 A.D.

The inscription, inlaid in silver and divided into three sections of equal size, gives more precise information:

Glory to our lord, our king, the ruler of our age and our time, the sultan al-Malik al-Mujahid, Sayf al-Dunya wa al-Din 'Ali, the son of the sultan al-Malik al-Mu'ayyad Mubarriz al-Dunya wa al-Din Da'ud, endowed with the glory of the two masteries, of the sword and of the pen.

At the peak of their power in the thirteenth and fourteenth centuries the Rasulids controlled, not only the Yemen, but also Mecca and a large part of central Arabia. Although much of the Yemeni populace was Shi'a, the dynasty was strongly Sunni, acknowledging the authority of the 'Abbasid caliph and maintaining strong ties with Ayyubid and Mamluk Egypt. Thus the titulature of this inscription follows the Ayyubid pattern of a century before,[1] while the tray itself was almost certainly made in Mamluk Egypt on commission from al-Malik al-Mujahid.[2]

The division of space between epigraphic and ornamental areas is typical of Mamluk metalwork, and so too is the superb *thuluth*, the elegant cursive script used so often and with such effect by thirteenth and fourteenth century Egyptian artisans. A sense of order, clarity, and balance permeates the three sections of the inscription, particularly in the repetition of verticals: in two sections there are nineteen verticals; in one there are eighteen. The tips of the verticals are cut in sharp diagonals down to the left, while most, but not all, of these letters bear heads turned slightly to the right, their presence and direction caused by aesthetic rather than orthographic considerations. The pronounced accentuation of verticals produces a dramatic, wheel-like motion, which can be seen in other Mamluk metalworks,[3] and one wonders how much the choice of specific titles might have been governed, not only by reasons of state, but also by potential visual appeal, similar to the verticality of the Muslim *shahada*.

Letters too are not always of the same size, and there are marked differences of scale and proportion between the three sections. In each, however, letters that normally ride the horizontal are seated higher, midway up and sometimes intertwined with a vertical shaft. As is also true with the floral ornamentation, beauty here is of great complexity; and, where it rested in the former on fine and subtle deployment of exquisite patterns, its force in the script is derived from starker color, bolder line, and the dramatic interplay of different epigraphic forms.

NOTES

1. For Ayyubid metalwork see No. 21.
2. For Mamluk metalwork see No. 22. Mamluk metalworkers also filled commissions for other patrons (see No. 24).
3. See Nos. 23 and 24.

PREVIOUSLY PUBLISHED IN

Gaston Migeon, *Manuel d'art musulman*, II, fig. 172.
Les arts de l'Islam, Catalogue of an Exhibition, No. 81.
Arts de l'Islam, Catalogue of an Exhibition at the Orangerie des Tuileries, No. 170.
L'Islam dans les collections nationales, Catalogue of an Exhibition at the Grand Palais, No. 95.

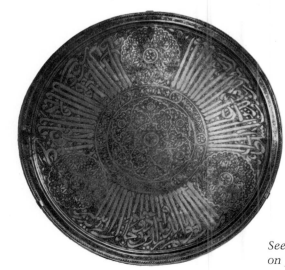

See color illustration on page 16

25. Ivory panel

Egypt; fourteenth century
H. 6.3 cm., W. 28.2 cm.
The Walters Art Gallery

Ivory was used throughout the Mediterranean Muslim world, and fine objects in this choice material that were produced in Spain, North Africa, Sicily, and Egypt are still extant. Particularly notable, in both their numbers and their quality, are small caskets, made either wholly of ivory or of wood with ivory inlays or applied panels and intended to hold jewels, perfumes, or cosmetics. Many of these boxes are inscribed, some in *Kufic*, other in *naskhi* or, as in this panel, in *thuluth*, a highly favored script during the Mamluk period in Egypt. While inscribed ivory panels were sometimes applied to the doors and minbars of religious institutions (and bear epigraphs appropriate to these situations),[1] the inscription here indicates that this handsome panel probably once constituted a side of a casket made for a wealthy, fourteenth century Egyptian:

Night and day have mixed in the enjoyment of it.

The sentence is interesting on two levels. The juxtaposition of two opposites is an admired rhetorical device in Arabic; but the inscription probably refers, not only to the times in which the panel provided aesthetic satisfaction, but also to its erstwhile appearance: spiraling white arabesque and stately white *thuluth* letters dramatically set against a recessed background painted black or perhaps even fitted with pieces of ebony, subsequently removed. Then too, the inscription has a double meaning: in Arabic the second form of the root *ta'ima* means "to inlay" but the fifth form means "to taste" or "to enjoy." While the fifth form is used here, the other meaning is clearly implied, so that the epigraph contains a pun both on the production of the panel and on the aesthetic satisfaction derived from it.[2]

NOTES

1. See *The Arts of Islam*, Catalogue of an Exhibition at the Hayward Gallery, Nos. 154, 155, and 156.
2. I am grateful to Prof. Roy P. Mottahedeh for suggesting these interpretations of this inscription.

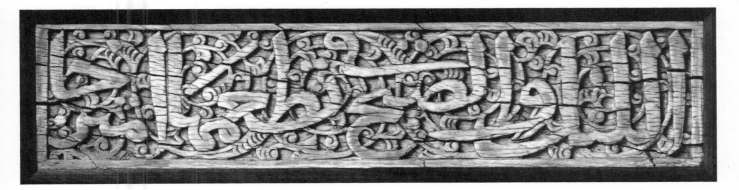

26. Printed cotton cloth

Egypt; fourteenth century
H. 24 cm., W. 23.8 cm.
The Textile Museum

This fragment of a cloth, gray printed on white cotton, closely approximates Mamluk metalwork in its combination of geometric ornament and stately *thuluth* letters. In the main band, where tall letters, white against gray, achieve the strident, but stable, verticality favored in Mamluk objects, the Arabic words "Glory and nobility" are repeated in a recitation of good wishes similar to standard inscriptions on metal and ceramic objects. The identical borders at top and bottom are inscribed between geometric cartouches with smaller *thuluth* letters, one-third the size of the main ones. They read "Glory and nobility and grandeur and praise."

Despite its handsome and aristocratic epigraphs, this cloth is printed, rather than woven or embroidered, and executed on cotton, instead of silk; and it was probably designed and intended for a humbler clientele.

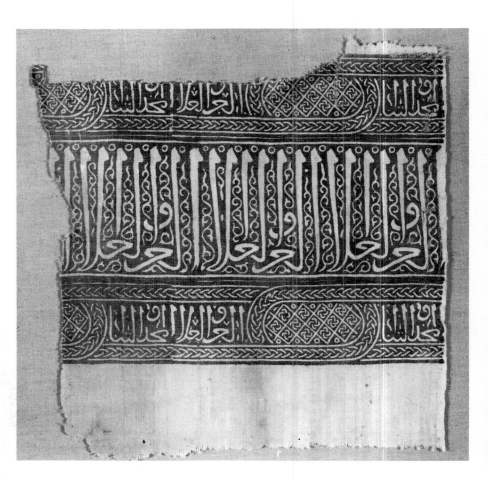

27. Juz' 15 of the Qur'an

Egypt; Mamluk period, late fourteenth century
H. 37.4 cm., W. 28.2 cm.
Collection of Prince Sadruddin Aga Khan

The fifteenth *juz'* (or part) of the *Qur'an* comprises all of *surah Bani' Isra'il* (The Children of Israel) and verses 1–73 of *surah al-Kahf* (The Cave). The initial pages, illustrated here, are illuminated in gold and blue with the chapter heading in white (now somewhat abraded) *thuluth* script and the text in a splendid *muhaqqaq*:

In the Name of Allah, the Beneficent, the Merciful.
Glorified be He Who carried his ser-vant by night from the inviolable Place of Worship to the Far Distant Place of Worship, the neighborhood whereof We have blessed, that We might show him of Our tokens! Lo! He, only He, is the Hearer, the Seer.
We gave

Verse divisions are marked by small gold and blue rosettes, and every tenth verse is indicated in the margins by an oval, gold enclosed by blue.

Individual sections of the *Qur'an* were often commissioned rather than the whole book. According to a note in English on the endpaper of this *juz'*, this manuscript once belonged to the mosque attached to the tomb of the Mamluk Sultan Barquq (ruled 1382–1399 A.D.) near Cairo.

PREVIOUSLY PUBLISHED IN

Anthony Welch. *Collection of Islamic Art: Prince Sadruddin Aga Khan.* 4 vols. Geneva (1972–1977).

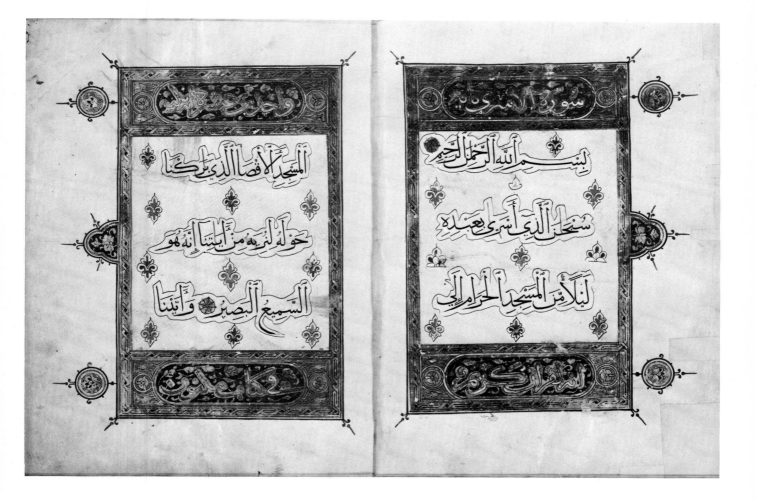

28. Fragment of a priest's chasuble

Italy; second half of the fourteenth century
L. 117.8 cm., W. 79.3 cm.
The Cleveland Museum of Art; Purchase from the J. H. Wade Fund

The orphrey of this chasuble was made in Cologne in the fourteenth century, but the more southerly origins of the rest of the garment are indicated by heavy reliance on Islamic fabrics. The figural motif of a bird of prey attacking a lion-like animal is frequent in Muslim art, while the five vertical letters, seen behind a flowering plant, are derived either from the word Allah or from the repeating verticals of the Muslim creed "There is no god but Allah."

The rapid expansion of the textile industry in fourteenth century Italy owed much to fine textiles imported from Muslim Spain and Egypt in particular, and not only the figural and epigraphic elements, but also the technique—lampas weave with silk and gold threads—reveals the impact of Muslim art. Cursive script had come widely into use in Islamic portable objects in the late twelfth and thirteenth centuries; thus while *Kufic* was imitated on an early thirteenth century Limoges enamel (No. 15), it was the *thuluth* script, widely used in the arts of the great Mediterranean power of Mamluk Egypt, which was the model for the pseudo-inscriptions here.

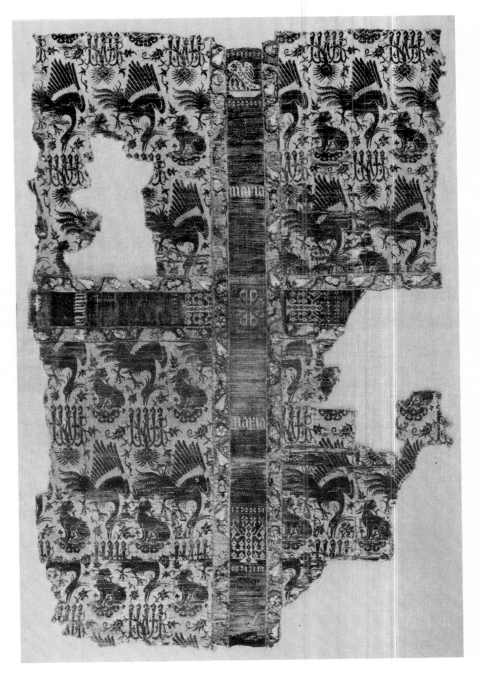

Turkey

29. Manuscript of the Qur'an

Turkey; ca. 1500–1510 A.D.
H. 38.8 cm., W. 26.3 cm.
Collection of Prince Sadruddin Aga Khan

One of the finest known Ottoman *Qur'ans*, this manuscript was created early in the sixteenth century. Although the colophon does not mention the name of the patron, it must have been created in Istanbul for the Ottoman sultan Bayazid II (reign, 1481–1512), since the colophon identifies the scribe as Shaykh Hamd Allah ibn Shaykh Mustafa, "the perfect *hajji*[1] and the head of the scribes." It can only be referring to Hamd Allah ibn Mustafa, the greatest classical master of Ottoman calligraphy and an intimate companion of the sultan during his entire reign. Thus it is one of a few surviving early Ottoman royal *Qur'ans* and is probably the finest complete *Qur'an* by Shaykh Hamd Allah.[2]

Born about 1439 or 1440 A.D. in Amasya, where he was trained as a calligrapher, Shaykh Hamd Allah rapidly became known as an innovative scribe in the tradition of the formidable mid-thirteenth century master, Yaqut. In Amasya he became the teacher of Prince Bayazid, the heir to the Ottoman throne; and, when Bayazid became sultan in 1481, Shaykh Hamd Allah moved to Istanbul with him. Given the same epithet as Yaqut—"*qibla* of the calligraphers"—he is reputed to have written a total of forty-six large and small *Qur'ans*, as well as a thousand separate *ajza'* (parts) of the holy book. He also functioned as a designer of architectural epigraphs, and the inscription over the main door of the Mosque of Bayazid in Istanbul is by his hand. The sultan so cherished his work that the revenues from several Hungarian villages were assigned to him, and his high income aroused the jealousy of many of his contemporaries.

He died in 1519 in Istanbul. His son and two of his cousins were well-known calligraphers, and his students were many. A succession of nine masters are recognized as the transmitters of his style well into the nineteenth century.[3]

This manuscript contains 278 pages. The text, generally thirteen lines of *naskhi* script to the page, is framed by a simple gold and blue-lined border. *Surah* headings exactly occupy the space of two lines of text and are written in white *thuluth*. Small gold roundels, divided into six parts by light blue lines and dots on the perimeter, mark the end of each verse, while finely illuminated medallions and lozenges in gold and blue mark the end of each fifth and tenth verse.

Surah al-Fatihah (The Opening) 1:1–7, and *surah al-Baqarah* (The Cow) 2:1–4 (illustrated here) are magnificently illuminated. Six lines of text are enclosed by rectangular gold, blue, and red panels, bordered by a lighter blue margin, and by an outer band of triangular forms, culminating in a gold *ansa* projecting toward the edge of the page.

The binding is almost certainly the original cover for the book and is of outstanding quality—a dark red brown leather with gold cartouches and raised black arabesques.

The script itself is a beautifully proportioned *naskhi*, fully pointed and preserving its horizontal layout with remarkable clarity. Individual letters are formed from a stroke of nearly uniform thickness, tapering only slightly in the verticals, and the lines of text sustain a measured, fluid pace, clear and predictable in its classical order.

NOTES

1. *Hajji* is a title used by a Muslim who has completed the pilgrimage to Mecca.
2. One whole *Qur'an* and portions of two others, signed with the name of Shaykh Hamd Allah, are in the Beatty Library (see Arthur J. Arberry, *The Koran Illuminated: A Handlist of the Korans in the Chester Beatty Library*, Nos. 189, 190, and 191). Three albums in Istanbul contain samples of his work (Museum of Turkish and Islamic Art, Mss. 2465 and 2487; and Topkapi Palace Museum, H. 2180).
3. Other discussions of Shaykh Hamd Allah can be found in Clément Huart, *Les Calligraphes et les Miniaturistes de l'Orient Musulman*, pp. 108–112, and O. Aslanapa, *Turkish Art and Architecture*, p. 324.

PREVIOUSLY PUBLISHED IN

Anthony Welch, *Collection of Islamic Art, Prince Sadruddin Aga Khan*, I and II, Ms. 5.
Martin Lings and Yasin H. Safadi. *The Qur'an*, No. 129.

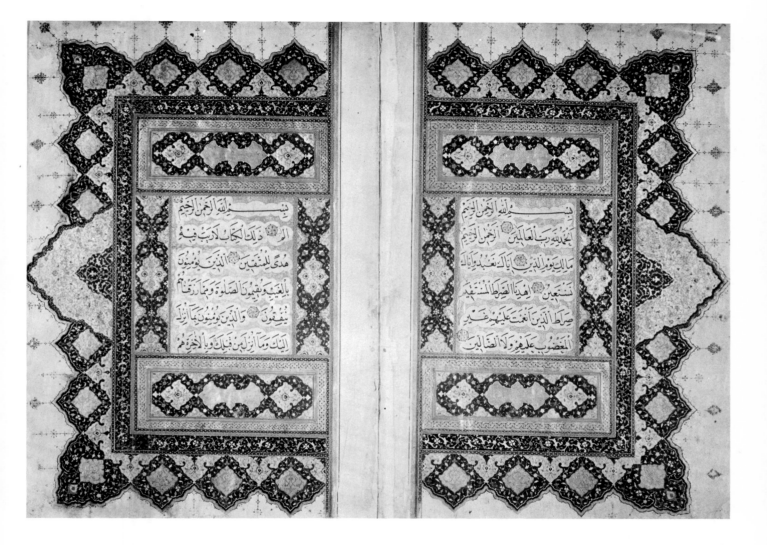

30. Steel sabre

Turkey; ca. 1520–1566 A.D.
L. 97.0 cm.
The Metropolitan Museum of Art; Bequest of George C. Stone, 1936

Known as a *kilij*, this type of Ottoman sabre has a pistol-shaped hilt, a straight guard, and a long blade that widens slightly about twenty-three centimeters from the point.[1] Its fine steel blade, decorated with minute gilded arabesques and superb inscriptions written in gilded cartouches of various shapes and sizes, bears neither date nor the name of the weapon's owner or maker. Instead, it is inscribed with verses from four different *surahs*, which together form a complex and appropriate epigraphic program.

Eleven verses from *surah al-Fath* (Victory), appear in three different areas: on side *a* in large *thuluth* script in the ten medium-sized cartouches (48:1–4) and on side *b* in large *thuluth* in the ten medium-sized cartouches (48:5–6) and in small *thuluth* in the three long cartouches (48:7–11):

Lo! We have given thee (O Muhammad) a signal victory,

That Allah may forgive thee of thy sin that which is past and that which is to come, and may perfect His favor unto thee, and may guide thee on a right path,

And that Allah may help thee with strong help—

He it is Who sent down peace of reassurance into the hearts of the believers that they might add faith unto their faith. Allah's are the hosts of the heavens and the earth, and Allah is ever Knower, Wise—

That He may bring the believing men and the believing women into Gardens underneath which rivers flow, wherein they will abide, and may remit from them their evil deeds—That, in the sight of Allah, is the supreme triumph—

And may punish the hypocritical men and the hypocritical women, and the idolatrous men and the idolatrous women, who think an evil thought concerning Allah. For them is the evil turn of fortune, and Allah is wroth against them

and hath cursed them, and hath made ready for them hell, a hapless journey's end.

Allah's are the hosts of the heavens and the earth, and Allah is ever Mighty, Wise.

Lo! We have sent thee (O Muhammad) as a witness and a bearer of good tidings and a warner,

That ye (mankind) may believe in Allah and His messenger, and may honor Him, and may revere Him, and may glorify Him at early dawn and at the close of day.

Lo! those who swear allegiance unto thee (Muhammad), swear allegiance only unto Allah. The Hand of Allah is above their hands. So whosoever breaketh his oath, breaketh it only to his soul's hurt; while whosoever keepeth his covenant with Allah, on him will He bestow immense reward.

Those of the wandering Arabs who were left behind will tell thee: Our possessions and our households occupied us, so ask forgiveness for us! They speak with their tongues that which is not in their hearts. Say: Who can avail you aught against Allah, if He intend you hurt or intend you profit? . . .

A single verse (61:13) from *surah al-Saff* (The Ranks) is written on side *a* in small *thuluth* in the long cartouche nearest the hilt:

And (He will give you) another (blessing) which ye love: help from Allah and present victory.[2] Give good tidings (O Muhammad) to believers.

In the long middle cartouche on side *a*, written in small *thuluth*, is the often-used *ayat al-kursi* (throne verse, 2:255) from the *surah al-Baqarah* (The Cow):

Allah! There is no God save Him, the Alive, the Eternal. Neither slumber nor sleep overtaketh Him. Unto Him be-

longeth whatsoever is in the heavens and whatsoever is in the earth. Who is he that intercedeth with Him save by His leave? He knoweth that which is in front of them and that which is behind them, while they encompass nothing of His knowledge save what He will. His Throne includeth the heavens and the earth, and He is never weary of preserving them. He is the Sublime, the Tremendous.

In the last long cartouche written in small *thuluth* and ending at the point of side *a* is inscribed one verse, 27:17, from *surah al-Naml* (The Ant). It is continued in fine *naskhi* in further verses from the same *surah*, 27:18–19, in the ten small four-lobed medallions on side *b*:

And there were gathered together unto Solomon his armies of the jinn and humankind, and of the birds, and they were set in battle order. Allah has spoken truly.[3]

Till, when they reached the Valley of the Ants, an ant exclaimed: O ants! Enter your dwellings lest Solomon and his armies crush you, unperceiving.

And (Solomon) smiled, laughing at her speech, and said: My Lord, arouse me to be thankful for Thy favor wherewith Thou hast favored me and my parents, and to do good that shall be pleasing unto Thee, and include me in (the number of) Thy righteous slaves.

The reference to Solomon is sustained in three additional verses from *surah al-Naml* 27:29–31:

(The Queen of Sheba) said (when she received the letter): O chieftains! Lo! there hath been thrown unto me a noble letter.

Lo! it is from Solomon, and lo! it is: In the name of Allah, the Beneficent, the Merciful.

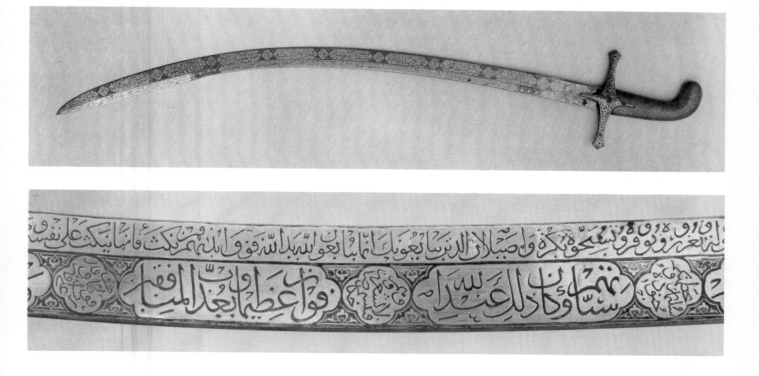

Exalt not yourselves against me, but come unto me as those who surrender.

In these abundant, superbly written inscriptions three themes are evident, which can be summarized as follows: (a) Allah's omniscience and omnipotence; (b) Allah's gift of victory and paradise to the faithful; and (c) Solomon's control (through Allah) over the forces of nature, his faithful submission to Allah, and Sheba's recognition of his power.

While *Qur'anic* verses (particularly from *surahs al-Fath* and *al-Baqarah*) exalting Allah's power and extolling Islam's victory are frequently encountered on inscribed objects, the references to Solomon in the six verses carefully selected from *surah al-Naml* are far less

common. Muslim monarchs often implicitly compared themselves with the great king, whose knowledge and power were proverbial,[4] but the choice of verses here on a magnificent sabre of the sixteenth century may well be more explicit: Sultan Sulayman (Solomon) the Magnificent ruled from 1520 to 1566, and his reign is justly considered the greatest period of Ottoman power. The Safavis in Iran had been decisively defeated in 1514 by Salim I, who also deposed the last of the Mamluks in 1517 and brought Egypt and Syria into the Ottoman Empire. In 1524 the armies of Sulayman II won an overwhelming victory over Christian forces at the battle of Mohacz and ensured Ottoman domination of southeastern Europe for a century

and a half. In this regally inscribed *kilij*, which combines the celebration of the victory of Allah and Islam with specific examples of Solomon's power, we most likely have a weapon made for the greatest of the Ottoman sultans.

NOTES

1. For a discussion of this and other types of Islamic swords see A. Rahman Zaky, "On Islamic Swords," in *Studies in Islamic Art and Architecture in Honour of K. A. C. Creswell*, pp. 270–291.
2. This particular phrase ("help from Allah and present victory") appears on two other objects in this exhibition, Nos. 62 and 64.
3. This last sentence does not occur in this verse but has been added by the scribe, apparently to fill the available space.
4. See No. 82.

31. Ceramic mosque lamp

Turkey; mid-sixteenth century
H. 32.2 cm.
The Walters Art Gallery

The rightful succession to the leadership of Islam after the death of the Prophet Muhammad has been a major issue in Islamic history. Sunni Muslims have held that Muhammad's successors—Abu Bakr, ʿUmar, ʿUthman, and ʿAli—were properly chosen and justly entitled in that order to the caliphate. Shiʿas, however, have held that to ʿAli and his descendants alone belonged the leadership of Islam, and they have regarded the first three caliphs as usurpers.

With its conquest of the Mamluk state in 1517 and its concomitant control over the holy cities of Mecca and Medina, the Ottoman sultanate became the single most important upholder of Sunni orthodoxy in the Muslim world. But both in Safavi Iran, where a Shiʿa dynasty ruled, and in the eastern reaches of the Ottoman Empire, where the Safavis encouraged Shiʿa Turkish nomads, Sunnism was challenged. Thus the epigraphs on this lamp, used to illuminate an Ottoman mosque, assume wider significance. The words "Allah, Muhammad, Abu Bakr, ʿUmar, ʿUthman, ʿAli" are written on both the neck and the body of the vessel in a flowing *thuluth* script, superbly contoured to fit the shape of the lamp.

Ottoman ceramic art, along with the architecture of Sinan and the calligraphy of Shaykh Hamd Allah (see No. 29), achieved high classical form in the first century after the conquest of Istanbul. Termed Iznik ware after the major site where they were produced, these ceramics are based not only upon sure form and bold colors—here blue, red, and green—but also upon designs by accomplished court painters and calligraphers.

*See color
illustration on
page 10*

32. Page from a manuscript of the Shahnamah of Firdausi

Iran and Turkey; 970–991 H. (1562–1583 A.D.)
H. 47.5 cm., W. 33 cm.
Museum of Fine Arts, Boston; Francis Bartlett Donation of 1912 and Picture Fund

This splendid page was originally the penultimate folio of a huge copy of Firdausi's *Shahnamah*.[1] The great poet's text, however, occupies only the central rectangle, where it is written in twenty-five lines of small, fine *nasta'liq*. Two horizontal panels within the text enclose chapter titles written in gold or white *naskhi*. Both scripts are bounded by illumination, according to the colophon on the following page provided by the original text's calligrapher, Muhammad al-Qiwam al-Katib al-Shirazi. In the sumptuously colored margins are ten lines of a commentary, composed and appended to the book by a later calligrapher-illuminator, Muhammad ibn Taj al-Din Haydar Shirazi, who wrote them in a stately *naskhi* script and boldly illuminated them in brilliant hues of lavender, orange, green, dark blue, light blue, black, and gold. Though the juxtaposition of different scripts on the same page is not unusual, seldom has their use been more felicitous. The balance and harmony of scripts is as vital to the aesthetic effect of this page as is its arrangement of colors and geometric shapes.

The commentary in the margins is a major document as well as an aesthetic delight. The first two lines are in Arabic; the remaining eight are in Persian.

In the name of Allah, auspicious of mention, the High, the Most High, the Giver; Praise be to Allah, who revealed to His servant the Book.[2]
And Blessings and Peace upon Muhammad and on his Kin and his Companions, the best of mankind; and to continue: [due to] the blessing of divine assistance and gracious favors [appears]
This noble book, worthy of honor, every opening verse of which is a star shining high in the East, and every couplet from its felicitous pages
Is a luminous body shining in the guiding heavens; its phraseology in refinement
Is like a sweet soul and in freshness like coral; its ornate, heart-ravishing verses
Are like the coquettry of the heart-agitating, sugar-lipped beauties, and its soul-stirring themes are like the lovelocks of
Fresh-cheeked charmers. The ancient geometers of the heavens, although they have circled around
The earth for many years, have not taken notice of the excellent, dark-veiled book in their circuit.[3]
[Like] the lovelocks of the idols of Chegel,[4] everywhere there is life and the abode of hearts. Beneath the black letters its themes shine like the sun and are illuminated like the moon.
. . . the wonders of [his] works and the image of the pages are filled with novelties of expression and the arrangement of gilded tablets which the ultimate [master] in excellence in the naskhi *script (has written) on the gilded* shamsa *[illuminated sunburst] and the tablet.[5]*

This page was the next to last of this great *Shahnamah*, and the final page (also in the Museum of Fine Arts, Boston) is the aesthetic counterpart of this one:[6] the epic's text ends with the signature of Muhammad al-Qiwam al-Shirazi, while the ten lines of commentary in the margins cite him again, praising him as a scribe, as the designer of this book, and as a poet of note. It also states that the book, begun by Muhammad al-Qiwam in 970 H. (1562 A.D.), was with the help of certain unnamed patrons brought to completion in 991 H. (1583 A.D.) by Muhammad ibn Taj al-Din Haydar, who composed this commentary poignantly ending with a plea for the prayers of future readers.

Though now only a fragment, the book had an unusual history. The text of this *Shahnamah* was copied by Muhammad al-Qiwam in his home town of Shiraz. As is evident from the twenty-line commentary, his work was well known and highly appreciated. Twenty-one manuscripts bear his name[7] and provide a range of dates from 943 H. (1536–1537 A.D.) to 974 H. (1567 A.D.). In all of these works both illumination and illustration are wholly characteristic of the Shiraz style, and we are safe in assuming that Muhammad al-Qiwam was employed all of his life in that city, where he seems to have worked for patrons of discernment.

His panegyrist, Muhammad ibn Taj al-Din Haydar, was more often known by the name of Taj Bek Zadah, the author of a treatise of calligraphy, now unfortunately lost.[8] His words here reveal a keen appreciation of one of his great predecessors and may be indicative of the quality of his vanished treatise. He was considered a very innovative master in *diwani*, *thuluth*, and *naskhi*, the script he employed here.

A plausible history of this copy of the *Shahnamah* is now possible. Written after 970 H. (1562 A.D.) by Muhammad al-Qiwam in Shiraz, it was not supplied with illustrations until it ended up in Ottoman hands, perhaps as a gift from a Safavi Iranian authority. Apparently through Muhammad Taj al-Din Haydar's initiative, the book was supplied with illustrations, five of which have survived, by an unnamed Ottoman master fully conversant with Shirazi painting. As a final touch, Muhammad Taj al-Din added his own fine illuminations and his panegyric account of both scribe and book. Completed in 991 H. (1583 A.D.), the commentary implies that Muhammad al-Qiwam is already dead. Muhammad ibn Taj al-Din Haydar died five years later and was buried near the madrasa of Mahmud Pasha in Istanbul.

NOTES

1. Seven pages from this now dispersed manuscript (originally containing approximately 570 folios) are known: three in the Museum of Fine Arts, Boston (published in Ananda Coomaraswamy, *Les Miniatures orientales de la collection Goloubew au Museum of Fine Arts, Boston, Ars Asiatica* [Paris] 13 [1929], pp. 60–63 and pl. LIV–LVIII) and four in the Metropolitan Museum of Art, New York (published in Ernst Grube, "Four pages from a Turkish 16th century *Shahnamah* in the collection of the Metropolitan Museum of Art in New York," in *Beiträge zur Kunstgeschichte Asiens: In Memoriam Ernst Diez*, pp. 237–255). All three of the Boston pages and two of the Metropolitan's pages have fine illustrations on the reverse.

2. That is, who revealed the *Qur'an* to the Prophet Muhammad.

3. That is, despite the manifold excellence of the *Shahnamah* of Firdausi, it has not been accorded the recognition it deserves.

4. The youths of Chegel, a town in Turkestan, were famed for their beauty. The *Shahnamah*, according to this simile, is a source of passion and vitality as powerful as these ideal beauties.

5. Prof. Annemarie Schimmel has pointed out to me that "*khatt-i naskh*" means not only "*naskhi* script" but also "line of abrogation." Thus this final sentence means also that this manuscript is so beautiful that it abrogates the celestial medallion of the sun.

6. The reverse sides of both calligraphies form a superb double-page illustration of the arrival at court of a triumphal procession. Their style and quality indicate that the painter was one of the artists active at the court of Sultan Murad III (1574–1595) in Istanbul.

7. Nothing is known about the scribe's life other than that he was active in Shiraz from 1536 to the middle of the 1580s. Manuscripts bearing his name are listed in Mehdi Bayani, *Khushnevisan*, vol. III, pp. 814–816; Grace D. Guest, *Shiraz Painting in the Sixteenth Century*, p. 64; and Basil W. Robinson, *Descriptive Catalogue of the Persian Paintings in the Bodleian Library*, pp. 108, 121–125.

8. Clément Huart, *Les Calligraphes et les Miniaturistes de l'Orient Musulman*, p. 125.

See color illustration on page 2

33. Tughra and firman of Sultan Ahmed III

Turkey; 1703–1730 A.D.
H. 124 cm., W. 50.2 cm.
Collection of Edwin Binney, 3rd

The Ottoman *tughra* was a unique form in Islamic culture: the equivalent of a royal seal, it was, nevertheless, individually created for each document by a *nishanghi* or *tughrakesh*, a scribe specializing only in writing *tughras*. Thus this *tughra* was done by one master (indeed, a *tughrakesh* was a highly placed royal official), while the text of the royal *firman*, or epistle, below it was the work of another calligrapher, writing in the tight, unpredictable, and energetic *diwani* script singularly favored by Ottoman officialdom. The development of this imperial form (or formula)—typologically, hovering somewhere between a seal impression and a signature—can be clearly traced only from the fifteenth century, when *tughras* consisted solely of calligraphy, however convoluted. By the sixteenth century flowers and arabesques had come to fill the swirls and flourishes of the sultan's name. From near the end of the sixteenth until well into the nineteenth century the immediate environment of the *tughra* grew lush with abstract vegetation, often bounded, as here, by triangular form.[1]

This elegant form is attenuated at the right but expansively full at the left; dense and diagonal at the bottom but almost haughtily in order at the top. Nearly all *tughras* are morphologically similar to this one, the calligraphic portion of which consists of the following words: "Ahmed [son of] Mehmed, khan [and] shah, perpetually victorious."

The twenty-third in the line of Ottoman sultans, Ahmed III (1703–1730 A.D.) was a calligrapher of marked ability, a skillful poet, and a sensitive patron of the arts, who presided over the *lalah* or "tulip" period of Ottoman history, when a virtual revolution in official taste took place. Instead of documenting the heroic exploits and achievements of Ottoman history, court painters rendered scenes of beautiful youths engaged in sophisticated pleasures; secular themes, exalting pleasure, replaced mystical ideals in poetry; architecture moved from the classical canons established by Sinan in the fifteenth century toward styles influenced by the French Baroque; while the institutions of France were studied and in some cases partially imitated. In an era of change, however, the imperial *tughra* remained constant, and despite the spiraling welter of vegetation above it, the basic calligraphic form here is deeply rooted in Ottoman tradition. It is ironic then that the text of the *firman* below it should grant royal permission to certain French merchants to sail through the Dardanelles to Istanbul.

NOTES

1. The basic monograph on the Ottoman *tughra* is E. Kühnel, "Die osmanische Tughra," *Kunst des Orients* 2 (1955), pp. 71–82.

PREVIOUSLY PUBLISHED IN

Islamic Art across the World, Catalogue of an exhibition at the University of Indiana Art Museum, No. 27.
Edwin Binney, 3rd, *Turkish Miniature Paintings and Manuscripts from the Collection of Edwin Binney, 3rd*, Catalogue of an exhibition held in the Metropolitan Museum of Art, New York and the Los Angeles County Museum of Art, No. 37.

34. Silk tomb cover

Turkey; eighteenth century
H. 420 cm., W. 70 cm.
Musée Historique des Tissus

Many Ottoman tombs were provided
with triangular grave markers and the
zigzag bands of this cloth are presumably
intended to accentuate this form. It is a
lampas weave with satin ground and
tabby pattern and is made entirely of silk,
the ground green and the inscriptions
white.[1]

Cloths of this type do not generally
provide the name of the deceased but in-
stead repeat orthodox statements of
faith. Thus in keeping with Sunni Islam
the inscriptions here all stress the role
of Muhammad as the human bearer of
Allah's revelation. There are four differ-
ent epigraphs, two wide bands in *thuluth
jali* alternating with two narrow bands
in *thuluth*. Beginning with the wide band
at the top, they read:

*O Allah! Bless Muhammad and his
family and his companions and [grant
them] peace.*[2]
*Muhammad is not the father of any man
among you, but he is the messenger of
Allah and the Seal of the Prophets.*[3]
*There is no god but Allah; Muhammad
is the Prophet of Allah.*[4]
*Lo! Allah and His angels shower bless-
ings on the Prophet. O ye who believe!
Ask blessings on him and salute them
with a worthy salutation.*[5]

NOTES

1. For other silks of this type see Walter B.
 Denny, "Ottoman Turkish textiles," *Tex-
 tile Museum Journal* 3 (1972), pp. 55–66,
 fig. 24; Mohamed Aziza, *La Calligraphie
 arabe*, p. 96; *Arts of Islam*, Nos. 32 and 33.
2. This is a frequent Muslim prayer.
3. This statement of Muhammad's role as the
 Messenger of Allah is from the *Qur'an*,
 surah al-Ahzab (The Clans) 33:40.
4. This statement is called the *shahada*, the
 fundamental creed of Islam.
5. This is also from *surah al-Ahzab* (The
 Clans) 33:56.

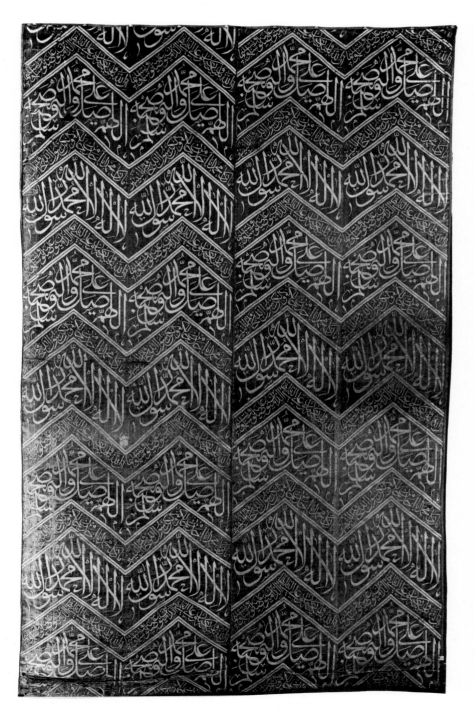

35. Wooden roundel with the name of Abu Bakr

Turkey; eighteenth century
Diam. 63 cm.
AXIA; ex collection J. Soustiel

Its letters carved, painted, and slightly raised above the dark surface, this roundel is inscribed with the following pious phrase:

Abu Bakr, the Righteous, may Allah be pleased with him.

Its script—*thuluth jali*—was most often used for large Ottoman architectural inscriptions, for it is not only admirably stately and clear but also legible from a considerable distance.

Roundels bearing names central to the Muslim faith were a basic part of almost all Ottoman mosques from early times and, shorter and simpler to read, were a striking complement to longer, more learned inscriptions over doorways and mihrabs and under domes. Whether painted on the surface or composed of inset ceramics or, as here, constructed in wood in a more portable fashion, they were most often located on the pendentives beneath a dome, an architectural position expressing the key Islamic role of those named. Thus the divine name—Allah—was invariably hung to the right of the mihrab, while Muhammad's name was suspended at the left. Roundels bearing the names of the first four, "rightly guided" caliphs (Abu Bakr, 'Umar, 'Uthman, and 'Ali), central to Ottoman Sunni orthodoxy, were then usually placed in the chronological sequence of their caliphates proceeding away from the mihrab. Last might be hung other names, such as those of Muhammad's daughter Fatima and her (and 'Ali's) sons Husayn and Hasan.

Roundels of this sort were not found in Islamic architecture to the east, in Iran and India, where domes were generally supported by squinches, a form not well suited for such architectural objects. The Ottomans' great predecessor, Byzantium, had used architectural pendentives as areas for the pictorial display of central Christian figures. In a similar fashion, though with epigraphs rather than icons, the Ottomans used these dome-supporting areas to show the faithful the sources and upholders of their faith.

PREVIOUSLY PUBLISHED IN

Jean Soustiel, *Objets d'art de l'Islam*, No. 44.

Arts of Islam, Catalogue of an Exhibition at the Hayward Gallery, No. 466.

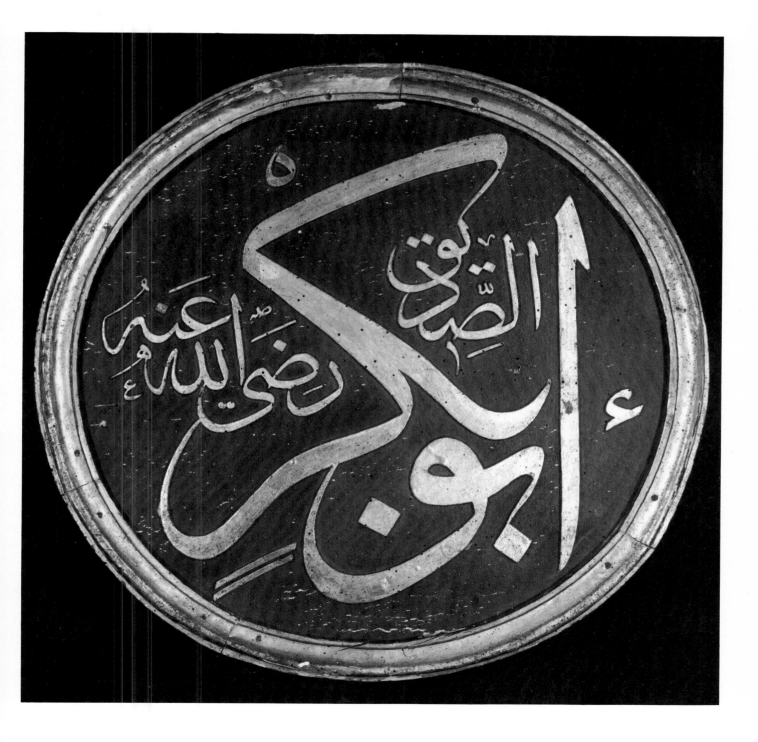

36. Linen kerchief

Turkey; nineteenth century
H. 54.6 cm., W. 53.3 cm.
The Textile Museum

The kerchief is a plain-weave linen with
embroidery in silk and metallic threads.
Against an ivory-colored ground are
flowering plants, animals, human fig-
ures, and epigraphs in brown, blue,
yellow, and red. The composition de-
pends upon a repetition of balanced ele-
ments: a pair of horsemen is placed so
each faces the other on either side of the
central square; a pair of plants grows on
either side of the single woman at top and
bottom; a pair of facing birds is placed
between each of the complex squares on
the sides. While this predilection for
dualism reflects Near Eastern principles
of design long predating Islam, the six
side squares reveal the permeation of
epigraphic art to the folk level of a rural
or nomadic Muslim society. Each square
contains a central square in which is re-
peated four times the name Muhammad,
each repetition occupying one quadrant
of the square.[1]

NOTES

1. This basic design type is seen in architec-
tural tiles as well (for example, Anthony
Welch, *Shah ʿAbbas and the Arts of Isfahan*,
No. 36). Other kerchiefs of this type are in
the Textile Museum.

37. Coat of chain mail

Eastern Turkey, Iraq, or Iran; 1232 H. (1816–1817 A.D.)
L. 77.5 cm., W. 200.0 cm. (cuff to cuff)
The Metropolitan Museum of Art; Bequest of George C. Stone, 1936

Brass rings, linked with steel, provided talismanic as well as physical protection for the possessor of this remarkably crafted chain mail coat: the brass links form Arabic invocations requesting aid and assistance. Clearly visible in this illustration are a number of names: on the right arm, "Muhammad, Allah's blessing on him, Fatima, Husayn"; on the right side, "O 'Ali!"; on the left arm, "Allah, 'Ali, Hasan, [in the] year 1232"; on the left side, "Call on 'Ali."

The appeals and prayers are appropriate only for a Shi'a, probably in one of the areas indicated but perhaps elsewhere in the Muslim world.

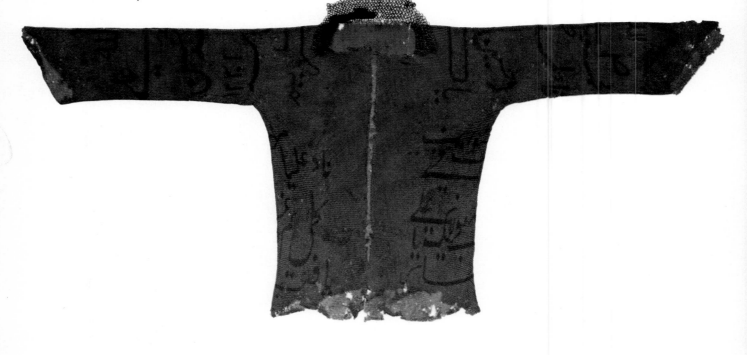

Iran and Central Asia

38. Marble tombstone

Iran or northern Mesopotamia; 533 H. (1138 A.D.)
H. 94.2 cm., W. 69.9 cm.
Museum of Fine Arts, Boston; Maria Antoinette Evans Fund

A number of *Hadith* (traditional sayings) of the Prophet Muhammad discourage the practice of marking a grave, either by a stone or by a mausoleum, and this attitude may have been intended to spare expense or to avoid the possibility of subsequent ancestor worship. Nevertheless, both tombs and tombstones were produced, at least from the ninth century and probably earlier as well. In keeping with their function, gravestones were almost always richly inscribed, and many used, as does this one, *mihrab*-like shapes in their centers in order to provide a pious air. Six different varieties of cursive and *Kufic* scripts were used here to record the epigraphs, mostly from the *Qur'an*, over the grave of an otherwise unknown individual of wealthy family. As is evident from the analysis, the passages were carefully selected to suit the tombstone's purpose.

In the central arch immediately above the *mihrab* shape is a *Kufic* rendering of the *surah al-Tauhid* (Unity), the 112th surah, in its entirety, though without the initial *bismillah*:

Say: He is Allah, the One!
Allah, the eternally Besought of all!
He begetteth not nor was begotten.
And there is none comparable unto Him.

Immediately around the *mihrab* on all sides except the bottom are verses 21–22 of the ninth *surah*, *al-Taubah* (Repentance), in *naskhi* script:

In the name of Allah, the Beneficent, the Merciful.
Their Lord giveth them good tidings of mercy from Him, and acceptance, and Gardens where enduring pleasure will be theirs;
There they will abide forever. Lo! with Allah there is immense reward.

Directly above this inscription is a horizontal panel with arabesques curling around a *thuluth* presentation of the *shahada*:

There is no god but Allah; Muhammad is the Messenger of Allah.

In the next band, written on all sides except the bottom in a tall *Kufic* similar to that in the *mihrab* niche, are two verses from the *surah Fussilat* (They are Expounded) 41:30–31:

In the name of Allah, the Beneficent, the Merciful.
Lo! those who say: Our Lord is Allah, and afterward are upright, the angels descend upon them, saying: Fear not nor grieve, but hear good tidings of the paradise which ye are promised.
We are your protecting friends in the life of the world and in the Hereafter.[1]

A bottom line, carved in an angular and somewhat less elegant small *Kufic*, runs beneath the *mihrab* and the two bands of verses from the *Qur'an* and records factual information about the deceased:

Died in [the month of] Muharram in the year 533, 'Umar ibn Qasim al-Harrani.[2]

A further band of *naskhi* contains a single verse from *surah Luqman* 31:34, introduced by the *bismillah*:

In the name of Allah, the Beneficent, the Merciful.
Lo! Allah! With Him is knowledge of the Hour. He sendeth down the rain, and knoweth that which is in the wombs. No soul knoweth what it will earn tomorrow, and no soul knoweth in what land it will die. Lo! Allah is Knower, Aware.
And He is the Tremendous.[3]

Finally, an outer band of *Kufic* bounds all four sides of the rectangular stone, but while the script is mostly of moderate size, the vertical elements ascend dramatically in the middle of the upper band, and the bottom band contains script of a more restricted size. It is the celebrated *ayat al-kursi* (throne verse) from *surah al-Baqarah* (The Cow) 2:255:

In the name of Allah, the Beneficent, the Merciful.
Allah! There is no God save Him, the Alive, the Eternal. Neither slumber nor sleep overtaketh Him. Unto Him belongeth whatsoever is in the heavens and whatsoever is in the earth. Who is he that intercedeth with Him save by His leave? He knoweth that which is in front of them and that which is behind them, while they encompass nothing of His knowledge save what He will. His throne includeth the heavens and the earth, and He is never weary of preserving them. He is the Sublime, the Tremendous.
Allah has spoken truly.[4]

Four main themes dominate these inscriptions from the *Qur'an*: (a) Allah's oneness and uniqueness; (b) Allah's promise of paradise to the faithful; (c) Allah's omniscience; and (d) Allah's omnipotence.

Combined, they form a unified statement of Islamic belief and express a medieval Muslim's hopes for the hereafter.

1. This verse has not been completed.
2. The Muslim date corresponds to September 1138 A.D. The words after the date have also been read as "The work of Abu'l-Qasim al-Harrani" (Arthur Upham Pope and Phyllis Ackerman, eds., *A Survey of Persian Art*, p. 1790 and pl. 520). "Al-Harrani" refers to this individual's place of origin, Harran, a strategic and commercially important city in northern Mesopotamia (now in Turkey), which in 1138 was under the control of the Zangid dynasty.
3. This last line is not part of the *surah*.
4. These four words are not part of the *surah*, and they have presumably been added in order to fill the available space.

PREVIOUSLY PUBLISHED IN

Arthur Upham Pope and Phyllis Ackerman, eds., *A Survey of Persian Art*, p. 1790 and pl. 520.

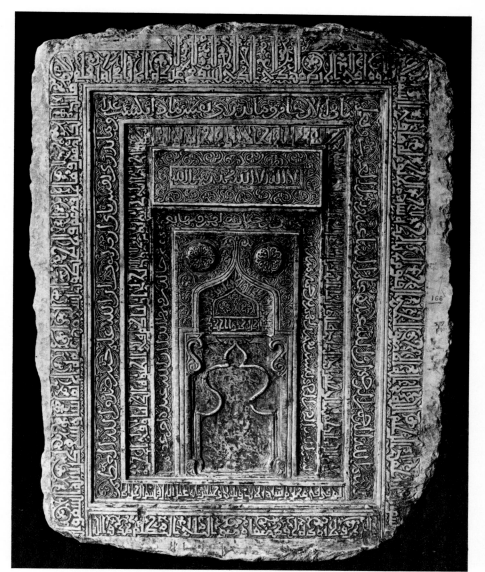

39. Bronze vase inlaid with silver

Iran, Khorasan; twelfth or early thirteenth century
H. 16.3 cm.
The Walters Art Gallery

This small bronze vase from northeastern Iran was produced during one of the most creative and technically proficient periods of Islamic metalwork. Its form is based on prototypes in silver and gold, its ten sides are finely decorated with silver-inlaid zodiacal figures and panels of *Kufic* script; the round bottom and base are ornamented with silver designs, those on the bottom far more complex than those on the base; and the neck is inlaid with a playful, silver *naskhi* inscription. In its combination of figural, epigraphic, and geometric elements this vessel uses the full repertory of Islamic ornament.

With the tips of its verticals almost provided with faces, the *Kufic* inscription around the body, though partly illegible, is a standard invocation of blessings on the unidentified owner:

Victory, blessings, ascendancy, well-being, [?], good fortune, [?], [?], thanks, permanence, [?], intercession [of the Prophet], and long life always.

The *naskhi* inscription around the neck is similar in content:

Glory, good fortune, prosperity, contentment, glory, [?], favor, and long life always.

The tips of the verticals here have been expanded in size and articulated to form broad human heads perched on tapering bodies; all rather somber in expression, this line of stolid faces stares soberly to the left.

Neighboring cultures—Coptic, Armenian, and Byzantine—also had made use of anthropomorphic and zoomorphic initial letters in manuscripts,[1] and it is most likely from this latter source that Islamic metalworkers in the twelfth century adopted the figural treatment of letters, which here, and in most other similar epigraphs, appear to express aesthetic instead of symbolic concerns: an otherwise humdrum inscription is transformed into alphabetic playfulness.

NOTES

1. For a discussion of this subject see Adolf Grohmann, "Anthropomorphic and zoomorphic letters in the history of Arabic writing," *Bulletin de l'Institut d'Égypte*, 1958, pp. 117–122.

PREVIOUSLY PUBLISHED IN

Arthur Upham Pope and Phyllis Ackerman, eds., *A Survey of Persian Art*, pl. 1317A.
The Arts of Islam, Catalogue of an Exhibition at the Hayward Gallery, No. 189.

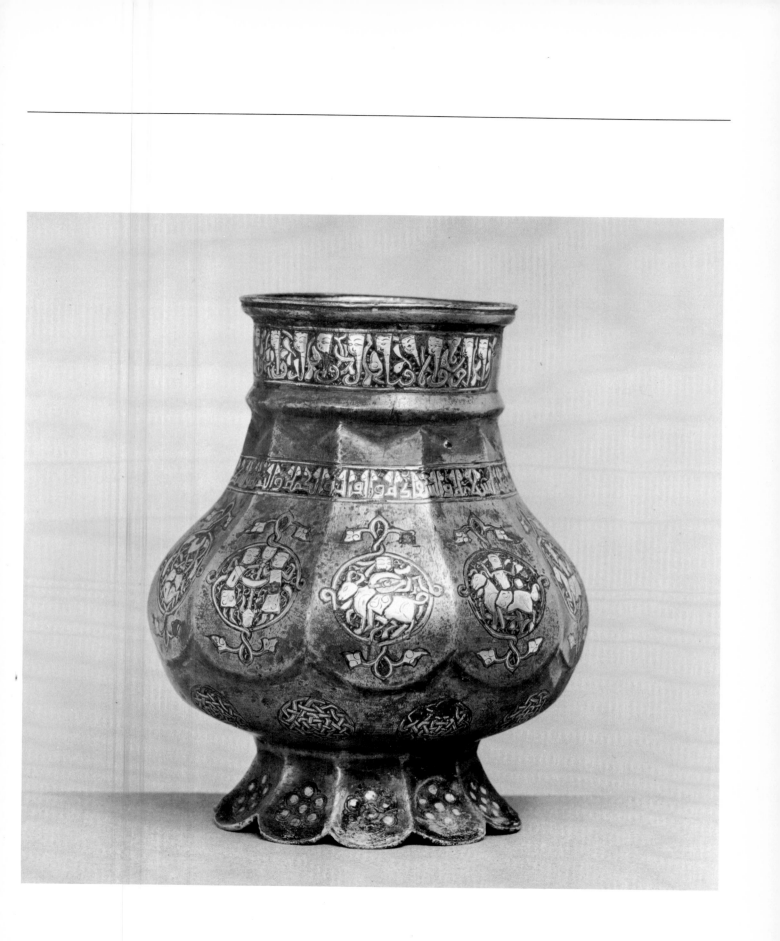

40. Bronze inkwell

Iran; twelfth or early thirteenth century
H. 9.5 cm., Diam. 7.8 cm.
David Collection

Known as a *mihbara*, this type of inkwell was used to hold a kind of ink called *hibr*, made from gallnuts and vitriol.[1] Loops on the body and the lid held cords so that the inkwell could be easily carried by the scribe. Incised and inlaid with copper and silver, its surface is decorated with inscription panels on the body and the lid as well as six human figures, either drinking or playing musical instruments, and three panels of hunting dogs chasing wild animals.

Written in a slightly rounded, eastern *Kufic* script similar to that of twelfth and thirteenth century *Qur'ans*,[2] the inscriptions principally offer standard good wishes to the owner. In the lower panel on the body only half the inscription is legible:

... happiness, well-being, comfort, and long life to its owner.

In the upper panel are listed similar blessings:

Glory, good fortune, wealth, happiness, repose, well-being, kindness, and long life to its owner.

The benedictions continue on the lid:

Glory, good fortune, wealth, happiness, repose, and long life to its owner.

The words are inscribed against a background of curling arabesques, so that each panel strikingly resembles illuminated chapter or title headings in contemporary manuscripts, the likely pictorial source for this combination of elements. Most metalwork inscriptions are similarly repetitive, perhaps because of lack of invention on the metalworker's part or a belief in the talismanic efficacy of repeated good wishes.

The superbly crafted human and animal forms function as the figural counterparts of the epigraphs: they represent the comfort, and good fortune, and happiness open to the aristocracy and high officials.

Three small roundels on the lid inform us of the name of the metalworker: "Made by Shah Malik."

NOTES

1. Discussed in *Arts of Islam*, Catalogue of an Exhibition at the Hayward Gallery, No. 183.
2. See Martin Lings, *The Quranic Art of Calligraphy and Illumination*, pl. 21.

PREVIOUSLY PUBLISHED IN

Arthur Upham Pope and Phyllis Ackerman, eds., *A Survey of Persian Art*, pl. 1311A.
Leo A. Mayer, *Islamic Metalworkers and Their Work*, pp. 82–83 and pl. XIII.
Davids Samling, *Islamisk Kunst*, p. 82.
Arts of Islam, A Catalogue of an Exhibition at the Hayward Gallery, No. 183.

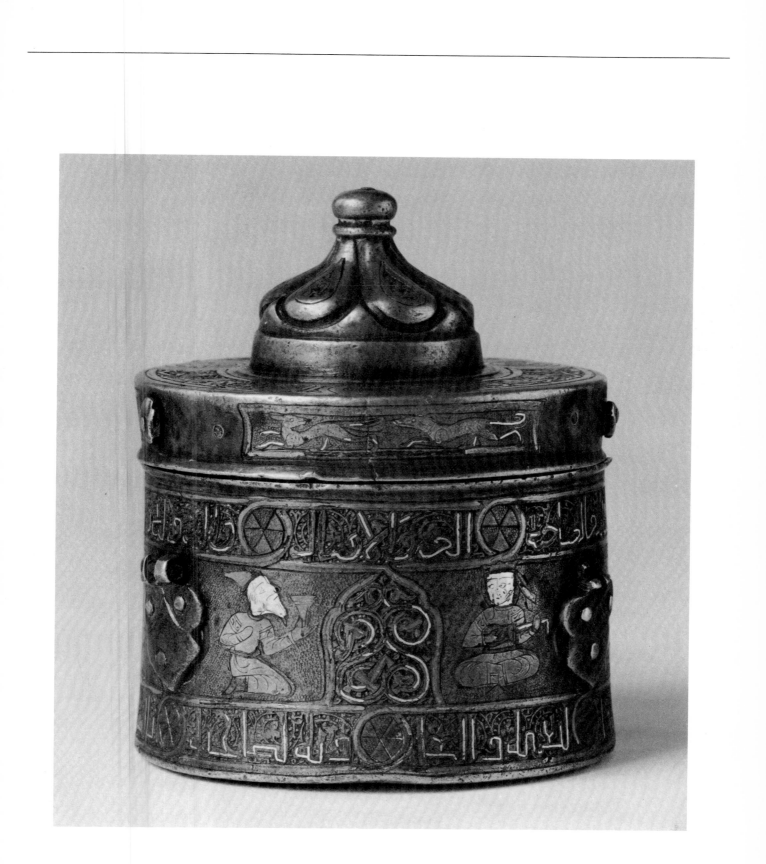

41. Ceramic bowl

Iran, Kashan; early thirteenth century
H. 7.4 cm., Diam. 27.0 cm.
Collection of Prince Sadruddin Aga Khan

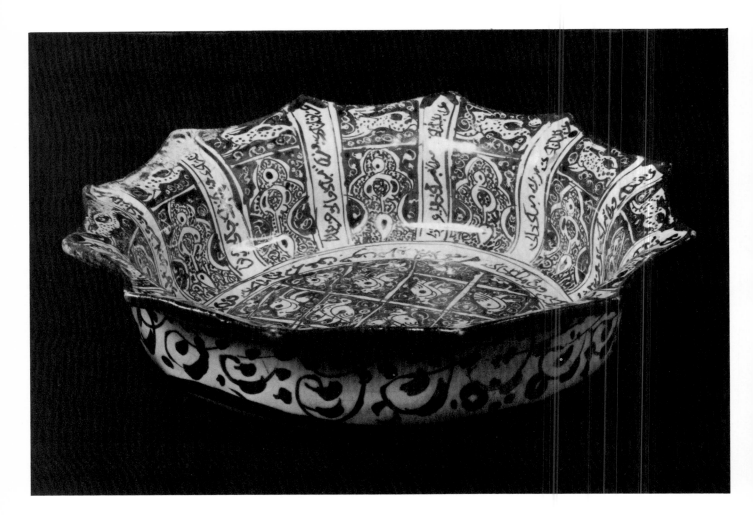

Working for what must have been a large and well-off clientele, Kashan potters of the twelfth and thirteenth centuries excelled in the production of ceramics combining figural and epigraphic decoration. Its shape imitating that of more costly metalworks, this twelve-pointed bowl is painted in golden brown luster over a white ground, one of the favored color schemes in pottery of this period. The vessel's exterior is marked by large, freely drawn arabesques. The bottom of its interior is largely filled by nine full squares and thirteen portions of squares, each containing a standing bird or part of one. This inner area is bounded by a circular inscription in a sketchy *naskhi*: only some words are legible, and much of the space is occupied by repeated single letters. Twelve panels, each topped by an image of a running animal, alternate with twelve inscription bands, dropping vertically from the bowl's points. Here again a sketchy *naskhi* renders partially repeated epigraphs that are not wholly legible.

To the painter of this fine piece, who used a similarly fluid style for arabesques, animals, and epigraphs, these words were such familiar, perhaps even commonplace, forms in his art, that a strictly literal rendition of them was less important than their simple presence.

PREVIOUSLY PUBLISHED IN

Anthony Welch, *Collection of Islamic Art: Prince Sadruddin Aga Khan*, III and IV, No. P. 69.

42. Ceramic mihrab

Iran, Kashan; early thirteenth century
H. 50.8 cm., W. 31.9 cm.
The Art Institute of Chicago; Mary Jane Gunsaulus Collection

Kashan in central Iran was one of the major centers of medieval ceramic production, and a considerable number of dated Kashan potteries, wall tiles, and *mihrabs* are known. Some *mihrabs* were of great size and were commissioned for specific mosques, tombs, and other religious buildings, while smaller *mihrabs* of this sort were made in larger numbers to grace the prayer walls of humbler structures.

Typical of Kashan work of this period is the range of colors here—dark blue, turquoise, brown, and white—and the use of two different scripts. The minute, very fine *ta'liq* script written on the raised arches is too badly effaced to be read, although a few words are clear. The bold, dark blue, raised *thuluth* script presents two verses from the *Qur'an*. The first—*surah al-Rahman* (The Beneficent) 55:26–27—at the top of *mihrab*, speaks of the transience of life and the eternity of Allah:

Everyone that is thereon will pass away.
There remaineth but the Countenance
. . . .

The second, filling the area under the two arches, is the whole of *surah al-'Asr* (The Declining Day):

In the name of Allah, the Beneficent, the
 Merciful.
By the declining day,
Lo! man is in a state of loss,
Save those who believe and do good
 works, and exhort one another to truth
 and exhort one another to endurance.

See color illustration on page 11

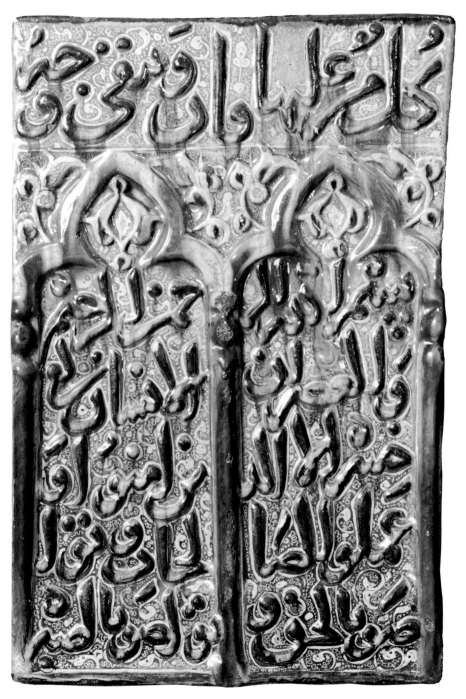

43. Star tile from the shrine of Imamzadah Yahyah

Iran, Veramin; 1261–1263 A.D.
Diam. 30.5 cm.
The Detroit Institute of Arts; Presented by the Founders Society

A domed structure with an octagonal interior, the thirteenth-century shrine of the Imamzadah Yahyah[1] was provided with a ceramic dado rising to a height of about 185 centimeters above the floor and composed of light blue cross tiles interlocked with brown and white star tiles, of which this particular tile was one.[2] Although this tile is not dated, various others of the same size and decoration bear dates between 660 and 662 H. (1261–1263 A.D.). This tile was probably removed from the shrine in the late nineteenth century.

As a part of a religious structure, this piece and its companions had no figural decoration and instead displayed vegetal ornamentation divided into four equal quadrants by a central cross. Every tile bore an inscription, and the sheer number of epigraphs may have been the reason why the *naskhi* script used here, while fluidly fitting the overall design, does not always achieve formal mastery of individual letters. These particular lines, however, come from the verse from the *Qur'an* that is most frequently used in eastern Muslim tombs, the celebrated throne verse from *surah al-Baqarah* (The Cow) 2:255, which reveals and exalts the omnipotence of Allah:

In the name of Allah, the Beneficent, the Merciful.
Allah! There is no God save Him, the Alive, the Eternal. Neither slumber nor sleep overtaketh Him. Unto Him belongeth whatsoever is in the heavens and whatsoever is in the earth. Who is he that intercedeth with Him save by His leave? He knoweth that which is in front of them and that which is behind them, while they encompass nothing of His knowledge save what He will. His Throne includeth the heavens and the earth, and He is never weary of preserving them. He is the Sublime, the Tremendous.

There is no compulsion in religion. [The right direction] is henceforth distinct [from error].[3]

A small town south of the present Tehran, Veramin became prominent after the Mongol destruction of the great Seljuq city of Rayy in 1220 A.D. and continued to be important until its decline in the fifteenth century. It was the center of a thriving agricultural region and with the construction of several buildings—notably its fine *jami'* mosque[4] and several shrines of *imamzadahs*—it became a religious center as well. The erection of such structures was, of course, considered a pious act, and pilgrimages to shrines were believed to bring spiritual blessings on the devotee.

Kashan was the major center of ceramic production in late Seljuq and early Il-Khanid Iran, and its workshops were particularly celebrated for the production of large and small *mihrabs*[5] and other ceramic revetments, such as tiles inscribed with quotations from the *Qur'an*, for religious structures.

NOTES

1. *Imamzadah* means "the son of an imam," or spiritual leader of a Muslim community.
2. See Donald Wilber, *The Architecture of Islamic Iran: The Il-Khanid Period*, pp. 109–111; and *The Arts of Islam*, No. 379, where additional bibliography is listed. More than one hundred tiles from the shrine of the Imamzadah Yahyah are known.
3. The tile ends with the initial words of verse 256, which must have been continued on an adjoining tile. Several others of the known tiles also are inscribed with the throne verse.
4. A *jami'* mosque is the central mosque of an individual Muslim community.
5. See No. 42.

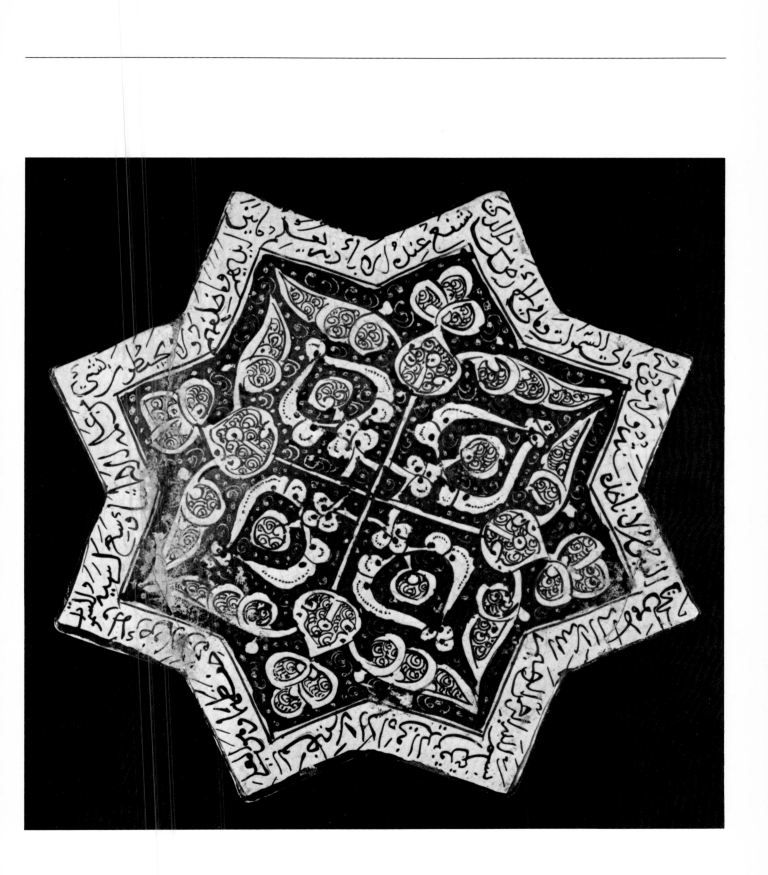

44. Star tile with combat of Rustam and Suhrab

Iran; late thirteenth century
Diam. 20.7 cm.
The Walters Art Gallery

Tiles and pottery provide us with some of our earliest illustrated scenes from Firdausi's *Shahnamah*, the great epic poem which is of central importance to virtually all aspects of Iranian culture.[1] While illustrated copies of the celebrated book may have been produced before the fourteenth century, none has survived intact.[2] As a result, pictorial ceramics such as this one are of vital importance, not only in providing information concerning the early history of Iranian painting and *Shahnamah* illustration, but also in indicating the extent to which the poem's imagery had penetrated contemporary culture.

Filling the blue band bordering this scene of two fighting men, the script itself is of a very loose, fluid, and irregular cursive sort that does not fit easily into the available typology for calligraphic styles used in manuscripts. It is closest, however, to the "archaic *naskhi*" of what must be one of the earliest extant illustrated copies of the *Shahnamah*.[3] Its text occurs near the beginning of the tragic story of Rustam and Suhrab:

We have an account from the Mobad thus,
That Rustam arrayed himself at dawn.
His heart was sad. He planned to hunt.
He girded himself [and] filled his quiver with arrows.[4]

When he engaged in single combat with an unknown champion, Suhrab did not know that he was battling his father, Rustam, whom he had never met but knew by reputation alone. After three successive vicious encounters, Rustam managed to overcome and mortally wound Suhrab, who revealed his parentage as he died. Rustam's grief at having unwittingly killed his son is one of the most moving passages in the entire *Shahnamah*.[5]

The scribe who wrote the text on this tile did not strive for legibility or choose a passage that directly related to the illustration, which may have been in itself familiar enough that explanatory words were not necessary. The relation between words and text does not therefore seem to be an explicitly narrative one; instead, it is sequential: the text indicates the beginning of the incident, and the picture renders the end. Together they form a logical and coherent entity.

The tile must have been one of many star and cross tiles that formed the dado of an Il-Khanid palace chamber. Presumably the other tiles represented additional scenes from Firdausi's poem, so that the interior walls of a room, where the *Shahnamah* itself may have been recited to an aristocratic audience, presented a visual summary of the epic.

NOTES

1. Some other examples are illustrated in Arthur Upham Pope and Phyllis Ackerman, eds., *A Survey of Persian Art*, pls. 660B, 664, 672, 679, and 706. The transition from ceramics bearing rote scenes and rote inscriptions to those rendering specific scenes from known works of literature is one of the most fascinating aspects of the cultural history of late medieval Iran.
2. The earliest illustrated copies of the *Shahnamah* are the so-called small *Shahnamahs*, the Demotte *Shahnamah*, and portions of the *Shahnamah* preserved in albums in the Topkapi Palace Museum. The use of *Shahnamah* texts on tiles has been examined by L. T. Giuzalian in three articles in *Epigraphika Vostoka* 3:72–81; 4:40–55; and 5:35–50.
3. In the Chester Beatty Library, Ms. 104, published in Arthur J. Arberry, M. Minovi, and Ernest Blochet, *The Chester Beatty Library: A Catalogue of the Persian Manuscripts and Miniatures*, vol. I, pp. 11–16, where Minovi describes the script as "archaic *naskhi*."
4. For the original text see the Persian edition of the *Shahnamah* published by Beroukhim in Tehran, vol. 2, p. 434, lines 23–24.
5. The story, in its basic incident resembling the Celtic myth of Cuchulain and Conlai and the German myth of Hildebrand and Hadubrand, has been impressively rendered in English by Matthew Arnold, as "Sohrab and Rustam."

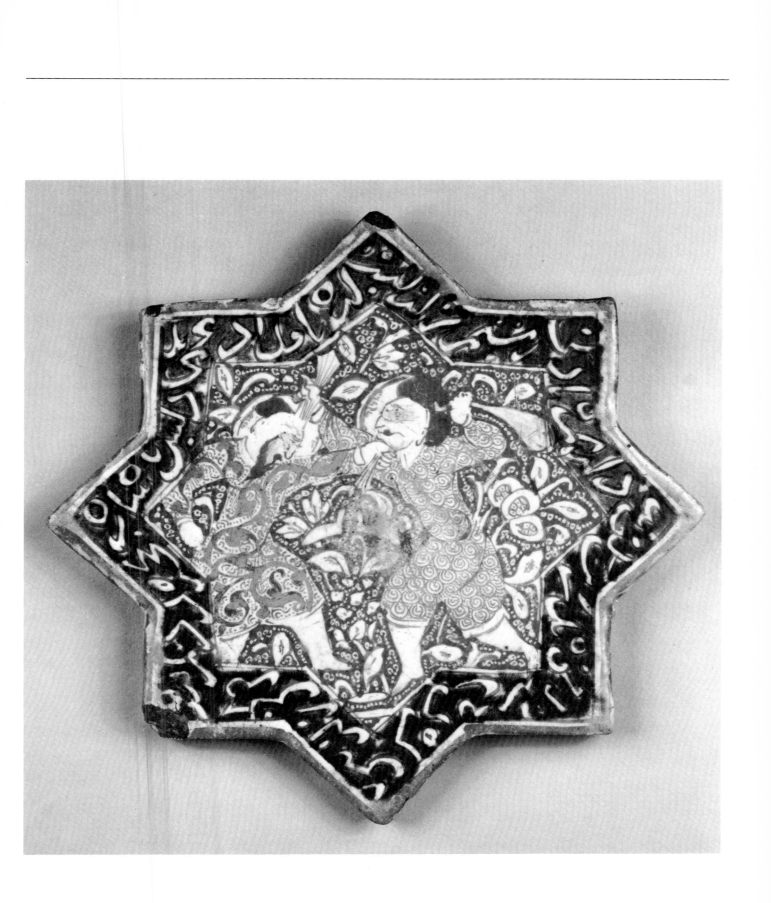

45. Star tile with horse

Iran; 710 H. (1310 A.D.)
Diam. 19.6 cm.
Museum of Fine Arts, Boston; Maria Antoinette Evans Fund and gift of Edward J. Holmes

This single tile was once part of a larger complex of interlocking cross and star tiles that formed the dado of the interior of a fine residence or, possibly, of a religious structure.[1] The white *naskhi* inscription against a blue ground is a Persian mystical quatrain, followed by the date in which the tile was made:

O, my appealing friend, thou knowest
* why at night*
My skirt is damp from my two eyes'
* tears;*
From desire for thy lips [my eyes express]
Water from the mouth of the pupil of my
* eye.*[2]

in the year 710

The relation between the verse and the figural decoration—a horse standing before what appears to be a well or a trough—is not clear, and similar apparent incongruities between figural and epigraphic content can be seen in other tiles of this type.[3] Probably produced in western Iran under Il-Khanid patronage, this tile is rendered in what is usually termed the "Sultanabad style."

NOTES

1. That tiles of this type were also used in religious structures has been established by Oliver Watson, "The Masjed-i 'Ali Quhrud: An Architectural and Epigraphical Survey," *Iran* 13 (1975).
2. The words in brackets have been omitted on the tile but can be reconstructed through a comparison with No. 46, where the same poem, with other words deleted, has been used.
3. Among others, six Kashan tiles from the Godman collection, reproduced in *The Arts of Islam*, No. 384.

PREVIOUSLY PUBLISHED IN

Richard Ettinghausen, *Bulletin of the American Institute of Persian Art and Archaeology* 4 (1936), p. 226, fig. 9.

————, "Ceramic Art in Islamic Times. B. Dated Faience." In Arthur Upham Pope and Phyllis Ackerman, eds., *A Survey of Persian Art*, p. 1684, No. 106.

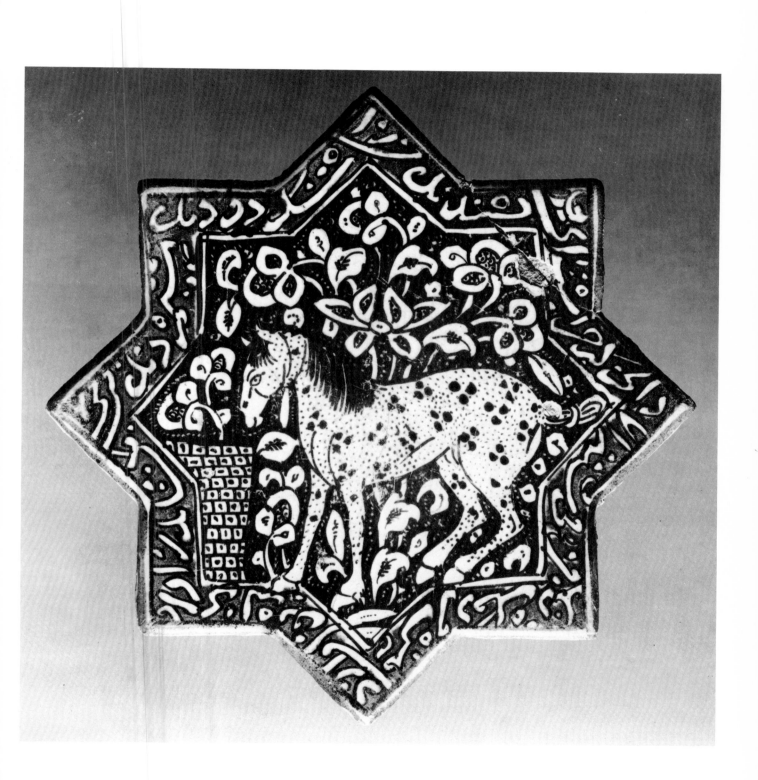

46. Star tile with camel and birds

Iran; probably 710 H. (1310 A.D.)[1]
Diam. 20.5 cm.
Museum of Fine Arts, Boston; Gift of the estate of Mrs. Martin Brimmer

Three birds fly above and behind this finely drawn camel. Well-groomed and wearing a saddlecloth and bridle, it was obviously intended to carry someone or something, and this fact may be an oblique reference to one of the two poems that fill the margin of this eight-pointed star tile:

When my friend to journey intends,
For me all happiness of heart ends.[1]
My heart said in envy that the soul could
In excitement escape.[2]

. . . now all thou hast

The verses are poor in quality, a fact which implies that the person who chose them was no judge of literature and that poetic merit was not here a criterion in the selection of inscriptions. This view is strengthened by the rest of the epigraph, which repeats the verse used in No. 45, where broader letters made it possible for only four lines to fill the available space:

O, my appealing friend, thou knowest
why at night
[My skirt is damp] from my two eyes'
tears;
From desire for thy lips my eyes express
Water from the mouth of the pupil of my
eyes.[3]

This poem is little better than the first. Its repetition indicates that it may very well have been used in the same dado composition; but it is also proof that the scribes who rendered these verses had a small stock of often mediocre verse that they employed on tiles unless they were instructed to do otherwise (as in No. 44). Images and epigraphs had little, if any, connection, and pictorial scenes may have been selected in the same way from a limited available repertory.

The ceramic calligrapher here was less skillful than his contemporary in No. 45,

and his cursive script is less carefully applied than the animal figures. In both star tiles, however, particular portions of the poem have been omitted; the scribes, who, we can presume, were not especially literate, either had little concern for formal accuracy or judged, perhaps rightly, that the presence and appearance of script was more important here than its content.

NOTES
1. This English rendering accurately matches the plodding Persian original.
2. That is, the heart is fixed in place, while the soul can move quickly away through a sigh.
3. The four words in brackets, omitted from the tile, have been reconstructed from the same verse on No. 45.

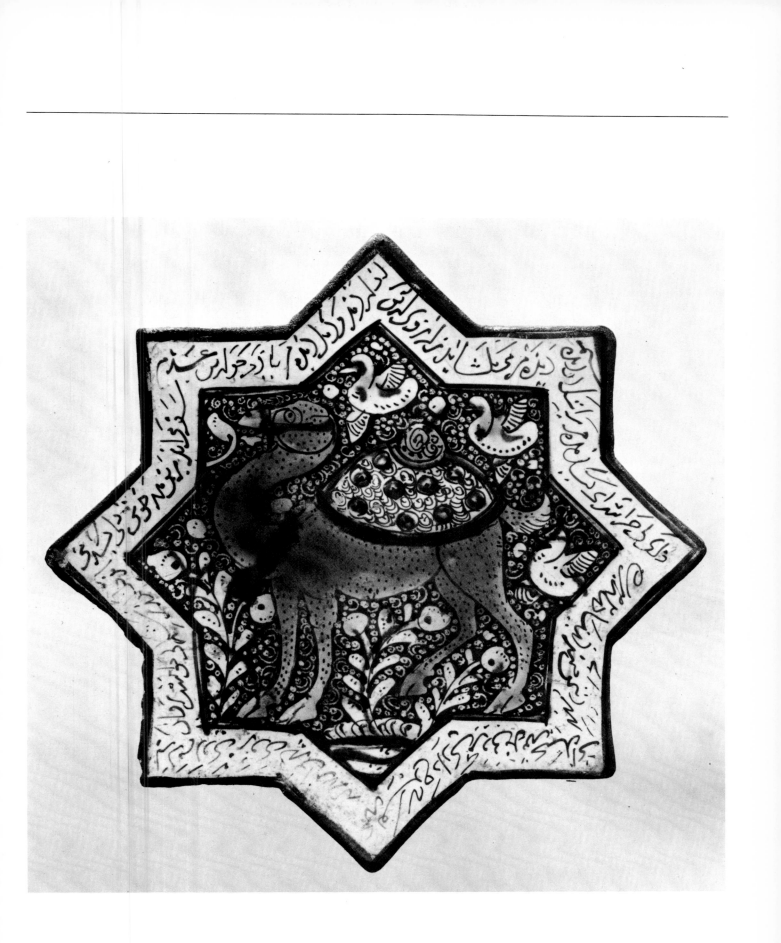

47. Juz' 13 of the Qur'an

Iran, Maraghah; May 1338 A.D.
H. 32.3 cm., W. 24.7 cm.
Museum of Fine Arts, Boston; Helen and Alice Colburn Fund

In addition to its organization into one hundred and fourteen surahs, the *Qur'an* is divided into thirty *ajza'* (or parts) of approximately equal size. Shown here is the title page to *juz'* (part) 13.[1] According to the colophon, this part was completed in the city of Maraghah in the month of Shawwal 738 H. (May 1338), when the scribe, 'Abd Allah ibn Ahmad ibn Fadlallah ibn 'Abd al-Hamid, was seventy-seven years old.

At the top of the two pages splendidly illuminated headings read: "The thirteenth part of thirty parts"; and at the bottom almost identically illuminated headings state: "It is of the word of Allah, the Lord of the Two Worlds."[2] A very angular *Kufic* with some foliated letters is used for both headings.

The text is written in a clear, simple *naskhi*, restrained in size and movement, but with an occasional shaky line, perhaps the result of the scribe's advanced age. The right-hand page begins verse 53, and the left-hand page ends with the first words of verse 57 of the twelfth *surah Yusuf* (Joseph), which presents the life story of the prophet Joseph. The text shown here centers on the fulfillment of Allah's will through Pharaoh's appointment of Joseph to high office; it begins with Joseph's words about himself and his faith:

I do not exculpate myself. Lo! the (human) soul enjoineth unto evil, save that whereon my Lord hath mercy. Lo! my Lord is Forgiving, Merciful.

And the king said: Bring him unto me that I may attach him to my person. And when he had talked with him he said: Lo! thou art today in our presence established and trusted.

He said: Set me over the storehouses of the land. Lo! I am a skilled custodian.

Thus gave We power to Joseph in the land. He was the owner of it where he pleased. We reach with Our mercy

whom We will. We lost not the reward of the good.

And the reward of the Hereafter [is better, for those who believe and ward off (evil)].

The text is enclosed in cloud-like forms "floating" over wave patterns, and this element, as well as the types of flowers in the illuminations, indicate the survival of the Chinese-derived motifs which were influential in both illumination and figural painting in Iran in the Il-Khanid period (ca. 1220–1336 A.D.). Though initially destroyers of Muslim culture, the Mongols, founders of Iran's Il-Khanid dynasty, had by the end of the thirteenth century emerged as some of the most lavish patrons of that culture. In particular, Sultan Muhammad Khodabandah Uljaytu (reign, 1304–1317) was a patron of architecture and the art of the precious book. A number of very large and sumptuous *Qur'ans*, written in monumental *thuluth* or *rayhani* script, were produced for him and some of his successors.

By 1336 Il-Khanid dominion was effectively at an end, and this *Qur'an*, though elaborately illuminated, is both smaller in size and more restrained in its art. For such a book a large cursive script, like *thuluth* or *rayhani*, would have been out of proportion, and this temperate *naskhi* is admirably suited to it. Little is known about the scribe, 'Abd Allah ibn Ahmad, or about the conditions under which he wrote. From 1336 until July 1338 Maraghah, the Mongol capital mentioned in the colophon, was in the hands of Amir Hasan Jala'ir,[3] a former Il-Khanid aristocrat, and it seems likely that these sections of the holy book were produced for him. Whether this *Qur'an* was ever completed is not known; for in July 1338 Amir Hasan Jala'ir was chased out of Maraghah and much of northwestern Iran by his rival, Hasan Kuchuk Chupani, and the production of this

Qur'an, one of the last creations of the short-lived Il-Khanid style, may have ceased then.

NOTES

1. *Juz'* 24 is also in the Museum of Fine Arts, Boston, No. 29.57. *Juz'* 21 is in the Beatty Library, Dublin (see Arthur J. Arberry, *The Koran Illuminated: A Handlist of the Korans in the Chester Beatty Library*, No. 137, p. 41).
2. "The Lord of the Two Worlds," that is, the temporal and the eternal worlds, is a term often used to indicate Allah's complete sovereignty.
3. For the turbulent history of this period see Berthold Spuler, *Die Mongolen in Iran*, pp. 128–133.

PREVIOUSLY PUBLISHED IN

Arthur Upham Pope and Phyllis Ackerman, eds., *A Survey of Persian Art*, pl. 938b, and pp. 1955–1959.
The Arts of Islam, Catalogue of an Exhibition at the Hayward Gallery, No. 532.

48. Bronze penbox

Iran; late fourteenth or early fifteenth century
H. 5 cm., L. 29.8 cm.
Institut de France, Musée Jacquemart-André

This exceptional metalwork in nearly perfect condition is made of beaten bronze, incised and inlaid with gold and silver. A shape developed in the twelfth century, the *qalamdan* (penbox) was designed to hold a scribe's writing implements—pens, knives, scissors, sharpening stones, and ink.

Both the exterior and the underside of the cover are densely decorated. Individual parts of a continuous inscription are enclosed within six-sided cartouches that form an upper and lower "frieze." The cartouches are separated by large roundels, each enclosing a six-petalled blossom, and by small roundels, filled with a six-part geometric design. A similar combination of elements ornaments the underside of the cover. It is the balanced rhythm of these various parts—polygons contrasting with circles and epigraphs balancing abstract designs—that creates the stunningly complex aesthetic harmony of this piece.

Remarkable as is the metalwork, its inscriptions are commonplace. Written in a minute, slender *naskhi*, they are characterized, not only by repetitiveness, but also by numerous orthographical errors and omissions[1] that clearly indicate that aesthetic effect, rather than accuracy, was their primary purpose.

On the upper level of the exterior the inscription reads as follows:

Glory to our lord, the possessing, the knowing, [he who is] fortified by Allah, the triumphant, the victorious, the holy warrior, the protector of frontiers, the defender, the pillar of Islam and the Muslims, ruler over kings and sultans, shelter of the humble and the poor, [Glory] to our lord, the possessing, the knowing, the just, [he who is] fortified by Allah, the triumphant, the victorious, the holy warrior, the protector of frontiers, the king, the conqueror, the pillar of Islam.

On the lower level of the exterior the same statements are repeated with slight variations:

Glory to our lord, the possessing, the knowing, the just, [he who is] fortified by Allah, the triumphant, the holy warrior, the protector of frontiers, the defender, the conqueror, the pillar of Islam and the Muslims, ruler over kings and sultans, the shelter of the humble and the poor, [Glory] to our lord, the possessing, the knowing, the just, [he who is] fortified by Allah, the triumphant, the victorious, the holy warrior, the protector of frontiers, the defender, the conqueror.

Finally, on the underside of the cover is found an abbreviated version of the above epithets:

[Glory] to our lord, the possessing, the knowing, the just, [he who is] fortified by Allah, the triumphant, the victorious, the holy warrior, the defender, the conqueror, the pillar of Islam and the Muslims, ruler over kings and sultans, shelter of the humble and the poor.

This combination of superb design and refined technique with a banal, often inaccurate, and numbingly repetitive inscription is not uncommon; in fact, the content here is international and differs little from metalwork inscriptions on contemporary Mamluk metalworks from Egypt and Syria. The epithets do indicate, however, that the *qalamdan*, despite the absence of the figural images so frequently found on medieval metalwork, was intended for secular use, presumably for a scribe in the service of a high official or a ruler. Neither patron nor maker is mentioned.

NOTES
1. A. S. Melikian-Shirvani, *Le bronze iranien*, pp. 84–85, analyzes the inscription and its errors.

PREVIOUSLY PUBLISHED IN
E. Bertaux, *Musée Jacquemart-André: Catalogue itineraire*, p. 139.
Arts de l'Islam, Catalogue of an Exhibition at the Orangerie des Tuileries, No. 141.
A. S. Melikian-Shirvani, *Le bronze iranien*, pp. 84–85.
The Arts of Islam, Catalogue of an Exhibition at the Hayward Gallery, No. 206.

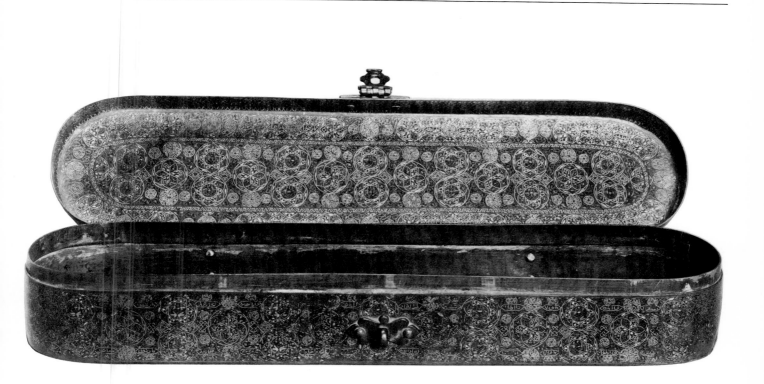

49. Two lines from a Qur'an, written by Prince Baysunghur

Iran; ca. 1420–1433 A.D.
H. 44 cm., W. 97.2 cm.
The Metropolitan Museum of Art; Anonymous gift, 1972

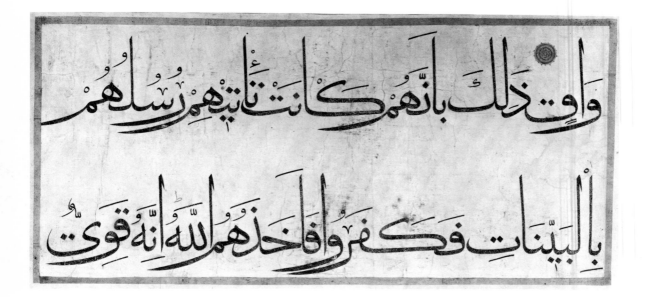

The son of Shah Rukh, who ruled Iran from 1405 to 1444, and the grandson of Timur, Baysunghur was one of the notable figures in the history of Iranian art. Occupying various government offices, he lived in Herat for most of his life and distinguished himself as a patron instrumental in shaping the arts of the precious book in the fifteenth century. Trained as a calligrapher by one of Yaqut's leading followers, Maulana Shams Baysunghuri, he was also a poet and a connoisseur of painting. Through such wide-ranging interests and talents he set a model of princely patronage for later Timurids and for the Safavis of the sixteenth and seventeenth centuries. He died in Herat in 1433 at the age of 38.

It is virtually certain that Baysunghur learned the six cursive scripts practiced by Yaqut in the thirteenth century, but though he is known to have been an avid calligrapher, little of his work has survived. The no-longer-extant inscriptions on the mosque and madrasa of his mother Gauharshad at Mashhad are said to have been his work, and presumably there were books, poems, and samples of calligraphy as well. This now-dispersed Qur'an is a document of enormous aesthetic and historical importance.[1] Its full pages measure 101 by 177 centimeters and have seven lines of text to a page. Surah headings are in gold, and verse endings are marked by small gold roundels.

The lines are written in a majestic jalil al-muhaqqaq script, wonderfully legible and sonorously rhythmic, combining strong slender verticals of great height with sweeping sublinear horizontals. Uniting grandeur and movement, muhaqqaq was the favored script for large Qur'ans in the fourteenth and fifteenth centuries from Egypt east to India.

These two lines are from surah al-Mu'min (The Believer) 40:21–22, which deals with the states of belief and disbelief and describes several past examples of the rewards attained by those who accepted Allah's revelation and the punishments incurred by those who rejected it. The two lines here constitute the last part of verse 21 and most of verse 22:

[Yet Allah seized them for their sins, and they had] no protector (from Allah).

That was because their messengers kept bringing them clear proofs (of Allah's Sovereignty) but they disbelieved; so Allah seized them. Lo! He is strong, [severe in punishment].

NOTES

1. One other page from this Qur'an is in the Metropolitan Museum. Others are in the Library of the Imam Riza Shrine at Mashhad; the Malik Library, Tehran; the Iran-e Bastan Museum, Tehran; and the Imperial Gulistan Library, Tehran. Some of the pages in Iranian possession have been published in the following works: A. Ma'ani, *Catalogue of the Qur'an Exhibition*, No. 59; *The Arts of Islam*, No. 558; and Martin Lings, *The Qur'anic Art of Calligraphy and Illumination*, pl. 51.

50. Nephrite and gold signet ring

Iran; fifteenth century
H. 3.5 cm., Diam. 2.6 cm.
The Metropolitan Museum of Art; Purchase, Rogers Fund, 1912

(Shown only at Asia House)

The bezel circling this light green nephrite signet is gripped by two dragon heads whose necks form the band of the ring. On the stone a central square and four surrounding segments enclose an Arabic inscription, written in a tall, thin, *thuluth* script and asking for divine blessings on the owner:

May you be free from all cares and anxieties in your possessions with [the help of] the most High! May the great wonders be manifest! God aid you in calamities! May your life be without death! [1]

Around the bezel is a minute cursive inscription in Persian:

O my Lord! Instead of writing Thy name I say the following sentence. O my soul! In consequence of my love Thy image is everywhere with me. O my soul! Be as wise in thy conversation as Solomon. My world and my heaven are in this ring.

The owner was clearly in tune with mystical thought of the period: his love for Allah causes him to be constantly aware of the divine presence; he hopes that his soul's conversation will be as wise as that of Solomon, famed both in the *Qur'an* and in mystical literature for his knowledge;[2] and since his soul's aspiration is inscribed here, along with the divine name, the ring encompasses his whole existence.

On the inside of the ring is written the single word Muhammad, probably the name of the owner.

A signet of this quality obviously indicated power, prestige, and wealth; it also had to fulfill its essential role of creating a unique impression when used to seal a document. Whereas other cultures could rely upon figural images for this purpose, the Islamic signet depended upon varieties of script, inscription, and design.

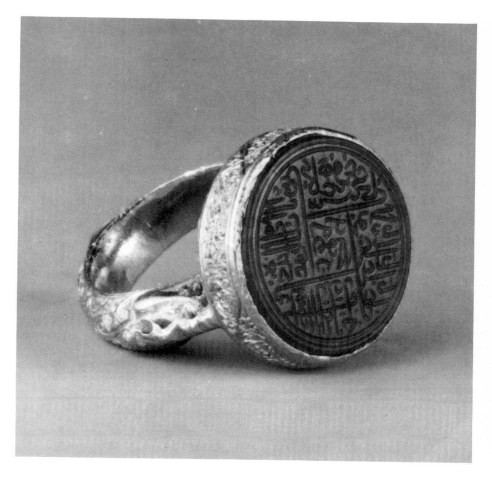

NOTES
1. This and the following translation have been supplied by the Islamic Department of the Metropolitan Museum of Art.
2. For further references to Solomon see Nos. 30 and 82.

51. Epigraphic panel from the door of a tomb

Iran; probably 873 H. (1468 A.D.)
H. 17.8 cm., W. 28.6 cm.
Los Angeles County Museum of Art; Indian Art Discretionary Fund

Three horizontal levels of fine *thuluth* script are carved in sharp relief against a background of slender arabesque tendrils. Five tall verticals rise from the lowest level to the top of the panel to divide the surface into five unequal segments. Slight traces of pigment indicate that this panel (and assuredly the door from which it has been separated) was originally painted in several colors.[1] It is highly probable that this inscription was located at the top or bottom of one of a pair of doors and that an opposite panel on the other door enclosed the name of the donor or calligrapher.

The inscription provides the name of the maker of the door:

Made by Husayn, the son of Master Ahmed, the carpenter, of Sari.

Located in the heavily forested, subtropical region of Mazandaran south of the Caspian Sea in northern Iran, Sari was an important economic center until Timur's invasions in the late fourteenth century when the area was ravaged. Even after this disaster, however, this northern province continued to be a timber-producing area, which exported both wood and woodworkers to the arid lands to the south.[2]

Fifty years ago a brief survey of the Caspian provinces revealed the survival of a considerable number of wooden doors and cenotaphs of the fifteenth century.[3] In one shrine—that of the Imamzadah Buland Imam in Limrosk near Ashraf—was a pair of doors, dated 873 H. (1468 A.D.) and bearing the name of a donor, Sayyid Zayn al-ʿAbidin ibn Sayyid Ismaʿil, and the carpenter, Husayn ibn Ustad Ahmed Najjar Sarawi (Husayn, the son of Master Ahmed, the carpenter, of Sari).[4] While it has not been possible to verify this supposition, it is highly likely that this panel with its identical inscription comes from this door.

NOTES

1. Manuscript painting of the period indicates that doors of this sort were usually painted.
2. George Le Strange, *The Lands of the Eastern Caliphate*, p. 370, provides a brief description of Sari.
3. H. L. Rabino, *Mazandaran and Astarabad*, conducted this survey but unfortunately published no photographs of the material discovered.
4. See Rabino, *Mazandaran and Astarabad*, p. 65; Arthur Upham Pope and Phyllis Ackerman, eds., *A Survey of Persian Art*, p. 2623, n. 11; and Leo A. Mayer, *Islamic Woodcarvers and their Works*, p. 42.

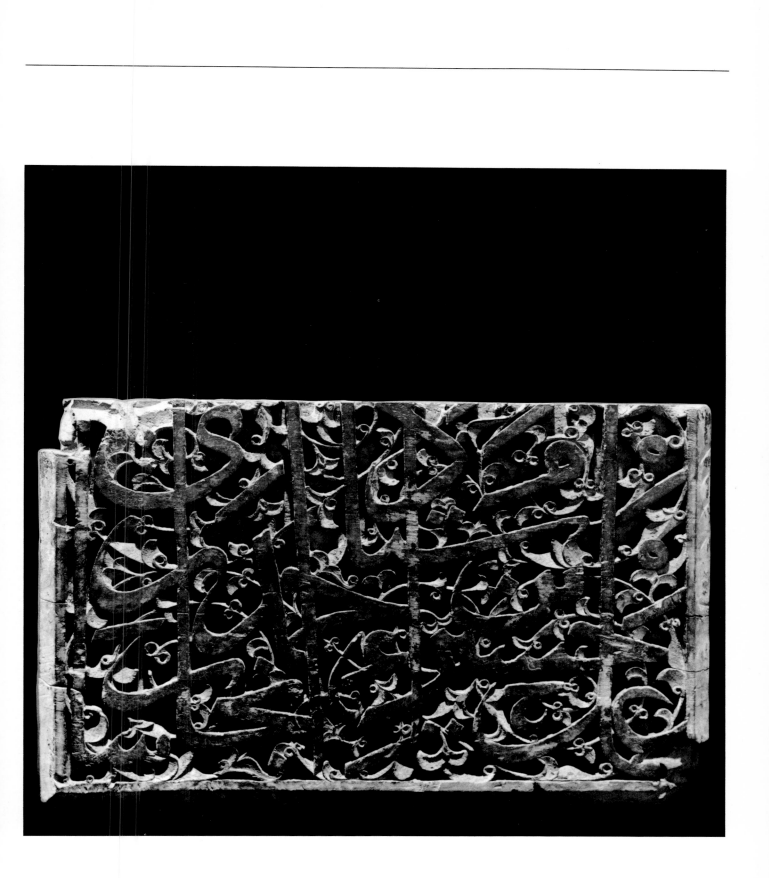

52. Illuminated frontispiece

Signed by Sultan ʿAli al-Mashhadi
Iran; ca. 1500–1520 A.D.
H. 30.4 cm., W. 20.3 cm.
Fogg Art Museum; Gift of John Goelet

While the earlier master Mir ʿAli al-Tabrizi (ca. 1360–1420 A.D.) was credited with the invention of the *nastaʿliq* script, Sultan ʿAli al-Mashhadi (1442–1519) was regarded as one of its foremost practitioners and played a very significant role in perfecting and disseminating the new hand. For the benefit of posterity he also composed a treatise on calligraphy that is one of the major surviving documents for the theory and practice of Safavi calligraphy.[1]

According to this long poetic essay, he was attracted to calligraphy while still quite young, and under the influence of an unnamed sayyid-scribe he decided to devote himself to the art of fine penmanship. While he was raised and acquired early fame in Mashhad, his career flourished in the capital city of Herat under the patronage of Khurasan's gifted, late Timurid ruler, Sultan Husayn Bayqara (reign, 1467–1506 A.D.). This period was, according to the Mughal Emperor Babur, who knew it well and described it shortly after its demise, "a wonderful age; in it Khurasan, and Herat above all, was full of learned and matchless men. Whatever the work a man took up, he aimed and aspired at bringing that work to perfection."[2] Like many calligraphers, Sultan ʿAli not only penned manuscripts and single pages but also designed architectural epigraphs, and the inscriptions in the Jahanara Garden in Herat were his work.[3] Other patrons at the royal court employed him too, most notably Sultan Husayn's great friend Mir ʿAli Shir Nawaʾi, an astute statesman and brilliant poet in Turkish. As one of an illustrious circle of Timurid artists, Sultan ʿAli must have known and associated with some of the other Herat luminaries, like the Persian poets Jami, Banaʾi, and Hilali, the painter Bihzad, and a number of acclaimed musicians.[4] Babur, who lists these individuals and many more, singles

out Sultan ʿAli from all the other court calligraphers and accords him high praise: "Of fine pen-men there were many; the one standing-out in *naskh taʿliq* [i.e. *nastaʿliq*] was Sultan ʿAli of Mashhad who copied many books for the Mirza [Sultan Husayn] and ʿAli Shir Bek [Mir ʿAli Shir Nawaʾi], writing daily thirty couplets for the first, twenty for the second."[5]

Sultan Husayn's death in 1506 precipitated the rapid disintegration of Timurid rule in Khurasan. Herat itself was taken in 1507 by the much-feared Uzbek leader, Shaybani Khan, who appropriated many of its persons of talent. Among them was Sultan ʿAli, who probably remained in the khan's service until 1510, when the Uzbek ruler was killed in battle by Ismaʿil I, the first Safavi shah (reign, 1501–1524). Sixty-eight years old at the time, Sultan ʿAli apparently did not accompany Ismaʿil back to his capital of Tabriz in western Iran but spent the remaining nine years of his life in Mashhad, which he describes as "ruined and deserted, / and lying in utter desolation."[6] Though destitute and very ill, he completed his treatise in 1514, leaving it, his works, and his many students to perpetuate his name.[7]

The *nastaʿliq* letters of this frontispiece are written in outline form, and the manuscript or album that they once introduced is not identified. The text's middle four lines are identical to the first four lines of the frontispiece to the *Shah Jahan Album* (No. 85). Sultan ʿAli's ten lines have been translated as follows:

In the name of Allah, the Beneficent, the Merciful.
There is an invitation to the noble feast.
Praise without limit and thanks without number
To the Creator since the painted patchwork of the heavens is a fragment

Of his gracious and perfect works.
And the illuminated tatters of the sun are a portion of
His beauteous and excellent lights.
Praise to Him at Whose essence all others than He are astonished
And to the depths of Whose perfection wisdom could not travel.

Sultan ʿAli al-Mashhadi.

NOTES

1. See Qadi Ahmad, *Calligraphers and Painters*, pp. 106–125.
2. A. S. Beveridge, trans., *The Babur-nama in English*, p. 283.
3. Qadi Ahmad, *Calligraphers and Painters*, p. 102.
4. *The Babur-nama in English*, pp. 286–292.
5. Ibid., p. 291.
6. Qadi Ahmad, *Calligraphers and Painters*, p. 124.
7. For further information on Sultan ʿAli see the following works: Clément Huart, *Les calligraphes et les miniaturistes de l'Orient musulman*, p. 221; G. I. Kostigova, "Traktat Sultan ʿAli Mashhadi," *Trudi Gosud. Publ. Bibl. imeni Saltikova-Shchedrina* II (5, 1957), pp. 103–163; and Mehdi Bayani, *Khushnevisan*, vol. I, pp. 241–266.

53. Binding for a manuscript of the Qur'an

Iran; sixteenth century
H. 50 cm., W. 36 cm.
Collection of Prince Sadruddin Aga Khan

To a culture that set great value on manuscripts and the written word, bookbinding was a highly respected art, flourishing in most periods and places of Islamic culture. Particularly important were, of course, Qur'an bindings, often lavishly provided with geometric, arabesque, and epigraphic decoration.

This Safavi Iranian example of the bookbinder's art is composed of dark brown leather over a pasteboard core. The interior surface of the cover is divided into a larger inner rectangle and two borders, all colored blue, green, and red and overlaid with gilt cut-paper filigree.

The exterior displays a large inner, gold rectangle, impressed with a pattern of arabesque tendrils, flowers, and cloud forms. It is enclosed by a narrow border divided into small cartouches and panels and a wider outer border with eleven panels containing two *Hadith* of the Prophet. They are written in *thuluth* script and appropriately deal with the desirability of reading the *Qur'an*.[1]

NOTES

1. This binding represents a common Safavi type, both in its division of space and in its use of *Hadith*. For a similar seventeenth century *Qur'an* binding with different *Hadith* see Martin Lings and Yasin H. Safadi, *The Qur'an*, No. 163.

PREVIOUSLY PUBLISHED IN

Anthony Welch, *Collection of Islamic Art: Prince Sadruddin Aga Khan*, III and IV. Binding 3.

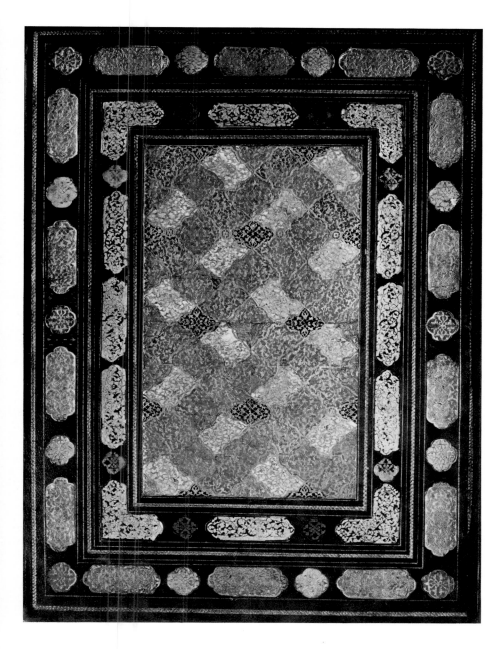

54. Silk double cloth

Iran; ca. 1550–1560 A.D.
H. 31.5 cm., W. 16 cm.
The Textile Museum

Once part of a much larger textile now dispersed in several collections,[1] this small fragment is a compound double cloth, woven in brilliant red and white silk so that identical images and epigraphs, in opposite colors, are shown on each side.[2] This reversal of color scheme is complemented by the use of *muthanna* inscriptions: the vertical band at the right is the mirror image of the band at the left. Reciprocity of design is matched by the shared theme: epigraphy and iconography are closely linked in this complex textile, for each centers on the visions of temporal and eternal love that dominate Safavi visual and verbal culture.

Four lines of *nasta'liq*, repeated throughout the textile in vertical and horizontal cartouches, form a poem with imagery quite common in Persian poetry and singularly appropriate to this cloth:

*There is no other cloth as beautiful as
 this one.
It is as though it has been woven from
 the thread of one's soul.
Through its beauty the manifestation of
 thy form
Has refreshed the soul with its cruel
 coquettry.*[3]

In the upper right riding a high-stepping horse is a young woman whose crown and fine apparel imply royal descent: she closely resembles manuscript images of Shirin, the beloved queen of Khusrau. The poem's third line, below the feet of her horse, refers to her beauty. In the frame below, where the same flowers grow, a man kneeling beside a stream wields a stone-cutting hammer: he is obviously Farhad, haplessly in love with Shirin and breaking this passage through the nearby mountain so that refreshing drink can reach his beloved. It is one of the most poignant tales from Nizami's *Khusrau and Shirin*.

The other two pictures can be less precisely identified. A garden pavilion, richly decorated with tiles, occupies one frame, while in the next stand two youths on either side of a cypress, a symbol of the beloved. In these two frames, flanked by the first two lines of the poem, is a less particular reference to lovers longing for their beloveds: their garden setting mirrors the bliss of paradise.

Small vertical cartouches repeat the image of a single springing ibex, perhaps a metaphor of the lover hunted by his passion for the beloved; small horizontal cartouches show two ducks, facing each other and presumably meant to convey the concept of faithfulness.

In its four major and two minor images, in its horizontal inscriptions repeated in normal *nasta'liq* and its vertical inscriptions repeated in *muthanna* form, and in the overall curving linear movement in landscape, figures, and script, this textile's images and text combine to form a remarkable unity of theme and pattern.

NOTES

1. The largest fragment is in the Metropolitan Museum of Art, No. 46.156.7.
2. For another fine example of the double cloth, a favorite technique of Safavi weavers, see Anthony Welch, *Shah 'Abbas and the Arts of Isfahan*, No. 19.
3. Prof. Jerome Clinton has referred me to another poetic use of the image of a textile in the famous initial lines of a *qasidah* (elegy) by the great medieval Persian poet, Farrukhi Sistani (fl. 987–1037 A.D.):

In a caravan for Hilla bound from Sistan
 did I start
With fabrics spun within my brain and
 woven by my heart.

This translation is from E. G. Browne, *A Literary History of Persia*, II, p. 125.

136

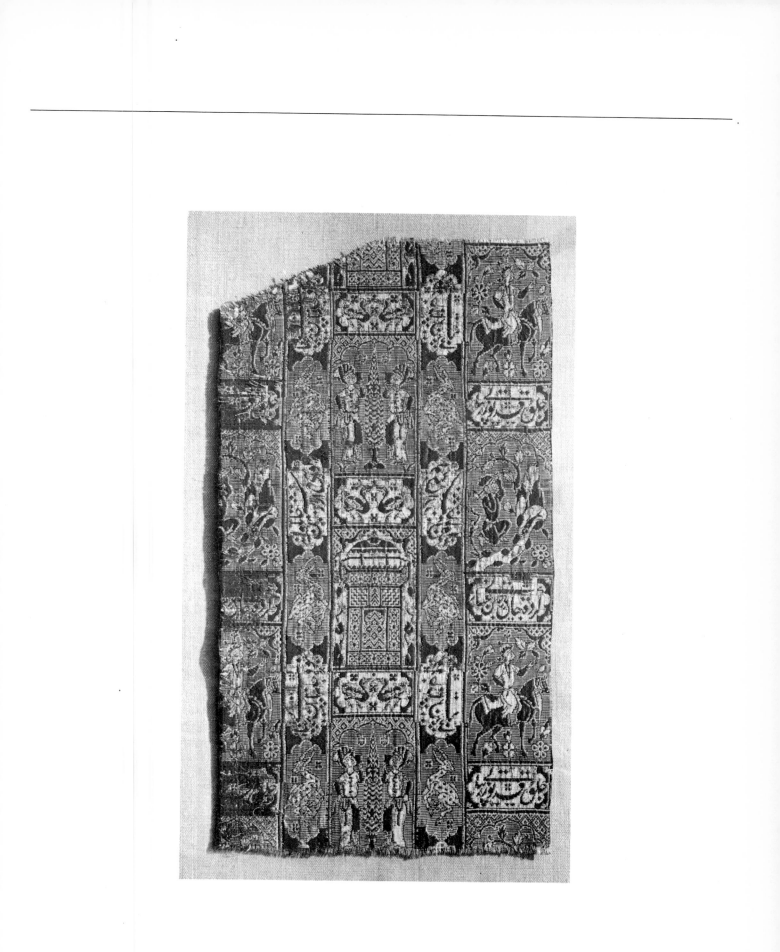

55. Wooden doors to a tomb

Iran; 1003 H. (1594–1595 A.D.)
H. 166.4 cm., W. 43.2 cm.
Nelson Gallery—Atkins Museum; Gift of H. Kevorkian

These doors with their arabesque borders and interior panels are fine examples of Safavi decorative woodcarving. Provided with four different kinds of script, they are richly calligraphic. At the top of both doors and at the bottom of the right-hand door are rectangular panels, each containing two squares in which the name 'Ali is repeated four times in ornamental *Kufic*. In much larger panels in the upper and lower portions of both doors is a fine *thuluth* script with extremely tall, thin verticals:

Call upon 'Ali, manifester of miracles.
You will find him an aid in adversities.
Every care and grief will be dispelled through your guardianship, O 'Ali,
O 'Ali, O 'Ali!
The descendants of the exalted Mirza Ibrahim—may Allah grant him peace—had this door completed in 1003 as an expression of honor.

According to this information, these doors originally opened into the tomb of Mirza Ibrahim, whose descendants in 1594–1595 A.D., some time after his death, commissioned this work in his memory. The inscriptions make it clear that they were pious Shi'as.

At the bottom of the right-hand door is a rectangular panel (bounded by two 'Ali squares) containing a short inscription, written in a squat *naskhi*:

The work of Ahmed ibn 'Abd al-Ghani, the carpenter.

Opposite it on the left-hand door is a larger panel inscribed in *thuluth*:

Written by the servant [of Allah] Mir 'Ali ibn Mahmud in 1002.

The date, a year earlier than the actual carving of the doors, presumably refers to the time when the inscriptions were designed. The fact that this information is written not only larger but in a more monumental script than the epigraph in the panel at the right strongly implies that the calligrapher's art was considered far more significant than that of the woodcarver.

PREVIOUSLY PUBLISHED IN

Leo A. Mayer, *Islamic Woodcarvers and their Works*, p. 27 and pl. X.

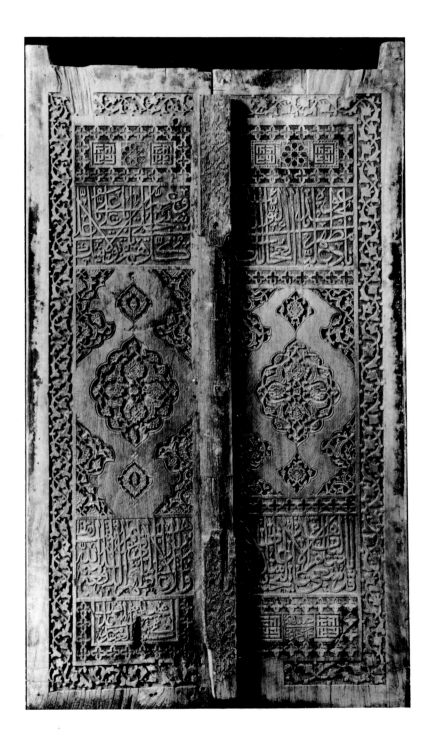

56. A wise saying

Iran; ca. 1596–1599 A.D.
H. 22.1 cm., W. 10.6 cm.
Private collection

Four long lines of gold *nastaʿliq* stretch diagonally across this album page. The words and purple background are lightly contained by a thin gilded line, forming rolling clouds in a dark blue sky, illumined with flowers. The four main calligraphic clouds are linked by cumulus extensions down to the lower left, where the calligrapher's name—"The servant [of Allah] ʿImad al-Husayni wrote it, [May Allah] forgive him"—floats in a similar setting. Only in the upper right are there words in a separate environment, a distinct and regular cartouche and not a cloud, which frames the pious affirmation, "He [Allah] is the Exalted!"

The four larger lines are in Chaghatai Turkish, widely spoken in Iran's eastern province of Khurasan, and they constitute a wise saying or homey aphorism, perhaps based on an Arabic original:

The death of your parents is enough of a
* preacher for you*
And advises you just as they would;
A preacher [sometimes] does not prac-
* tice what he preaches,*
And the preacher of yours is to be pre-
* ferred to such a one.*

One of the most accomplished masters of *nastaʿliq*, ʿImad al-Husayni justly enjoyed a high reputation during his lifetime and after his death. Enough is known about his life to assemble a plausible biography.[1] He was born in Qazvin in 960 H. (1552 A.D.); his family were noted Sayyids.[2] Taking early to calligraphy, he served an initial apprenticeship with the renowned master, Malik Daylami,[3] who died in 1562 in Qazvin, and afterward studied with Muhammad Husayn, a Tabrizi scribe. On completing his studies, he undertook extensive travels, journeying in Ottoman Turkey, where he apparently remained for some years, and going on pilgrimage to Mecca and Medina. Around 1595 he was back in

Qazvin, for the Safavi chronicler, Qazi Ahmad, mentions him briefly, though with much respect, in his treatise of the following year. From 1596 until 1599 he was in the service of the powerful general and ambitious patron, Farhad Khan Qaramanlu, in Khurasan and Mazandaran, and an extant calligraphy, bearing the name of the latter province, was probably written at this time.[4] Its similarities to the Turkish wise saying under discussion here are many, and it seems justified to posit that these four aphoristic lines were written for a Turkish-speaking Safavi amir, perhaps Farhad Khan himself, in the last years of the sixteenth century. ʿImad al-Husayni's future rival and competitor for royal favor, ʿAli Riza Tabrizi, was in the khan's entourage as well.

Farhad Khan Qaramanlu was executed by Shah ʿAbbas in 1007 H. (1598–1599 A.D.), and both ʿImad al-Husayni and ʿAli Riza passed directly into the service of Shah ʿAbbas, also an energetic patron. Established in the new capital of Isfahan, ʿImad did not, like ʿAli Riza, extend his talents to the designing of monumental inscriptions for the structures erected under the shah's patronage.[5] He appears instead to have restricted himself to writings on paper, and six signed and dated calligraphies—two of them done on royal command—ranging in their dates from 1009 H. (1600–1601 A.D.) to 1023 H. (1614–1615 A.D.), were almost certainly done in Isfahan.[6]

Apparently not in complete agreement with the Shiʿism of the Safavi state and engaged in often bitter competition with ʿAli Riza, ʿImad gained the hostility of both the shah and the monarch's favorite calligrapher. One evening in 1024 H. (1615–1616 A.D.), as he walked through one of Isfahan's streets, he was set upon by hired assassins and brutally murdered.

NOTES

1. This account is based upon the following sources: Clément Huart, *Les Calligraphes et les Miniaturistes de l'Orient Musulman*, pp. 239–242; Qadi Ahmad, *Calligraphers and Painters*, pp. 167–168; and Mehdi Bayani, *Khushnevisan*, pp. 518–538.
2. Sayyids were descendants of the Prophet Muhammad and thus held in special repute.
3. Malik Daylami was at first on the staff of Shah Tahmasp's vizier, Qadi-yi Jahan, and was later assigned to work for the shah's gifted nephew, Ibrahim Mirza. He wrote two books of the 1556–1565 *Haft Awrang* of Jami (now in the Freer Gallery) for this prince. Recalled to Qazvin by the shah in 1559, he designed architectural inscriptions and had ʿImad al-Husayni as a youthful student.
4. See Anatoli A. Ivanov, Tania B. Grek, and Oleg F. Akimushkin, *Album Indiskikh i Persidskikh Miniatur*, 16–18, v., pl. 111.
5. ʿAli Riza designed, among others, the inscriptions for the Royal Mosque and the Mosque of Shaykh Lotfallah in Isfahan.
6. Twenty-three calligraphies signed by ʿImad al-Husayni are included in the great album now in Leningrad and found in Ivanov, Grek, and Akimushkin, *Album Indiskikh i Persidskikh Miniatur*, pls. 6 and 104–111. The following bear dates: pls. 6, 107, 108, 109, 110, and 111.

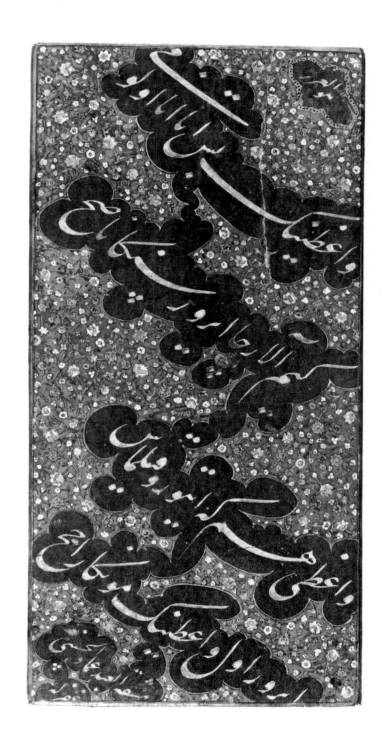

57. Copper wine bowl

Iran; early seventeenth century
H. 11.5 cm., Diam. 21.1 cm. (at top)
Musée du Louvre, Département des Antiquités Orientales (Section Islamique)

This low wide-mouthed bowl is made of copper, and its arabesque and epigraphic decoration is in low relief against a background, incised and darkened with black paste. Its finely proportioned body carries a precisely cut, symmetric, balanced, and controlled arabesque with thin tendrils, small flowers, and broad leaves—a type of ornament altogether typical of Safavi tiles, manuscripts, wood, and metal of the period. Seven cartouches circle the short neck; six contain verses in a handsome *nasta'liq*. The background behind these letters is a subdued and delicate arabesque with none of the large leaves visible in the arabesque on the body, and the letters themselves provide similar wide surfaces of varying thickness. The seventh cartouche encloses an inscription in Armenian script that informs us that the bowl was the work of an Armenian living in New Julfa.

The *nasta'liq* inscription is a Persian mystical poem:

Bring me the cup of awareness, O Saqi,
So that nothing remains in my heart save
* this love for the friend.*[1]
Give it to me that I may gratify my
* desires,*
That I may be young in my old age,
That I may become drunk with the wine
* of eternity,*
That I may free myself from the bonds of
* the self.*

Mystical poems of this sort were common on metalwork, miniatures, and other arts of Safavi Iran, to a large extent replacing the eulogies of rulers and blessings on owners that mark earlier pieces.[2] Mystical thought—generally strongly binding the religious and the sensual, the longing for the divine beloved with the desire for the earthly beloved—permeated virtually all levels of upper-class Safavi society, whatever languages they spoke or faiths they adhered to. Thus the Armenians, who had been forced by Shah 'Abbas I to migrate from northwestern Iran to the outskirts of his capital of Isfahan in order to provide the mercantile expertise necessary for his ambitious new economic policies, used a theme developed in Persian poetry and a script and arabesque indigenous to Islamic Iran. Not only in metalwork, but also in miniature painting and architecture, the wealthy Christian Armenians were important patrons of Safavi culture.[3]

NOTES

1. The friend signifies both the mortal and the immortal beloved, Allah, the desire for whom brings gratification of desire, the sensation of youthfulness, inebriation, and freedom from self. The reference to drunkenness obviously has bearing on the bowl's use too.
2. For an impressive scholarly discussion of the use of mystical inscriptions on this and other metalworks of the Safavi period see Asadullah Souren Melikian-Shirvani, "Safavid Metalwork: A Study in Continuity," *Studies on Isfahan, Iranian Studies* 7 (1974), pp. 543–585.
3. For the Armenians of New Julfa see John Carswell, *New Julfa: The Armenian Churches and Other Buildings*, and Vartan Gregorian, "Minorities of Isfahan. The Armenian Community of Isfahan, 1587–1722," *Studies on Isfahan, Iranian Studies* 7 (1974), pp. 652–680.

PREVIOUSLY PUBLISHED IN

A. S. Melikian-Shirvani, *Le Bronze Iranian*, p. 113.
———, "Safavid Metalwork: A Study in Continuity," *Studies on Isfahan, Iranian Studies* 7 (1974), p. 551.
L'Islam dans les Collections nationales, Catalogue of an Exhibition at the Grand Palais, No. 93.

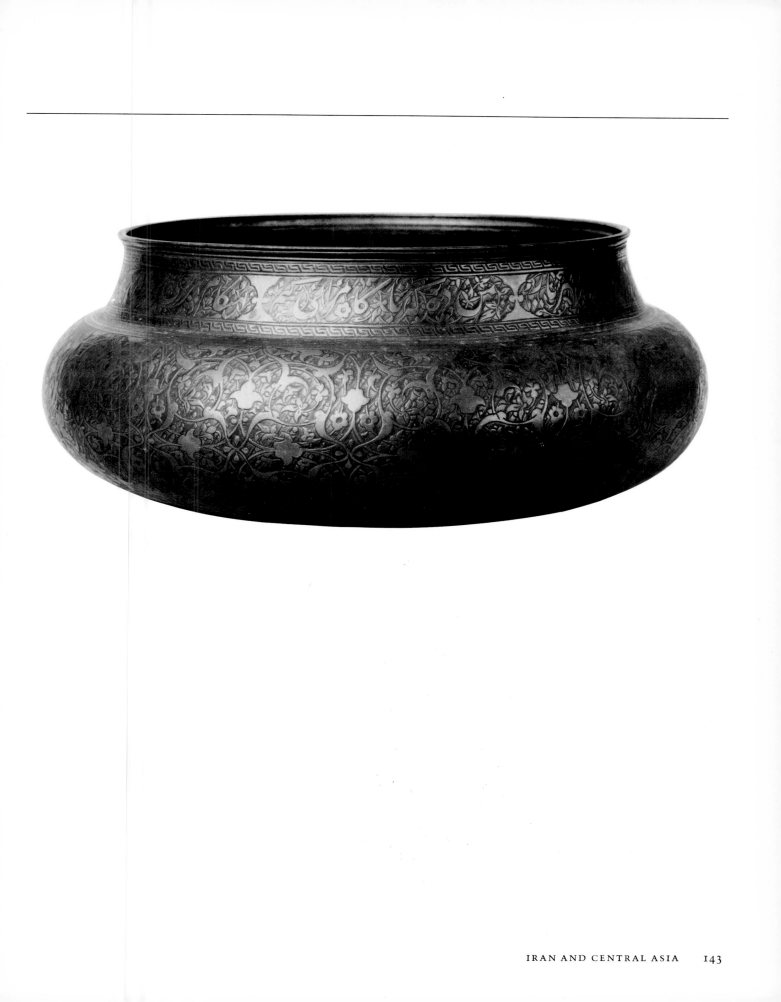

58. Calligraphic exercise

Iran; early seventeenth century
H. 32.6 cm., W. 22.4 cm.
Fogg Art Museum; Purchase, Grace Nichols Strong, Francis H. Burr, and Friends of the Fogg Art Museum Funds

The equivalent of a page from a painter or draftsman's sketchbook, this un-signed practice sheet shows individual *nasta'liq* letters and some recognizable words. Either the scribe or a contemporary collector (whose seal, too damaged to be read, can be seen at the bottom) appreciated the work enough to provide it with a gilded floral and arabesque background and to mount it on an album page with a handsome dark and light blue border.

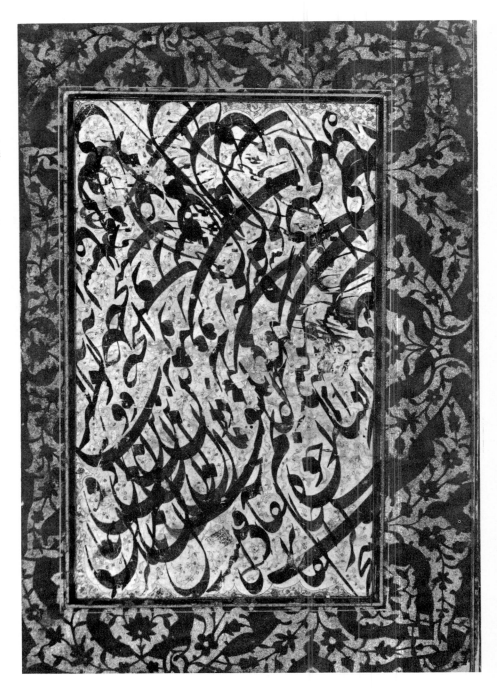

59. Openwork steel plaque from the door of a tomb

Iran; seventeenth century
H. 27.8 cm., W. 32.6 cm.
The Art Institute of Chicago; Oriental Art Purchase Account

This brilliant plaque was once part of a larger epigraphic ensemble adorning the door leading into a tomb, for its inscription comes from the *surah al-Insan* (Time) which describes in very tangible and sensual terms the eternal joys awaiting the righteous in paradise. Written here is one verse (76:13):

Reclining there upon couches, they will find there neither (heat of) a sun nor bitter cold.

Other plaques probably continued this same theme of the pleasures of the afterlife. They may have shown verses from this same *surah* or presented verses from other parts of the *Qur'an*, but their relation to a tomb and its function would surely have been as clear as it is in this plaque.

It is a superbly crafted piece, and its cut steel (a technique much favored by the Safavis) would have glistened brilliantly against a dark wood background. Designed by a calligrapher of great ability—whose style is close to that of the towering master of seventeenth-century *thuluth* script, 'Ali Riza 'Abbasi—it is written in a very clear, precise *thuluth* over a delicate background of slender arabesques.

Other door plaques of this openwork sort are known—in steel, gold, and ivory—from Iran, and, while some also bear verses from the *Qur'an*, others are inscribed with specifically Shi'a invocations.[1]

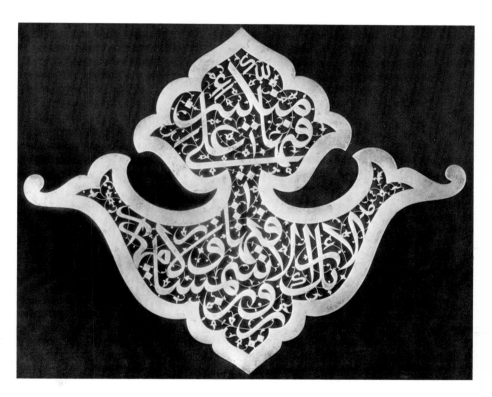

NOTES

1. Several are published in *The Arts of Islam*. No. 235 and 237 in this Hayward Gallery catalog are both also openwork steel, the former using a verse from the *Qur'an*, the latter Shi'a invocations; No. 247 is gold and refers specifically to the donor, Shah 'Abbas I; and No. 156 is ivory and from the *Qur'an*.

60. Ceremonial iron anchor

Iran; sixteenth century
H. 53.3 cm., W. 21.4 cm.
Musée des Arts Décoratifs

(Shown only at Asia House)

Such superb decoration would only have been used on a nonutilitarian object, and it has been suggested that this anchor may have been a ceremonial accessory on a princely ship.[1] Safavi representations of ships can be seen in textiles and book illustrations, but objects of this sort are not depicted. Since the Safavi state had neither merchant nor military fleet but was wholly a land-based power, the anchor's use is even more puzzling.

The inscription, composed in the thirteenth century or later, probably comes from a literary genre known as the Mirror of Princes, advices and counsel offered to rulers or future rulers by wise vazirs:

From your ancestral land do not curtail water or the judgments of a man of quality, for the former has made canals and (the latter) has nourished souls.

Rendered in a very fine *muhaqqaq* script, this epigraph occupies an area almost equal to that of the arabesque pattern below it. Neither element intrudes upon the other: there is no arabesque background to the inscription, and there are no letters intertwined with arabesque. Yet both are controlled by the same visual rhythm, a virtual identity of curvilinear pattern created by a master designer.

NOTES

1. This unusual piece was first published and analyzed by Asadullah Souren Melikian-Shirvani, *Le Bronze Iranien*, p. 104.

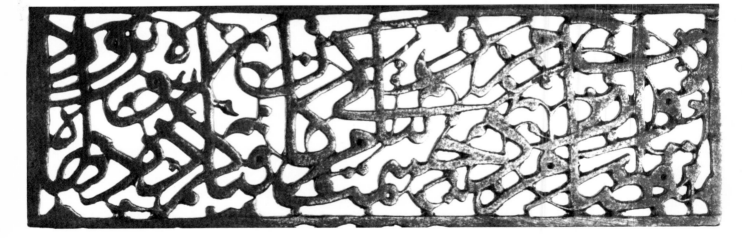

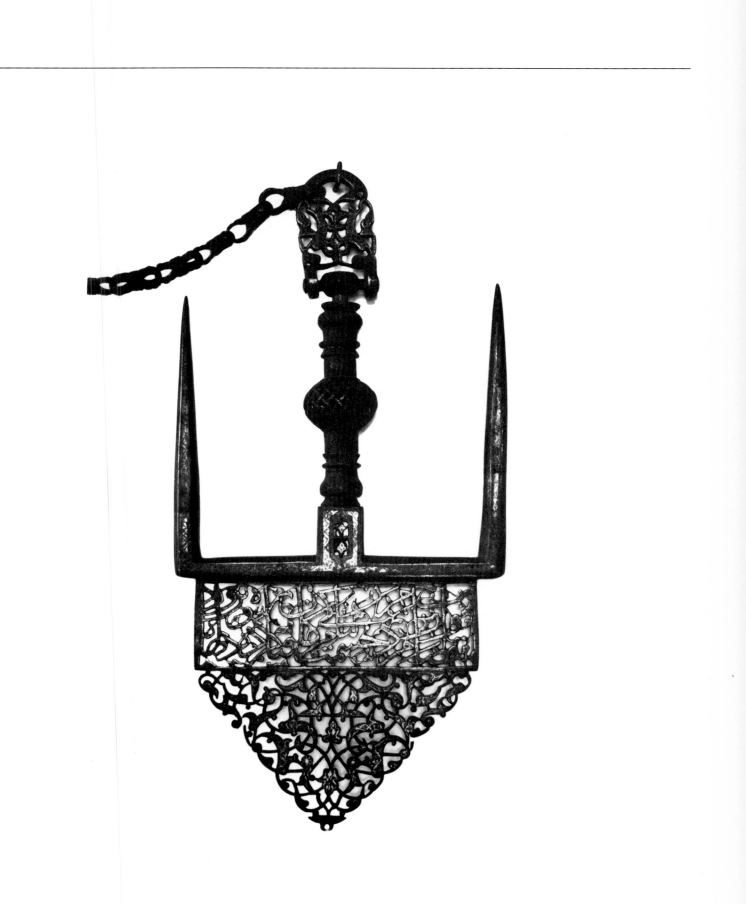

61. Steel Shiʿa standard

Iran; seventeenth century
H. 61.5 cm., W. 25.8 cm.
Kungl. Livrustkammaren

The use of cut steel as a major material for fine objects was a Safavi innovation, not supplanting but instead adding to the repertory of metals worked in Iran. While earlier objects in brass, bronze, or copper had been incised and inlaid with silver and gold (as in No. 48), steel was nearly always gilded, a technique that was simpler, though less durable.

The two halves (mirror images of each other) of the central arabesque area are framed by a gilded inscription band, badly effaced. Two cylindrical cables circle the exterior: most likely they functioned once as the bodies of dragons whose heads have since been broken off.[1] The standard's top, also damaged, was originally inscribed as well. Mounted on a tall pole and carried in a prominent position in religious processions, such as the festivals during the Shiʿa holy month of Muharram when Shiʿa martyrs, in particular al-Husayn, are honored, the standard was a conspicuous and important ritual object, functioning in a way similar to images of saints and martyrs carried in Christian processions.[2] Here, however, it is the written word rather than the figural representation that is the manifestation of these holy personages and the focus of religious attention.

The inscriptions in battered but once fine *rayhani* script can be reconstructed on one side (illustrated here). The top portion must have been inscribed with the three names central to Shiʿa piety— Allah, Muhammad, ʿAli—proceeding from the top in that order. Then, beginning in the upper left of the inscription band and moving down and up again to the upper right, were originally twelve oval cartouches, their bounding lines now partially visible, which contained the names of the twelve Shiʿa imams, key figures in Shiʿa religious history. Thus the first cartouche, now almost completely obliterated, named the Prophet's cousin, foster brother, and son-in-law ʿAli, the first imam. The second cartouche, well preserved, names ʿAli's first son, Imam al-Hasan, while the third contains the name of his second son, Imam al-Husayn. The Shiʿa succession continues with the names of the next three imams—ʿAli Zayn al-ʿAbidin, Muhammad al-Baqir, and Jaʿfar al-Sadiq —being just visible. On the right side only the name of the final, twelfth imam —Muhammad al-Mahdi—can be made out at the top.

While the reverse inscription is so badly damaged that it cannot be reconstructed, it most likely was also topped by the names, Allah, Muhammad, and ʿAli. Although the encircling band might also have repeated the names of the twelve imams, it more likely presented key statements about Islam, Shiʿism, and the Safavi state.

Relying on Shiʿa support for their rise to power in Iran, during the first years of the sixteenth century, the Safavis institutionalized Shiʿism as the national faith. Subsequently, Safavi shahs even claimed descent from the seventh imam, Musa al-Kazim (whose name would have been inscribed in the lower right of this standard), and declared that they were the representatives on earth of the twelve (or hidden) imam, Muhammad al-Mahdi, until his return to the world to establish a perfect order. This direct connection with Shiʿism was of vital importance to the strength of the Safavi state. Shiʿa festivals, literature, and ceremonies were carefully encouraged, and the shahs promoted Iranian cities like Mashhab, Qum, and Ardabil as Shiʿa pilgrimage sites. Thus the inscription on this ritual object is not simply a recitation of Shiʿa belief but is also a statement of the convictions that upheld the Safavi state.[3]

NOTES

1. Extant standards of a similar sort in which the dragon heads are preserved are in the Detroit Institute of Arts, the Topkapi Palace Museum (published in Arthur Upham Pope and Phyllis Ackerman, eds., *A Survey of Persian Art*, pl. 1433), and the David Collection (published in Davids Samling, *Islamisk Kunst*, pl. 87).
2. Shiʿa banners were also displayed (see *Arts of Islam*, No. 91).
3. Formerly in the collection of Prince Sachovskoy, St. Petersburg, this standard probably came from the shrine of the founder of the Safavi order, Shaykh Safi, at Ardabil. The city was seized by a Russian army in the early nineteenth century, and in 1827 treasures deposited there by successive shahs were removed and transported to Russia.

PREVIOUSLY PUBLISHED IN

Förtecknig över Greve Kellers samling av orientaliska och europeiska vapen, Auction catalogue No. 225, A. B. H. Bukowskis Konsthandel.
Arts of Islam, Catalogue of an Exhibition at the Hayward Gallery, No. 236.

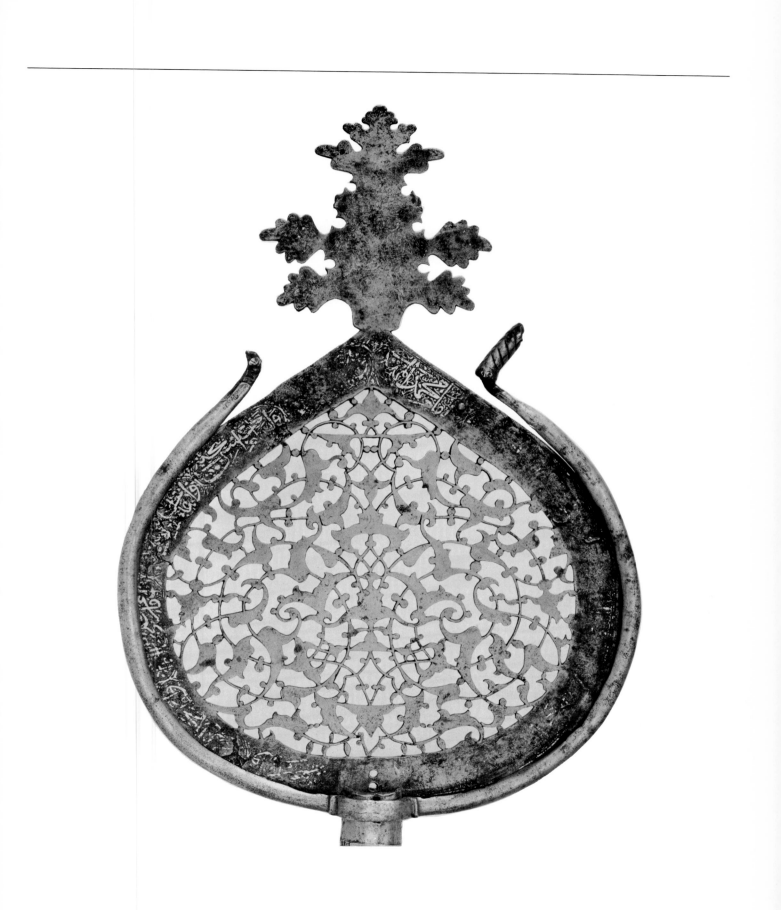

62. Silk tomb cloth

Iran; 1053 H. (1643–1644 A.D.)
H. 119 cm., W. 90 cm.
David Collection

Shi'a piety conceived this cloth, determined its epigraphs, paid for its creation, and caused its donation to the tomb of an unidentified holy person whose shrine it no longer graces. According to the *nasta'liq* inscriptions in five identical cartouches repeated at the top and at the bottom of the textile, this silk was "bequeathed by Hajjiyya Khawanzadah, daughter of Qasim of Ibanaki [in the year] 1053 H." Though nothing is known about the donor, her religious devotion is indicated not only by the gift of this costly cloth but also by her title *hajjiyya*, signifying that she had completed the pilgrimage to Mecca.

The area between these donor borders is divided into four bands, each with large cartouches of *thuluth* script separated by smaller cartouches of *nasta'liq*, both scripts written in blue on a yellow ground. In the first (top) and third bands identical *thuluth* inscriptions invoke the power of 'Ali, whom Shi'as regard with particular reverence:

*Call on 'Ali, the place of manifestation
of all miracles.*

The neighboring *nasta'liq* inscription is in two parts. The lower one repeats the most frequent Muslim invocation:

*In the name of Allah, the Beneficent, the
Merciful.*

The upper one supplies factual information about the calligrapher who designed the inscriptions:

Written by Muhammad Mu'min.

The proximity of the scribe's name to the invocations to Allah and to 'Ali is an indication not simply of a desire for artistic recognition but also of the fact that the writing of a religious message was a pious act.

The second and fourth bands of *thuluth* render the first verse of the *surah al-Nasr* (Succor) 110:1:

*When Allah's succor and the triumph
cometh*

In the cartouches are again two *nasta'liq* inscriptions. The lower one straightforwardly states

Help from Allah

The upper one continues this sentence in mirror (*muthanna*) writing:

and present victory.[1]

Finally, at the very bottom of the cloth, is repeated six times the following information about the weaver:

*Made by Muhammad Husayn, son of
Hajji Muhammad Kashani.*

In its masterful, repetitive design the cloth is a visual metaphor of the verbal prayers piously repeated in a Shi'a shrine.

NOTES

1. This phrase—"help from Allah and present victory"—is from *surah al-Saff* (The Ranks) and is also found on No. 64.

PREVIOUSLY PUBLISHED IN

Davids Samling, *Islamisk Kunst*, p. 115.
The Arts of Islam, Catalogue of an Exhibition at the Hayward Gallery, No. 80.

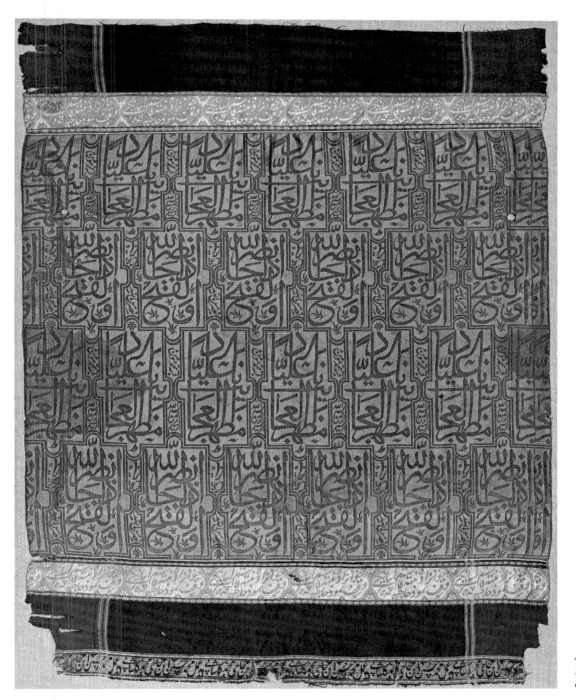

See color illustration on page 5

63. Youth regarding a poem

Iran, Isfahan; ca. 1650 A.D.
H. 19.1 cm., W. 10.4 cm.
Collection of Prince Sadruddin Aga Khan

Standing beside a small stream, this elegantly dressed fashion plate casually observes a large sheet of paper, which he holds displayed for the viewer. In a fine clear *nasta'liq* is written a short poem:

He [Allah]
May the world fulfill your wishes from
* three lips:*
The lips of the beloved, the lips of a
* stream, and the lips of a cup.*
May you remain in this world so long
That you pray on the grave of the firma-
* ment.*
* [by] the humblest of your worshipful*
* subjects,*
* Muhammad Qasim Musavvir.*

Equating the beauty of the loved one with the beauty of a garden stream and a wine cup (and presumably its contents), the poetic conceit of the three lips is frequent in the mystical poetry of Iran. As the initial invocation of the divine name indicates, the metaphor is to be understood both in a worldly and otherworldly sense, for the beauty of the mortal beloved is a reflection, however distant, of the immortal beauty sought by the yearning human soul. This youth, however postured in stance and vacant in visage, is therefore not simply a refined dandy admiring a handsome calligraphy: he is the poem's beloved, given visual form.

On the reverse of this page, formerly part of an album, are written several *Hadith* (traditional sayings) of the Prophet Muhammad in a competent *nasta'liq*. They are signed by the "artist 'Ali al-Mashhadi on the order of Nur al-Din Ni'matallah in the year 971." The Muslim date corresponds to 1563–1564 A.D. The great scribe and master of *nasta'liq* Sultan 'Ali Mashhadi had died in 926 H. (1520 A.D.),[1] and this callig-

rapher is obviously a later namesake, working for a member of the powerful Ni'matallah family that was closely allied with the ruling Safavi house.

NOTES
1. See No. 52.

PREVIOUSLY PUBLISHED IN

Anthony Welch, *Collection of Islamic Art: Prince Sadruddin Aga Khan*, III and IV, No. Ir. M. 91.

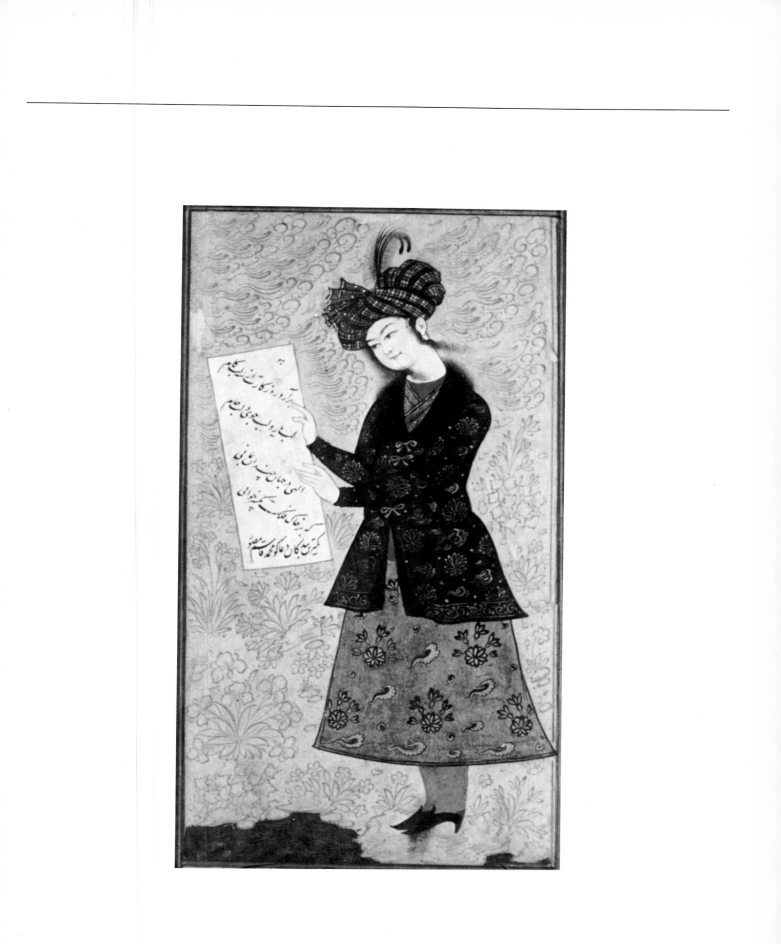

64. Silk tomb cloth

Iran; 1123 H. (1711–1712 A.D.)
L. 213 cm., W. 132 cm.
Musée Historique des Tissus

This silk cloth is a superb example of the *muthanna* (or mirror-image) style of writing. It is not a separate script, since any script can be written in *muthanna* form. Here three different cursive scripts are used. Along the sides are six rectangular panels that contain a *muthanna nasta'liq* inscription:

Help from Allah and present victory.[1]

Here the reverse images face each other in the same panel, and the final letters of their upper and lower parts nearly touch.

The second epigraph is written at the top and bottom of the textile, the right panel in a normal *ta'liq* script, the left panel repeated in *muthanna* style:

O, Husayn, son of 'Ali, [in the year] 1123.[2]

The third epigraph is written in *thuluth* script but in a highly complex manner. It is the first verse of *surah al-Fath* (Victory) 48:1 when Allah says to Muhammad:

Lo! We have given thee a signal victory[3]

Although the verse refers to both physical and spiritual victory and is therefore appropriate for a tomb, it must also have been chosen because of its calligraphic potential; for the second word in Arabic is *fatahna* (We have given) which, being of the same root, is visually nearly identical to *fatha* (victory). Each of the *thuluth* segments is bounded on one side by *fatahna* and on the other by *fatha*, but going in the opposite direction in an intricate play of nearly equal and not quite symmetric elements. Each verse written in regular *thuluth* is faced on the other side by its mirror image. There are, moreover, no noncalligraphic elements in this central design, and the binding horizon-

tals and verticals that seem to form a many-runged ladder are identifiable letters extending beyond their normal boundaries to link the different phases of the verse.

It is an intricate masterpiece of verbal design and must rank among the highest achievements of Safavi calligraphy.

NOTES

1. This phrase is a portion of the *surah al-Saff* (The Ranks) 61:13:

 And (He will give you) another (blessing) which ye love: help from Allah and present victory. Give good tidings (O Muhammad) to believers.

 This same inscription, the second part of it in *muthanna nasta'liq*, is to be found in No. 62.

2. This is a reference to the third Shi'a imam, al-Husayn, whose martyrdom at Karbala is annually commemorated.

3. The explicit reference here is to the epoch-making truce of al-Hudaybiyay between the early Muslims and their opponents, the Quraysh tribe. In subsequent verses it is also clear that these words refer to Allah's forgiveness of human sins. *Surah al-Fath* is also used on Nos. 20 and 30.

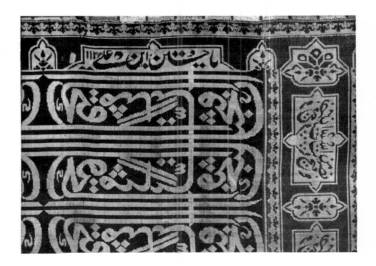

65. Document in shikastah

Iran; 1210 H. (1795–1796 A.D.)
H. 16.8 cm., W. 9.9 cm.
Fogg Art Museum; Gift of John Goelet

The development of *shikastah* script had already been implied by developments in earlier calligraphy in Iran, but it was not until the sixteenth century that it became an independent, vital, and enduring style on its own. The word *shikastah* means broken, and the term itself explains some of this remarkable script's characteristics. Horizontal regularity is not the norm; instead, words rise and fall in fluid motions emphasizing delicate grace and airy ebullience. The ordered, geometric proportions and predictable rhythms of other scripts—like *naskhi*, *nasta'liq*, *muhaqqaq*, or *thuluth*—are not considered virtues here, and the hitherto valued principles of Ibn Muqla are circumvented. *Shikastah*'s falling forms and cloud-like setting clearly owe much to *ta'liq* (the fluent script which also yielded *nasta'liq*), but, to the modern eye at least, its virtuosity seems overdone and obfuscating.

It was a script that had little currency beyond the borders of Iran. For buildings and for *Qur'ans* it was deemed unsuitable: its ideals are hardly monumental. It was much used in private correspondence, in poetry, and in administrative documents; the present page is a sound example of the last.

The page is dated 1210 H. (1795–1796 A.D.) and was prepared by the scribe Mirza Kuchik Khan on the order of Hajji Mashkur. Neither seems to have been a significant figure in late eighteenth century Iran. By this year Iran was firmly under the control of the first shah of the Qajar dynasty, Agha Muhammad (ruled 1779–1797), who had established his capital a decade earlier at Tehran, where this document may have been written. It records a successful plea for tax relief that had been entered somewhat earlier, apparently, in oral and less-refined written form but was presented here in a final, formal, polished version—a calligraphic thanksgiving for a bureaucratic

blessing. In keeping with established Persian forms of address, this document is filled with laudatory honorifics, directed from a pleading subordinate to a powerful superior. These phrases simply cannot be translated in any meaningful way, but the page's contents can be accurately summarized.

Most of the script is in fluctuating long lines, in this illustration written with the correct side up. It records the initial plea from Hajji Mashkur to the unnamed official. After a number of appropriate honorifics the content runs as follows:

Since you have always been concerned for the welfare of your subordinates, you prescribed that last year's taxes—that which was to be paid to the High Court from the funds of previous years—were to be compassionately reduced. You did not make clear the undersigned's final obligation, nor, when you gave this order, was it indicated how the matter would be reported to subordinate officials. Now the Honorable 'Abbas Quli Khan and the Honorable Aslan Bek Afshar and the Honorable Mirza Muhammad Mohsen and others have come to collect that which is due to the High Court and are exercising diligence. Since this very morning [this] group has specified and requested the sum first designated [rather than the reduced amount], the Honorable Fazlallah Bek together with my son Mirza Musa have been sent at once to wait upon your excellency on [our] behalf. Thus please send a copy of that order to us and another to 'Abbas Quli Khan and the others.

In this regard [I hope you] will inform the subordinate officials and give a detailed account of the matter. However, with regard to the Honorable Aslan Bek, for reasons well known to you, it would be better if he did not learn of these matters.

This portion of the document bears the name of the calligrapher, "[by] the least of thy servants, Mirza Kuchik Khan, [in the] year 1210."

Written upside down in eight additional, somewhat shorter lines is a clearly jubilant record of the successful outcome of the initial, frenzied plea with its implications of behind-the-scenes intrigues and jealousies:

Your Excellency must be both informed and yourself aware that the difficulty was responsibly resolved in a pleasant discussion of the matter. What a [fortunate] horoscope have I! [Indeed], I sigh over it. May Allah be my advocate against [untoward] fortune. One may glance with mercy on the state of my justice [?]. It was prescribed in the place specified by the agent of his Excellency; the agent whom the Honorable Mirza Abu'l-Hasan brought with him ordered a generous reduction. Written at the command of the Honorable Hajji Mashkur by Mirza Kuchik Khan, 1210.

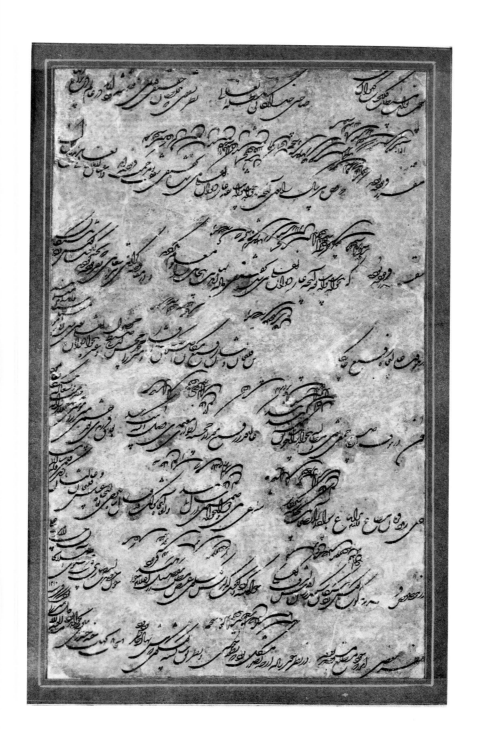

66. Ivory-handled dagger

Iran; blade, 1215 H. (1800–1801 A.D.) handle, 1834–1838 A.D.
L. 33.0 cm.
Fogg Art Museum; Purchase, Alpheus Hyatt Fund

Clearly done by a master swordsmith, this dagger's fine blade of watered (or damascened) steel is gilded with two simple patterns on both sides. Written between them on both sides in a small *nasta'liq* is information about its creation:

[Done by] order of Aqa Qadalu; made by Muhammad Hadi [in the] year [12]15.[1]

The *hijri* date corresponds to 1800–1801 A.D. Originally provided with another hilt, the dagger must have been valued by a later owner who ordered the ivory hilt that now adorns it. On one side appears an image of a tall fit bearded man, who wears a crown and rests his right hand on a curving sword, while his left hand is held open at his waist near a knife, in form identical to this one. His head and shoulders are framed by a cusped arch, stylistically influenced by European art. Above and below this imposing figure is an identifying *ta'liq* inscription:

The likeness of the incomparable Muhammad Shah, a heaven of grandeur, a vessel of beauty.

This likeness is therefore a royal portrait of the third ruler of the Qajar dynasty. Son of the heir apparent—'Abbas Mirza, who died in 1833—Muhammad Shah succeeded to the throne in 1834 on the death of his grandfather Fath 'Ali Shah.[2] Not a monarch of great gifts, he reigned for fourteen years (1834–1848).

On the other side of the knife is another male figure, smaller and slimmer in stature as well as younger in years and not bearded. He stands holding a sword and a rifle and wears a conical hat, common in the mid-nineteenth century for high officials. A cartouche directly above his head identifies him: "Portrait of Sayyid 'Ali Khan." At the top and bottom of the hilt are two further *ta'liq* inscriptions, referring to this same person:

It was finished by command of the slaves of Hasan Khan, entitled Aqa Khan, beklarbeki[3] of Kirman.

Both names—Sayyid 'Ali Khan and Hasan Khan—appear to refer to the same individual, the first Aqa Khan of the Isma'ilis.[4]

Descended, according to family history, from 'Ali and Fatima and from the Isma'ili Fatimid dynasty of Egypt, Hasan 'Ali Shah was born in 1800. When his father was assassinated in 1817 in Yazd, Hasan 'Ali was supported by the Qajar monarch of Iran, Fath 'Ali Shah, who gave him one of his forty-six daughters in marriage and granted him the title of Aqa Khan. Later installed as governor of the southeastern Iranian city of Kirman, he was initially treated with similar favor by Fath 'Ali Shah's successor, Muhammad Shah. Four years later in 1838, however, Hasan 'Ali felt himself dangerously threatened by intrigues at the royal court and rose in revolt. The insurrection was unsuccessful, and the Aqa Khan fled to India.

Added to an earlier fine blade dating from the first years of the Qajar dynasty, this knife's handle was, therefore, made on the order of some of the Aqa Khan's political or religious followers. Since its two portraits link the governor of Kirman and the Qajar monarch, it must have been done between the years 1834 and 1838, when such a visual juxtaposition would no longer have been appropriate. Presumably it was commissioned as a gift to the Aqa Khan whose fortunes were at that time closely tied to those of the Qajar royal house.

Carved in relief by an unknown master of high ability, the *ta'liq* inscriptions do not simply provide aesthetic balance to the portraits, also in relief and equally gentle in their curves and distinctive for their portrayal of real individuals rather than ideals; they also give information about one of the most interesting episodes of nineteenth century Iranian history. Where earlier opulent objects usually conveyed verbal and visual images of pleasure or beauty or recited honorifics or rote blessings on the owner, the imagery and inscriptions on this dagger bespeak particular political interests and personalities.

NOTES

1. At least one other dagger blade signed by this master is known. It is dated 1214 H. (1799–1800 A.D.) and is now in the Historisches Museum, Bern, No. 1374. See Rudolf Zeller and Ernest F. Rohrer, *Orientalische Sammlung Henri Moser-Charlottenfels: Beschreibender Katalog der Waffensammlung*, No. 177 and pl. XLIV; and Leo A. Mayer, *Islamic Armourers and Their Works*, p. 60. Mayer identifies Muhammad Hadi with Muhammad Nami, who is known for three other daggers.

2. Fath 'Ali Shah, who stabilized the regime established by his uncle Aqa Muhammad Shah, ruled from 1797–1834.

3. A word of Turkish origin meaning literally "prince of princes," and actually signifying "governor."

4. The name is more usually anglicized as Aga Khan. Since the early nineteenth century the Aga Khans have provided the spiritual leadership for the wide-spread Isma'ili Muslim community.

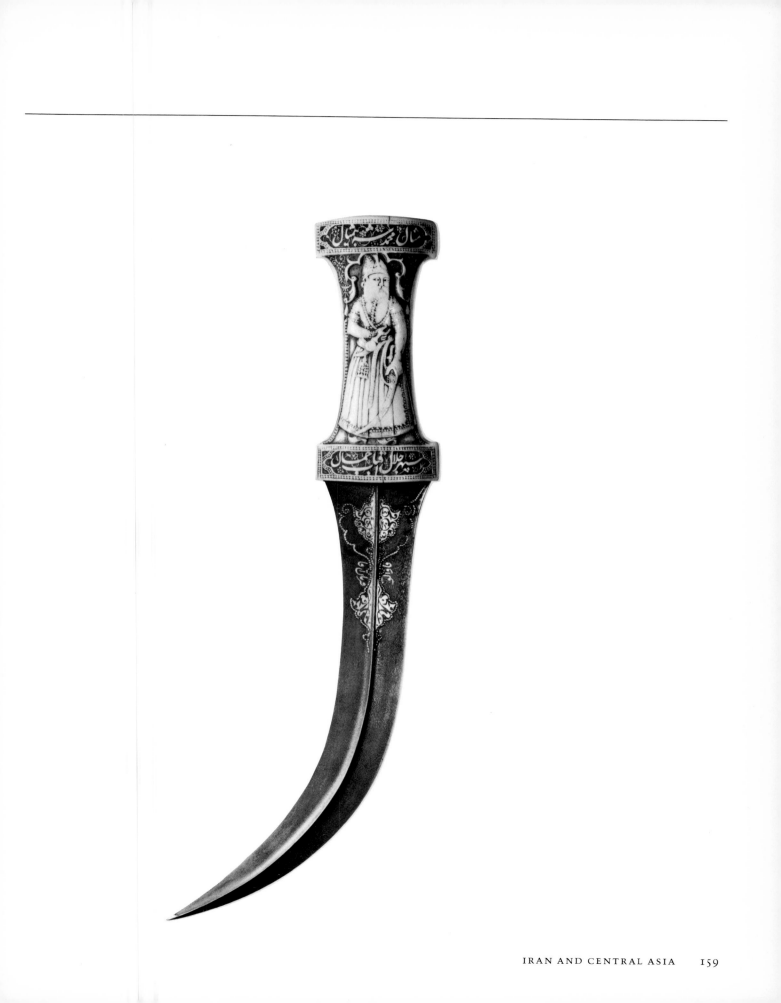

67. Calligraphy by Fath ʿAli Shah Qajar

Iran; 1797–1834 A.D.
H. 25.4 cm., W. 19 cm.
Collection of Prince Sadruddin Aga Khan

Like many of his predecessors on the Iranian throne, Fath ʿAli Shah had received training in calligraphy, presumably before his succession to the kingship in 1797. Apparently written after he became king at the age of twenty-six, the script here is a steady *nastaʿliq*. A traditional test of ability and steadiness of hand was the repetition in close succession of individual letters, words, or lines; particular elements could thus be compared in terms of consistency and identical treatment. Here the shah submits to this examination of skill by repeating four times a single line, of which he may have been the author:

My reed pen shames Jupiter and Mercury.

Below the first line is written once in a more fluid *nastaʿliq*:

Fath ʿAli Shah Qajar drew this.

While he did provide the text and the calligraphy, it is not likely that the shah supplied the fine illumination that surrounds and sets off his script. An artist in the royal employ must have provided the light-reflecting, pin-pricked gold surface and slender arabesques with blue and red flowers.

Thus while the shah's reign was noted more for its public pomp and private avarice than for its leadership or high distinction, the king obviously considered himself a scribe of note: Jupiter (Birjis) was the lord of the planets, and Mercury (Tir) was the scribe of the heavens.

PREVIOUSLY PUBLISHED IN

Anthony Welch, *Collection of Islamic Art: Prince Sadruddin Aga Khan*, III and IV, Calligraphy No. 12.

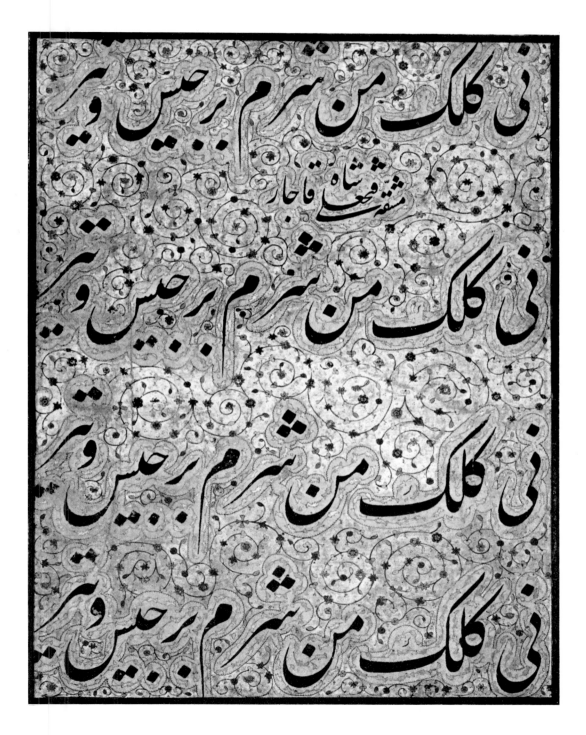

68. Quatrain written for Fath ʿAli Shah

Iran, Tehran; ca. 1820–1834 A.D.
H. 28.7 cm., W. 16.3 cm.
Fogg Art Museum; Gift of John Goelet

As is evident in No. 67, the second Qajar monarch, Fath ʿAli Shah (reign, 1797–1834) possessed a trained taste for calligraphy and was himself a calligrapher of ability. For centuries it had been a recognized test of ability for a scribe to measure his skill against the models of the past by attempting to reproduce with unfailing accuracy the script of an earlier, celebrated master. It must have been for this reason that Fath ʿAli Shah ordered ʿAbbas Nuri, one of his court calligraphers, to copy the *taʿliq* script of the greatest Safavi master of that style, Mir ʿImad.[1] The master's hand is reproduced in the four lines of large diagonal *taʿliq*; the letters, elongated in strokes of varying widths and lengths, center the page on words of visual grace and elegant rhythm. What is fine to the eye, however, need not be fine to the ear, and the poem itself is an undistinguished quatrain by an unknown and unidentified author:

*O, the ruby of thy lips is famous for
 caressing hearts;[2]
Thy black eyes are famous for Turkish
 raiding.[3]
There is a difficult tale for us in thy
 lovelock,[4]
Which, like the night of Yalda, is famous
 for its length.[5]*

The rest of the page provides purely documentary information, written in much less fine *taʿliq*. In the upper right is a pious acknowledgement of Allah written in black ink:

He is the Beloved!

It is immediately followed by the king's name in gold ink:

The Sultan Fath ʿAli Shah

In the lower left corner the scribe has given his reasons for copying his predecessor's hand:

By the imperial, divine, viceregal command of the Most Highly Honored (Our soul be his sacrifice!), copied by this slave of the court, ʿAbbas Nuri, from the masterly hand of Mir ʿImad, Allah's mercy be on him.

In the triangle at the right the date was originally supplied but has since been obliterated, while at the left is mentioned the place where this page was written: "at the Dar al-Khilafa, Tehran."

NOTES

1. For Mir ʿImad see No. 56.
2. That is, the beauty of your lips has stirred many hearts.
3. In racial metaphors in Persian poetry the black eyes and arrow-like eyelashes of Hindus were capable of "killing" victorious Turks. (See Annemarie Schimmel, "Turk and Hindu," in *Proceedings of the Levi della Vida Conference*, 4.)
4. The lovelock (*zulf*) not only signifies a curling lock of hair that attracts the lover, but also refers more obliquely to the calligraphy itself, for several letters (*wa, dal, lam, jim,* and *ʿayn*) of the Arabic alphabet were often compared to a loved one's curling lock.
5. That is, the winter solstice, the longest and darkest night of the year.

162

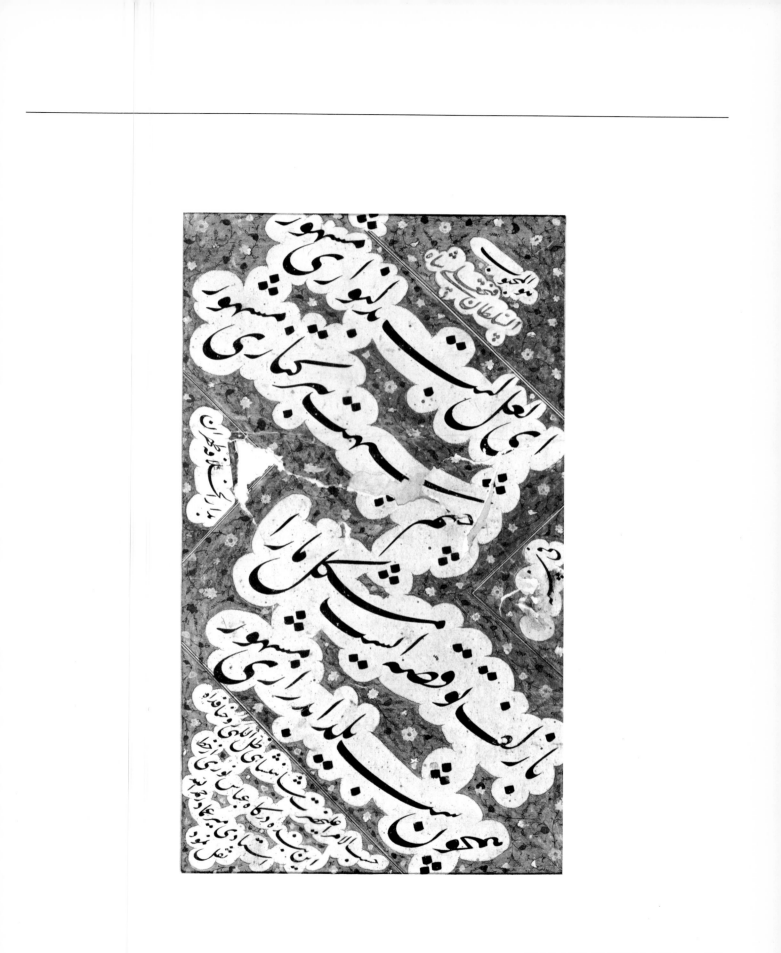

69. Bismillah in the form of a parrot

Iran; 1250 H. (1834–1835 A.D.)
H. 16.5 cm., W. 24.8 cm.
Cincinnati Art Museum; Fanny Bryce Lehmer Fund

The words *Bismillah al-rahman al-rahim* (In the name of Allah, the Beneficent, the Merciful) begin the entire *Qur'an* and each separate *surah* of the holy book, and since the time of the writing down of the *Qur'an* these words have been used to commence all Muslim books. Thus it is likely that this page with this bird, whose form is drawn from the *bismillah*, was placed at the beginning of an album of calligraphies (and perhaps paintings as well) assembled in nineteenth century Qajar Iran.

The inscription starts directly over the large dot and date in the lower middle of the page, and "Allah" appears on the parrot's neck directly behind the head. This position is a pointed reference to the function of the parrot (*tuti*) in Persian mystical poetry where the bird that repeats without understanding what it is told was considered a symbol of human beings, reiterating the words of their master, Allah, but with imperfect comprehension. Yet it is through this very repetition, particularly in prayer, that a being is able to rise above the limitations placed on it by earthly form.

Mystical thought in Islam frequently transgressed the borders of orthodoxy and so too these words, properly written as calligraphy, most improperly come together to form the image of a living being, though one whose existence is interpreted by mystics as symbolizing the relationship between the divine and the human.[1]

While other animals are also represented calligraphically,[2] the parrot and the lion (symbol of 'Ali) were most frequently done. The choice of colors here—black ink on a brown paper—is a favorite Qajar combination for calligraphies. Above the parrot's tail are two additional words, written in an ornate, archaistic *Kufic* popular in Qajar times.[3] They are most likely to be read either as "Muhammad said" (*Qala Muhammad*) or "Property of Muhammad" (*Mal-i Muhammad*).

NOTES

1. The Safavi chronicler Qadi Ahmad attributes the invention of calligraphic animals to Maulana Mahmud Chapnivis who "was a calligrapher in Herat and wrote in *nasta'liq* neatly and with good taste. He invented a style of writing in which combinations of letters formed images of men and beasts" (Qadi Ahmad, *Calligraphers and Painters*, pp. 132–133).
2. See Nos. 71 and 77. For two other calligraphic parrots see Ernest Kühnel, *Islamische Miniaturmalerei*, p. 13, and Annemarie Schimmel, *Islamic Calligraphy*, pl. 47b.
3. See *The Arts of Islam*, No. 639.

70. Firman of Shah Muhammad Nasr al-Din Qajar

Iran, Tehran; September 1848
H. 56.4 cm., W. 41.0 cm.
Private collection

A royal epistle (*firman*) must have been an exacting task for a calligrapher employed at a court: a badly written text would bring shame on the ruler as well as dismissal for the scribe. The beauty of the written message could be as important as its contents. Thus gold and color (chiefly red and blue) illumination accompany the three different scripts that appear on this page.

At the top, enclosed in a gold, blue, and red medallion is the seal of the monarch, who had only recently ascended the throne: Muhammad Nasr al-Din Shah, the fourth Qajar ruler of Iran, who reigned from 1264 to 1313 H. (1848–1896 A.D.). It is written in a thin *ta'liq* script. At the beginning of the first line of text appear the words "God is the Great King" in gold *tughra* script. The text itself is written in an elegant *nasta'liq*:

Muhammad Nasr al-Din Shah announces the following: Since the excellent services of the Greek merchant, the Christian Rovas Safarandi, finest of merchants [followed by other eulogies], have become known to the great ethereal ruler whose nest is in Paradise, and for this reason through the bestowing upon him of a decoration of the second class, he has found preferment among his fellows, now also he has pleased the royal personage by his most meritorious services, and he has become worthy of diverse favors and boundless kindness (from his Majesty). Therefore this year we have honored him by granting the decoration of the Lion and the Sun (First Class) that he may, taking the emblem as a symbol of his pride and worthiness, always strive even more in the service of the rulers of this country and always be deserving of royal kindnesses and attention; it is ordained that the decoration be registered in the scroll of decorations in the month of the Arabic lunar year, Shawwal, Hijri 1264.

In the lower right is a notation, in *shikastah* script on a white ground surrounded by gold, that this document is for royal attention.

71. Calligraphic cock

Iran; 1305 H. (1887–1888 A.D.)
H. 48.3 cm., W. 36 cm.
Fogg Art Museum; Gift of John Goelet

Originating in nineteenth century Iran, the Baha'i faith, like Islam, used calligraphy as a major vehicle for the visual expression of religious conviction. The concept of combining epigraph and image in a figural calligraphy was widespread in Turkey, Iran, and India, and this Baha'i cock has impressive Muslim antecedents.[1] Like them too, its form has important symbolic content, for it stands here proudly announcing the dawn of a new faith. The outline of the bird's body is the same width as the broad cursive letters—nine of them turning and deftly passing through adjacent forms—that fill its feathery interior and compose the name Baha'ullah.

The cock holds up two bound pages in his left claw. They are inscribed with a long, supportive prayer in Arabic by Baha'ullah, the founder of the Baha'i faith. Addressed to a suffering adherent named Zia, these fifteen lines are written in a flowing, clear *shikastah*, the "broken" script derived from *ta'liq* and most widely used in eighteenth and nineteenth century Iran.[2]

He is the Eternal! Allah bears witness that I have believed in the One at the mention of Whose name those brought near drink the wine of life; and those who are sincere have drunk that which all in heaven and earth are powerless to comprehend, unless your Lord, the All-knowing and All-wise, has wished them to do so. O, Zia, be patient in adversity, content in worldly matters, and firm in your conviction of the truth. Be quick to strive for the good, be humble toward Allah, and be one who overlooks the shortcomings of other men. Be one who turns from foolish passions and hastens to the truth. Be one who is compassionate in the presence of errors and forgiving in the presence of sin. Be one who upholds Allah's covenant and is firm in Allah's cause. This wronged one coun-sels you to these things and to the fear of Allah. He counsels you to fidelity and truthfulness: both are incumbent on you; truly, both are incumbent on you. Blessed are you and blessed is the one who loves you for the sake of Allah. Woe to the one who annoys you and turns from what Allah has commanded.

In the lower left is a large cartouche, inscribed in a broad *nasta'liq*: "The servant of Bab-i Baha, Mishkin Qalam (in the) year 1305." In that year (1887–1888), Baha'ullah (Bab-i Baha) was living in Bahji, not far from Acre in Ottoman-controlled Palestine, and Mishkin Qalam, the most famous of Baha'i calligraphers, may have been in his service there.

NOTES
1. See nos. 69 and 77.
2. See no. 65.

PREVIOUSLY PUBLISHED IN
Annemarie Schimmel, *Islamic Calligraphy*, pl. XLVI.
The Arts of Islam, Catalogue of an Exhibition at the Hayward Gallery, No. 641.

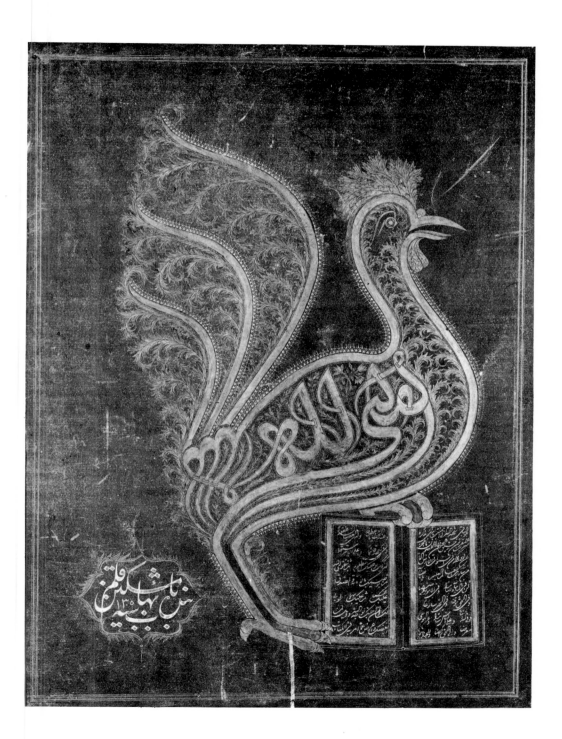

72. Page from the Diwan of Sultan Husayn Bayqara

Afghanistan, Herat; late fifteenth or early sixteenth century
H. 15.9 cm., W. 10.3 cm.
Private collection

Born in Herat in 842 H. (1438 A.D.), Sultan Husayn Mirza ibn Mansur ibn Bayqara was the great-great-grandson of Timur. After several years of struggle with other Timurid princes, he took control of Khurasan in 1467 and ruled a relatively stable and prosperous kingdom until his death in 1506. One of the most impressive figures in the rich tradition of Timurid patronage of scholarship and the arts,[1] he presided over a thirty-nine-year period of high cultural attainment and brought together in Herat an assemblage of talent only rarely equalled in Islamic history.

His closest friend, Mir ʿAli Shir Nawaʾi, was also a sensitive and energetic patron, as well as a poet of great distinction who did much to establish Turkish as a major literary language. The last great classical master of Persian poetry, Jami, enjoyed the sultan's patronage, as did other poets, like Asafi, Banaʾi, and Hilali. Historians, chief among them Mirkhwand, were employed at his court, as were also philosophers, theologians, and masters of jurisprudence. Musicians, both composers and instrumentalists, received his support and encouragement; so too did painters, like Shah Muzaffar and Bihzad,[2] and calligraphers, like the great master of nastaʿliq, Sultan ʿAli.[3]

The sultan's relative, Babur, later to found the Mughal dynasty in India, greatly admired him and described him at length in his *Memoirs*:

He was slant-eyed and lion-bodied, being slender from the waist downwards. Even when old and white-bearded, he wore silken garments of fine red and green.... He could not perform the Prayers on account of a trouble in the joints, and he kept no fasts. He was lively and pleasant, rather immoderate in temper, and with words that matched his temper.... He was abstinent for six or seven years after he took the throne;
later on he degraded himself to drink.... There may not have been one single day on which he did not drink after the midday prayer.... What happened with his sons, the soldiers and the town was that everyone pursued vice and pleasure to excess. Bold and daring he was! Time and again he got to work with his own sword, getting his own hand in wherever he arrayed to fight; no man of Timur Bek's line has been known to match him in the slashing of swords. He had a leaning to poetry and even put a diwan *together, writing in Turki with Husayni for his pen-name. Many couplets in his* diwan *are not bad; it is, however, in one and the same meter throughout.*[4]

This dark blue page, its margins sprinkled with gold, comes from a now dispersed manuscript of this Turkish *diwan*, critically evaluated by Babur but highly praised by Mir ʿAli Shir Nawaʾi.[5] The top two lines conclude one *ghazal* (or "ode"):

Do not say "If a youth is tyrannical to me, let me show it!"
For [if you do] so, O Husayni, the youth will not appear again.

A superbly painted illuminated heading introduces six lines of another *ghazal*:

When the sparks of my fiery sigh are scattered over his face,
It is as if a golden casket were made for his rose-face.
Who has ever seen the golden rays of the sun when the moon is out?
In the monastery [of the world], whose face can be made [to look] like this?
If the rays of a hundred suns were brought together, they would [still] not be
Like my moon-faced one when he pulls his hair back, making [his face] golden-rayed.

These eight lines of refined light blue, yellow, and white *nastaʿliq* on dark blue paper were not written with a pen. Instead, the letters were cut out from colored papers in a kind of calligraphic découpage known as *qitʿa*. The master (*qatiʿ*) responsible for the work is not identified, either here or on other surviving pages from the *diwan*,[6] but it would seem to be a reasonable conjecture that the great Khurasani master of *nastaʿliq*, Sultan ʿAli, the only one of Sultan Husayn's calligraphers whom Babur honors with mention and praise, was the creator of these lines.

NOTES

1. For an earlier Timurid patron see No. 49.
2. These individuals and many others are discussed by the Mughal Emperor Babur in his memoirs (see A. S. Beveridge, trans., *The Babur-nama in English*, pp. 283–293). According to Babur, both Shah Muzaffar and Bihzad enjoyed the special attention of Mir ʿAli Shir Nawaʾi, and it "was through his effort and supervision that [they] became so distinguished in painting" (ibid., p. 272).
3. For Sultan ʿAli and an example of his work see No. 52.
4. Beveridge, trans., *Babur-nama*, pp. 258–259.
5. Sultan Husayn also composed a brief treatise outlining his theory of the proper practice of kingship. See *Encyclopaedia of Islam*, 2nd ed., vol. III, p. 603 (article "Sultan Husayn" by T. Gandjei).
6. For another published page see Anthony Welch, *Collection of Islamic Art: Prince Sadruddin Aga Khan*, I and II, Calligraphy 5.

73. Page of poetry for Husayn Khan Shamlu

Afghanistan, Herat; ca. 1599–1607 A.D.
H. 19.2 cm., W. 11.5 cm.
Private collection

The fortunes of the city of Herat, the splendid center of late Timurid culture,[1] were unsteady through much of the sixteenth century, and devastating Uzbek incursions left the surrounding province of Khurasan in disarray. In 1007 H. (1598–1599 A.D.), however, Iranian forces under Shah ʿAbbas I (reign, 1587–1629 A.D.) brought the city under Safavi control and gave it a measure of stability, even though it never regained its former cultural preeminence. Initially, the shah bestowed Herat on his general Farhad Khan Qaramanlu. In the same year, however, he changed his mind and executed him.[2] The prominent aristocrat, Husayn Khan Shamlu, was subsequently appointed to this post and held it for a number of years, for in his *Memoirs* for the year 1607 the Mughal emperor Jahangir disapprovingly notes that Husayn Khan aided the Iranian forces which unsuccessfully tried to wrest Qandahar from the Mughals.[3]

Except for intermittent quarrels over Qandahar, the Mughals and Safavis enjoyed a political entente that served both dynasties well. Commercial and social links between the two empires were extensive, and their cultural ties were close and fruitful. In this regard Herat benefitted from its location near the eastern borders of Iran, for it was a meeting ground of the two civilizations.

Many Indian poets, writing in Persian in the style known as the *sabk-i Hindi* (Indian mode) were widely appreciated in Iran and exercised significant influence upon the development of later Persian poetry. This album page, written by an unidentified but very able master in *nastaʿliq* for the Iranian governor of Herat, typifies the taste of an educated, literate Safavi aristocrat. It presents a mixture of poetry (much of it *sabk-i Hindi*) from the works of eight different poets, some Iranian and some Indian and ranging in date from the thirteenth through the sixteenth centuries. The

selections may represent some of Husayn Khan Shamlu's favorite verses.

The album page is skillfully divided into horizontal and diagonal segments, separated by geometric and floral illumination on gold and dark blue backgrounds, so that the works of the individual poets are distinctly marked off from one another. All are identified by name in light gold script. Seven selections are penned in a small, fine *nastaʿliq*; four lines, however, are written horizontally in a broader, larger, bolder *nastaʿliq*: the more prominent script is designed to indicate the particular importance of the poet, Amir Khusrau Dehlevi, the acknowledged progenitor of the *sabk-i Hindi*. A single panel near the center of the page bears a line of gold *nastaʿliq* saying that this page was produced in the library of Husayn Khan Shamlu.[4]

Five horizontal lines in the upper right and left bear the name of Fayzi (1547–1592 A.D.), the poet laureate at the court of the Mughal emperor Akbar and the brother of the monarch's boon companion and biographer, Abuʾl-Fazl:

I am slain by that beautiful, tyrannical
 Turk, whose heartless heart
Won't kill its prey so long as it does not
 give up the ghost.[5]
Thou hast shed my blood, then lifted me
 from the earth.
The prey which is bound to the saddle of
 its slayer is yet alive.
Fayzi's secrets have not been pierced by
 her sharp glance.
I want a sad wise man to solve this
 quandary.

You must not show your mole to him
 who is slain by that drunken eye.[6]
No one throws grain before a dead
 chicken.
Why must the candle have dust on its
 heart,

When love has thrown the ashes of the
 moth to the winds of annihilation?[7]

In the upper center are four diagonal lines ascribed to ʿAbd al-Razzaq (1413–1482 A.D.), a Persian historian who served in various capacities under several Timurid rulers. From 1441 to 1444 he also headed an embassy to India:

On my heart's way thy love has set a
 hundred snares.
My hopes are raw as burnt crops.[8]
The one whose intimate thou art has
 naught to fear,
And the one whose friend thou art finds
 fate his foe.[9]

Four bold *nastaʿliq* lines written horizontally in the right and left upper and lower center are by Amir Khusrau Dehlevi (1253–1324 A.D.), the great Indian mystic and poet who enjoyed the patronage of Khalji and Tughluq rulers in sultanate India:

The heart-seared are denied thy lips, but
 the cup enjoys them.
Those whose hearts thou hast wounded
 require at last some balm.
How often have the knives of thy co-
 quettish eyes fallen on Khusrau!
Thy knife-wielders must bare the shame
 of his blood.

At the center right are four diagonal lines of poetry accompanied by the name of Ahli Shirazi, a considerable figure in late Timurid and early Safavi literature in Iran, who died in Shiraz in 942 H. (1535–1536 A.D.). Some of his poems were dedicated to Turcoman rulers in western Iran, others to Sultan Husayn Bayqara in Herat and Shah Ismaʿil I in Tabriz:

O, excellent loveliness that is beloved
 in thee!

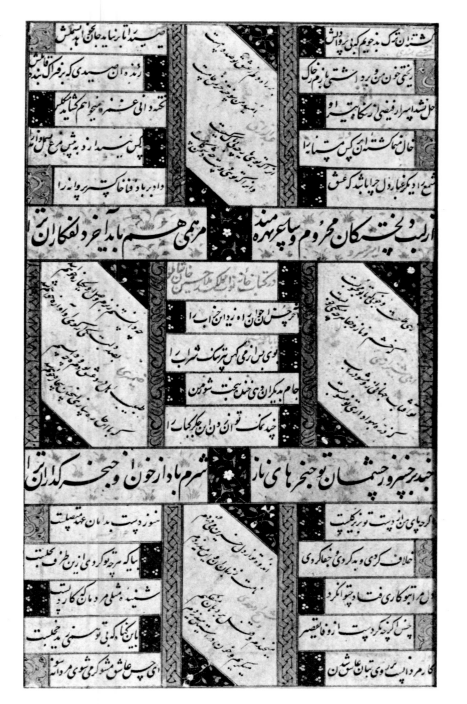

Of anger, flirting, or cruelty, whatsoever thou doest is good.
Thou art the sun of the world, be not troubled by him. [10]
For he appears as but a mote adoring thee.

In the center of the page, directly below the gold inscription naming Husayn Khan Shamlu, are four horizontal lines, identified as being by Baba Nasibi, apparently the Kashmiri Muslim saint who died in 1047 H. (1637–1638 A.D.). The author of the *Rishinama*, he was one of two living authors included on this page:

At the last of [youthful] beauty that youth attacked this ruin.
The smell of old wine is enough for one with a weak head.
My cheerful misfortune would hand the cup to others.
How much salt can be poured on this broiled heart!

A diagonal panel at the left center holds four lines by Zamiri, a poet at the court of Shah 'Abbas in Isfahan: [11]

What did I know? From quarrel of union with her I shall fly.
Wretched with a hundred thoughts, from her street I shall fly.
I was a physician to those who knew the pains of love. What did I know how
In finding remedies, beyond all remedies I should fly.

The five horizontal lines in the lower right and left are by Khwajah Hasan Dehlevi (1275–1336 A.D.), a poet and author of religious works. Closely associated with Amir Khusrau Dehlevi, he also enjoyed the patronage of the Khalji and Tughluq sultans of Delhi:

(continued on next page)

*Although thou hast put my foot into the
 grave,
My hand still clings to Time's skirt.
Thou hast been cruel, wicked, and
 contrary,
Yet come, for whate'er thou hast done,
 on my side it is forgiven.
My heart has fallen on thee. What's to be
 done?
Men know the saying of what work the
 heart brings.
Although Hasan has not failed of loyalty,
He is shamed that he can live on without
 thee.
Men are meant to fall in love with idols,
O, Hasan, fall not in love or if thou dost,
 be a man.*

Finally, in the lower center are four diagonal lines by Shaykh Awhadi Maragha'i (1281–1338 A.D.), who was a popular (though now not much esteemed) poet in Il-Khanid Iran:

*I steal thy grief from a sad heart.
I steal thy name from the lips of this and
 that one.
I laugh, but set a lock upon my tongue.
I weep and stealthily stain my sleeve
 with blood.*

5. The Turk was often used as a symbol of beauty and cruelty in Persian poetry.
6. That is, you must not show your beauty to one who falls too easily in love.
7. The moth, fatally drawn to the candle's fire, symbolizes the destructiveness of love's passion.
8. That is, my hopes are as fruitless as unharvestable crops.
9. That is, the lover is alternately wretched and delirious with joy.
10. "By him" means by the sun.
11. Iskandar Munshi, writing in 1616, gives brief mention to this poet in his *Tarikh-i 'Alamara-yi 'Abbasi* (History of Shah 'Abbas and his Predecessors), as does Sadiqi Bek around 1600 in his *Majma' al-Khawass* (An Assembly of Worthies).

NOTES

1. For late Timurid Herat see No. 72.
2. K. M. Röhrborn, *Provinzen und Zentralgewalt Persiens im 16. und 17. Jahrhundert*, p. 34. For Farhad Khan Qaramanlu's activities as a patron see No. 56.
3. See Alexander Rogers and Henry Beveridge, trans., *The Tuzuk-i Jahangiri* (Memoirs of Jahangir), 1, p. 86. For Jahangir himself see No. 79.
4. This Safavi aristocrat came from a distinguished line of Shi'a Shamlu tribesmen who were early supporters of the Safavi house. Husayn Khan himself played a prominent part in Iranian political life in the second half of the sixteenth century and was a patron of note. For some aspects of his patronage of painting see Anthony Welch, *Artists for the Shah*, p. 173 and note 38.

74. Manuscript of the Tuhfat al-Ahrar of Jami

Central Asia, Bukhara; 971 H. (1563–1564 A.D.)
H. 28 cm., W. 18 cm.
Collection of Prince Sadruddin Aga Khan

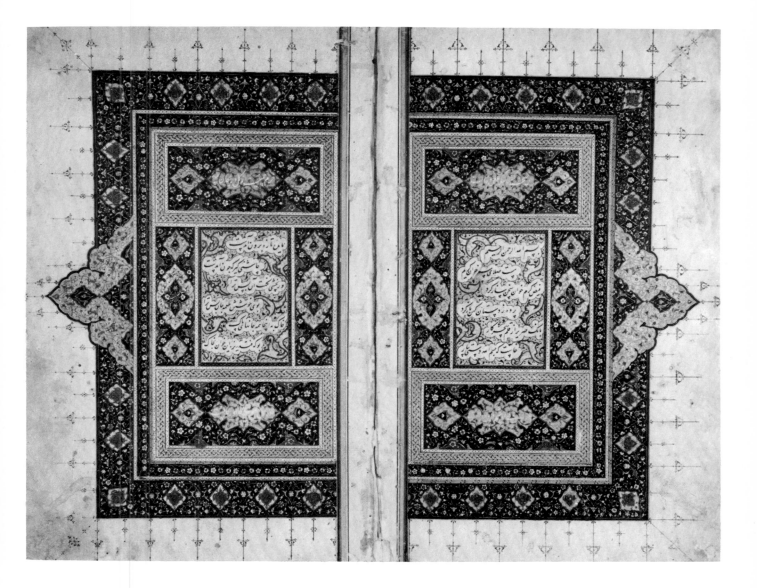

The last great classical master of Persian poetry, the poet and mystic Jami flourished in the late fifteenth century under the patronage of Sultan Husayn Bayqara in Herat (see No. 72). Among his many works is the *Tuhfat al-Ahrar* (A Gift to the Free), a didactic poem in *mathnawi* verse, which expounded various theological and ethical positions. It was particularly popular with the Shaybani Uzbek rulers of Samarqand and Bukhara in the sixteenth century. This particular copy consists of sixty-nine pages, variously colored brown, blue, green, and yellow and delicately illuminated with gold arabesques. In one of the manuscript's two miniatures the patron is named: Abu'l-Ghazi 'Abdullah, the most notable of the

(continued on next page)

Shaybani rulers, who from Bukhara ruled a vast central Asian empire between 1557–1598. An orthodox Sunni and a man of high culture, he was a poet and an admirer of fine painting and calligraphy. This manuscript is the only known one citing him as patron.

Folios 1b–2a, illustrated here, present the first six couplets of Jami's poem. Though technically as fine as Safavi or Ottoman work, Shaybani illumination tends to be less subtle: colors are bolder and less modulated, and individual abstract elements stand out more strongly. The triangular *ansas* project sharply into the margins; an outer border of dark blue is punctuated on each side by fourteen lozenges, gold with vivid rust-red centers, and encloses an inner composition of five rectangles. Of these rectangles two are horizontal and contain cartouches with the book's title and author written in thin, white *ta'liq* script on a gold ground, while two narrow vertical bands (richly colored in gold, blue, and red) frame the core, which contains the text.

The text's black *nasta'liq* script is compact, delicate, and airy, floating lightly and easily between claw-like gold arabesques. It is an eminently clear, fluid calligraphy, displaying the confidence of a practiced master, identified in the manuscript's colophon as Mahmud ibn Ishaq al-Shahabi, a celebrated practitioner of *nasta'liq* who spent his entire creative life working for various Uzbek patrons. His art, however, was appreciated beyond the borders of central Asia, for specimens of his writing were collected and prized by the Shaybanis' bitter political and religious rivals, the Safavis of Iran. Well trained under the great Mir 'Ali in Bukhara in the early sixteenth century, Mahmud ibn Ishaq lived in

Balkh for some years before returning to Bukhara to work for Abu'l-Ghazi 'Abdullah. He is said to have been a competent lutanist and an entertaining conversationalist whose written work was already rare in the early seventeenth century. He died in 991 H. (1583 A.D.) when he was advanced in years.

PREVIOUSLY PUBLISHED IN

Anthony Welch, *Collection of Islamic Art: Prince Sadruddin Aga Khan*, III and IV, Ms. No. 17.

India and China

75. Manuscript of the Qur'an

India, Gwalior Fort; 801 H. (1399 A.D.)
H. 24 cm., W. 17 cm.
Collection of Prince Sadruddin Aga Khan

This copy of Islam's holy book consists of 550 folios, written for a Muslim apparently not completely at ease with its Arabic text, for there is an interlinear Persian translation, penned in a smaller hand. Thirty-four double pages are splendidly illuminated with rich, lush, and extremely colorful floral and vegetal patterns in gold, black, red, brown, yellow, blue, and white, far more exuberant than the illumination current in contemporary *Qur'ans* in the more westerly Islamic lands.[1] Other manuscripts sharing the same style of script and illumination are known,[2] but this *Qur'an* is both the earliest and the most impressive of its type. As such, it is, not only one of the most beautiful, but also one of the most critically important documents for our understanding of the arts of Sultanate India.

The Arabic text is written in the *khatt-i Bihari*, or *Bihari* script, a slow-moving and stately script, accentuating both horizontal and vertical elements while markedly restraining linear curves.[3] The Persian translation, in a cursive script that hugs the horizontal and eschews virtuosity in favor of straightforward legibility, is almost certainly the work of the same master, who may perhaps also have executed the bold *Kufic surah* headings. According to his own Persian colophon, the scribe, Mahmud Sha'ban, was an inhabitant of the fort of Gwalior when he completed the book on the seventh day of the month of Dhu'l-Qa'da in the year 801 H. (21 July 1399 A.D.).

Nothing more is known about the calligrapher, but he lived in turbulent times and may well have written this copy of the *Qur'an* under difficult conditions. When the most successful of the Tughluq dynasty's monarchs, Firuz Shah, died in 1388, violent wars of succession for the next decade undid the social stability and economic prosperity he had so carefully nurtured. After the demise of several short-lived monarchs, two claimants to the Tughluq throne each seized partial power in 797 H. (1394–1395 A.D.), and from different quarters of the capital city of Delhi King Mahmud and King Nusrat watched each other's actions warily. In its weakened condition the formerly powerful Tughluq sultanate of northern India was easy prey, and in 801 H. (1398–1399 A.D.) the central Asian conqueror, Timur, fresh from his successful campaign in Iran, raided deep into India, driving both Tughluq rivals from their capital and thoroughly sacking the city. In the spring of 1399 Timur withdrew and returned to Samarqand with enormous treasures and with some of the sultanate's most valued artisans.

The fort of Gwalior, a major stronghold south of Agra, was not attacked by Timur; but, shortly after his departure from India, Tonwar Rajputs, encouraged by the virtual obliteration of Tughluq power, seized the citadel and returned the area briefly to Hindu suzerainty. It seems most likely that Mahmud Sha'ban fled from Delhi as Timur's army approached in 1398 and with his unfinished *Qur'an* (perhaps begun for one of the two feuding Tughluq kings) took refuge in the mighty fortress at Gwalior, where he must have felt secure enough to bring his work to completion in the middle of the summer of 1399 A.D.[4]

See color illustration on page 14

NOTES

1. Six of these illuminated double pages had to be substantially repaired at a later date, probably in the eighteenth century, because of the corrosive effects of their green pigment. A number of pages bear verse markers that may be of the fifteenth or sixteenth century.
2. See *The Arts of Islam*, No. 635.
3. It has been suggested in the above cited work that this script may be derived from "the extremely angular cursive *naskhi* script current in the eleventh century empire of the Ghaznavids in Afghanistan and the Punjab."
4. The manuscript's history is unknown for the next two centuries. On the last page of the manuscript as it is now bound is an owner's note, dated 945 H. (1538–1539 A.D.).

PREVIOUSLY PUBLISHED IN

The Arts of Islam, Catalogue of an Exhibition at the Hayward Gallery, No. 635.
Exhibition of Islamic Art, Spinks, No. 6.

76. Portrait of the calligrapher Husayn Zarin Qalam and the painter Manohar

By Manohar
India; 990 H. (1581 A.D.)
H. 21 cm., W. 32.3 cm.
Royal Asiatic Society

Portraits of calligraphers or painters at work are rare in Islamic art, but they provide documentation of the most direct sort about the ways in which these artists worked. Seated on a carpet and resting against a large cushion, the older calligrapher in this portrait holds his reed pen poised over four lines of *nasta'liq*: "Allah is Great! Portrait of Husayn Zarin Qalam." His kind but attentive gaze is directed toward the work of a student. This student is almost certainly to be identified as the youthful Manohar, a painter who was to become a great Mughal master, for the page is inscribed with the words "The work of Manohar, son of Basawan." Between teacher and pupil is a large, inlaid *qalamdan* (penbox) from which their two reeds have been taken: it must still contain the knives, scissors, sharpening stones, and dried ink necessary for their work. A manuscript rests near the student's knee, while closer to Husayn Zarin Qalam is the portfolio that contained the paper they are using.

Muhammad Husayn al-Kashmiri, known as Husayn Zarin Qalam, was one of the most celebrated calligraphers at the court of the Mughal emperor Akbar (1556–1605), and he is discussed at some length in the *A'in-i Akbari*, the compendium of information about Akbar's reign and administration compiled by the monarch's boon companion, Abu'l-Fazl:

His Majesty shows much regard to the art [of calligraphy], and takes a great interest in the different systems of writing; hence the large number of skillful calligraphists. Nasta'liq has especially received a new impetus. The artist who, in the shadow of the throne of his Majesty, has become a master of calligraphy, is Muhammad Husayn of Kashmir. He has been honored with the title of Zarin Qalam, the gold pen. He surpassed his master, Mawlana 'Abd al-'Aziz; his

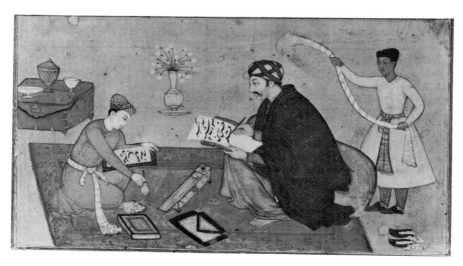

See color illustration on page 12

maddat and dawa'ir[1] show everywhere a proper proportion to each other, and art critics consider him equal to Mulla Mir 'Ali.[2]

In this portrait the great master would appear to be around forty years old. He died at about the age of seventy in 1020 H. (1611–1612 A.D.).

His companion and pupil here, Manohar, was the son of Basawan, a towering figure in early Mughal painting, and flourished between about 1580 and 1620 under both Akbar and Jahangir. He was particularly noted for his manuscript illustrations and for his portraits, of which this is one of his earliest, painted when he must have been about fifteen years old.

The painting is appended to a manuscript of the *Gulistan* of Sa'di, copied by Husayn Zarin Qalam at Fatehpur Sikri, Akbar's capital city near Agra, in 1581. Like their Safavi contemporaries, Mughal artists seem to have been far

more conscious of their own individuality and significance than had been earlier masters, and presumably this increased sense of self-awareness (which their patrons apparently appreciated) led to this portrait of painter and scribe being added to the manuscript.

NOTES

1. The term *maddat* refers to horizontally extended letters, while *dawa'ir* denotes those letters which markedly curve.
2. Mir 'Ali was the legendary inventor of *nasta'liq* script and flourished in late fourteenth and early fifteenth century Iran. For centuries thereafter his name was a metaphor for calligraphic perfection, particularly in *nasta'liq*. The passage here is quoted from Abu'l-Fazl, *A'in-i Akbari*, p. 109.

PREVIOUSLY PUBLISHED IN

Leigh Ashton, ed., *The Art of India and Pakistan*, No. 642, pl. 121.
Ralph Pinder-Wilson, *Paintings from the Muslim Courts of India*, No. 16.

77. Rider on an epigraphic horse

India, perhaps Bijapur; late sixteenth century
H. 16.7 cm., W. 25.5 cm.
Private collection

Inscriptions appear occasionally in the form of animals, though most usually as either birds (see Nos. 69 and 71), mystical symbols of humanity, or as lions, the symbols of ʿAli who is especially revered by Shiʿa Muslims. Other creatures appear far more rarely, and their particular symbolism is less readily explained.

Both outline and interior of this stately horse are constructed from the famous throne verse (surah al-Baqarah [The Cow] 2:255), so popular in Muslim India:

Allah! There is no God save Him, the Alive, the Eternal. Neither slumber nor sleep overtaketh Him. Unto Him belongeth whatsoever is in the heavens and whatsoever is in the earth. Who is he that intercedeth with Him save by His leave? He knoweth that which is in front of them and that which is behind them, while they encompass nothing of His knowledge save what He will. His throne includeth the heavens and the earth, and He is never weary of preserving them. He is the Sublime, the Tremendous.

The verse begins at the horse's head and proceeds along its back, hindquarters, and stomach; it ends at the raised forefoot. Nose and mouth form the word Allah, as if this animal of Allah's creation were piously invoking the divine name. The rider, though drawn in the highly calligraphic style widespread in Iran and the Deccan in the late sixteenth and early seventeenth centuries, is not part of the inscription and neither is his saddle.

Like many of the other figural renderings of verses from the *Qurʾan* this image was used as a talisman to protect the owner against evil. Orthodox Islam regarded these *Qurʾanic* images with severe disapproval, and indeed this representation of a tiny man riding the great verse itself might be particularly suspect. There is, however, another interpretation that is theologically more appropriate. Representations of equestrian opposites—broken down, emaciated horses ridden by large men—have been interpreted as mystical symbols of the aging, decaying, and transient body, bearing a more vital soul, longing to be free.[1] It is more than possible that this calligraphic horse is a pious pun on this other well-known pictorial use, for here the holy words describing Allah's omnipotence form a mighty horse bearing a minuscule human being, or human soul.

NOTES

1. See Annemarie Schimmel, "Nur ein störrisches Pferd," in *Festschrift George Widengren*, pp. 98–107; Anthony Welch, *Shah ʿAbbas and the Arts of Isfahan*, No. 10 and pp. 64–65; S. C. Welch, *Indian Drawings and Painted Sketches*, No. 34.

PREVIOUSLY PUBLISHED IN

S. C. Welch, "Portfolio," *Marg* 16 (no. 2, 1963), p. 31.
S. C. Welch, *Indian Drawings and Painted Sketches*, No. 34, p. 74.

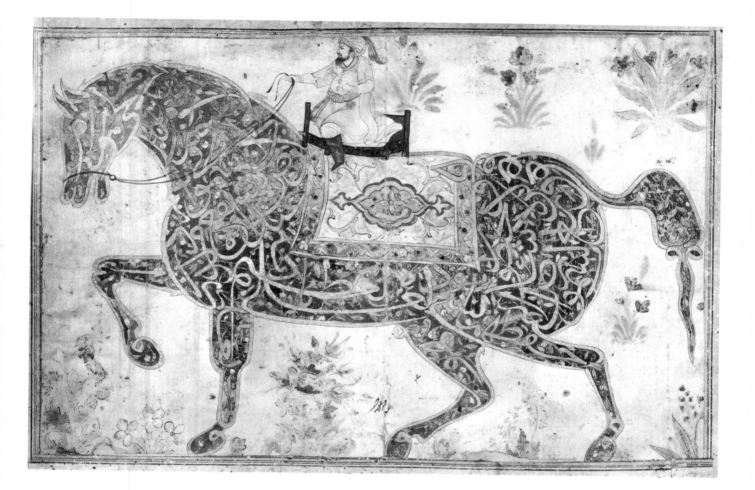

78. Quatrain copied by Prince Khurram

India; 1020 H. (1611–1612 A.D.)
H. 15 cm., W. 9.9 cm.
The Keir Collection

Over blue paper lightly decorated with gold leaves are written six lines of open, loose, and even rather shaky *nasta'liq*: it is a Persian quatrain, introduced by a pious invocation and signed at the end by the calligrapher, Sultan Khurram, the eldest son and heir apparent of the Mughal emperor Jahangir.[1]

> *He [Allah] is the Wealthy One*
> *Tonight there is I, and one companion like me.*
> *A convivial meeting upon a grassy spot,*
> *A cup of wine, fine sweets, and a minstrel all are here.*
> *O, would that thou wast here, but not all these!*
> *He who penned it is Sultan Khurram, [in the] year 1020.*

The verse is typical of the mystical love poetry popular in aristocratic circles in India as well as in the Safavi and Ottoman empires, where royalty also pursued the calligraphic art.[2] *Nasta'liq* was the script most favored for this sort of poetry, and Sultan Khurram considered his effort an achievement worth his signature. In 1020 H. (1611–1612 A.D.) the princely scribe was nineteen years old, had been married a year, and had recently been raised in rank by his doting father.[3] His education had been rigorous and had provided him with training not only in government but also in the courtly arts. During his reign of thirty years from 1627–1658 Shah Jahan (the imperial name which Khurram took) proved himself a highly refined aesthete with a sophisticated taste for precious objects, painting, calligraphy, and architecture, and it was his reign that determined the future course and dissemination of the Mughal aesthetic.

Here in this early holograph he left us with a sample of his hand and with the proof that he was a better connoisseur than master. While it does not equal the creations of the great scribes whom he employed and whose entire lives were devoted to their skills, it shows him with sufficient mastery to appreciate the demands and achievements of this art.[4]

NOTES

1. See No. 79.
2. Calligraphies reliably signed by Jahangir and by Shah Jahan's favorite son, Dara Shukoh, are known. See No. 81. Albums in the Topkapi Palace Museum in Istanbul contain numerous examples of calligraphies by Safavi and Ottoman princes.
3. See A. Rogers and H. Beveridge, trans., *Tuzuk-i Jahangiri* [Memoirs of Jahangir], I, p. 192.
4. On the other side of this page is a portrait of an unidentified Mughal courtier with a book tucked under his arm.

PREVIOUSLY PUBLISHED IN

Sotheby & Co., *Catalogue of Highly Important Oriental Manuscripts and Miniatures*, lot 107.
Robert Skelton, "Indian Painting of the Mughal Period," in B. W. Robinson et al., *Islamic Painting and the Arts of the Book: The Keir Collection*, part V, no. 60.
Ralph H. Pinder-Wilson, *Paintings from the Muslim Courts of India*, No. 110.

هوالغنى

امشب منم ويكى حريفى چو منى
ارآيدة مجلسى برسم چينى

جام مى ونقل خوش ومطرب هست
اى كاش تو مى بودى وآنهمى

رآقمه سلطان خسرم

79. Jade and gold inkpot

Made for Emperor Jahangir
India; 1028 H. (1619 A.D.)
H. 6.4 cm.
The Metropolitan Museum of Art; Gift of George Coe Graves, 1929

(Shown only at Asia House)

On March 10, 1619, began the fourteenth year of the reign of the Mughal emperor Jahangir. For many days thereafter and particularly during the Nauruz (New Year) celebrations at the time of the vernal equinox the monarch received visits and offerings of gifts from well-wishing relatives and officials, eager to commemorate this anniversary of his rule.[1] Jewels and objects made from precious and semiprecious stones were many, for the emperor's cultivated taste for gems was well known. In return, Jahangir bestowed on the givers presents from his imperial workshops.

It is quite possible that this vessel was given to the emperor during these days of celebration. It is a squat dark green jade pot with a flat gold top. Gold inlay highlights the incised decorative areas and the four cartouches containing inscriptions which read:

This form was completed for Jahangir Shah [son of] Akbar Shah in the fourteenth regnal year, corresponding to the year 1028 Hijri.

On the bottom of the pot is written "Made by Mu'min Jahangiri," a master otherwise unknown who was presumably employed in the royal workshops. Jahangir was a gifted connoisseur of all the arts, and his sensitivity to beautiful form and fine technique must have led him to value this piece. As a devoted patron of calligraphy and a competent, though not distinguished, calligrapher himself, he must have sensed the appropriateness of this gift—a regal ink-pot for a royal scribe.

NOTES

1. Alexander Rogers and Henry Beveridge, trans., *The Tuzuk-i Jahangiri* (Memoirs of Jahangir), 2, pp. 78–83.

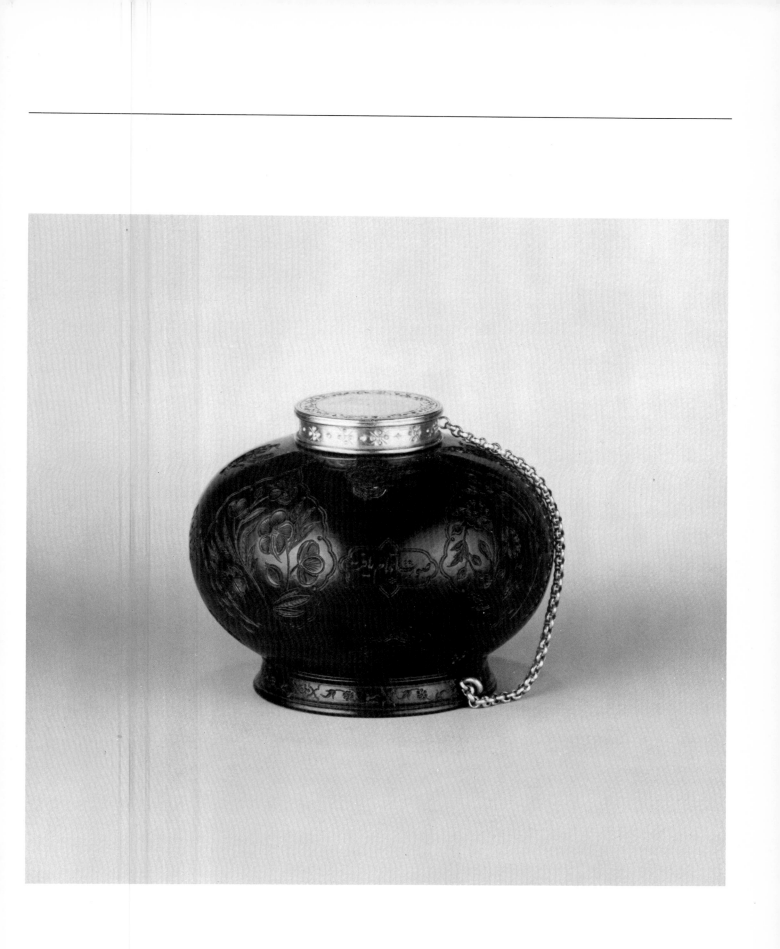

80. Brass bowl

India; first half of seventeenth century
H. 6.0 cm., Diam. 19.4 cm.
Private collection

Twelve zodiacal figures are incised at regular intervals on the exterior of this bowl, but the remainder of the surface is filled by a clear, though not particularly elegant, *naskhi* script. The inscriptions include the *asma᾽ al-husna* (the most beautiful names of Allah) and a number of lengthy, popular prayers, requesting divine aid in times of adversity. Some formulas from the *Qur᾽an* are also used, such as the following portion of *surah al-Mu᾽min* (The Believer) 40:60:

And your Lord hath said: Pray unto Me and I will hear your prayer. Lo! those who scorn My service, they will enter hell, disgraced.

Along the horizontal surface of the rim is written the throne verse, as well as the verse immediately following it, from *surah al-Baqarah* (The Cow) 2:255–256:

Allah! There is no God save Him, the Alive, the Eternal. Neither slumber nor sleep overtaketh Him. Unto Him belongeth whatsoever is in the heavens and whatsoever is in the earth. Who is he that intercedeth with Him save by His leave? He knoweth that which is in front of them and that which is behind them, while they encompass nothing of His knowledge save what He will. His Throne includeth the heavens and the earth, and He is never weary of preserving them. He is the Sublime, the Tremendous.

There is no compulsion in religion. The right direction is henceforth distinct from error. And he who rejecteth false deities and believeth in Allah hath grasped a firm handhold which will never break. Allah is Hearer, Knower.

One of the most revered and repeated verses from the *Qur᾽an*, the throne verse appears on objects and buildings throughout the Muslim world.[1]

The inner surface of this bowl is incised with the whole of *surah Ya Sin* (36), a highly regarded *surah* often recited over the dead and dying, but also spoken during times of sickness, fasting, and trouble. While the entire *surah* cannot be included in this entry, several selected verses will give some idea of its major themes and indicate why it was used on this bowl:

Lo! We it is Who bring the Dead to life. We record that which they send before (them) and their footprints. And all things We have kept in a clear Register.
[verse 12]

It was said (unto him): Enter paradise. He said: Would that my people knew With what (Munificence) my Lord hath pardoned me and made me of the honored ones.
[verses 26–27]

And the trumpet is blown and lo! from the graves they hie unto their Lord,
Crying: Woe upon us! Who hath raised us from our place of sleep? This is that which the Beneficent did promise, and the messengers spoke truth.
It is but one Shout, and behold them brought together before Us!
This day no soul is wronged in aught; nor are ye requited aught save what ye used to do.
Lo! those who merit paradise this day are happily employed,
They and their wives, in pleasant shade, on thrones reclining;
Theirs the fruit (of their good deeds) and theirs (all) that they ask;
The word from a Merciful Lord (for them) is: Peace!
[verses 51–58]

Hath not man seen that We have created him from a drop of seed? Yet lo! he is an open opponent.
And he hath coined Us a similitude, and hath forgotten the fact of his creation, saying: Who will revive these bones when they have rotted away?
Say: He will revive them Who produced them at the first, for He is Knower of every creation,
Who hath appointed for you fire from the green tree, and behold! ye kindle from it.
Is not He Who created the heavens and the earth Able to create the like of them? Aye, that He is! for He is the All-Wise Creator,
But His command, when He intendeth a thing, is only that He saith unto it: Be! and it is.
Therefore Glory be to Him in Whose hand is the dominion over all things! Unto Him ye will be brought back.
[verses 77–83]

Midway in the interior of the bowl and interrupting the text of the *surah* are eight lines of numbers and words, apparently combinations with magical significance and presumably intended to be efficacious in restoring the sick to good health and replacing adversity with good fortune.[2]

The bowl, thick with verses from the *Qur᾽an* (stressing Allah's omnipotence and role as sole creator and giver of eternal life), prayers for aid, cabalistic numbers and letters, and astrological figures, is charged with formidable talismanic power of varied sorts and would seem to have been most likely used in the care of the sick.

NOTES

1. See Nos. 30, 43, 77, and 84.
2. The relation between letters and numbers is discussed at greater length in the Introduction to this book.

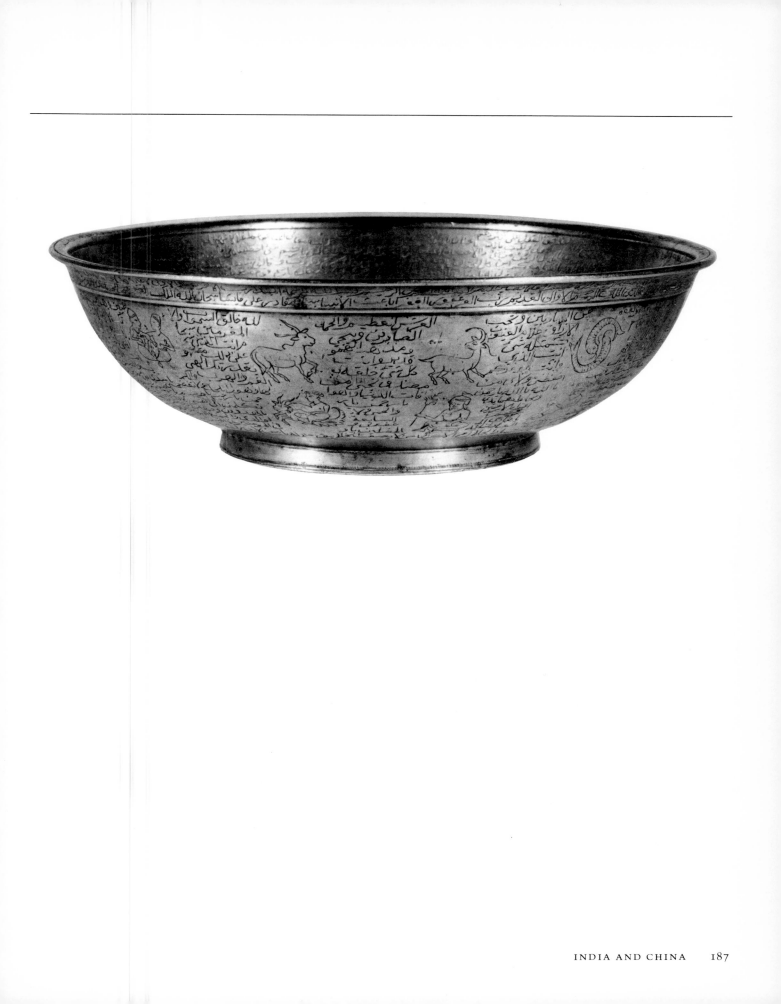

81. The Chronologies of the Prophet and the Rightly Guided Caliphs

India; 1040 H. (1630–1631 A.D.)
H. 40 cm., W. 26.1 cm.
Victoria and Albert Museum

These pious lines are written on a page belonging to an album that contains several calligraphies written in an identical hand and signed by Prince Dara Shukoh (1615–1659), the favorite son of the Mughal emperor, Shah Jahan. They are written in a shapely, graceful *nasta'liq*, the script in which the prince specialized, and enumerate the years and ages of the leaders of Islam from the time of Muhammad to the end of the reign of the fourth caliph, 'Ali, in 661 A.D. The page should be read in the following order: the horizontal and diagonal lines from top to bottom; the left-hand vertical lines from bottom to top; the right-hand vertical lines from top to bottom; and, finally, the four small, side panels of minute script, beginning in the upper right and ending in the upper left:

The blessed years of the honored Prophet[1] *[were] sixty-three,*
 And the period of his prophethood [was] twenty-three years.
 Allah is Great!
For two years and three months Siddiq Taqi[2]
 Reclined on the throne of the divine law of Mostafa.[3]
 For ten years and six months, Faruq,[4]
 The celestial magistrate, was Caliph.
 For twelve years 'Uthman Zaki.[5]
 Was a guide to all men.
 Four years and nine months more
 Were the days of 'Ali Mortaza.[6]

The noble age of the honored Siddiq [was] sixty-three.
 The noble age of the honored Faruq [was] sixty-three.
 The noble age of the honored Dhu'l-Nurayn[7] *[was] eighty-eight.*
 The noble age of Mortaza 'Ali [was] sixty-three.

 [In] the year 1040, regnal year 3, in the city of Burhanpur, it was written.

One of the most remarkable and appealing members of the Mughal dynasty, Dara Shukoh was born in 1024 H. (1615 A.D.) in Ajmer. The eldest of Shah Jahan's four sons, he was also his father's distinct favorite and from the time of his first official appointment in 1633 was rapidly elevated to positions of great authority. His status as heir apparent was not, however, uniformly accepted. The emperor's three other sons resented his advancement, as did many members of the orthodox Muslim religious establishment who feared his broad-minded interest in India's other faiths. In 1659 the monarch's third son, Awrangzeb, who had already deposed his father two years before, captured and executed the gifted prince.

While his political career was unfortunate, Dara Shukoh was one of the most brilliant royal figures in India's cultural history. Like his great-grandfather Akbar, he was keenly interested in the doctrines of all religions, and his close association with Muslim and Hindu mystics won him the hostility of the orthodox elements that had also opposed Akbar. Though a sufi by inclination,[8] Dara Shukoh had been educated in an orthodox manner and apparently accepted the fundamental tenets of Islam throughout his life.

He was an energetic and productive writer: much of his prose and poetry dealt with various aspects of sufism and he translated extensively from the Hindu religious classics into Persian. He was also a discerning patron of the arts and an excellent calligrapher, primarily employing the *nasta'liq* script.

The erased area in the lower part of this page probably contained the young prince's signature, perhaps rubbed out in 1659. But in 1630–1631 when this testimony to religious history was penned, the prince was a fifteen-year-old youth, residing in the central Indian city of Burhanpur with his mother, Mumtaz Mahall (for whom the Taj Mahal was built following her death in 1631), and his father, Shah Jahan, who was busily conducting costly military operations against recalcitrant Deccani states.

NOTES
1. Muhammad.
2. The first caliph, Abu Bakr, who reigned from 632 to 634.
3. An alternate name for Muhammad.
4. The second caliph, 'Umar, who reigned 634–644.
5. The third caliph, 'Uthman, who reigned 644–656.
6. The fourth caliph, 'Ali, who reigned 656–661.
7. An alternate name for 'Uthman, derived from his marriage to two of Muhammad's daughters.
8. He was an active member of the Qadiriyya order (see No. 20 for a seventeenth-century banner made for Qadiriyya pilgrims).

PREVIOUSLY PUBLISHED IN
Ralph H. Pinder-Wilson, *Paintings from the Muslim Courts of India*, No. 140.

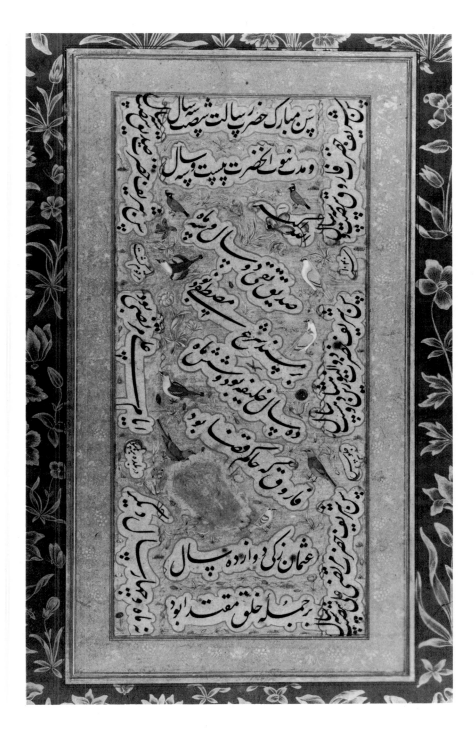

82. White jade archer's ring

Made for Emperor Shah Jahan
India; 1042 H. (1632–1633 A.D.)
H. 1.2 cm., Diam. 2 cm.
Victoria and Albert Museum

A favorite material of Timurid and
Mughal rulers, jade, as well as other
splendid stones and gems, was used with
lavish abandon by Shah Jahan whose
legendary lapidary passion found expres-
sion not only in objects but also in archi-
tecture. Though he was far less a hunter
and warrior than his father Jahangir
(reign, 1605–1627) and his grandfather
Akbar, the archer's ring (in Persian *zihgir*)
was an important part of his regalia; and
many formal portraits prominently show
a ring of this type on his right thumb.

The inscription—"Second Lord of the
Astral Conjunction, 1042 H."—identifies
its owner as Shah Jahan, for whom this
phrase was a personal epithet, referring
directly to auspicious astrology and
obliquely to his descent from Timur who
had termed himself "Lord of the Astral
Conjunction."[1] In paintings, precious
objects, and memoirs Mughal emperors
regularly alluded to the Timurid ancestry
that provided the theoretical basis for
their claim to the throne of Delhi. Occa-
sionally the astrological epithet was also
applied to religious figures like Jesus,
with whom Jahangir had been fond of
juxtaposing himself in portraits.

Shah Jahan's father frequently chose to
have himself portrayed wearing rings and
holding a cup in what seems to have been
a calculated reference to Sulayman, in
Islamic literature the topos of the ideal
king in whose magic cup the whole world
could be seen and through whose magic
ring, inscribed with the *Ism-i A'zam*
(Allah's Most Great Name), he brought
all living things and all forces of nature
under royal control. The image of
Sulayman, both as saint and king, had
long possessed special appeal for Muslim
rulers; for Jahangir and Shah Jahan, who
fostered a cult of the detached and semi-
divine monarch, it was a powerful and
appropriate symbol to be regularly re-
ferred to by objects of this sort.

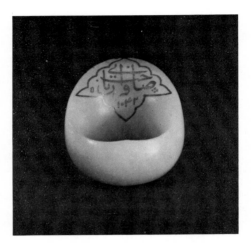

NOTES

1. It was a term with an earlier history in
 Arabic epigraphy, notably used by the
 Mamluk sultan Baybars (reign, 1260–1277)
 as part of his official titulature.

83. A page of nasta'liq

India; ca. 1630 A.D.
H. 16 cm., W. 7.5 cm.
Collection of Prince Sadruddin Aga Khan

Album pages combining fine calligraphy
and broad borders richly illuminated
with animals, flowers, and, even, human
beings had been a favored art under the
Mughal emperor Jahangir,[1] whose taste
in this regard paralleled that of his con-
temporary in Iran, the Safavi shah 'Abbas
I, who also held calligraphy in high es-
teem.[2] It was an age in which the pre-
cious album (*muraqqa'*) supplanted in
part the illustrated manuscript, for an
album could present an assemblage of
varied pictorial works ranging from por-
traits and natural studies to choice cal-
ligraphies of past and present masters.[3]
An album was in many ways the equiv-
alent of a present-day collection, and
its range of quality and inner coherence
depended upon the energy and connois-
seurship of its patron.

Educated and sensitive like his father,
Shah Jahan was sure of his taste. He loved
gems and precious stones, whether set in
brilliant jewelry or in marble architec-
ture; and his passionate admiration for
the lapidary arts seems to have affected
painting done under his patronage, for
animals, as in this album page, become
almost frozen in place, sharply outlined
but immobile against a background of
immutable nature. Immediately around
the main inscription are flowers and two
white sheep, but in the upper right corner
of this central panel is a *simurgh*, flying
against a green blue sky. The mythical
bird, often a symbol in Persian mystical
poetry of the divine essence, occupies the
position frequently filled with a calli-
graphic expression, such as "He is Allah"
or "He is the Glorious";[4] and its place-
ment here is not accidental, for the four
lines of large and very fine *nasta'liq* cal-
ligraphy written diagonally across the
panel render a mystical poem by the
eleventh century Persian sufi Shaykh
'Abdullah Ansari:[5]

(continued on next page)

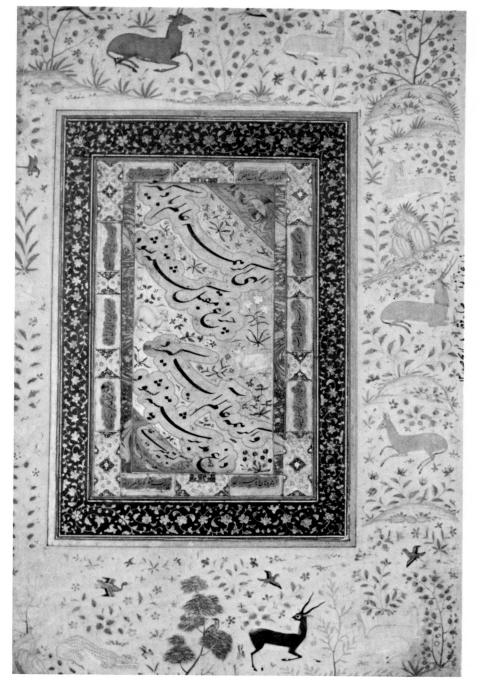

O God, should wind seize all the world,
 [Thy] auspicious lamp would not be
 slain;
And should water cover all the world,
 The brand of the wretch would not be
 scrubbed clean.

The ten verses in smaller, more delicate
nasta'liq along the sides continue the
same mystical theme.

In the lower left corner of the central
panel is the information that the page
was written by Mir 'Ali, a reference not
to the master of the fourteenth and early
fifteenth centuries, Mir 'Ali Tabrizi,[6] but
to Mir 'Ali Haravi, who lived a century
later[7] and whose work was much ad-
mired and collected by the Mughals.[8]
Although expert calligraphers prided
themselves on their ability to produce
exact copies of the works of great and
admired predecessors, it is reasonable to
suppose that this page, bearing Mir 'Ali's
name and once part of a sumptuous
album perhaps made for Shah Jahan, is
the work of his hand.

On the reverse side of this page is a
narrow panel of *nasta'liq*; most of
the surrounding area is taken up by very
ample margins set with many flowers,
rich in color and precise in form but
stirred by no wind and moved by no inner
vitality. Eight lines of *nasta'liq*, slen-
derer and less dynamic than those by Mir
'Ali, are written diagonally, and they too
are a poem, more attuned to the earthly
than to the divine beloved:

O, thy unadorned body is filled with
 beauty,
And O, when clothed, the center point of
 the compass of beauty.
Thy entrancing dimpled chin, O heart
 enchanter,
Is like thy chin a treasure house of
 beauty's secrets.
When love saw beauty in the mirror,
It saw that to be taken by love is good.

The eye that had the power of sight
Veiled [itself] from the manifestation of
 all this beauty.

Written horizontally under them we find
the name of the scribe, Muhammad Salih
Mir 'Abd Allah.[9]

NOTES

1. S. C. Welch, *The Art of Mughal India*, No.
127, illustrates a splendid album page made
for Jahangir and now in the Nelson Gallery
in Kansas City. Though far more animated
in its realism, this type of album page clearly
served as a model for the later page under
discussion here.

2. For Shah 'Abbas' taste in calligraphy see
Anthony Welch, *Shah 'Abbas and the Arts
of Isfahan*, Nos. 15–18, and idem, *Artists
for the Shah*, pp. 10, 191, and 194.

3. For the development of the *muraqqa'* as
an art form see Anthony Welch, *Artists for
the Shah*, pp. 198–199.

4. As in Nos. 56, 63, 68, 76, 78, and 87.

5. Ansari was born in Herat in 1005 A.D. and
died in 1090. This poem is from his *Munajat*
(Invocations), the first Persian collection of
prayers in rhymed prose with interspersed
verses.

6. Little is known about the career of the
alleged inventor of *nasta'liq*. The cele-
brated manuscript of the *mathnawi* of
Khwaju Kirmani in the British Museum
(Ms. Add. 18.113) is signed "Mir 'Ali ibn
Ilyas al-Tabrizi." Sultan 'Ali Mashhadi,
who was the teacher of Mir 'Ali Haravi,
accords the earlier Mir 'Ali high praise in his
treatise on calligraphy (see Qadi Ahmad,
Calligraphers and Painters, pp. 106–125).

7. According to Qadi Ahmad (ibid., pp. 126–
131), Mir 'Ali Haravi came from a prom-
inent family in Herat. In addition to writing
individual pages and whole manuscripts, he
designed architectural inscriptions; pre-
sumably the master of many scripts, he
excelled at *nasta'liq*. After living most of
his life in Herat and working for both
Timurid and Safavi patrons there, he was
appropriated by the Uzbeks when they took
the city in 935 H. (1528–1529 A.D.) and re-
moved to their capital at Bukhara, where he
spent the remainder of his life. He died

around 1544. Qadi Ahmad, *Calligraphers
and Painters*, p. 131, reports that "albums,
specimens, and writings of the Mir are
scattered throughout the inhabited quarter
of the world."

8. At one point in his life Mir 'Ali, apparently
wishing to leave Bukhara and its Uzbek
rulers, wrote a poem in praise of the first
Mughal emperor, Babur, who occupied the
throne in Delhi from 1526–1530 (see ibid.,
pp. 128–129).

9. This individual may possibly be identified
with an official who served as *sadr* (a high
official) under Akbar (see Abu'l-Fazl, *The
A'in-i Akbari*, p. 596).

84. Silver Qur'an page holder

India; ca. 1630–1640 A.D.
H. 2.9 cm., L. 11.5 cm.
Private collection

This small oblong octagonal case was hung from the belt by means of three metal loops on one side. Four sides are decorated with incised arabesque decoration, contained within almond-shaped borders. The four alternate sides are provided with incised verse from the *Qur'an* in *naskhi* script. They are portions of two of the most famous verses of the *surah al-Baqarah* (The Cow) 2:255–256:

His throne (includeth) the heavens and the earth, and He is never weary of preserving them. He is the Sublime, the Tremendous.
There is no compulsion in religion. The right direction is henceforth distinct from error. And he who rejecteth false deities and believeth in Allah hath grasped a firm handhold which will never break.

Extremely popular in Muslim India, these verses, exemplifying divine power, were often inscribed in tombs. Here, however, their use is also appropriate, since the small case was designed to hold several rolled-up pages (or perhaps the whole) of *surah al-Baqarah*, often described as the *Qur'an* in little, since it contains virtually all the principal themes of the revelation, or perhaps an entire, miniature *Qur'an* written in scroll form.

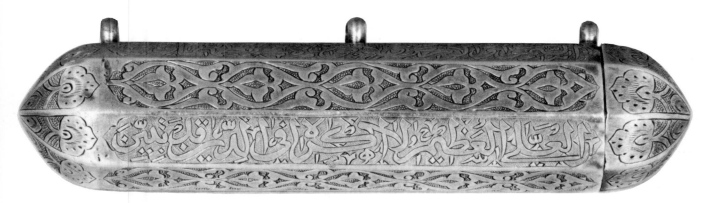

85. Ex libris from an album made for Shah Jahan

India; ca. 1640 A.D.
H. 38.7 cm., W. 26.6 cm.
The Metropolitan Museum of Art; Purchase, funds given by the Kevorkian Foundation supplementing the Rogers Fund, 1955

See color illustration on page 9

The production of albums or portfolios of samples of calligraphy and painting by leading masters had long been a major activity of royal ateliers in Iran, and the Mughal and Deccani rulers of India continued the practice, assembling valued works by esteemed masters from India, Iran, central Asia, and sometimes even more distant lands, both Muslim and Christian. Not bound to a literary text and thus less restrictive in pictorial scope, an album (or *muraqqa'*) could include favorite original works, as well as skillful copies of works not obtainable; and it was an accepted test of a scribe's or painter's ability to compare his work with that of the earlier master whose style he followed or whose design he imitated.

Some of the most magnificent of royal albums were assembled by the rulers of the great Muslim empires of the sixteenth and seventeenth centuries, and Ottoman sultans, Safavi shahs, and Mughal emperors were devoted patrons of this art form, perhaps eclectic in concept but usually unified in execution. Not all royal albums, however, were provided with patron's pages, such as this one, which both identifies and brilliantly exalts Shah Jahan.

Allah preserve his sovereignty and his authority—Muhammad Shihab al-Din Jahanshah Padshah the Ghazi.

In pious fashion the emperor's name appears at the bottom of the central medallion, while the divine name appears at the top. From the ruler's name and titles at the bottom rise three verticals that bend and turn into figure eights returning to their source and binding the entire inscription together, which is written appropriately in *thuluth* script. It is a brilliant epigraphic design, preserving legibility, while linking Mughal emperor and divine power—a connection befitting the Mughal concept of the semi-divine monarch.

Barely containing the radiant words are six thin circles of color—red, blue, green, and gold—beyond which radiate successive and symmetric bursts of gold and blue, finally encompassed by an aura of golden energy. Yet this brilliant design is not simply superb ornament: it makes implicit visual reference to the mystical concept of Allah as light and explicitly builds upon the emperor's name, Shihab al-Din—the Meteor of Faith. Both epigraphically and abstractly this *ex libris* is a visible statement of the Mughal concept of kingship.

On the other side, which the viewer turning the album's pages would have seen next, are six lines of splendid

nasta'liq, immediately surrounded by floral patterns and bordered by four richly illuminated rectangles, themselves framed by an expanding pattern of petal-like forms and an outer margin of delicate floral tracery:

Praise without limit and thanks without number to the Creator, since
The painted patchwork of the heavens is a fragment of His gracious and perfect works,
And the illuminated tatters of the sun are a portion
Of His beauteous and excellent light[s]. He [is] an Artificer, the arts
Of whose pen draw the down on the cheeks of heart-ravishing beauties.[1]
And He [is] an Innovator, the inventions of Whose figures illuminate

The passage would have been completed on the facing page, but this portion of it clearly builds upon the image of the sun —with the emperor's and the divine name—which precedes it on the obverse. The passage also refers to Allah as the ultimate calligrapher and the supreme maker of figural forms, a wholly appropriate reference as the introduction to an album containing calligraphies and pictures assembled for Shah Jahan.

NOTES

1. The word *khatt* means not only *down* but also *line* or *script*. Hence its use here is a pun of a sort frequent in Persian and Turkish poetry and discussed at greater length in the Introduction to this book.

86. Surah 114 of the Qur'an

India; eighteenth century
H. 16.7 cm., W. 28.5 cm.
Private collection

*"Say: I seek refuge in the Lord of
 mankind,
The King of mankind,
The God of mankind,
From the evil of the sneaking whisperer,
Who whispereth in the hearts of man-
 kind,
Of the jinn and of mankind."*

The last *surah* in the *Qur'an*, the *surah
al-Nas* (Mankind) is a passionate plea for
protection from evil. The powerful *surah*
is written twice on this page, and it is
likely that this calligraphy served its
owner as a talisman, for neither of its two
styles of writing is a favored vehicle for a
whole *Qur'an*.

The page is divided into five horizontal
segments, all slightly different in height.
In the top (1) and bottom (5) segments
surah 114 is written in *musalsal* (linked)
script. In the three middle segments (2, 3,

and 4) *surah* 114 is rendered in the state-
ly, slow-moving *thuluth* script that was
most often used for *surah* headings in
copies of the *Qur'an* and for monumen-
tal and architectural inscriptions. In its
striking rectilinear composition this por-
tion of the page strongly resembles many
Muslim Indian stone epigraphs.

Aesthetic potential is fully exploited
in each calligraphic style. In the *musalsal*
rendition (segments 1 and 5) virtually all
the individual words are divided onto
two levels, linked by a calligraphic loop.
As a result, there is a sense of constant
flow, a ripple of connected letters and
words forming a visual unity resembling
an arabesque border.

In the *thuluth* inscription words are
also broken up so that a word beginning
in segment 4 may be completed in seg-
ment 2. In keeping with the script the
visual rhythm is also slower, dominated

by twenty-nine verticals, equally spaced,
all rising from segment 4 and ascending
to segment 2. At the end of segments 2
and 3 two letters end in a vertical dip,
which first drops down and then bends
back to the right. The intersection of
verticals and horizontals forms a grid of
rectangular units: here the environment
of *surah* 114 is ordered, almost predict-
able—a different, perhaps more cerebral,
world from the surge and flow of its bor-
dering companion.

This calligraphic tour de force is the
work of Muhammad Qamar al-Din 'Ali
Khan Bahadur, who has signed it in a
minute *naskhi* script, written vertically
near the upper left.

PREVIOUSLY PUBLISHED IN
Annemarie Schimmel, *Islamic Calligraphy*,
 pl. 45.

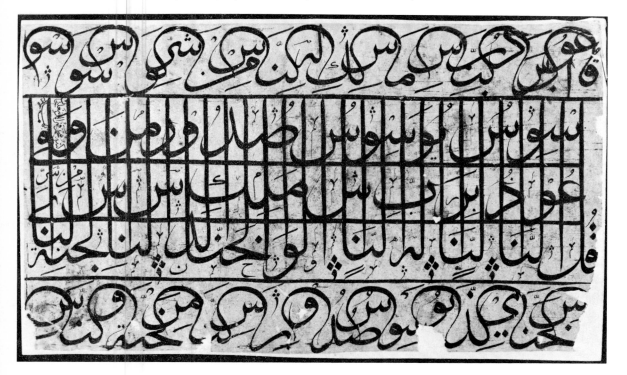

87. Album page with three poems

India; 1195 H. (1781 A.D.)
H. 59.4 cm., W. 43.3 cm.
Collection of Edwin Binney, 3rd

By the reign of Shah ʿAlam II (1760–1806) Mughal power in India had declined to a shadow of what it had been under Shah Jahan and Awrangzeb (1658–1707), and the throne in Delhi was occupied by an emperor who was little more than an English pensioner. With the decline of Mughal fortunes other political forces naturally arose, not only European but also Indian. The fragmentation of political power meant a dispersion of patronage as well, and not only regional Indian princes, Hindu and Muslim, filled the gap but also some notable Europeans. One of them, a French soldier named Louis Antoine Henri Polier, commissioned an album of calligraphies and paintings that demonstrates a temporary fusion, not always successful, of traditional Indian and Western arts. That a European of this period would appreciate fine calligraphy is in itself unusual, but the influence of Polier's own taste is shown not only in the Europeanizing style of the floral borders but also in the rather straightforward composition of the page panels.

Beginning at the top, the verses have been translated as follows:

I. *He is the Glorifier!*[1]

> *My spirit be thy sacrifice, O idol*
> *called Abtahi!*
> *Disruptive Turk, fervent Persian,*
> *seditious Arab,*
> *There is no one in the world who*
> *has not wondered at thy beauty.*
> *—the sinner, Hafiz Nurallah,*
> *may Allah forgive him.*[2]

II. *He is the Glorifier.*

> *To thy threshold came*
> *The tip of our desire.*
> *If thou shouldst accept (it),*
> *Bravo [to] our good fortune!*
> *—Muhammad ʿAli, 1195*[3]

III. *He . . .*[4]

> *If with musky wine my heart is*
> *taken, it is right,*
> *For from hypocritical abstinence*
> *no sweet scent comes.*
> *Do not despair of the blessing of*
> *grace, for creation is generous.*
> *It forgives sins and grants absolu-*
> *tion to lovers.*
> *—The slave (of Allah) Hafiz*
> *Nurallah*[5]

Written in a thin, rather fragile *nastaʿliq*, the first and third verses bear the name of the great mystical love poet, Hafiz (ca. 1325–1390 A.D.), claimed as their author. The second verse, penned in a larger, broader, and more fluid *nastaʿliq*, is followed by the presumed signature of the scribe, one Muhammad ʿAli, and the date 1195 H. (1781 A.D.). Muhammad ʿAli was surely the calligrapher of the rest of the page. It has not yet been possible to find further information about his career.

NOTES

1. One of the *asmaʾ al-husna* (most beautiful names) of Allah, this type of pious formula was used to begin many calligraphies and inscriptions.
2. This verse is not included in any of the published *diwans* of Hafiz.
3. This is the name of the calligrapher, not the poet, who is not named. This verse is also not to be found in any of the *diwans* of Hafiz.
4. This single word with its implied completion by the word Allah or one of the *asmaʾ al-husna* is also a standard form of beginning a poem or calligraphy.
5. This verse is included in most published *diwans* of Hafiz.

PREVIOUSLY PUBLISHED IN

Edwin Binney, 3rd, *Persian and Indian Miniatures from the Collection of Edwin Binney, 3rd*, No. 91.
———, *Indian Miniature Painting from the Collection of Edwin Binney, 3rd*, No. 113.

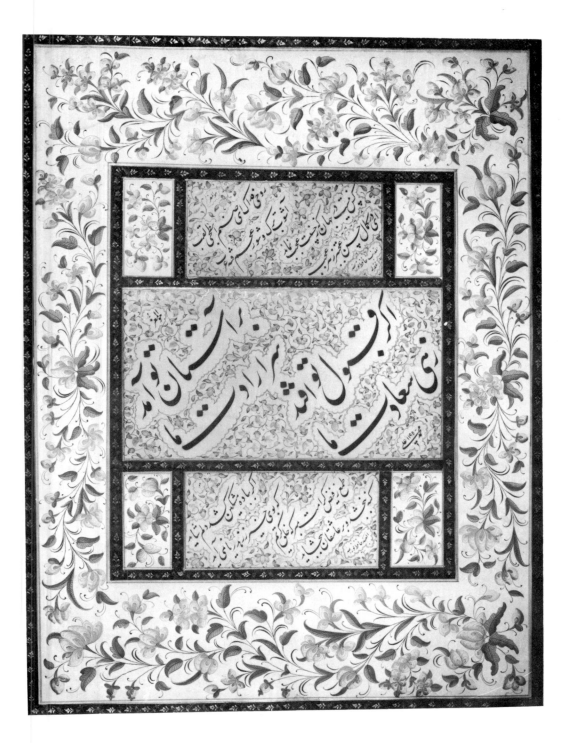

88. Qur'anic mihrab

India, perhaps Haydarabad; early nineteenth century
H. 20.6 cm., W. 13.6 cm.
Collection of Edwin Binney, 3rd

The relation between divine word and human prayer is intrinsic, and nowhere is it more explicitly expressed than in the physical association of the *mihrab* (prayer niche) and verses from the *Qur'an*. Whether of stone, wood, plaster, brick, ceramic, or some other material, the *mihrab* is the architectural focus of the faith, for it is directed toward Mecca, as are all Muslims in prayer. To inscribe it with a portion of Allah's revelation not only places the divine word before all believers, but also puts it at the heart of prayer.

Thus the way in which this calligraphic *mihrab* is constructed—conversely, the form in which these holy words are rendered—is not simply a chance perception by a clever scribe. It is a statement fundamental to the Muslim faith.

Appropriately too, what is written here in an archaic *Kufic* script are the two final verses of the *surah al-Qalam* (the Pen) 68:51–52, in which Allah reassures Muhammad (and by extension all the faithful), confronted by the barbs and calumny of unbelievers:

And lo! those who disbelieve would fain disconcert thee with their eyes when they hear the Reminder, and they say: Lo! he is indeed mad;
When it is naught else than a Reminder to creation.

With its promise of protection against those who practice social evil the text may well have been regarded by its maker and its owner as a talisman, particularly effective in India where Muslims were a religious minority.[1]

NOTES

1. A nearly identical rendering of this same verse is published in S. C. Welch, *Indian Drawings and Painted Sketches*, No. 38. There are minor differences between the two versions: one may be a copy of the other by a later, admiring, but still improvising calligrapher; or the two might be the results of a single, competitive test of skill between two masters.

While I have interpreted this design as a *mihrab*, it has also been suggested that it may represent an arrow, made to defend the possessor against the evil eye.

89. Blue and white dish

China; reign of Emperor Cheng-te (1506–1521 A.D.)
H. 7.5 cm., Diam. 41.8 cm.
Collection of Prince Sadruddin Aga Khan

While Muslim military invasion had been stopped by T'ang armies in the eighth century, the faith of Islam had penetrated deep into China, and by the sixteenth century there were not only important Muslim communities in present-day Sinkiang and southern China, but there were also Muslim officials of high rank at the Ming court in Peking. The Ottoman geographer ʿAli Akbar resided in China between 1505–1506, and his *Khitaynamah* (Book on China) was finished a decade later and presented to the Ottoman sultan in Istanbul. It is a rich and still insufficiently investigated source of information. According to ʿAli Akbar, Emperor Hsiao-tsung (1488–1505) not only employed many Muslim officials but also had a marked personal inclination toward the faith of Islam itself; his successor, the scholarly Cheng-te (1506–1521), studied Arabic and is even rumored to have become a Muslim.[1] Though this report may reflect ʿAli Akbar's hopes rather than solid fact, it is evident that Islam enjoyed its greatest power and influence in China during the Ming dynasty.

The vast Ming empire also enjoyed profitable commercial contacts with the three great Muslim empires of the period —Ottoman Turkey, Safavi Iran, and Mughal India. One of the most important elements of trade between China and the Muslim lands to the west was porcelain, and sumptuous blue-and-white vessels complemented not only the refectories of Christian Europe but also the carpets of Islam.[2]

Thus while this large vessel may have been made for a Muslim at the Ming court, it was just as likely to have been designed as a piece of superb export ware, its use as a basin for ablutions before prayer clearly predicated by its Arabic inscriptions. In the central medallion is the word *taharat* (purity), while four small panels on the rim form a pious statement, reminiscent of tenth century Samanid ware: "Blessed is he who purifies his hand from wrongdoing." In six lozenges on the underside is a further inscription: "Ablution upon ablution is light upon light." In the center of the underside is the regnal mark of Emperor Cheng-te.

Made with a brush, rather than a reed, the script is a careful imitation of the stately *thuluth*, combining cursive fluidity with *Kufic* monumentality. As in Chinese Muslim *Qurʾans*,[3] the script here closely approximates the styles of the central lands of Islam and does not reflect indigenous permutations of the Arabic alphabet.[4]

NOTES

1. P. Kahle, "Eine islamische Quelle über China um 1500," *Acta Orientalia* 12 (1934), pp. 91–110.
2. Among other fine examples of Cheng-te period blue and white inscribed with similar epigraphs are the following: a large penbox in the Musée Guimet, Inv. G 4558 (published in *Arts de l'Islam*, No. 112); a penbox in the Royal Ontario Museum (published in H. Garner, *Oriental Blue and White*, p. 43); and a brush rest and table screen in the Percival David Foundation (published in Margaret Medley, *The Chinese Potter*, figures 161 & 162). Many examples of imported Chinese blue and white porcelain have been preserved in the Topkapi Palace Museum, Istanbul, and formerly in the Shrine of Shaykh Safi at Ardabil (published in John A. Pope, *Chinese Porcelains from the Ardebil Shrine*). This and other wares from China were widely imitated in Safavi Iran, both for home consumption and for export to Europe. (See Anthony Welch, *Shah ʿAbbas and the Arts of Isfahan*, p. 19, and Nos. 34, 55, 69, 80, 81, & 82.)
3. Two *Qurʾanic ajzaʾ* (parts) are in the Beatty Library. (See Arthur J. Arberry, *The Koran Illuminated: A Handlist of the Korans in the Chester Beatty Library*, Nos. 243 & 244.)
4. Some objects that reflect a Chinese regional style of calligraphy are the following: a number of bronzes in the Field Museum of Natural History, Chicago (published in Berthold Laufer, "Chinese Muhammedan Bronzes," *Ars Islamica* 1 [part 2, 1934], pp. 133–148); a glass vase in the Victoria and Albert Museum, No. 121–1883; some of the Chinese Muslim textiles in the same collection; and a jade stand in the Los Angeles County Museum of Art, M.73.5.367. Muslim art in China is a rich and potentially very rewarding area for future research.

PREVIOUSLY PUBLISHED IN

R. L. Hobson and A. L. Hetherington, *The Art of the Chinese Potter*, pl. 150.
R. L. Hobson, *Catalogue of the George Eumorfopoulos Collection of Chinese, Corean, and Persian Pottery and Porcelain*, 4, pl. IV.
Anthony Welch, *Collection of Islamic Art: Prince Sadruddin Aga Khan*, III and IV, No. P. 89.

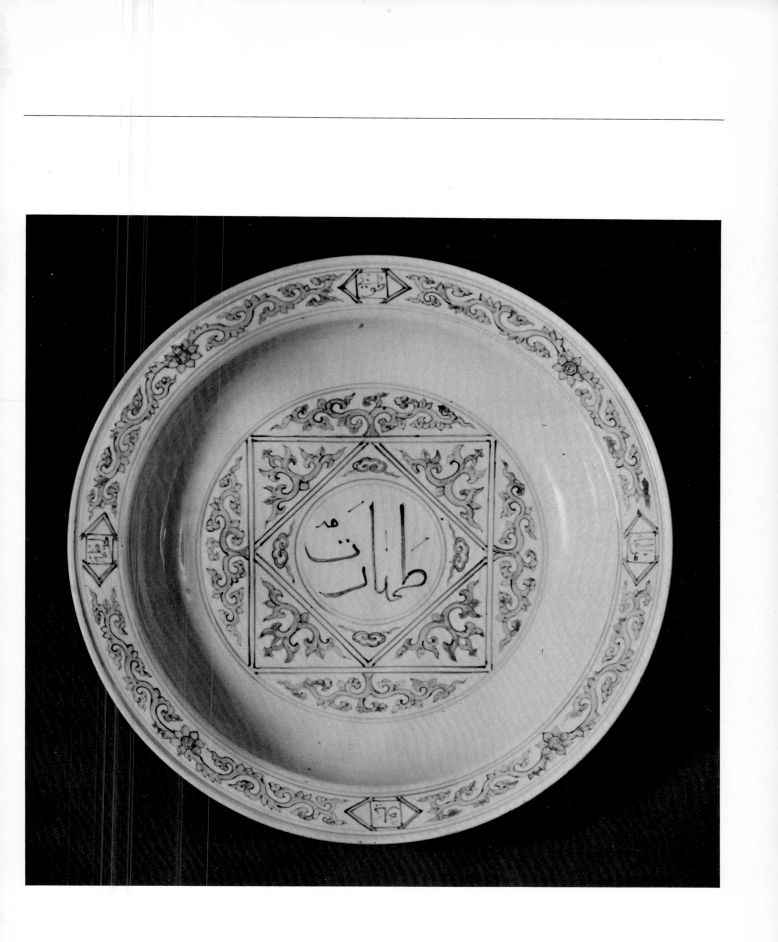

Coins of Islam

American Numismatic Society

A. Iran, Bishapur
Al-Hajjaj ibn Yusuf,
78 H. (697–698 A.D.)
Silver, Diam. 31 mm.

Of humble origins, great courage, and remarkable determination, al-Hajjaj was one of the notable figures in early Muslim history. After serving in a variety of commands, he was appointed in 697–698 by Caliph 'Abd al-Malik to the governorship of Khurasan and Sistan in eastern Iran, and this coin was struck in that year. Its obverse illustrates the continuing efficacy of imperial Sasanian imagery, many decades after the demise of the last Sasanian rulers, for the bearded man wears a crown of Sasanian type. Despite the fact that 'Abd al-Malik had reformed the currency in 76 H. (695–696 A.D.) by directing that epigraphic legends should replace figural imagery on coinage, this coin still reflects the transitional period between the old and new orders, for next to the crowned head are the words "al-Hajjaj ibn Yusuf, Bishapur" and around the enclosing circle is the Muslim declaration of faith.

B. Central Asia, Marw
Reign of 'Abd al-Malik,
80 H. (699–700 A.D.)
Silver, Diam. 26 mm.

The caliph's decision of 695–696 A.D. to use Arabic as the administrative language of the Islamic state and to employ epigraphy rather than figural imagery on coinage resulted in a new, distinctively Muslim numismatic type that set Islam apart both from its non-Muslim neighbors and its pre-Muslim past. As the most frequently seen product of the state and the official affirmation of the faith, its politics, and its economy, coinage played a vital role in asserting Islam's

uniqueness and the legitimacy of its rule. This coin, issued in a city on the frontier of Islam's empire, bears the name of neither caliph nor governor but instead the basic testimonies of the faith, written in a stately script, slightly more cursive than that in 90A.

C. Northern Mesopotamia, Harran
Al-Mu'tadid,
284 H. (897–898 A.D.)
Gold, Diam. 23 mm.

Script used on coins, like that used on precious objects and in manuscripts, varied widely according to region and period. Many of the angular letters here end in small round slightly raised drops, while the letters of the outer inscription are written so closely together that they seem to form a base line, concentric with the edge. The thirteenth 'Abbasid caliph, al-Mu'tadid (892–902 A.D.) attempted to deal with the increasing political fragmentation of his empire by reorganizing the central administration in Baghdad and by instituting a thorough financial reform. His ultimately unsuccessful efforts ended with his defeat by Qarmathian revolutionaries.

D. Iraq, Madinat al-Salam (Baghdad)
Rukn al-Dawla and Mu'izz al-Dawla
 Buwayh,
339 H. (950–951 A.D.)
Gold, Diam. 24 mm.

Near the middle of the tenth century three brothers, the first of the Buyid dynasty, seized control of Iraq and southern and western Iran.[1] Of moderate Shi'a persuasion they gained control of the 'Abbasid capital, Baghdad, in 945 A.D. but did not supplant the Sunni caliph and chose to rule his diminished empire as

his nominal vassals. Thus both in form and content the Buyid coins of the tenth century do not differ dramatically from those of their orthodox contemporaries, the Samanids, to the east, and this coin, with some minor variation, repeats the legends of 90E. The ruling 'Abbasid caliph, al-Muti' (946–974) is mentioned on the reverse along with the name of the Buyid Rukn al-Dawla, who controlled western Iran, while on the obverse is written the name of Mu'izz al-Dawla, who ruled Iraq.

NOTES

1. For an object attributed to the early Buyids see No. 8.

E. Eastern Iran, Nishapur
Nuh ibn Mansur,
383 H. (993–994 A.D.)
Gold, Diam. 24 mm.

Dominating the politics of eastern Iran and central Asia in the ninth and tenth centuries, the Samanids were vigorous upholders of Sunni orthodoxy,[1] and their coins reflect their religious convictions. On the obverse in the outer margin is a portion of the *surah al-Rum* (Romans) 30:4–5:

*. . . Allah's is the command in the former case and in the latter—and in that day believers will rejoice
 In Allah's help*

In the center is the *shahada* and the name of the local governor of Nishapur. On the reverse the outer margin contains an affirmation of Muhammad's role as Allah's Messenger, while in the center are repeated the words "Muhammad is the Messenger of Allah," followed by the name of the 'Abbasid caliph al-Ta'i' (974–991 A.D.), whom the Samanids had

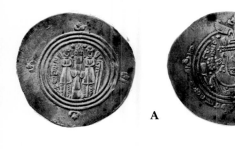

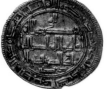

A

B

C

D

E

F

recognized as overlord, and the name of the Samanid ruler, Nuh ibn Mansur (976–997 A.D.).

NOTES

1. Nos. 9 and 10 were almost certainly produced in Samanid domains.

F. Central Asia, Uzkand
Nasir al-Haqq,
423 H. (1032 A.D.)
Silver, Diam. 26 mm.

The Ilek Khans or Karakhanids were descended from Turkish tribes of central Asia, and they came to rule much of the territory between Iran and Sinkiang in the eleventh and twelfth centuries. By the third decade of the eleventh century they had separated into a western and an eastern dynasty; the western branch for a time had its capital at Uzkand, where this coin was minted. Staunchly Sunni, the western Ilek Khans recognized the suzerainty of the ʿAbbasid caliph in distant Baghdad, and their coins, inscribed in a very angular, tall, and often horizontally elongated *Kufic*, carry the *shahada* and standard statements of belief, such as one sees on Samanid coins, as well as the phrase "Mawla Amir al-Muʾminun," a title of respect applying to the caliph. The Karakhanid leader, Nasir al-Haqq, took Bukhara in 999 A.D. and played a major role in central Asian and eastern Iranian history for more than three decades.

American Numismatic Society

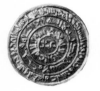
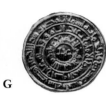

G

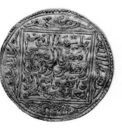
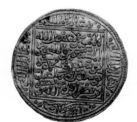

H

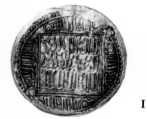
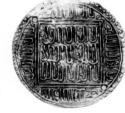

I

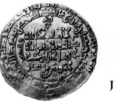

J

K

G. Egypt
Al-Zahir,
423 H. (1032 A.D.)
Gold, Diam. 22 mm.

The Fatimids were Isma'ili Shi'as who claimed descent from Fatima, the Prophet Muhammad's daughter and the wife of the fourth caliph 'Ali. From a territorial base in North Africa where they first rose to power in the early tenth century, they had by 969 A.D. expanded eastward to take Egypt, and by the end of the reign of al-Zahir (1021–1036 A.D.) they controlled the holy cities of Mecca and Medina as well as much of Palestine and Syria. Assuming the title of caliph, they posed a direct political and religious threat to the Sunni 'Abbasid caliphs in Baghdad and from their capital of Cairo sent missionaries throughout the world to convince Muslims of the rectitude of Isma'ili Islam.

Fatimid coins bear inscriptions proclaiming their special convictions. Arranged in three concentric circles—a distinctly Fatimid pattern—crisp *Kufic* contains the words "'Ali is the Friend of Allah," a phrase indicating the special reverence that Shi'as accorded to the Prophet's son-in-law. The caliph al-Zahir also refers to himself here as "Allah's slave and His Friend," words which imply that he has succeeded to 'Ali's particular position.

H. Spain, Granada
Muhammad VII,
(reign, 1395–1407 A.D.)
Gold, Diam. 31 mm.

Long after most of Spain had fallen to reconquering Christian forces, the small Muslim state of Granada under the Nasrid dynasty survived through a skillful combination of diplomacy and trib-

ute. A center of Islamic culture, it attracted students and men of learning from Christian Europe, as well as the Muslim West, until it fell to Spanish Christian forces in 1492. This coin's format—a square within a circle—is common in North African and Spanish coins from the twelfth through fifteenth centuries, and the legends used here are in a cursive script influenced by the *Maghribi* found in contemporary *Qur'ans*.[1] While the reverse names the city—Gharanata (Granada)—in which this coin was minted, the obverse inscribes within the square the full name of the monarch, Muhammad VII al-Musta'in (1395–1407). Around the square are written four times the words "There is no Victor save Allah," a phrase particularly associated with the Nasrids and repeated hundreds of times on the walls of their Granadan palace, the Alhambra.

NOTES
1. See No. 16.

I. The Maghrib or Spain
Fourteenth or fifteenth century
Gold, Diam. 31 mm.

Money like Coin H served as the model for this numismatic type, for it uses the square within a circle pattern seen on the Muslim coins of Spain and northwestern Africa. The inscriptions, however, are illegible and imitate the tall verticals of western Muslim coinage without conveying specific content. Thus the appearance of Arabic-like letters was sufficient to provide the coin with the legitimacy necessary for its acceptance as currency: as in the seventh century, when for many decades Islam retained figural imagery on coinage designed for a population accustomed to associating these forms

with reliable money, now Muslim epigraphy (or the skillful imitation of it) provided images that inspired trust and confidence in true value. While this coin might have been struck by less-than-literate Muslims in the Maghrib, it could also have been minted by Christians in Spain who needed to appropriate Islamic numismatic formulas for a time.

J. Iran, Isfahan
Mahmud ibn Malikshah,
486 H. (1093–1094 A.D.)
Gold, Diam. 27 mm.

As newly converted Muslims, the Seljuq Turks migrated into the eastern Islamic world in the late tenth century to serve as mercenary soldiers for established powers there. They soon took power themselves, and in 1055 A.D. their principal leader, Tughril, captured Baghdad, displaced the Buyids, and declared himself the sultan and protector of the 'Abbasid caliph. Orthodox Sunni in their beliefs, the Seljuqs vigorously expanded, forcing the Isma'ili Shi'as to retrench, driving Christian forces out of Anatolia and the Caucasus, and humbling the powerful Ilek Khans (see Coin F) of central Asia. At the peak of their power in 1092 when Malik Shah died, the Seljuqs experienced disastrous fratricidal conflicts in the ensuing years. The reign of Nasir al-Din Mahmud I lasted only two years (1092–1094), and this coin gives some idea of the complex political relationships of the time.

Its circular legends reiterate Sunni belief and do not differ from those of other dynasties, like the Samanids (see Coin E), who saw themselves as defenders of orthodoxy. On the obverse is the 'Abbasid caliph's name, al-Muqtadi (1075–1094), along with the name and titles of the sultan, Mahmud ibn

Malikshah, at the time only five years old and holding only nominal authority. His relative, Isma'il ibn Alp Sunqur, held real power and is appropriately named on the reverse side with a more resounding title than Mahmud.

K. Armenia, Sis
Het'um I,
637 H. (1239–1240 A.D.)
Silver, Diam. 24 mm.

After the Seljuq Turkish conquest of Anatolia in the late eleventh century much of the scattered Armenian Christian population of the Near East migrated to Cilicia, where a state (often termed Little or Lesser Armenia) was created that enjoyed varying degrees of autonomy until the late fourteenth century. Although often engaged in military struggles with the neighboring Anatolian Seljuqs, this Armenian state also occasionally offered official, if rather vague, allegiance to them. This coin reflects this circumspect and precarious relationship.

On the obverse is an Armenian inscription, naming King Het'um I (1226–1269), who is shown on horseback with a small cross floating behind him. Some Seljuq coins of the period show a similar mounted figure, though followed by a small star, and it is clear that the Armenian image has been appropriated from its more powerful Muslim neighbor. On the reverse is an Arabic inscription written in an angular *Kufic* and a more cursive script, again closely approximating the script on contemporary Seljuq coins. The epigraph names "the mighty sultan, Ghiyath al-Dawla wa al-Din Kay Khusraw Kay Qubadh," who ruled Seljuq Anatolia from 1237 to 1246 A.D.

American Numismatic Society

L. Kingdom of Jerusalem, Acre
1251 or 1253–1258 A.D.
Gold, Diam. 23 mm.

The Crusader Christians who invaded the Holy Land in the late eleventh century necessarily sought to provide the indigenous Muslim majority with money they would accept. Thus Crusader mints regularly issued more-or-less skillful imitations of Fatimid and, later, Ayyubid silver and gold coins. These Crusader issues generally bore the names of the Muslim rulers of neighboring lands, as well as the name of Muhammad, the Muslim profession of faith, and the Muslim date, and the fact that this currency differs so little from Islam's own indicates the fragility of the Crusader state. As the political and military demise of this state came closer, this pattern of imitation was altered; and, as the result of the decision of papal authorities in 1250, later coinage was based on an uneasy epigraphic compromise.[1] The coins continued to be written in Arabic, but they now recorded a Christian date and Christian religious content, as well as displaying a cross.

Written in the fluid cursive script characteristic of contemporary Ayyubid coinage, the legend on this coin's reverse circles a cross and affirms belief in Jesus Christ and hope for the resurrection. In the center of the obverse the Muslim statement "Allah is One" has been replaced by an epigraphically similar but more suitably Christian assertion of "One deity." Circling around it are the date and place of issue and the names of the Father, Son, and Holy Ghost.

NOTES

1. See the careful discussion by Michael Bates, "Thirteenth Century Crusader Imitations of Ayyubid Silver Coinage: A Preliminary Survey," in Dickran K. Kouymjian, ed.,

Near Eastern Numismatics, Iconography, Epigraphy, and History, pp. 393–409.

PREVIOUSLY PUBLISHED IN

Paul Balog and Jacques Yvon, "Monnaies à légendes arabes de l'Orient latin," *Revue numismatique* 1 (6ᵉ série, 1958), p. 158.

M. Egypt, Alexandria
Baybars,
661 H. (1262–1263 A.D.)
Gold, Diam. 24 mm.

Supplanting the Ayyubids in 1250 A.D. and destined to dominate Egypt until the Ottoman Conquest of 1517, the Mamluk sultans rose from the ranks of Turkish mercenaries imported as slaves to support the state. In a history of generally short-lived monarchs Sultan Baybars (reign, 1260–1277) enjoyed one of the longer reigns. He reorganized the state's administration, strengthened defenses against the threatening Mongols, and took the offensive against the Christian Crusaders. In virtually all his endeavors he was successful.

The Mongol capture and destruction of Baghdad in 1258 had meant the effective end of the 'Abbasid caliph, but in 1261 Baybars installed one of the few surviving 'Abbasids as caliph in Cairo. The move symbolically established the Mamluks as the leaders of Sunni Islam, though the caliph exercised no real power. Thus on the obverse of this coin is written the full name and titles of Baybars over an image of a lion: not only is a figural image included on the coin, but the name of the caliph is not even mentioned. Both obverse and reverse (which presents the profession of faith) are written in a cursive script, tall and stately, approximating the *thuluth* of which the Mamluks were to make such impressive use.

N. Iran, Jurjan
Uljaytu,
714 H. (1314–1315 A.D.)
Silver, Diam. 32 mm.

This splendidly minted coin is inscribed with complex legends—in the field a tall, partially cursive script and in the margin a dense *naskhi*—more extensive than those on other coins issued by this Il-Khanid ruler. Founded by the Mongols after their conquest of Iran in the middle of the thirteenth century, the Il-Khanid dynasty maintained loose links with Mongol regimes elsewhere in Asia, sought alliances with the Christian kings of Europe against the Mamluks, and presided over a generally prosperous economy and a vigorous program of architectural construction, most notably in Tabriz and the new Il-Khanid capital at Sultaniyya. After experiments with Buddhism and Christianity the Il-Khans accepted Islam in the late thirteenth century, and this coin of the able ruler Uljaytu (reign, 1304–1317) solidly proclaims his faith with a lengthy and very infrequently used passage from the *surah al-Fath* (Victory) 48:29, in the margin on the reverse side:

Muhammad is the messenger of Allah. And those with him are hard against the disbelievers and merciful among themselves. Thou (O Muhammad) seest them bowing and falling prostrate (in worship), seeking bounty from Allah and (His) acceptance. The mark of them is on their foreheads from the traces of prostration. Such is their likeness in the Torah and their likeness in the Gospel

In reaction against the contentiousness prevailing among the rival schools of Sunni thought, Uljaytu declared himself a Shi'a in 1309–1310, and the ob-

verse of this coin indicates his religious inclination, for in the field are the words "'Ali is the Friend of Allah" and in the margin are the names of the twelve Imams.

L

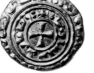

M

O. India
Firuz Shah,
785 H. (1383–1384 A.D.)
Gold, Diam. 22 mm.

Coming to power in northern India in 1320, the Tughluq dynasty re-established a sound administration and expanded militarily into the Deccan in a brief and, by the middle of the fourteenth century, clearly unsuccessful effort to unite all of India under one rule. The long reign of Firuz Shah III (1351–1388) was marked less by military accomplishments than by careful government of northern India, sound economic policies that led to a high level of general prosperity, and a massive building program, not only of palaces and religious edifices but also of utilitarian structures like caravan inns and irrigation dikes.

Piously attentive to formal Sunni obligations, the Tughluqs regularly sought investiture from the 'Abbasid caliph maintained by the Mamluks in distant Cairo. Thus while the obverse simply bears the name of the ruler, written in a clear, strong *thuluth*, the reverse identifies him also as the "viceroy of the Commander of the Faithful [the Caliph]."

N

O

P

P. Central Asia, Samarqand
Ulugh Beg,
853 H. (1449–1450 A.D.)
Silver, Diam. 19 mm.

Taking advantage of the weakness of Iran after the demise of the Il-Khans, Timur conducted a vicious war of conquest, which resulted in near total control of Iran by the end of the fourteenth century. His death in 1405 meant an end to Timurid military expansion, but his heirs developed into some of the most gifted and inspired patrons of art, learning, and culture in Islam's history. Among them Timur's grandson, Ulugh Beg, ranks high. As governor of Samarqand under his father Shah Rukh, he made the city a center of scholarship and patronage of Islamic culture. He was himself known as a poet, historian, scholar of the *Qur'an*, and highly gifted astronomer. His actual reign (1447–1449) was short and ineffectual, terminating in an assassination probably engineered by his son.

On the obverse of this coin, issued in Samarqand in the last year of his rule, is the Muslim profession of faith, written in an angular and archaic *Kufic*, similar to that found on much Timurid architecture. The reverse, giving the date, place of issue, and the hapless monarch's name, is inscribed less formally and less regularly in a very rounded cursive script.

American Numismatic Society

Q. India
Akbar,
995 H. (1587 A.D.)
Gold, Diam. 16 mm.

Q

Although his long reign (1556–1605) was the most successful in Indian history, Akbar was regarded with distrust by some orthodox Muslim elements within his state. Apparently determined to create a government transcending religious differences between India's non-Muslim majority and its largely Muslim ruling class, Akbar evinced an impartial interest in many faiths and advanced subordinates according to political, military, and social needs. Midway in his career, he even publically departed from Islam and instituted a court-centered Din-i Ilahi (Divine Faith), a syncretistic blend of religions, strongly colored by liberal sufism and proclaiming Akbar as its contemporary prophet.

This small, square coin reflects the emperor's brilliant foray into religious revelation. The few adherents of the Din-i Ilahi were supposed to greet each other in a prescribed fashion, one saying "Allahu Akbar" and the other responding "Jalla Jalaluhu." Both phrases had significant double meanings: the first signified either "Allah is Great" or "Akbar is Allah," while the second, translatable as "Glorious is His Glory," clearly alluded to Akbar's other name, Jalaluddin. The reverse shows the date and the words "Jalla Jalal[uhu]"; the obverse has the words "Allahu Akbar."

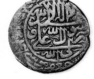

R

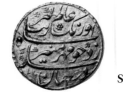
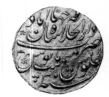

S

T

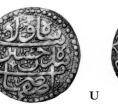

U

R. Iran, Tabriz
Shah 'Abbas I,
1026 H. (1617 A.D.)
Silver, Diam. 23 mm.

In 1587 'Abbas I seized control of a rapidly disintegrating Safavi Empire.

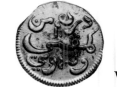
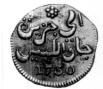

V

Within a decade he had skillfully managed to impose a centralized system of government, suppress rebellious provinces, and begin offensive action against external foes. Near the end of the sixteenth century he also established a new capital at Isfahan in central Iran and began a massive building program to commemorate his rule and his dynasty's aspirations.

'Abbas's great-grandfather, Isma'il I (1501–1524), had committed the Safavi dynasty to Shi'ism, and its adherence to this branch of Islam facilitated Iran's national distinction from the Sunni Ottomans to the west and the Sunni Uzbeks and Mughals to the east. Thus the obverse of this coin has inscribed in tall *thuluth* the profession of faith followed by the statement of Shi'a allegiance, "'Ali is the Friend of Allah." Around it in a compact *naskhi* are listed the names of the twelve imams. On the reverse field, together with the date and place of issue, is written a particularly Safavi honorific, "'Abbas, the servant of the king of holiness."[1]

NOTES

1. That is, 'Ali. For a discussion of Safavi Isfahan and other examples of Safavi coinage see Anthony Welch, *Shah 'Abbas and the Arts of Isfahan.*

S. India, Shahjahanabad (Delhi)
Awrangzeb,
1070 H. (1659–1660 A.D.)
Gold, Diam. 25 mm.

The coins of the great Islamic empires of the seventeenth and eighteenth centuries are among the handsomest ever struck, and this gold coin from the early reign of Awrangzeb (1658–1707) is an elegant example, inscribed in a clear, well-ordered *muhaqqaq*, on one side

giving the Muslim date and the emperor's name and on the other identifying the mint and the regnal year three. Having executed his brother Dara Shukoh on a charge of heresy,[1] Awrangzeb dramatically intensified the orthodoxy of the Mughal government; and while he necessarily retained the services of Hindu warriors and officials, he adopted a public policy of formal piety and waged fierce and debilitating wars against Hindu rebels and Shi'a kingdoms in the Deccan.

NOTES

1. See No. 81.

T. Turkey, Islambul (Istanbul)
Ahmed III,
1115 H. (1703–1704 A.D.)
Gold, Diam. 18 mm.

The Ottoman imperial *tughra* was used not only on official documents but also on coins. This striking example, in which the *tughra* itself is the only epigraph on the obverse, comes from the reign of Sultan Ahmed III, one of the most gifted patrons in the history of Ottoman art.[1]

NOTES

1. Both Ahmed III and the *tughra* form are discussed in No. 33.

U. Iran
Sultan Husayn,
1134 H. (1721–1722 A.D.)
Silver, Diam. 27 mm.

The last of the Safavi monarchs exercising real, even though ineffectual, power was Sultan Husayn (1694–1722 A.D.), a pious, flaccid ruler who allowed political decay to destroy the administrative and social structure established by 'Abbas I. Despite the shah's lack of vigor

in government and in patronage, the coins struck during his reign are aesthetically impressive. On the obverse of this coin the field is occupied by the Shi'a profession of faith: "There is no god but Allah; Muhammad is the Messenger of Allah; 'Ali is the Friend of Allah," while the circular margin is filled with the names of the twelve imams. On the reverse in a bold, broad cursive script is inscribed: "Husayn, the servant of the king of holiness. Struck [in] Isfahan [in] 1134." In the following year the city and the Safavi dynasty fell before the Afghans.

V. Java
Dutch East India Company,
1750 A.D.
Silver, Diam. 24 mm.

Islam's script accompanied the faith in its eastward expansion into Southeast Asia in the thirteenth through eighteenth centuries so that Java and the rest of the Indonesian archipelago were largely Muslim by the time the Dutch arrived in the late sixteenth century. Becoming firmly entrenched in the government and economy of Java in the seventeenth century, the Dutch East India Company issued coinage in its own name, though written here in Arabic script on one side of the coin, while the Christian, rather than the Muslim, date appears in European numerals on the other.

The Arabic Alphabet

SOURCE: R. A. Downie (comp.), "Languages of the World That Can Be Set on 'Monotype' Machines,"
The Monotype Recorder 42, no. 4 (Summer 1963), p. 10.

Name	Independent form	Final form	Medial form	Initial form	Transliteration
Alif	ا	ا			a
Be	ب	ب	‎	ب	b
Te	ت	ت	‎	ت	t
The	ث	ث	‎	ث	th
Jim	ج	ج	‎	ج	j
He	ح	ح	‎	ح	h
Khe	خ	خ	‎	خ	kh
Dal	د	د			d
Dhal	ذ	ذ			dh
Re	ر	ر			r
Ze	ز	ز			z
Sin	س	س	‎	س	s
Shin	ش	ش	‎	ش	sh
Sad	ص	ص	‎	ص	s
Zwad	ض	ض	‎	ض	zw
Toe	ط	ط	ط	ط	t
Zhoe	ظ	ظ	ظ	ظ	dh, z
'Ain	ع	ع	‎	ء	'
Ghain	غ	غ	‎	غ	gh
Fe	ف	ف	‎	ف	f
Qaf	ق	ق	‎	ق	q
Kaf	ك	ك	‎	‎	k
Lam	ل	ل	‎	‎	l
Mim	م	م	‎	م	m
Nun	ن	ن	‎	ن	n
Wau	و	و			w
Ha	ه	ه	‎	ه	h
Ye	ى	ى	‎	‎	y

Numerals

١	٢	٣	٤	٥	٦	٧	٨	٩	٠
1	2	3	4	5	6	7	8	9	0

The Persian Alphabet
The same letters and vowel signs are
used as for Arabic, with an additional
four characters: پ p, چ ch, ژ zh, گ g.

Bibliography

Abbott, Nabia. "Arabic Paleography." *Ars Islamica* 8 (1941): 65–104.

———. "The Contribution of Ibn Muklah to the North Arabic Script." *American Journal of Semitic Languages and Literatures* 56 (1939): 70–83.

———. *The Rise of the North Arabic Script*. Chicago, 1939.

Ahmad, Muin al-Din. *The Taj and Its Environments*. Agra, 1904.

Ali, Mawlana M. *A Manual of Hadith*. 2d ed. Lahore, n.d.

Ali, Mustafa. *Munaqib-i Hünerveran*. Edited by Mahmud Kemal Bey. Istanbul, 1926.

Arberry, Arthur J. *The Koran Illuminated: A Handlist of the Korans in the Chester Beatty Library*. Dublin, 1967.

———; Minovi, M.; and Blochet, Ernest. *The Chester Beatty Library: A Catalogue of the Persian Manuscripts and Miniatures*. Dublin, 1959.

Arif, Aida S. *Arabic Lapidary Kufic in Africa*. London, 1967.

Arnold, Thomas W. *Painting in Islam: A Study of the Place of Pictorial Art in Muslim Culture*. Oxford, 1928.

Arts de l'Islam. Catalogue of an Exhibition. Chambery, 1970.

Arts de l'Islam. Catalogue of an Exhibition at the Orangerie des Tuileries. Paris, 1971.

Arts of Islam. Catalogue of an Exhibition at the Hayward Gallery. London, 1976.

Ashton, Leigh, ed. *The Art of India and Pakistan*. A Commemorative Catalogue of the Exhibition Held at the Royal Academy of Arts. London, 1947–1948.

Aslanapa, O. *Turkish Art and Architecture*. London, 1971.

Atil, Esin. *Art of the Arab World*. Washington, D.C., 1975.

Aziza, Mohamed. *La Calligraphie arabe*. Tunis, 1973.

Balog, Paul, and Yvon, Jacques. "Monnaies à légendes arabes de l'Orient latin." *Revue Numismatique* 1 (6e serie, 1958): 158.

Baltacioglu, Ismayil H. *Türklerde Yazī Sanatī* [The art of writing among the Turks]. Ankara, 1958.

Bates, Michael. "Thirteenth Century Crusader Imitations of Ayyubid Silver Coinage: A Preliminary Survey." In *Near Eastern Numismatics, Iconography, Epigraphy, and History: Studies in Honor of George C. Miles*, edited by Dickran K. Kouymjian. Beirut, 1974.

Bayani, Mehdi. *Khushnevisan* [Calligraphers]. Tehran, 1966.

———. *Mir ʿImad*. Tehran, 1951.

Berchem, Max v. *Inscriptions arabes de Syrie*. Mémoires présentés à l'Institut Egyptien. III/5 (1897).

———. *Matériaux pour un Corpus Inscriptionum Arabicarum*. Cairo, 1894 ff.

Bertaux, E. *Musée Jacquemart-André: Catalogue itinéraire*. Paris, 1913.

Beveridge, A. S., trans. *The Babur-nama in English*. 1922. Reprint, London, 1969.

Binney, Edwin, 3rd. *Indian Miniature Painting from the Collection of Edwin Binney, 3rd*. Catalogue of an Exhibition at the Portland Art Museum. Portland, Ore., 1973.

———. *Persian and Indian Miniatures from the Collection of Edwin Binney, 3rd*. Catalogue of an Exhibition at the Portland Art Museum. Portland, Ore., 1962.

———. *Turkish Miniature Paintings and Manuscripts from the Collection of Edwin Binney 3rd*. Catalogue of an Exhibition Held in the Metropolitan Museum of Art and the Los Angeles County Museum of Art. New York and Los Angeles, 1973.

Britton, N. P. *A Study of Some Early Islamic Textiles in the Museum of Fine Arts, Boston*. Boston, 1938.

Browne, E. G. *A Literary History of Persia*. Cambridge, 1906.

Burckhardt, Titus. *The Art of Islam*. London, 1976.

———. *Moorish Culture in Spain*. London, 1972.

Carswell, John. *New Julfa: The Armenian Churches and Other Buildings*. Oxford, 1958.

Çig, Kemal. *Türk Oymacilari (Katiglari) ve eserleri* [The art of cutting calligraphic texts]. Ankara, 1957.

Coomaraswamy, Ananda. "Les Miniatures orientales de la collection Goloubew au Museum of Fine Arts, Boston." *Ars Asiatica* [Paris] 13 (1929).

Creswell, K. A. C. *A Bibliography of the Architecture, Arts and Crafts of Islam*. Cairo, 1961; supplement, 1973.

Davids Samling. *Islamisk Kunst*. Copenhagen, 1975.

Denny, Walter B. "A Group of Silk Islamic Banners." *Textile Museum Journal* 4, n. 1 (December 1974): 67–81.

———. "Ottoman Turkish Textiles." *Textile Museum Journal* 3 (1972): 55–66.

Dodds, Erica Cruikshank. "The Image of the Word." *Berytus* 18 (1969): 35–58.

Epigraphica Indica. Arabic and Persian Supplement. Delhi, 1955 and 1956.

Epigraphika Vostoka [Russian journal devoted to epigraphy]. 1947– .

Erdmann, Kurt. *Arabische Schriftzeichen als Ornamente in der abendländischen Kunst des Mittelalters*. Mainz, 1953.

Ettinghausen, Richard. "Arabic Epigraphy: Communication or Symbolic Affirmation." In *Near Eastern Numismatics, Iconography, Epigraphy and History*, edited by D. K. Kouymjian, pp. 297–317. Beirut, 1974.

———. *Aus der Welt der Islamischen Kunst: Festschrift für Ernst Kühnel*. Berlin, 1959.

———. *Bulletin of the American Institute of Persian Art and Architecture* 4 (1936).

————. "Ceramic Art in Islamic Times. B. Dated Faience." In *A Survey of Persian Art*, edited by Arthur Upham Pope and Phyllis Ackerman. Oxford, 1938–1939.

————. *Islamic Art in the Metropolitan Museum of Art*. New York, 1972.

————. "Kufesque in Byzantine Greece, the Latin West and the Muslim World." In *A Colloquium in Memory of George Carpenter Miles*. New York, 1976.

————. "Manuscript Illumination." In *A Survey of Persian Art*, edited by Arthur Upham Pope and Phyllis Ackerman. Oxford, 1938–1939.

Exhibition of Islamic Art, Spinks. London, April 1977.

Faris, Nabih A., and Miles, George C. "An Inscription of Barbak Shah of Bengal." *Ars Islamica* 7 (1940): 141–146.

Fazl, Abu'l-. *A'in-i Akbari*. Translated by H. Blochmann. New Delhi, 1871.

Flury, S. "Ornamental Kufic Inscriptions on Pottery." In *A Survey of Persian Art*, edited by Arthur Upham Pope and Phyllis Ackerman, pp. 1770–1784. Oxford, 1938–1939.

Förtecknig över Greve Kellers samling av orientaliska och europeiska vapen. Auction catalogue No. 225, A. B. H. Bukowskis Konsthandel. Stockholm, 1920.

Frothingham, Alice W. *Fine European Earthenware*. Catalogue of an Exhibition at the Museum of Fine Arts, St. Petersburg, Florida. St. Petersburg, 1973.

Garner, H. *Oriental Blue and White*. London, 1954.

Gibb, E. J. W. *A History of Ottoman Poetry*. 2 vols. London, 1902.

Grabar, Oleg. *The Formation of Islamic Art*. New Haven, 1973.

————. "The Inscriptions of the Madrasah-Mausoleum of Qaytbay." In *Near Eastern Numismatics, Iconography, Epigraphy and History*, edited by D. K. Kouymjian, pp. 465–468. Beirut, 1974.

————. "The Umayyad Dome of the Rock in Jerusalem." *Ars Orientalis* 3 (1959): 33–62.

Gregorian, Vartan. "Minorities of Isfahan: The Armenian Community of Isfahan, 1587–1722." *Studies in Isfahan, Iranian Studies* 7 (1974): 652–680.

Grohmann, Adolf. "Anthropomorphic and Zoomorphic Letters in the History of Arabic Writing." *Bulletin de l'Institut d'Egypte*, 1958, pp. 117–122.

————. *Arabische Paläographie*. 2 vols. Vienna, 1967–1971.

————. "The Origin and Early Development of Floriated Kufi." *Ars Orientalis* 2 (1957): 183–214.

Grube, Ernest. "Four Pages from a Turkish 16th Century Shahnamah in the Collection of the Metropolitan Museum of Art in New York." In *Beiträge zur Kunstgeschichte Asiens: In Memoriam Ernest Diez*. Istanbul, 1963.

Hobson, R. L. *Catalogue of the George Eumorfopoulos Collection of Chinese, Corean, and Persian Pottery and Porcelain*. 6 vols. London, 1925.

————, and Hetherington, A. L. *The Art of the Chinese Potter*. London, 1924.

Huart, Clémente. *Les Calligraphes et les miniaturistes de l'Orient musulman*. Paris, 1908.

Husband, Timothy. "Valencian Lustreware of the Fifteenth Century: Notes and Documents." *Metropolitan Museum of Art Bulletin* 20, no. 1 (1970): 11–19.

L'Islam dans les collections nationales. Catalogue of an Exhibition at the Grand Palais. Paris, 1977.

Islamic Art across the World. Catalogue of an Exhibition at the Indiana University Art Museum. Bloomington, 1970.

Ivanov, Anatoli; Grek, Tania B.; and Akimushkin, Oleg. *Album Indiskikh i Persidskikh Miniatur*. Moscow, 1962.

Kahle, P. "Eine islamische Quelle über China um 1500." *Acta Orientalia* 12 (1934): 91–110.

Khaldun, Ibn. *The Muqaddimah*. Translated by F. Rosenthal. 3 vols. 2d ed. Princeton, 1967.

Khatibi, Abdelkebir, and Sijelmassi, Mohammed. *The Splendour of Islamic Calligraphy*. New York, 1977.

Kostigova, G. I. *Abrazcj kalligrafii Irana y sredneyi Azii* [Samples of the calligraphy of Iran and central Asia, fifteenth–nineteenth centuries]. Moscow, 1963.

————. "Trakat Sultan 'Ali Mashhadi." In *Trudi Gosud. Publ. Bibl. imeni Saltikova-Shchedrina* 2, n. 5 (1957): 103–163.

Kouymjian, Dickran K., ed. *Near Eastern Numismatics, Iconography, Epigraphy and History: Studies in Honor of George C. Miles*. Beirut, 1974.

Kratchkovskaya, Vera A. "Ornamental Naskhi Inscriptions." In *A Survey of Persian Art*, edited by Arthur Upham Pope and Phyllis Ackerman, pp. 1770–1784. Oxford, 1938–1939.

Kühnel, Ernst. *Islamische Kleinkunst*. Berlin, 1925.

————. *Islamische Miniaturmalerei*. Berlin, 1923.

————. *Islamische Schriftkunst*. 2d ed. Graz, 1972.

————. "Die Osmanische Tughra." *Kunst des Orients* 2 (1955): 71–82.

————, and Bellinger, Louise. *Catalogue of Dated Tiraz Fabrics: Umayyad, Abbasid, Fatimid*. Washington, D.C., 1952.

Laufer, Berthold. "Chinese Muhammedan Bronzes." *Ars Islamica* 1, part 2 (1934): 133–148.

Le Strange, George. *The Lands of the Eastern Caliphate*. 1905. Reprint, London, 1966.

Lings, Martin. "Andalusian Qorans." *British Museum Quarterly* 24 (1961–1962): 94–96.

————. *The Quranic Art of Calligraphy and Illumination.* London, 1977.

————, and Safadi, Yasin H. *The Qurʾan.* Catalogue of an Exhibition at the British Library. London, 1976.

Maʾani, A. *Catalogue of the Qurʾan Exhibition.* Tehran, 1966.

Martin, Frederick R. *The Miniature Paintings and Painters of Persia, India, and Turkey.* London, 1912.

Massé, Henri. "The Persian Inscriptions of Persia." In *A Survey of Persian Art,* edited by Arthur Upham Pope and Phyllis Ackerman, pp. 1795–1804. Oxford, 1938–1939.

Mayer, Leo A. *Islamic Armourers and Their Works.* Geneva, 1962.

————. *Islamic Metalworkers and Their Work.* Geneva, 1959.

————. *Islamic Woodcarvers and Their Works.* Geneva, 1958.

Medley, Margaret. *The Chinese Potter.* New York, 1976.

Melikian-Shirvani, Asadullah Souren. *Le Bronze iranien.* Paris, 1973.

————. "Safavid Metalwork: A Study in Continuity." *Studies on Isfahan, Iranian Studies* 7 (1974): 543–585.

Migeon, Gaston. *Manuel d'art musulman.* 2 vols. Paris, 1907.

Miles, George C. "Early Islamic Tombstones from Egypt in the Museum of Fine Arts, Boston." *Ars Orientalis* 2 (1957): 215–226.

Miner, Dorothy. "A Bracelet for a Princess." *Bulletin of the Walters Art Gallery* 15 (May 1963).

Minovi, M., et al. "Calligraphy: An Outline History." In *A Survey of Persian Art,* edited by Arthur Pope and Phyllis Ackerman, pp. 1707–1742. Oxford, 1938–1939.

Moritz, Bernhard. *Arabic Paleography.* Cairo, 1905.

Muhammad, Ibn Hassan al-Tibi. *The Kinds of Arabic Calligraphy According to the Method of Ibn al-Bawwab.* Edited by Salah al-Din al-Munajjid. Beirut, 1962.

Al-Munajjid, Salah al-Din. *Dirasat fi taʾrikh al-khatt al-ʿarabi* [Studies in the history of Arabic calligraphy]. Beirut, 1972.

————. *Le Manuscrit arabe.* Cairo, 1960.

Nagel, L. O. "Some Middle Eastern Ceramics in the City Art Museum of St. Louis." *Oriental Art* 4 (1958).

Ostoia, V. K. *The Middle Ages: Treasures from the Cloisters and the Metropolitan Museum of Art.* Catalogue of an Exhibition at the Los Angeles County Museum of Art and the Art Institute of Chicago. Los Angeles and Chicago, 1970.

Pal, Pratapaditya, ed. *Islamic Art: The Nasli M. Heeramaneck Collection.* Los Angeles County Museum of Art, 1973.

Palmer, E. H. *Oriental Penmanship.* London, 1886.

Pickthall, Marmaduke, trans. *The Glorious Koran.* London, 1976.

Pinder-Wilson, Ralph H. *Paintings from the Muslim Courts of India.* Catalogue of an Exhibition Held at the British Museum. London, 1976.

Pope, Arthur Upham, and Ackerman, Phyllis, eds. *A Survey of Persian Art.* Oxford, 1938–1939.

Pope, John A. *Chinese Porcelains from the Ardebil Shrine.* Washington, D.C., 1956.

Qadi Ahmad. *Calligraphers and Painters.* Translated by Vladimir Minorsky. Washington, D.C., 1959.

Rabino, H. L. *Mazandaran and Astarabad.* E. J. W. Gibb Memorial, New Series, vol. 7. London, 1928.

Rice, David Storm. "Arabic Inscriptions on a Brass Basin Made for Hugh IV de Lusignan." *Studi orientalistici in onore di Giorgio Levi della Vida* [Rome] 2 (1956): 390–402.

————. *The Unique Ibn al-Bawwab Manuscript in the Chester Beatty Library.* Dublin, 1955.

Robertson, Edward. "Muhammad ibn ʿAbd al-Rahman on Calligraphy." *Studia Semitica et Orientalia* [Glasgow] 1920, pp. 57–83.

Robinson, Basil. *Descriptive Catalogue of the Persian Paintings in the Bodleian Library.* Oxford, 1958.

Robinson, Basil, et al. *Islamic Painting and the Arts of the Book: The Keir Collection.* London, 1976.

Rodinson, Maxime. "Le Monde islamique et l'extension de l'écriture arabe." In *L'Ecriture et la psychologie des peuples.* Paris, 1963.

Rogers, Alexander, and Beveridge, Henry, trans. *The Tuzuk-i Jahangiri* [Memoirs of Jahangir]. 1909–1914. Reprint, Delhi, 1968.

Röhrborn, K. M. *Provinzen und Zentralgewalt Persiens im 16. und 17. Jahrhundert.* Berlin, 1966.

Rosen-Ayalon, Miriam. "Four Iranian Bracelets Seen in the Light of Early Islamic Art." In *Islamic Art in the Metropolitan Museum of Art,* edited by Richard Ettinghausen, pp. 169–186. New York, 1972.

Rosenthal, Franz. "Abu Haiyan al-Tawhidi on Penmanship." *Ars Islamica* 13–14 (1948): 1–30.

————. "Significant Uses of Arabic Writing." *Ars Orientalis* 4 (1961): 15–23.

Schimmel, Annemarie. *Islamic Calligraphy.* Leiden, 1970.

————. "Nur ein störrisches Pferd." In *Festschrift George Widengren.* Leiden, 1972.

————. "Schriftsymbolik im Islam." In *Aus der Welt der islamischen Kunst: Festschrift für Ernst Kühnel,* edited by Richard Ettinghausen, pp. 244–254. Berlin, 1959.

————. "Turk and Hindu." In *Proceedings of the Levi della Vida Conference.* Vol. 4. Wiesbaden, 1975.

Schroeder, Eric. "What Was the Badiʿ-Script?" *Ars Islamica* 4 (1937): 232–248.

Sellheim, Rudolf. "Die Madonna mit der Schahada." In *Fest-schrift Werner Caskel*. Leiden, 1968.

Serjeant, R. B. "Material for a History of Islamic Textiles up to the Mongol Conquest." *Ars Islamica* 13–14 (1948): 75–87.

Skelton, Robert. "Indian Painting of the Mughal Period." In *Islamic Painting and the Arts of the Book*, edited by B. W. Robinson et al. London, 1976.

Sotheby & Co. *Catalogue of Highly Important Oriental Manu-scripts and Miniatures*. London, December 7, 1970.

Sourdel-Thomine, Janine. "Le Coufique alépin de l'époque seljoukide." *Mélanges Louis Massignon* 3 (1957): 301–317.

———. "L'Ecriture arabe et son évolution ornementale." In *L'Ecriture et la psychologie des peuples*. Paris, 1963.

———. "Les Origines de l'écriture arabe à propos d'une hypothèse récente." *Revue des Etudes* 34, pp. 151–157.

Soustiel, Jean. *Objets d'art de l'Islam*. Paris, 1973.

Spuler, Berthold. *Die Mongolen in Iran*. 3d ed. Berlin, 1968.

Stern, S. M., ed. *Documents from Islamic Chanceries*. First Series. Oxford, 1965.

Volov-Golombek, Lisa. "Plaited Kufic on Samanid Epigraphic Pottery." *Ars Orientalis* 6 (1966): 107–134.

Watson, Oliver. "The Masjed-i ʿAli Quhrud: An Architectural and Epigraphical Survey." *Iran* 13 (1975).

Welch, Anthony. *Artists for the Shah*. New Haven, 1976.

———. *Collection of Islamic Art: Prince Sadruddin Aga Khan*. 4 vols. Geneva, 1972–1977.

———. "Epigraphs as Icons: The Role of the Written Word in Islamic Art." In *The Image and the Word: Confrontations in Judaism, Christianity, and Islam*, edited by J. Gutmann, pp. 63–74. American Academy of Religion and Society of Bibli-cal Literature, Religion and the Arts Series No. 4. Missoula, 1977.

———. "Patrons and Calligraphers in Safavi Iran." *MELA Notes* 12 (October 1977): 10–15.

———. *Shah ʿAbbas and the Arts of Isfahan*. New York, 1973.

Welch, S. C. *Indian Drawings and Painted Sketches*. New York, 1976.

———. "Portfolio." *Marg* 16, no. 2 (1963).

Wiet, Gaston. "The Arabic Inscriptions of Persia." In *A Survey of Persian Art*, edited by Arthur Upham Pope and Phyllis Ackerman, pp. 1785–1794. Oxford, 1938–1939.

———. *Répertoire chronologique d'épigraphie arabe*. 16 vols. Cairo, 1931–1964.

———. "La Valeur décorative de l'alphabet arabe." *Arts et Métiers Graphiques*, October 15, 1935, pp. 9–14.

Wilbur, Donald. *The Architecture of Islamic Iran: The Il-Khanid Period*. Princeton, 1955.

Wilkinson, Charles K. *Iranian Ceramics*. New York, 1933.

Zaky, A. Rahman. "On Islamic Swords." In *Studies in Islamic Art and Architecture in Honour of K. A. C. Creswell*. Cairo, 1965.

Zayn, Naji, al-Din. *Mutawwar al-khatt al-ʿarabi* [Atlas of Arabic calligraphy]. Baghdad, 1968.

Zeller, Rudolph, and Rohrer, Ernest. *Orientalische Sammlung Henri Moser-Charlottenfels: Beschreibender Katalog der Waffensammlung*. Bern, 1955.

Ziauddin, M. *Moslem Calligraphy*. Calcutta, 1936.

RITTER LIBRARY
BALDWIN-WALLACE COLLEGE

DATE DUE

JUN 1989		
NOV 1 5 1993		
WITHDRAWN		

DEMCO 38-297